A Guide to
Drawing

A Guide to Drawing

Daniel M. Mendelowitz

Holt, Rinehart and Winston / New York

Library of Congress Cataloging in Publication Data

Mendelowitz, Daniel Marcus.
A guide to drawing.

First ed. published in 1967 under title: Drawing: a study guide.
1. Drawing—Instruction.
2. Drawings.
I. Title.
NC730 1975 741 75-25923

College ISBN: 0-03-086565-4
Trade ISBN: 0-03-089937-0

Preface

A Guide to Drawing is an introduction to the materials, skills, and techniques of this most spontaneous and direct visual art. It provides a step-by-step program whereby the beginning artist, alone or under the direction of a teacher, can gradually explore the various aspects of draftsmanly expression.

In writing *A Guide to Drawing* I have attempted to distill the best elements from two previous volumes: *Drawing,* a historical survey of master works; and its *Study Guide,* which offered—by means of a series of "projects"—a practical outline of the art elements and materials involved in drawing. Thus, the present book integrates a cumulative progression of studio exercises with a bounteous selection of master drawings, the latter reproduced both for their intrinsic value as works of art and as a direct stimulus to the practicing artist. The exercises are designed in such a way that they will encourage the novice draftsman to develop habits and capacities that ultimately combine to build assurance in drawing.

The format of this new volume follows to a large extent that of the *Study Guide;* however, in order to make *A Guide to Drawing* a truly self-sufficient and useful handbook, I have made several changes and additions—changes that justify the independent title. Four completely new chapters, each dealing with a traditional area of subject matter—figure drawing, landscape, portraiture, and still life—introduce the beginner to the problems and delights particular to those genres. A greatly expanded series of black-and-white illustrations enables us to show how artists of the past and present have dealt with various types of expression. And a selection of 21 full-color plates serves to demonstrate the sumptuously rich form drawings can take when they venture beyond the limits

of black and white. One entire chapter, also new to this book, is devoted to the subject of color in drawings.

While the projects and concepts in this book do follow a program of increasing sophistication, this is not meant to dictate a rigid course of study for individuals or teachers. The beginning artist working alone with this book will inevitably want to pursue aspects of drawing that are of special interest to him or her, ignoring those that provide no challenge or inspiration. Similarly, the teacher who utilizes this book in the classroom no doubt will draw upon it as a starting point from which to elaborate on favorite problems and procedures. I have attempted to make the book as flexible as possible, so that it will serve the needs of many situations.

A Guide to Drawing is divided into six parts. After a general introduction to the nature of drawing that comprises Part I, Part II concentrates on certain familiar and easily accessible drawing materials. It goes on to explore the ways a beginner can learn to visualize, to symbolize, and to see. A group of simple exercises, such as doodling and scribbling, begins to develop notations that will become the trademark, the pictorial signature of an artistic personality.

Each of the chapters in Part III discusses in some detail one of the basic art elements—line, value, perspective, texture, and color. Part IV offers a systematic treatment of the various drawing media, and Part V considers each of the four broad areas of interest that artists have traditionally pursued. Because it is the quality of imagination, above all else, that distinguishes the artist from the competent craftsman, I have devoted Part VI to a discussion of this most elusive concept. To the degree that imagination is present, it is invaluable. And, like other capacities, it can be developed by a continuous involvement in creative activity. In a sense, then, the final chapter represents the overall aim of this book—to exploit to the fullest the innate expressive resources of each individual who seeks to learn the art of drawing.

A number of people have helped in the preparation of *A Guide to Drawing*, and I wish to thank them. The staff at Holt, Rinehart and Winston have been continuously supportive and dedicated to the excellence of the book. Professors David A. Lauer of the College of Alameda and John Hunter of San José State University offered extremely interesting and useful comments on a first draft of the manuscript, and I have gratefully adopted many of their suggestions. Finally, and most important, the unflagging devotion and help of my wife Mildred actually made this book possible.

Stanford, California D. M. M.
December 1975

Contents

one

Introduction

The Nature
of Drawing

In the literature of drawing and its history, there is an unusual occurrence of words that carry special implications of affection—"delightful," "intimate," "spontaneous," "direct," "unlabored." These adjectives reveal the love that many critics and connoisseurs feel for this particular form of artistic expression. Part of the reason for this fondness must certainly reside in the very informal and personal nature of the body of master drawings that comprise our legacy from the past. Unlike more elaborately finished works, drawings offer an intimate contact with the act of creation and thereby permit the viewer insights into the artist's personality. Like notes in a diary, drawings often present direct notation made by the artists for themselves alone, free of artificial elaboration or the excess finish that may impress the unsophisticated.

If we compare a master painting with one of its preparatory sketches, we see not only the different approach and manner of execution characteristic of the two processes, but we also find hints of the artist's progress in conceptualization (Figs. 1, 2). In the drawing, we can sense the impulses that formed the final work, can perhaps see the gestation process that accompanied its creation. An exciting empathy occurs as we recognize the artist's enthusiasms, the sense of discovery, the lively interplay of hand, eye, mind, brush, pen or pencil, and paper—all intensely human aspects of the creative act.

Another factor also helps to explain the appeal and power of drawing. The incomplete or fragmentary work, precisely because it does not provide

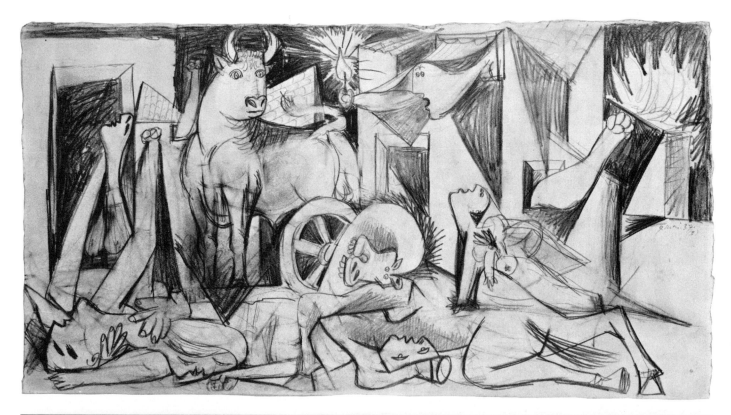

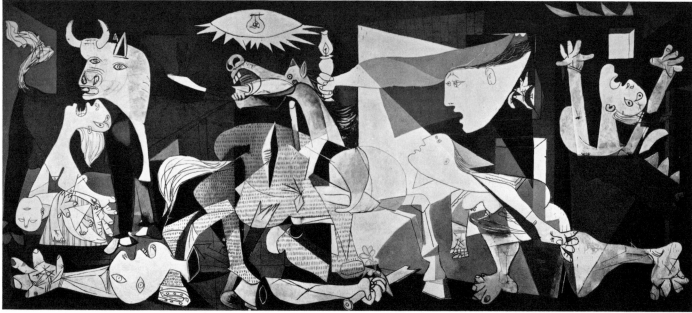

top: 1. PABLO PICASSO
(1881–1973; Spanish-French).
Compositional Study for "Guernica." May 9, 1937.
Pencil on white paper, $9\frac{1}{2} \times 17\frac{7}{8}''$.
Formerly collection the artist.

above: 2. PABLO PICASSO
(1881–1973; Spanish-French).
Guernica. 1937.
Oil on canvas, $11'5\frac{1}{2}'' \times 25'5\frac{3}{4}''$.
On extended loan from the artist's estate
to the Museum of Modern Art, New York.

4 *Introduction*

a fully developed statement, may evoke a greater play of the observer's imagination than does a more finished expression. We might seek a parallel in the fact, known to every parent, that children often prefer as playthings the empty boxes their toys came in, rather than the elaborate toys themselves. A box, after all, can be a hundred different things, whereas a fire engine is always a fire engine. So it is with drawing: the viewer can interpret and experience a sketchy work in terms he or she finds most meaningful. A finished painting, on the other hand, offers much more information, so that the viewer's responses are channeled. Our minds can readily supply the unspecified details in Eugène Delacroix's *Arab on Horseback Attacked by a Lion* (Fig. 3). The

3. EUGÈNE DELACROIX (1798–1863; French). *An Arab on Horseback Attacked by a Lion.* 1849. Pencil on tracing paper, $18\frac{1}{2} \times 12''$. Fogg Art Museum, Harvard University, Cambridge, Mass. (Meta and Paul J. Sachs Collection).

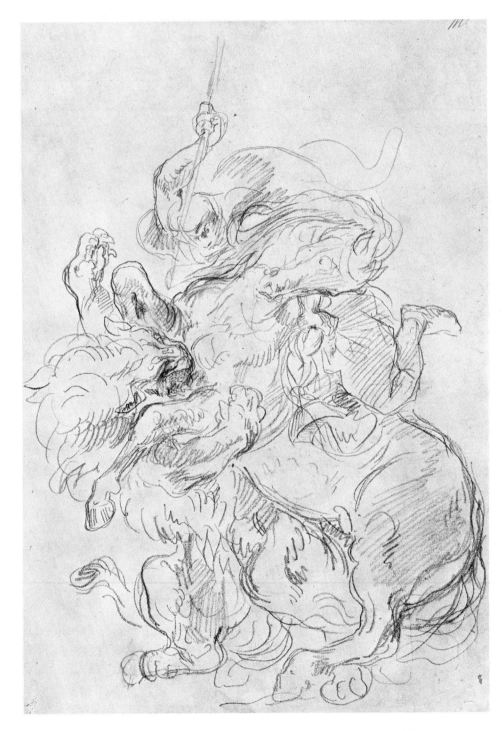

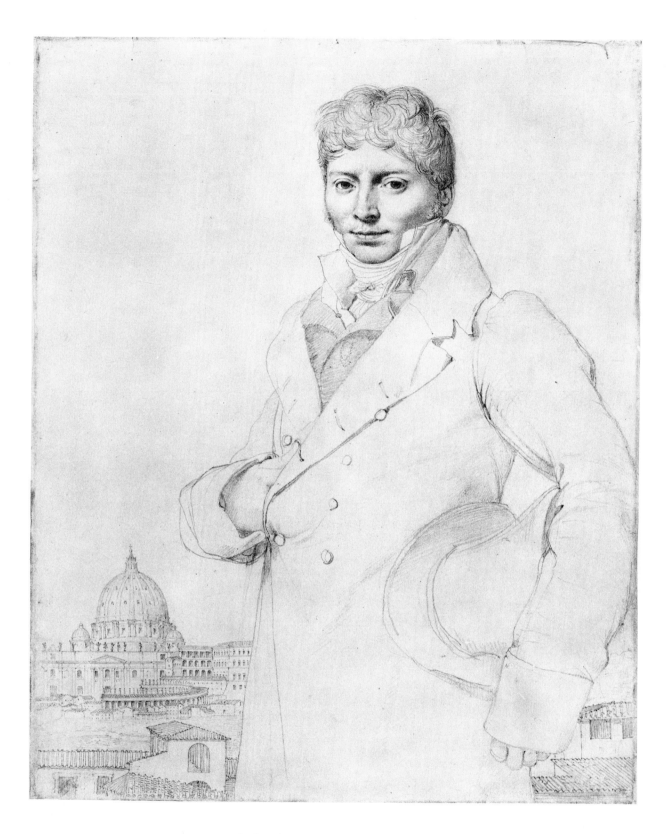

artist's sketchy jottings evoke vivid textural visions of torn and battered flesh, swirling robes punctuated by quick thrusts of the spear. We can imagine the frightened squeals and vicious snarls that must accompany the violent struggle. By contrast, a carefully finished work achieves a kind of closure, through its finite forms, that largely excludes such imaginative wanderings on the part of the viewer (Fig. 4).

What is Drawing?

The word "drawing" is used today almost exclusively in relation to the visual arts, and its meaning is generally understood. However, the origins of its precise definition offer interesting insights. "Draw" comes from a source common to both Latin and Teutonic languages and means to "pull" or "drag"—an idea still evident in nonartistic contexts, as when we say "drawing a cart across the road." Of course, the act of drawing implies pulling or dragging a tool across a receptive background, usually a piece of paper.

A quick glance through Part IV of this book will reveal that drawing encompasses a potentially endless variety of media (Fig. 5). While it is perhaps

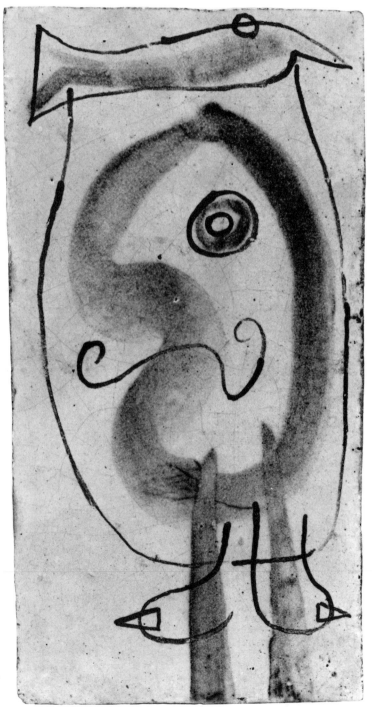

opposite: 4. Jean Auguste Dominique Ingres (1780–1867; French).
Portrait of Dr. Robin. c. 1808–09.
Pencil, 11 × 8¾".
Art Institute of Chicago
(gift of Emily Crane Chadbourne).

right: 5. Joan Miró (1893– ; Spanish-French), in collaboration with
Joseph Lloret Artigas (1892– ; Spanish-French).
Femme. 1955–56. Ceramic tile, 8⅞ × 4½".
Courtesy Pierre Matisse Gallery, New York.

The Nature of Drawing **7**

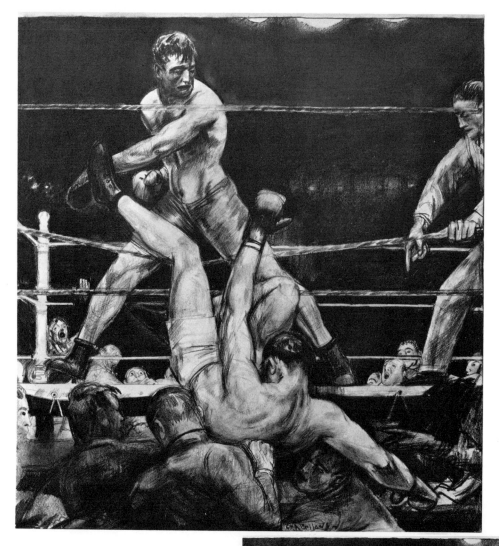

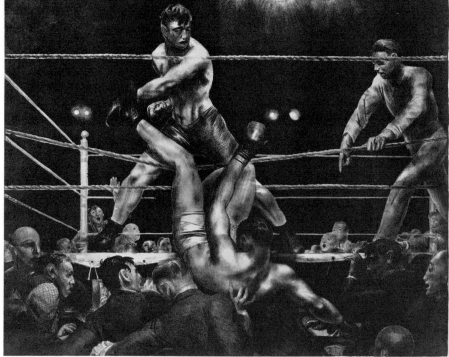

above: 6. GEORGE BELLOWS
(1882–1925; American).
Dempsey Through the Ropes. 1923.
Black crayon, $21\frac{1}{2} \times 19\frac{5}{8}''$.
Metropolitan Museum of Art, New York.

right: 7. GEORGE BELLOWS
(1882–1925; American).
Dempsey and Firpo. 1924.
Lithograph, $18\frac{1}{8} \times 22\frac{3}{8}''$.
Museum of Modern Art, New York.

8. M. C. ESCHER (1898–1972; Dutch).
Drawing Hands. 1948.
Lithograph, $11\frac{1}{4} \times 13\frac{3}{8}''$.
Escher Foundation,
Gementemuseum, The Hague.

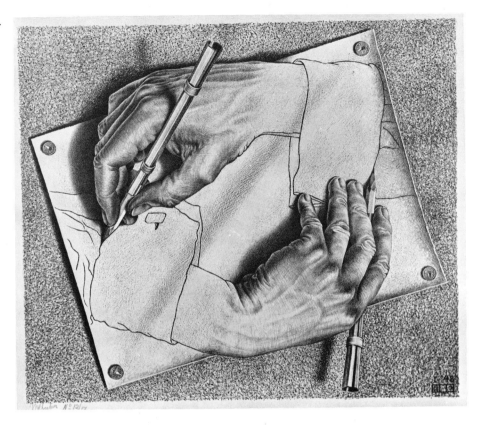

more common to think of drawing in terms of black marks on white paper, many drawings include color, even a full spectrum of colors, and at some point it may be almost impossible to separate drawing from painting. The only functional distinction is that most paintings exploit the weight and viscosity of such media as oils or acrylics to achieve what is termed a "painterly" quality; the consistency of the material makes up an important feature of the art's character. Drawings rarely exhibit this quality. The medium tends to lie flat on the ground or be absorbed into it, for while drawing can skillfully convey the illusion of three dimensions, it is, in fact, primarily two-dimensional expression.

One source of confusion is the common reference to drawing as a "graphic art." Technically, this term should be reserved for print processes such as etching, lithography, engraving, and silk screen, all of which involve the creation of *multiple* images from a master plate, block, or screen. Each drawing, by comparison, is unique, calling for the initial and direct application of image to ground. A drawing by George Bellows of the famous Dempsey-Firpo fight compares interestingly with the lithograph Bellows developed from it the following year (Figs. 6, 7). The two works are sufficiently similar in character that we can readily understand how a word like "graphic" can be applied indiscriminately to either. A lithograph of the act of drawing by that master wit and contriver M. C. Escher adds an amusing note to our discussion of mistaken identity (Fig. 8).

In attempting to describe what drawing is, we have tended to emphasize what drawing is *not*. This is because, in all the visual arts, categorization has become increasingly less important, and the lines separating one area of endeavor from another have blurred. We would have equal difficulty in isolating the nature of painting—as distinct from sculpture or drawing—in the work of some contemporary artists. The modern artist worries little about what process is being done, caring primarily that the desired effect is achieved.

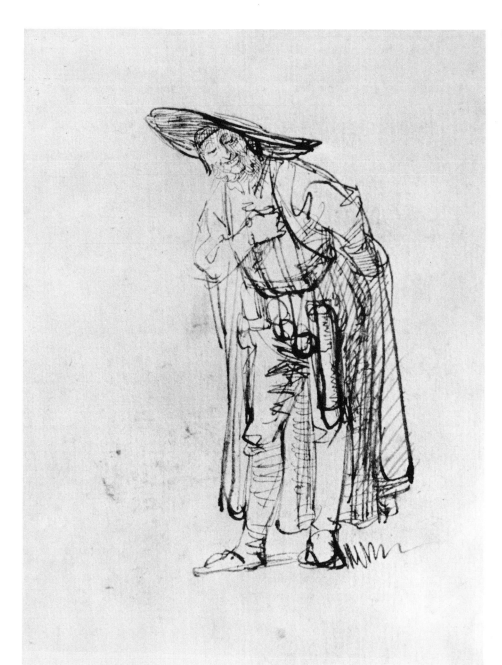

In spite of all these ambiguities, however, it is usually possible to identify a drawing—by medium, support, size, directness of approach, or all of these. And this ephemeral quality that marks a work as "drawing" constitutes its special charm.

Types of Drawings

Chapter 3 discusses at length the various types of drawings and the functions they can perform. However, as an introduction to the art, we should briefly touch upon the different roles drawing can fill. We might identify three broad categories.

To many, drawing means recording that which is before the eyes. This may entail a quick sketch executed in a personal shorthand that demonstrates the unique traits of the artist (Figs. 9–11) or a carefully observed study, greatly

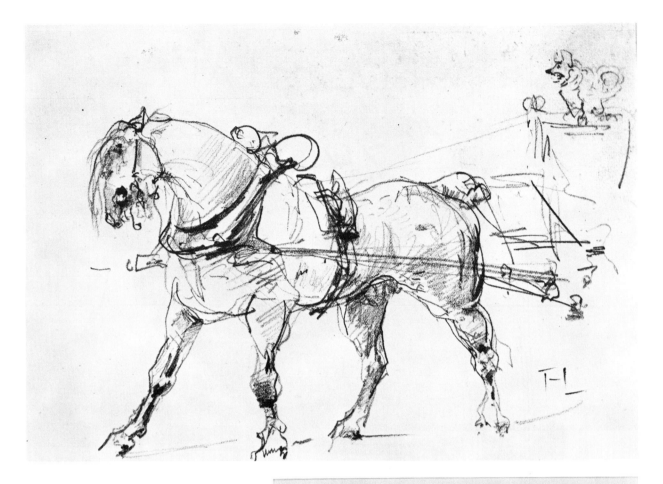

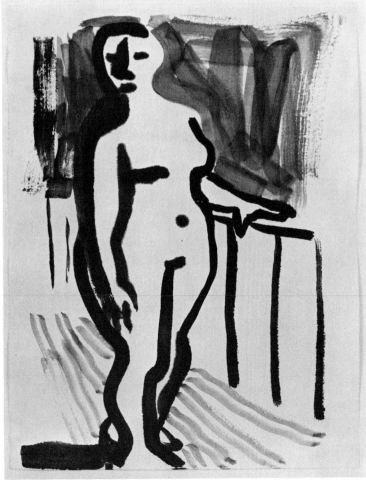

above: 10. HENRI DE TOULOUSE-LAUTREC
(1864–1901; French).
Horse and Carriage. c. 1880–82.
Pencil, $6\frac{1}{4} \times 10\frac{1}{8}''$.
Baltimore Museum of Art
(Wilmer Hoffman Bequest).

right: 11. DAVID PARK (1911–60; American).
Standing Nude. 1960. Ink, $11\frac{1}{8} \times 8\frac{1}{8}''$.
Courtesy Maxwell Galleries, Ltd.,
San Francisco.

detailed and nearly photographic in its accuracy (Figs. 12, 13). Such a drawing could be done in pure line (Fig. 14) or with lights and shadows for modeling (Fig. 15). The artist might choose to enrich it with highlights (Fig. 16) or with color (Pl. 1, p. 25).

Drawing can also describe a nonexistant situation or an object conceived in the imagination of the artist (Figs. 17, 18). It could even be an abstract

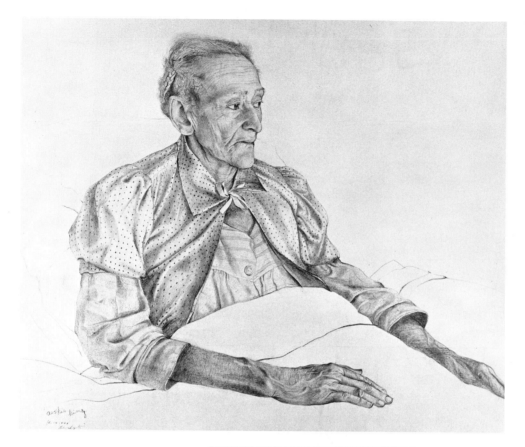

above: 12. ANDREW WYETH (1917– ; American). *Beckie King.* 1946. Pencil, 28½ × 34″. Dallas Museum of Fine Arts (gift of Everett L. DeGolyer).

right: 13. ROBERT BAXTER (1933– ; American). *Boundary Line,* detail. 1969. Silverpoint on gesso panel, 27 × 40″ (entire work). Courtesy the artist.

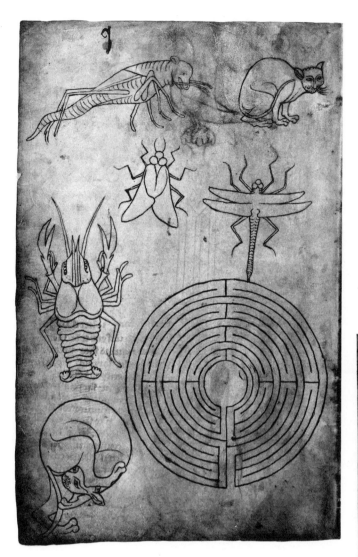

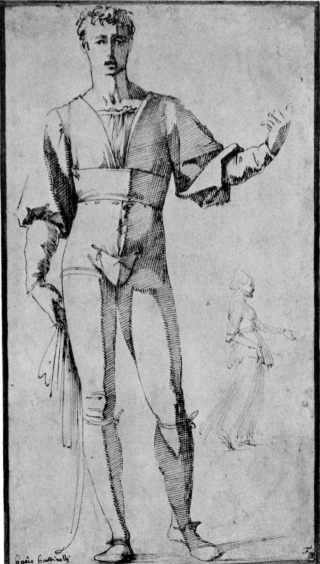

above: 14. VILLARD DE HONNECOURT (13th century; French).
Insects, Animals, and a Maze, page from a sketchbook.
c. 1240. Crayon, $9\frac{7}{8} \times 6''$.
Bibliothèque Nationale, Paris.

right: 15. BACCIO BANDINELLI (1493–1560; Italian).
Study of a Young Man in Contemporary Dress.
Pen and brown ink, $15\frac{3}{8} \times 8\frac{1}{2}''$.
Chatsworth Collection, Derbyshire, England.

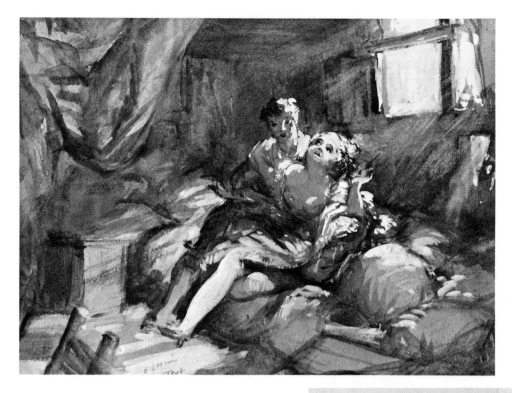

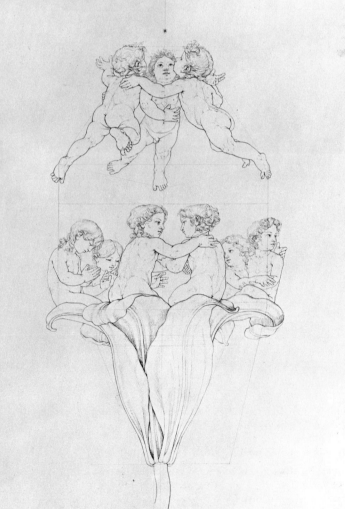

above: 16. EVERETT SHINN (1876–1953; American).
Lovers. 1908. Brown wash, red charcoal,
and Chinese white on tan paper, $10\frac{3}{16} \times 12\frac{7}{8}''$.
Allen Memorial Art Museum, Oberlin College, Ohio
(R. T. Miller, Jr. Fund).

right: 17. PHILLIP OTTO RÜNGE (1777–1810; German).
Die Lichtlilie mit Schwebenden Genien
(*Lily with Hovering Genii*). 1809.
Pen and ink, $26\frac{1}{2} \times 17\frac{11}{16}''$. Kunsthalle, Hamburg.

vision that gives few if any clues to its figurative origins—if indeed these exist. Controlled splotches, smears, streaks, and runs, valued for their own expressive character as well as for their textural variety, add still another dimension to the abstract repertoire (Fig. 19).

A third category of drawings includes those that employ familiar symbols in the visualization of ideas and concepts. A plan, diagram, or cartoon (Figs.

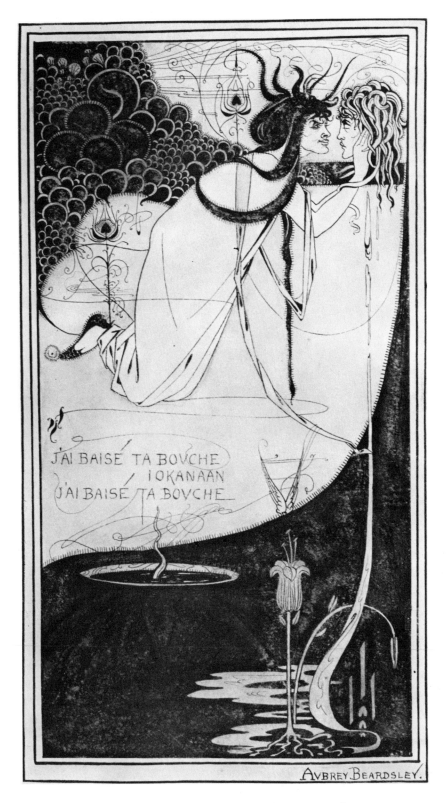

18. AUBREY BEARDSLEY (1872–98; English).
J'ai Baisé Ta Bouche, Jokanaan. 1893.
Pen and ink, $10\frac{7}{8} \times 5\frac{3}{4}''$.
Princeton University Library, N. J.

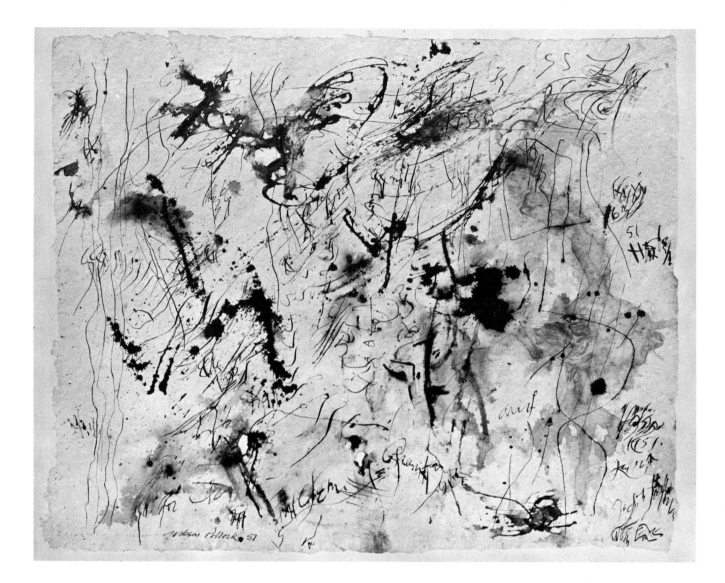

19. Jackson Pollock
(1912–56; American).
Birthday Card. 1951.
Ink and wash, 16 × 20″.
Collection Clement Greenberg,
New York.

20–22), a study done to analyze a complex project (Fig. 23), or an intricate detail forming part of a larger work (Fig. 24)—all exemplify the expressive function of drawing that allows precise yet fluid communication beyond the power of words.

The Creative Process

Creative behavior might be described as the potential to create or invent. The creative person has the ability to react to stimuli in fresh and unpredictable ways, a quality we call originality; to translate original responses into visual statements; and to give free rein to a kind of playfulness or invention.

Studies of creativeness have identified the steps that seem to occur in the course of any creative activity, whether in the arts, in science, or in other fields of endeavor. There appear to be four main phases, which can be described as *impulse, gestation, outpouring,* and *refining.* The artist "has an idea." It may emerge from an assigned problem (a commission, for example), from seeing a potential subject, or from any other stimulus. Frequently, the source of the idea remains unknown to the artist. After the impulse has manifested itself, the second phase occurs in the form of a period of gestation. The artist may play with a drawn form, abstract it, embellish it, modify it.

below: 20. MAGGIE WESLEY (1918– ; American).
Improper Use of Government Property is Frowned Upon.
1963. Silk screen, 30 × 40″.
Designed for Lockheed Missiles and Space Co.,
Sunnyvale, Calif. Courtesy the artist.

right: 21. Generalized acariform mite.
Anterior (A) and lateral (B) views.

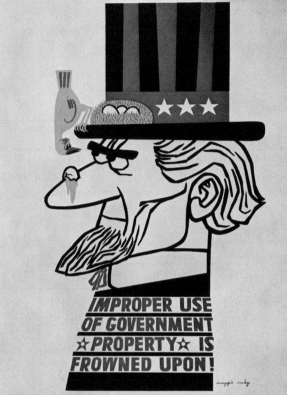

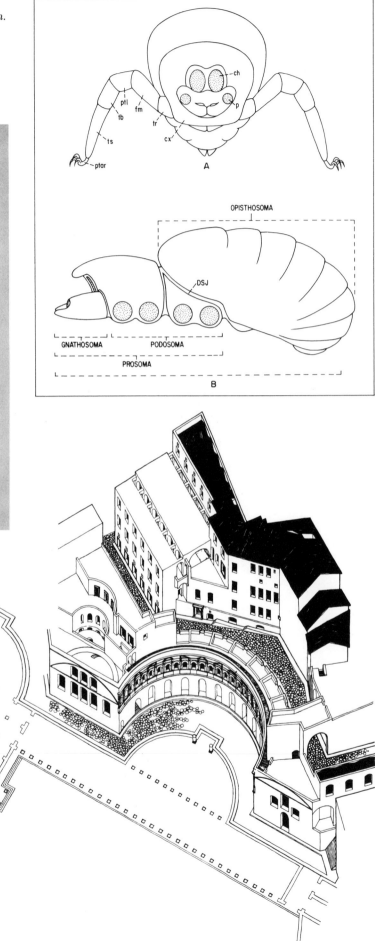

22. Market area, Forum of Trajan, Rome.
A.D. c. 115. Isometric reconstruction.

Often the initial impulse lies dormant during this phase, evolving and taking form in the subconscious mind. The third and most apparent step occurs when the imaginative projection assumes concrete form, when the drawing is committed to paper. If the gestation period has been fruitful, this producing phase may take place as a spontaneous outpouring, in which forms and relationships come easily, materials are handled without effort. Finally, the artist views the work with a critical eye, refines, reshapes, and makes minor changes. The artist assumes the role of an outsider, consciously adjusting the work to meet personal standards.

Of course, no serious artist would deliberately pigeonhole the creative process into these stages. In practice they blend, overlap, and flow into one another in a continuum that bridges the gap between vague idea and final work of art.

The Role of Drawing Today

Like much else in our artistic heritage, our conceptions about the role of drawing in the arts come to us largely from the Renaissance. It was during the early years of this period that drawing, as we now practice it, became established as the foundation of training in the arts. A long-term academic apprenticeship, which called for drawing from nature as well as copying studies executed by master artists, prepared students for their profession. In

23. HANS HOLBEIN THE YOUNGER (1497–1543; German).
The Family of Sir Thomas More. 1526.
Pen and ink, $15\frac{7}{16} \times 20\frac{1}{4}''$.
Kupferstichkabinett,
Offentlichen Kunstsammlung, Basel.

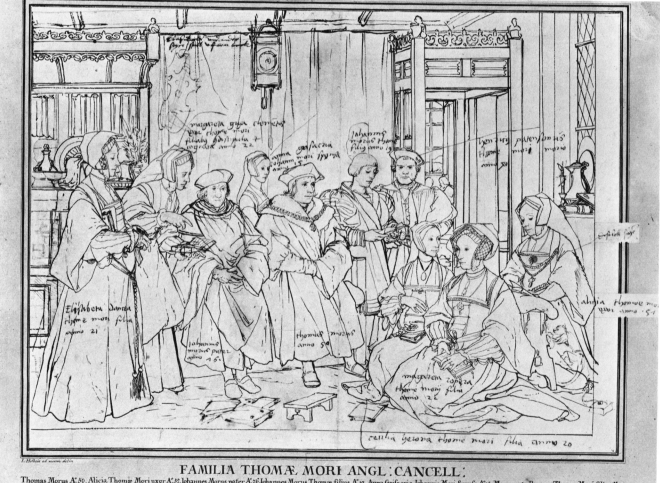

FAMILIA THOMÆ MORI ANGL : CANCELL :

Thomas Morus A: 50. Alicia Thomæ Mori uxor A: 57. Iohannes Morus pater A: 76. Iohannes Morus Thomæ filius A: 19. Anna Grisacria Iohannis Mori Sponsa A: 15. Margareta Ropera Thomæ Mori filia A: 22.
Elisabeta Damea Thomæ Mori filia A: 21. Cæcilia Heroina Thomæ Mori filia A: 20. Margareta Giga Clementis uxor Mori filiabus Condiscipula et cognata A: 22. Henricus Patensonus Thomæ Mori morio A: 40.

24. RAPHAEL (Raffaello Sanzio; 1483–1520; Italian).
Study for Madonna and Child with Book.
Entire composition with sketch of the landscape (above);
study of the Child (verso, below).
c. 1504. Pen and brown ink, $5\frac{1}{2} \times 5\frac{1}{8}''$.
Ashmolean Museum, Oxford.

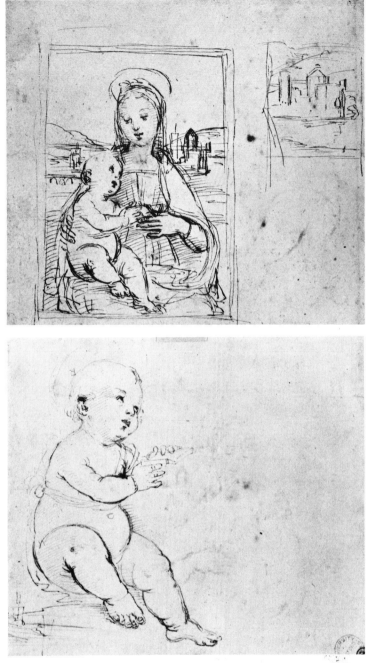

later centuries this system, with only slight alteration, continued as the accepted means of artistic training.

In the 20th century this procedure has been seriously challenged. The impact of abstract painting, of expressionism, conceptualism, minimal art, and other contemporary movements tends to make the arduous disciplines of earlier times seem irrelevant to the needs of the contemporary student. Many teachers and students go further: they feel that highly structured training can even inhibit the development of original and innovative forms of expression by encouraging students to depend upon trite and outworn formulas, rather than allowing their inner resources free play.

The early training of artists as diverse as Matisse, Picasso, Klee, Kandinsky, and Mondrian—all schooled in the conventional regimen—would seem to contradict this attitude. Henri Matisse himself, in a 1948 letter, wrote:

The Nature of Drawing **19**

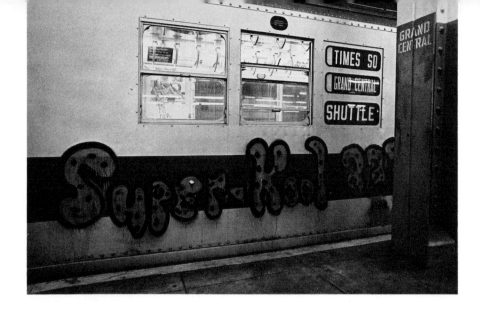

25. Graffito. 1973. Spray paint on a subway car. New York.

I have always tried to hide my own efforts and wished my work to have the lightness and joyousness of a springtime which never lets anyone know the labors it has cost. So I am afraid the young, seeing in my work only the apparent facility and negligence in the drawing, will use this as an excuse for dispensing with certain efforts I believe necessary.

The initial experiences of the beginner leave an indelible imprint upon subsequent development. While academic procedures of the rigidity maintained in the ateliers of past masters no longer seem appropriate, a program of introductory guidance and instruction remains vital to artistic development.

Rather than abandoning the discipline of drawing as irrelevant to contemporary art, we must learn to reinterpret the craft in terms of today's standards. A much wider range of expression is now accepted as drawing than was true in the past. This is a natural outgrowth of the increased variety of styles that exist generally in the art world, where abstractions (Fig. 19) flourish side by side with the most disciplined realism (Fig. 355) or with exuberant whimsey (Fig. 343). Our increased catholicity of taste is to an equal extent the result of psychological understanding about the nature of human beings, with a consequent sympathy toward a broader range of expression.

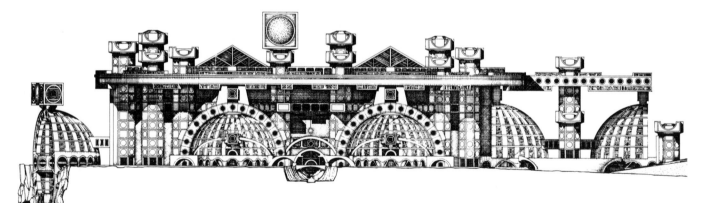

26. PAOLO SOLERI
(1919– ; Italian-American).
Arcosanti (elevation for a proposed megastructure). c. 1969.
Pen and ink, approx. 4 × 13′.

Drawing has an essential role to play in our world, both as a means to an end—in the development or conceptualization of other expressions—and as an end in itself. The popularity of such representational styles as Photorealism testifies to a felt need for draftsmanly qualities in art. Most important, however, is the immediacy of drawing—a quality perfectly in tune with the spontaneity and free expression so prized in contemporary society. From the garish graffito (Fig. 25) to the meticulously finished pen-and-ink sketch (Fig. 26), drawing is very much an art of today.

two
Initial Experiences

The subject chapters that follow have been structured around a series of "projects" with specific instructions for the novice artist. In order that each student be stimulated in the realization of his or her unique personal capacities, the projects encompass a very wide range of activities.

Students working without a teacher might prefer to carry out the suggested projects in the order in which they appear. Generally speaking, the exercises increase in difficulty throughout the progress of the book, although there is no rigid adherance to this scale. Even if all the projects are not executed, the student should read each one carefully, so that the concept presented will be understood. With increasing development of skills, confidence, and intensive interests, the student may wish to concentrate on one type of drawing, one medium, or one variety of subject. This natural tendency should be exploited, since growth in *depth* is more important to artistic maturity than growth in *breadth*. Breadth of experience serves the primary function of helping individuals to find themselves. It is true, however, that any serious and intensive activity eventually demands an expansion of horizons. The beginner must constantly guard against the tendency to buttress an emerging artistic ego by repeating minor successes and thus neglecting the possible discovery of full strengths and capacities.

The work of most mature artists reveals a pattern of periods of intensive concentration within a narrow framework of special problems alternating with periods of exploration and experimentation. The beginner will be wise to travel a similar path, concentrating on areas of particular interest as long as they remain challenging but, when success comes too easily, moving on to something else. Exploration in breadth combined with concentration in depth requires the unique discipline that characterizes the artist—an inner control in which deep satisfactions and dynamic dissatisfactions alternate to stimulate continued growth. Through such a discipline the art student discovers and reveals personal abilities, establishing the basis for mature artistic expression.

Beginners' Media

Beginners should concentrate on media that demand little skill. The important thing is to draw as freely and uninhibitedly as possible, so that the transmission of impressions, ideas, and impulses will be direct and unself-conscious. Pencil, charcoal, ball-point pen, felt-tip pen, and brush and ink should meet initial needs and provide ample possibilities for expression. The following equipment and materials are generally standard and suffice to commence working (Fig. 27); other materials and tools can be added later.

 drawing board (basswood), 20 by 26 inches
 thumb tacks (to hold individual pieces of paper to the drawing board)
 newsprint pad, 18 by 24 inches
 heavy clips (to hold newsprint pad to the drawing board)
 4B or 6B graphite drawing pencil
 large soft pencil eraser
 stick charcoal (soft) and compressed charcoal (0 or 00)
 kneaded eraser
 chamois
 fixative (and fixative blower if fixative does not come in pressurized cans)
 ball-point and felt-tip pens (medium and wide)
 India ink
 medium-size pointed brush (No. 10), of the best quality you can afford

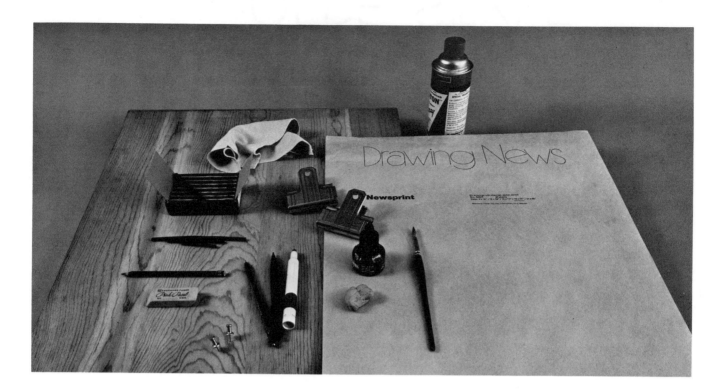

Charcoal

Charcoal is easy to apply and to remove; it provides a rich and versatile medium for the beginner. At the outset, one should not overvalue expertise. Timidity most often inhibits development, while a relaxed use of charcoal encourages the direct expression of perceptions. Depending on the angle of the stick and the pressure exerted upon it, charcoal lines will be pale, very dark, even in width, or of varying widths, creating a repertoire for line drawings as well as for value studies (Fig. 28). Charcoal is particularly prized

above: 27. Beginners' materials include: drawing board, newsprint, push pins, pencil eraser, drawing pencil (4B), stick and compressed charcoal, chamois, ball-point and felt-tip pens, clips, India ink, kneaded eraser, brush (No. 10 sable), and fixative.

right: 28. Charcoal lines can be pale or dark, even or varied in width.

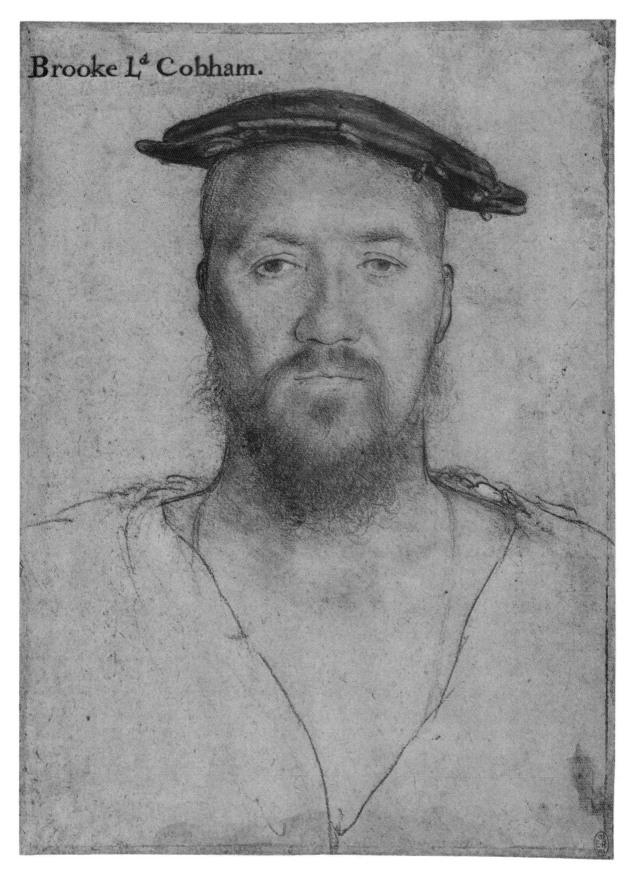

Plate 1. Hans Holbein the Younger (1497–1543; German). *George Brook, Lord Cobham.*
1538–40. Black, red, yellow, and brown chalks touched with pen and India ink, $11\frac{1}{2} \times 8\frac{1}{8}''$,
Royal Library, Windsor Castle, England
(reproduced by gracious permission of Her Majesty Queen Elizabeth II).

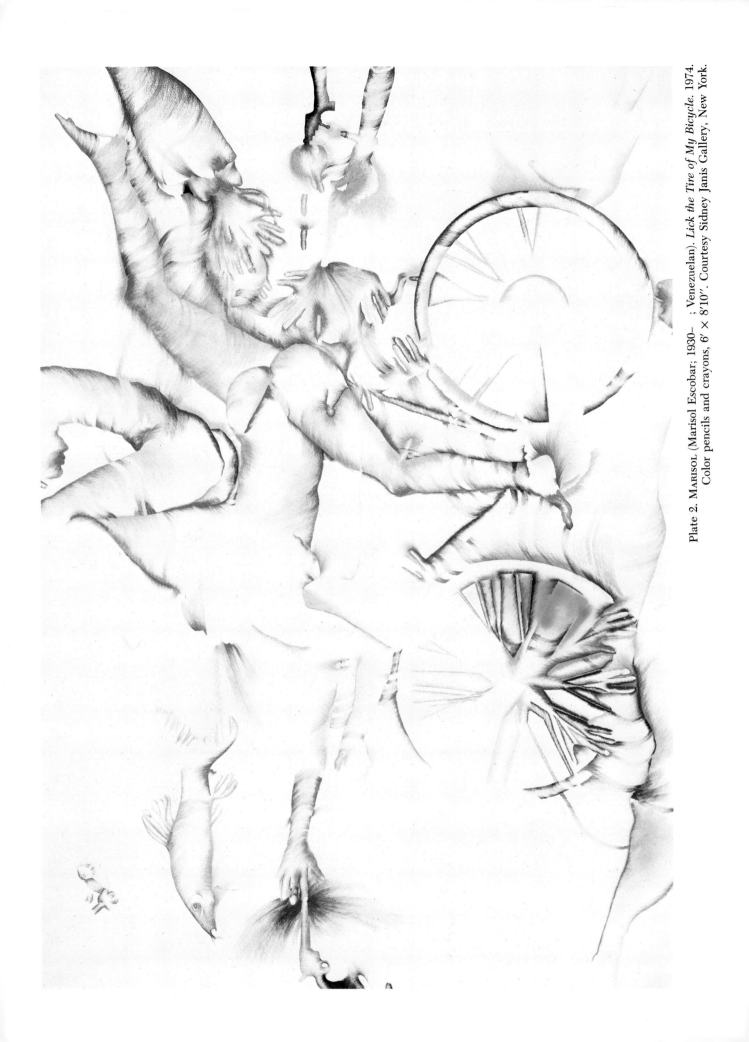

Plate 2. MARISOL (Marisol Escobar; 1930– ; Venezuelan). *Lick the Tire of My Bicycle*. 1974. Color pencils and crayons, 6′ × 8′10″. Courtesy Sidney Janis Gallery, New York.

29. Charcoal applied with the side
of the stick.

above: 30. Diagonal charcoal lines
applied with the point of the stick.

right: 31. Charcoal lines
cross-hatched with the point
of the stick.

for the ease with which it can serve to produce a wide range of darks and
lights of varying textures. Values from light gray to black result from dragging
the stick on its side (Fig. 29) or from the application of sets of parallel or
cross-hatched lines (Figs. 30, 31). When grays of minimum texture are desired,
parallel lines and cross-hatching can be fused by rubbing gently with the
fingers, with soft paper, or with a *tortillon* or paper stump (Fig. 32).

Project 1 *To practice using charcoal, draw lines, rapidly sketched clusters
of diagonal parallel lines, and cross-hatched tones with a pointed piece of
charcoal. With the side of a piece of charcoal, build a smooth graduation from
black to very light gray. Do the same with lines fused by your fingers, reinforced
by subsequent applications of charcoal and rubbing.*

32. Charcoal lines fused by rubbing.

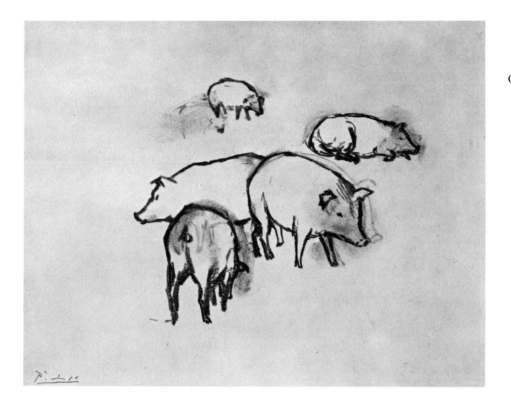

Study the drawings in Figures 33 to 37 for the use of charcoal. Much of the grain evident in these works derives from the texture of the paper. Charcoal paper used in the 19th century for most charcoal drawing—and still preferred by many artists—has a grainy texture that holds the charcoal. Newsprint, so popular today, has almost no texture. Compressed charcoal is often referred to as chalk, and indeed many chalks are very similar to charcoal, except that they tend to be harder to erase. All the activities of Project 1 could also be executed in chalk.

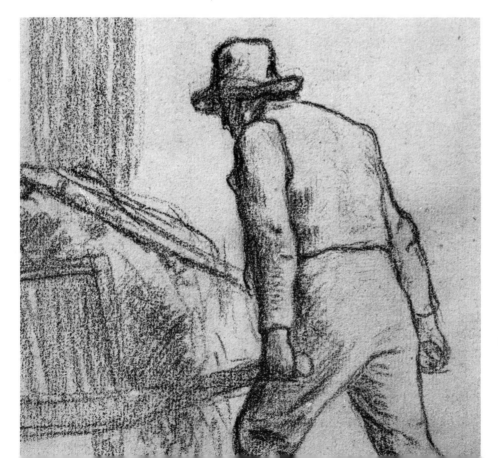

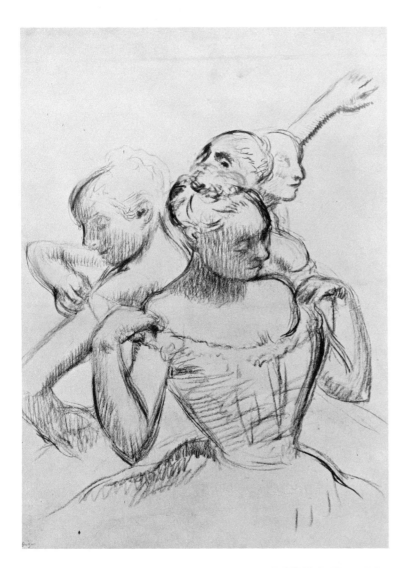

left: 35. EDGAR DEGAS (1834–1917; French).
Groupe de Danseuses Vues en Buste. c. 1902.
Charcoal, 28 × 19½″.
Allen Memorial Art Museum, Oberlin College, Ohio
(Friends of Art Fund).

below: 36. GEORGES SEURAT (1859–91; French).
Sous la Lampe. 1882–83. Charcoal, 9¼ × 12″.
Allen Memorial Art Museum, Oberlin College, Ohio
(R. T. Miller, Jr. Fund).

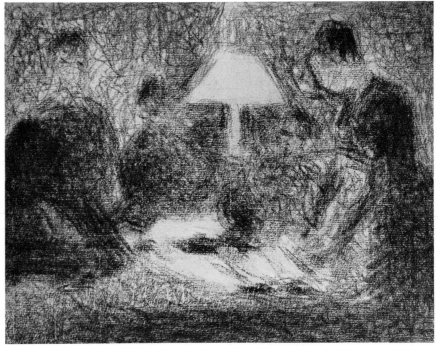

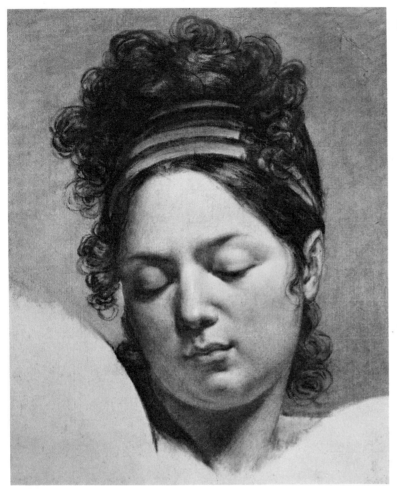

Pencil

below left: 38. Holding the pencil in an upright position, as for writing.

below right: 39. Holding the pencil under the hand between thumb and forefinger.

Project 2 The primary virtues of pencil for drawing are familiarity and relative cleanliness. *Sharpen your pencil and scribble freely on a piece of newsprint paper. Observe the quality of line produced by the point of the pencil and by the side of the lead. Note the difference in line quality achieved by holding the pencil in an upright position as for writing* (Fig. 38) *and by holding it between the thumb and forefinger but under your hand* (Fig. 39). Many artists prefer the latter position because it permits easier variation in thickness of the line; a slight shift of hand position utilizes either the point or the side of the lead (Figs. 40, 41). *Study the drawings in Figures 42 to 48, and see if you can duplicate the lines, textures, and values you see in them. You would probably profit from copying a part of each.*

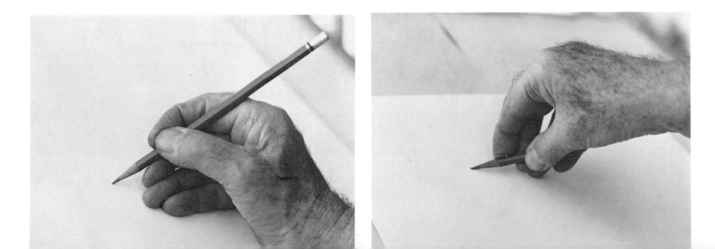

40. Line made by a pencil
held in writing position.

41. Line made by a pencil
held under the hand.

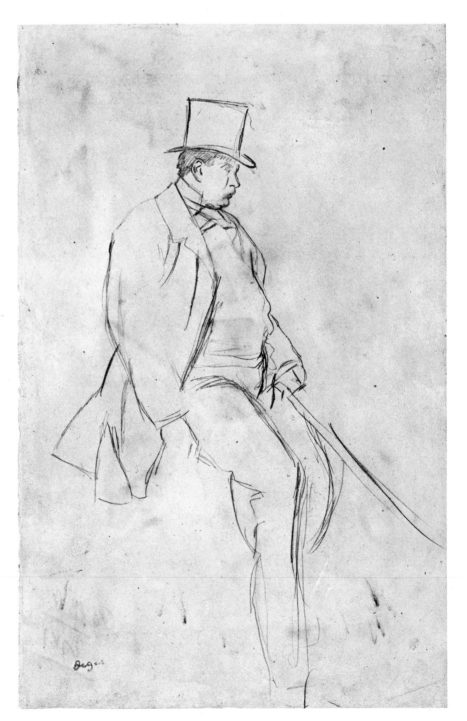

42. EDGAR DEGAS (1834–1917; French).
A Gentleman Rider. c. 1864–68.
Pencil and India ink heightened
with Chinese white, $17\frac{1}{8} \times 10\frac{1}{2}''$.
Art Institute of Chicago
(gift of Mrs. Josephine Albright).

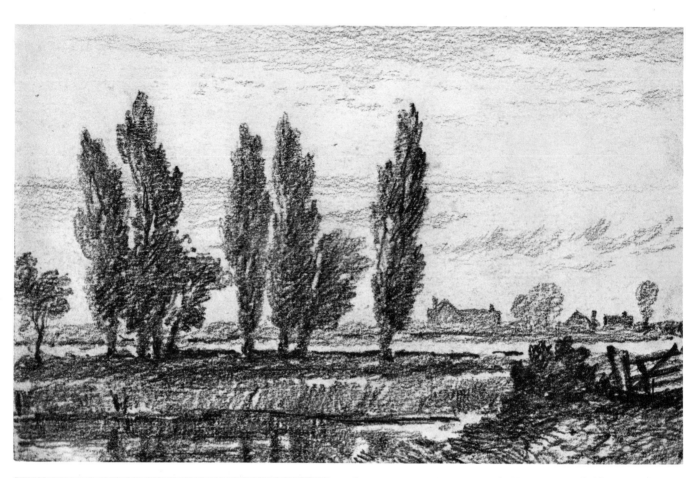

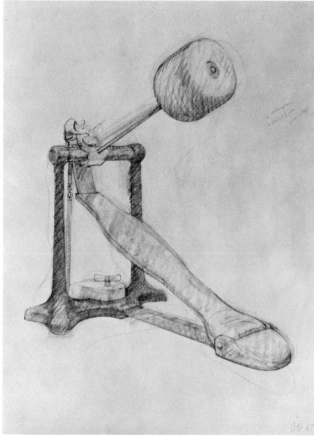

above: 43. JOHN CONSTABLE (1776–1837; English).
Poplars by a Stream. Pencil, $4\frac{3}{4} \times 7\frac{1}{8}''$.
Henry E. Huntington Library and Art Gallery, San Marino, Calif.

left: 44. CLAES OLDENBURG (1929– ; Swedish-American).
Drum Pedal Study. 1967. Pencil, $30 \times 22''$.
Collection John and Kimiko Powers, Aspen, Colo.

below: 45. Detail of Figure 44.

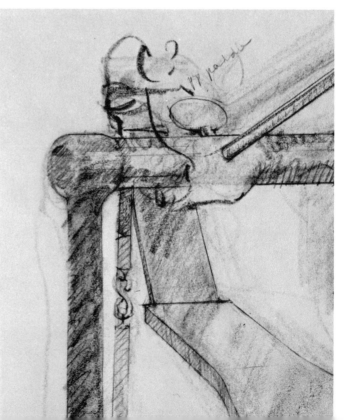

left: 46. ARISTIDE MAILLOL
(1861–1944; French).
Two Nudes. Pencil, $8\frac{1}{8} \times 8\frac{3}{4}''$.
California Palace of the
Legion of Honor, San Francisco
(gift of Manug K. Terzian).

above: 47. Detail of Figure 46.

below: 48. ALBERT GLEIZES
(1881–1953; French).
Port. 1912. Pencil, $6 \times 7\frac{5}{8}''$.
Solomon R. Guggenheim Museum,
New York.

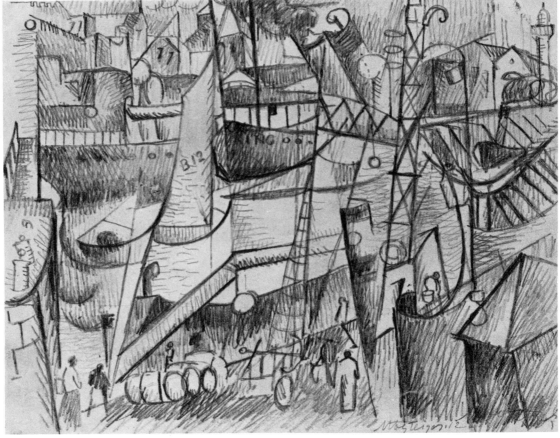

49. Geometric doodles in ball-point pen.

50. Biomorphic doodles in ball-point pen.

Ball-Point and Felt-Tip Pens

Ball-point and felt-tip pens are familiar, easy-to-use implements capable of producing a variety of line widths. They provide the beginner with a graceful transition from pencil and charcoal to brush and ink.

51. DANIEL M. MENDELOWITZ (1905– ; American). *From the Ramparts,* page from a sketchbook. 1954. Felt-tip pen, 5 × 8″.

Project 3 *Study the ball-point doodles in Figures 49 and 50, the felt-tip sketches in Figures 51 to 53, and Pamela Davis' sketch* (Fig. 54). Davis has smeared the felt-pen lines with a wet thumb to create light, semiwash smudges that add a painterly quality to what is essentially a line drawing. *Do some simple drawings using ball-point and felt-tip pens of a variety of widths, taking full advantage of the strength and rich textures these pens permit.*

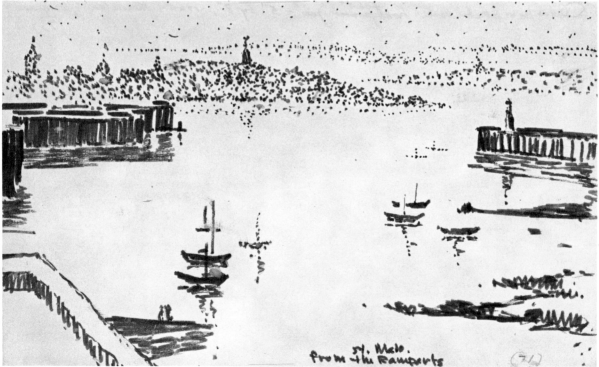

52. PAUL SCHMITT
(1937– ; American).
Farfields. c. 1971.
Felt-tip pen, 10 × 13¾″.
Collection Dan W. Wheeler,
New York.

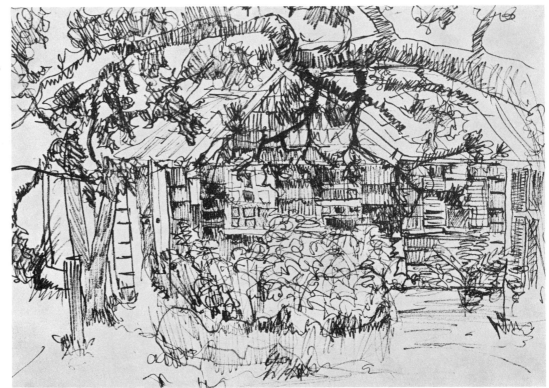

left: 53. DAVID PARK (1911–60; American).
Standing Nudes. 1960. Felt-tip marker, 9 × 11″.
Courtesy Maxwell Galleries, Ltd., San Francisco.

below: 54. PAMELA DAVIS (1956– ; American).
Carol. 1973. Felt-tip pen, with wash effect
obtained by smearing with wet fingers, 19½ × 17″.
Courtesy the artist.

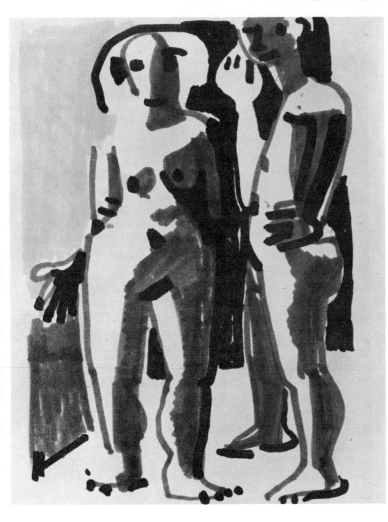

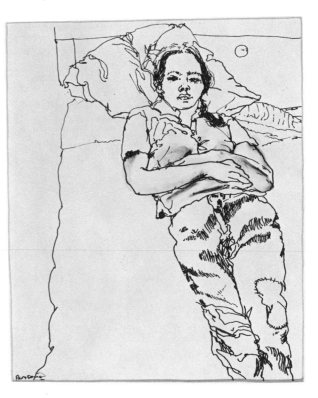

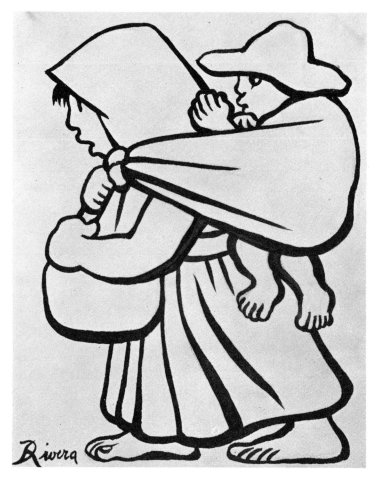

above left: 55. Flexible ink line
made with a pointed brush.

above right: 56. Dry-brush effect
created by using the side of the brush
with most of the ink wiped off.

right: 57. DIEGO RIVERA (1886–1957; Mexican).
Mother and Child. 1936. Brush and ink, $12 \times 9\frac{1}{4}''$.
San Francisco Museum of Art
(Albert M. Bender Collection).

below: 58. EMIL NOLDE (1867–1956; German).
Landscape with Windmill.
Brush and black printer's ink on tan paper, $17\frac{1}{2} \times 23\frac{1}{4}''$.
Solomon R. Guggenheim Museum, New York
(lender: Mrs. Stephen Alder, New York).

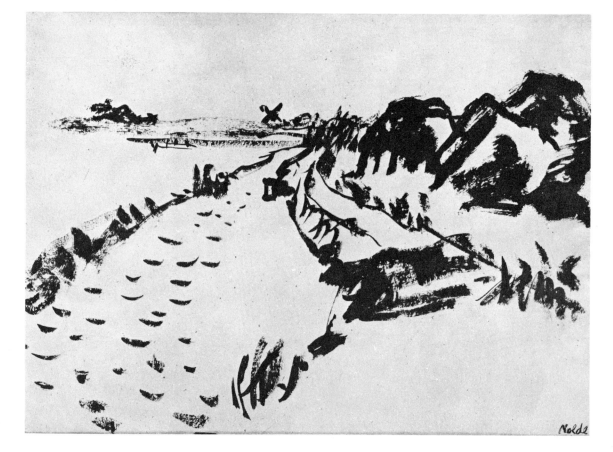

above: 59. HOKUSAI (1760–1849; Japanese).
The Mochi Makers, from an album of sketches. Brush and ink, $16\frac{1}{4} \times 23\frac{1}{4}''$.
Metropolitan Museum of Art, New York
(gift in memory of Charles Stewart Smith, 1914).

right: 60. Detail of Figure 59.

Brush and Ink

Brush and ink demand a certain assurance of execution, since lines cannot be erased. The bold lines that result from the free play of brush and India ink give a certain authority to a drawing, and a self-confidence emerges from the successful use of the brush.

Project 4 *To commence drawing, dip your brush in India ink and then gently press it against the side of the bottle neck to remove excess ink and create a point. Practice making graduated lines (Fig. 55). Investigate varied dry-brush effects by first wiping excess ink from the brush on paper toweling and then dragging the brush lightly over the drawing (Fig. 56). Observe the use of brush and ink in Figures 57 to 60. Copy a part of each drawing. Do not strive for an exact imitation but try to capture the quality of the brushed-ink lines.*

Learning
to Visualize,
to Symbolize,
to See

We could identify at least three distinct categories of drawings: those that record what is *seen*, those that *visualize* what is imagined, and those that *symbolize* ideas and concepts. At its most fundamental, drawing, by fixing visual impressions in static forms, makes it possible to build knowledge step by step and eventually to discover the nature of forms too complex to be comprehended at a single glance. Each person's understanding of the visual character of the physical world around us was achieved largely by this patient accumulation of impressions, and in this respect drawing constitutes a kind of visual exploration through which individuals become familiar with the various forms that make up the artistic repertoire of their own culture. Beyond this descriptive function, much drawing serves to visualize ideas and concepts that, no matter how vivid in the mind of the originator, must remain nebulous and undefined until given fixed form. The third general function of drawing is to symbolize. Throughout history the arts have played an important role in providing nonverbal symbols to communicate ideas. Many drawn symbols have the power to evoke the most complex train of associations, to unleash myriad interrelated concepts that historically surround certain motifs. These disparate aspects of drawing do not exclude one another; rather, the greatest drawings, such as Michelangelo's *Archers Shooting at Mark* (Fig. 61), achieve their full emotional power because of the grandeur with which they combine all three aesthetic purposes.

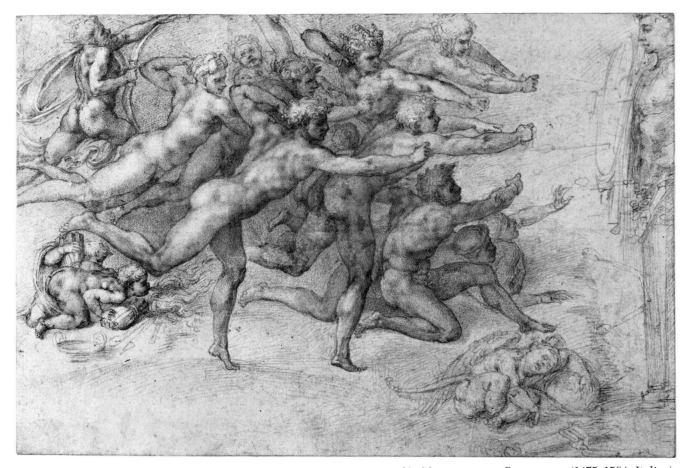

61. MICHELANGELO BUONARROTI (1475–1564; Italian).
Archers Shooting at Mark. c. 1500. Red chalk, $8\frac{5}{8} \times 12\frac{1}{8}''$.
Royal Library, Windsor Castle, England
(reproduced by gracious permission of Her Majesty Queen Elizabeth II).

Learning to Visualize

Doodling

Among the most important steps in developing one's art is discovering the creative resources that lie dormant within one. Many individuals become self-conscious and "block" when asked to draw from imagination. These same people probably "doodle" freely, for when doodling they follow unconscious impulses with no concern about the artistic quality of their scribblings. Doodles vary as much as any other form of expression. An individual may scribble, make geometric patterns, fill in the empty areas in letters or numbers, or improvise in other ways without realizing that this is a type of creative activity (Figs. 49, 50, 62).

Many mature artists, confident of their powers, improvise freely, placing a high value upon the unique character of the motifs that appear when they follow the dictates of their hands, allowing pictorial motifs to flow forth in a manner analogous to that which occurs in free-association speech or writing (Figs. 63, 64). For the beginning draftsman it is particularly valuable to give free play to powers of improvisation, since the uninhibited markings produced without preplanning further the development of a personal and characteristic style. The idosyncrasies of line, tone, and texture that appear, the angularities, curves, smoothness, blobbiness, regularity or irregularity of markings—all such preferences confirm and strengthen the unique aspects of an individual's way of working. Such elements identify an artistic personality even in more disciplined drawings.

62. Landscape doodles
in ball-point pen.

The several studies that follow can be executed in any material, except where a particular medium is specified.

63. Henri Michaux (1899– ; Belgian).
Untitled. 1960.
Brush and ink. $29\frac{3}{8} \times 42\frac{1}{2}''$.
Museum of Modern Art, New York
(gift of Michel Warren
and Daniel Cordier).

Project 5 *Scribble, make circular and zigzag lines or tic-tac-toe marks and enrich these with dots, circles, or any other patterns that come to your eye or mind. Produce at least five different doodles, and select the ones you like best for the following study. Enclose a few rectangles approximately 5 by 7 inches. Using pencil, compose in each rectangle enlarged duplicates of some of your most interesting doodles. When composing forms in a rectangle, have*

major forms touch the four edges, because this relates them in a very positive way to the defined area. If you are not satisfied with your composed doodle, add freely any elements that will suggest identifiable objects, give solidity or weight, or provide interesting contrasts and countermovements. Notice in Miró's Figures (Fig. 64) how little it takes to make figures from scribbles!

Diagrammatic Drawings

Most individuals can make a diagrammatic representation of an object if it is sufficiently familiar to them. They usually have a vocabulary of forms they can describe in a diagrammatic manner but hesitate to commit to paper as a part of a serious project because they do not consider these works to be of professional quality. Today diagrammatic drawings are often viewed as

64. JOAN MIRÓ
(1893– ; Spanish-French).
Figures. 1936.
Watercolor, 16 × 12½″.
Courtesy Richard L. Feigen
& Co., Inc., New York.

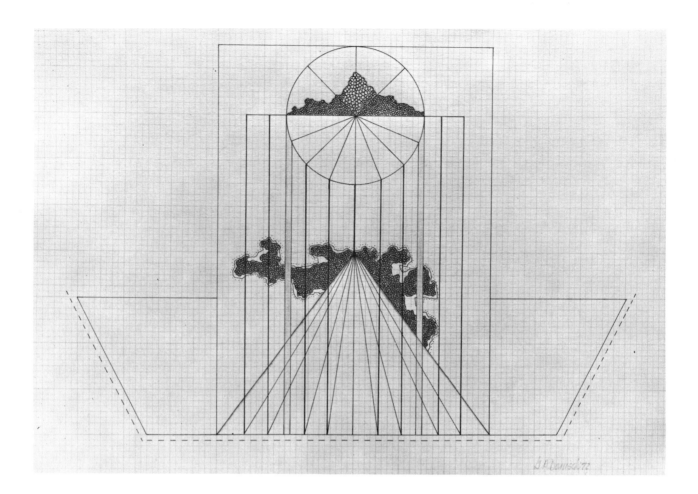

65. GRACE DANISCH
(1946– ; American).
Untitled. 1972.
Ink and color pencil, 10 × 14″.
Courtesy the artist.

abstractions, valued as patterns long after their symbolic content has ceased to matter (Fig. 65).

Project 6 The following exercises are planned to encourage beginners to draw freely and without critical restraint. In following them, you should work rapidly, and if you block, move on to the next problem.

Enclose a series of rectangles approximately 5 by 7 inches and place the following problems in them. Draw a jagged shape with straight lines to express an explosion. Add lines, dots, small broken shapes, and any other elements to intensify the sense of explosive energy. Continue the lines and movements to the edge of the rectangle (Fig. 66).

Draw two biomorphic shapes colliding. Add lines to suggest the movement that brought the two forms into conflict. Give evidence of the impact by indentation, flying fragments, radial lines, and any other devices you can create.

Draw a flat, irregular geometric shape using straight lines to establish its boundaries. Make it three-dimensional by adding thickness. Draw circular holes into it (like the holes in Swiss cheese). Draw spaghetti-like rods looping through the holes, and add any forms you wish that will give a sense of space and volume.

From imagination, compose diagrammatic drawings of three-dimensional forms that reveal a cross-section. Use familiar objects: a cross-section of an orange showing segments and seeds, an apple cut in half lengthwise showing core and seeds, a section of automobile tire showing tread and varying thicknesses of casing. Add other cross-sections of the same or related objects to create a composition.

66. Roy Lichtenstein
(1923– ; American).
Explosion Sketch. c. 1965.
Pencil, color pencil, and ink,
$5\frac{1}{2} \times 6\frac{1}{2}''$. Collection Mr. & Mrs.
Horace H. Solomon, New York.

Sketchbook Activities

It is wise to keep a sketchbook encompassing the full gamut of your drawing activities. *Doodle freely in your sketchbook, and then elaborate your favorite doodles to make them more interesting.*

Learning to Symbolize

To symbolize means to represent by a sign that, either arbitrarily or through convention, we associate with a more complex entity or idea. Objects and qualities can be represented by symbols that may or may not resemble the symbolized subject. For example, the symbol for a crescent moon mimics the crescent moon in shape, and the symbol for a star simplifies the effect of light radiating from a star; on the other hand, the symbol used in architectural plans for an electrical outlet has no physical resemblance to an electric outlet. Symbols for nonphysical qualities cannot, of course, resemble the qualities they symbolize. The cross that stands for Christianity and the flag of the United States illustrate this point. The basic necessity for a successful symbol is that it be generally understood. Symbols proliferate in folk arts, where they convey widely held and readily accepted meanings. Comic books and trade marks today partly fill the role earlier played by the decorative patterns of folk arts and crafts, in that they provide easily understood symbols for the people of a particular culture. The symbols that form part of a nation's heritage become symbols because they offer an effective means of embodying a complex of ideas into an immediately recognized form (Fig. 67). Thus, they serve as a convenient shorthand for nonverbal communication.

above: 67. RICHARD HENTZ
(1924– ; American).
Symbol. 1970. Pencil, 20 × 29″.
Chrysler Museum at Norfolk, Va.

right: 68. Anonymous, aged 5.
The Jellyfish.
Crayon, 8½ × 11″.
Collection the author.

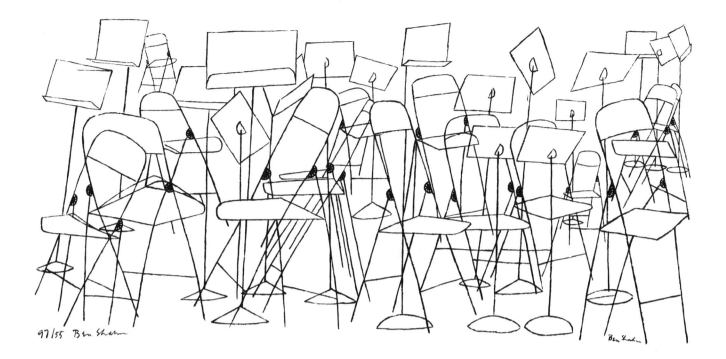

Maggie Wesley's drawing in Figure 20 contains weighty yet wittily formalized shapes that produce an authoritative but lighthearted warning. In *Explosion Sketch* (Fig. 66) Roy Lichtenstein has directly and simply symbolized the radiating waves of energy, matter, and sound that one typically associates with an explosion. Children between the ages of three and ten rely heavily upon universally understood symbols based on ideas rather than visual analysis. In the drawing reproduced as Figure 68, a small child has symbolized a jellyfish by drawing the one form for which he has a symbol, the human figure, but giving it a single characterizing feature—the jellylike legs.

69. BEN SHAHN
(1898–1969; Russian-American).
Silent Music. 1955.
Silk screen, $17\frac{1}{4} \times 35''$.
Philadelphia Museum of Art
(purchase, the Harrison Fund).

Inventing Symbolic Forms

Project 7 *Create one or more of the anthropomorphic figures (figures having human attributes) suggested below.*

1. *Make circles by drawing around coins or other small round objects and combine them with dollar signs ($) to create a figure entitled "Money Man."*
2. *Using scribbles that suggest anatomical forms, devise a symbol of "Confusion" or "Bewildered Man."*
3. *Combine straight ruled lines with business-machine, algebraic, and related symbols to portray "Automation."*
4. *Invent your own anthropomorphic figure and title it.*

Intensifying Expressive Character

Symbolic content alone does not determine the full range of meaning conveyed by a symbol. Equally important is the way in which it is drawn. Qualities such as thinness or thickness of lines, the textures resulting from different media and grounds, and all aspects of the art elements affect the expressive character of a symbol and help determine its full meaning. In Ben Shahn's *Silent Music* (Fig. 69) the vivacious, almost humorous delineation of music stands and chairs creates a pattern of criss-crossed and parallel, thin and light lines to suggest musical themes, counterpoint, and harmonies. Very different are the didactic,

authoritative, and weighty—though also humorous—forms so appropriate to *Improper Use of Government Property Is Frowned Upon* (Fig. 20).

Project 8 *Take any one of the figures you have created in Project 7 and alter the character of the image by changing the weights of lines, the proportions of parts, or the medium.*

1. *See if you can modify "Money Man" to suggest first a miser and then a successful capitalist.*
2. *Adapt the second figure to convey a sense of defeat, and then derive from the same form a searching but hopeful figure.*
3. *Change "Automation" to symbolize infinitesimal man caught in the vast complexity of a machine-ruled world; then treat "Automation" as the powerful servant man has created to free society from drudgery.*
4. *Modify your own symbolic figure to suggest varying qualities. Test the symbols you have devised by asking friends to interpret them.*

Sketchbook Activities

In your sketchbook create symbols to express ideas in visual form. Learn to work freely, placing minimum importance upon the initial qualities of a sketch; then, in subsequent steps, work to refine the sketch and intensify its expressive potential. Symbolizing draws upon different artistic resources than does sketching what you see. Each ability supplements the others in the fully rounded, mature artist.

Learning to See

Perhaps the most fundamental discipline involved in drawing is learning to record what one sees. Contrary to popular misconceptions, this is not primarily a matter of manual skills. The physical requisites for drawing are minimal: average sight and average manual dexterity. Drawing is a matter of seeing through the mind, of comprehension, rather than of 20-20 vision and deft fingers. Here we are not considering the qualities of an original or powerful artist but rather the skill and habits involved in becoming an adequate draftsman—a person who can look at an object, analyze the relationships of size, shape, value, and texture, and then create an analogous set of relationships on paper as a graphic record of visual perceptions.

Let us analyze what differentiates the seeing involved in learning to draw from the seeing that enables us to move about and identify objects in daily life. From birth we exist in spatial depth; that is, we live in a three dimensional world where we move about freely—back, forth, up, down, in space, and around objects. From earliest childhood our hands, our bodies, and most of all our eyes—placed in our swivel-pivoting heads—appraise objects in terms of their three-dimensional character. This is how we know them. It is, therefore, frequently difficult for a beginner drawing a cube placed at eye level to avoid showing the top plane of the cube, because one knows that it is there even though one cannot see it. When we commence to draw, we are shocked to discover the degree to which any object except a sphere presents a different appearance whenever we change the position of our eyes in relation to it. The beginning draftsman is faced with a new problem: three-dimensional knowledge must be reevaluated and translated into two-dimensional patterns based on a fixed relationship between the draftsman's eyes and the object being drawn. Since actual spatial depth is absent from the surface of the drawing paper, three-dimensional reality must be interpreted as a two-dimensional pattern. Much of learning to draw consists of discovering how things *appear*

rather than of how they *are,* and it is not until we begin to draw that most of us realize the tremendous difference between what we know about objects and what we see.

Learning to draw, then, demands a reevaluation of visual experience, a new dependence on visual cues about the appearance of objects and their relationships in space. The novice already has certain resources to call upon when confronted with a drawing problem. In the art of Oriental (Fig. 70), and primitive cultures as well as in children's art (Fig. 71), the front plane in a composition is placed at the bottom of the page. Higher on the page

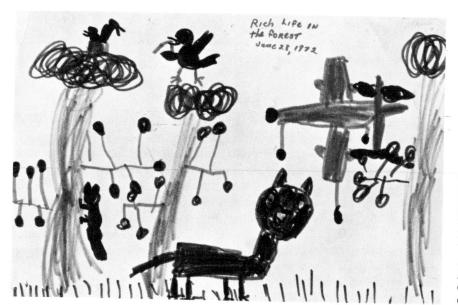

above: 70. KAWANABE KYOSAI (1831–89; Japanese).
Customs Office at Yokohama. 1870. Ink on paper, $14\frac{13}{16} \times 19\frac{7}{16}''$. Rijksmuseum voor Volkenkunde, Leiden.

left: 71. Anonymous child. *Rich Life in the Forest.* 1972. Color felt-tip marker, 6 × 9″. Collection the author.

Learning to Visualize, to Symbolize, to See **47**

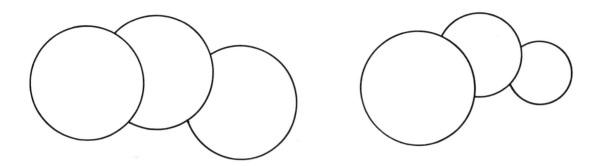

left: 72. Overlapping circular shapes create a sense of space.

right: 73. Diminishing the sizes of the overlapping circles intensifies the sense of intervening space.

means more distant, and frontal forms overlap those behind. If you were asked to draw three circles in space so they appear to be in front of one another, you might produce something like Figure 72. Should you be asked to repeat the project but to make the circles a great distance from one another, you might come up with something like Figure 73. In both instances you would rely upon your knowledge of seeing and employ devices that derive solely from seeing. Two familiar concepts are embodied in Figures 72 and 73: (1) When we see a sequence of objects in space, the objects in front can partially obscure (overlap) the objects in back; (2) the more distant objects are from the viewer, the smaller they appear. (Think how you shift your head in a motion picture theater to keep the relatively small head immediately in front of you from obscuring most of the giant screen.) Both of these aspects of drawing-related-to-seeing are common knowledge and can be observed without any special training; but when we try to describe more subtle phenomena, the problems become more difficult. The following projects are designed to introduce certain habits of observation, as well as simple perspective and foreshortening concepts.

Overlapping Forms, Diminishing Sizes, Layered Space

Project 9 *Using soft pencil, enclose four rectangular areas of about 6 by 8 inches on a piece of newsprint. In rectangle 1 draw a series of overlapping circular forms fairly similar in size. In rectangle 2 draw forms that overlap and diminish in size as they apparently recede, to intensify the sense of intervening distance. In rectangle 3 draw a series of forms, approximately the same size, using "layered" or "tiered" space; that is, place the front overlapping forms at the bottom and arrange the successive overlapped forms higher in the composition as they recede. In rectangle 4 draw a sequence of forms that combine all the above devices (overlapping, diminishing sizes, and layered space) to give maximum sense of spatial depth.*

Foreshortening

Overlapping, diminishing size, and layered space devices encountered in the previous project are means for describing relationships among objects in space. The following project is designed to stimulate the beginner's observation of changes that occur in the appearance of a single object when the viewpoint is altered. A body of principles termed *perspective* exists to describe such changes, as well as to represent them on a surface in a systematic way (see Chap. 6). The word perspective frequently refers to geometric and architectural forms, while *foreshortening* applies to the depiction of organic or anatomical forms. Good illustrations of foreshortened anatomical forms are displayed in Figures 74 and 75. Drawing the complex undulations of the large leaves on a thistle involves a careful analysis of the twistings and turnings of foreshortened leaf forms (Figs. 76, 77).

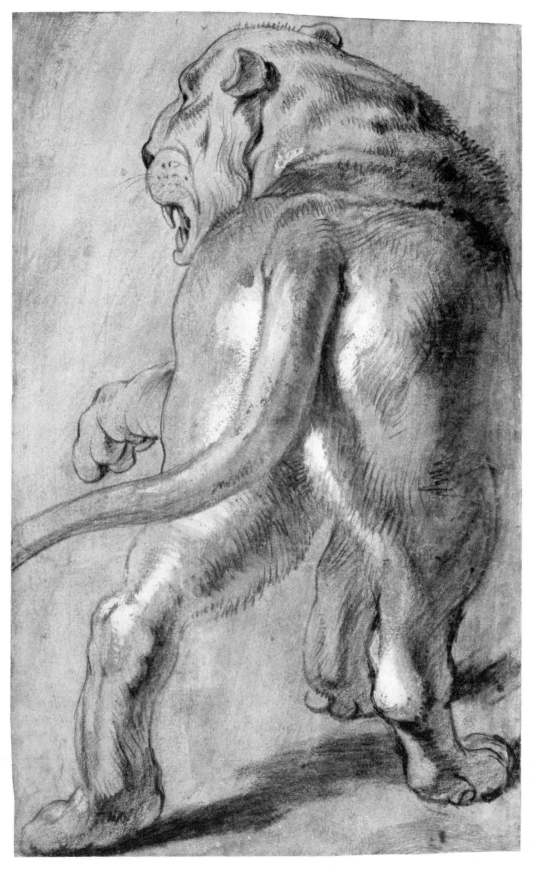

74. PETER PAUL RUBENS (1577–1640; Flemish). *The Lioness*. c. 1618.
Black, white, and yellow chalk, $15\frac{9}{16} \times 9\frac{1}{4}''$. British Museum, London.

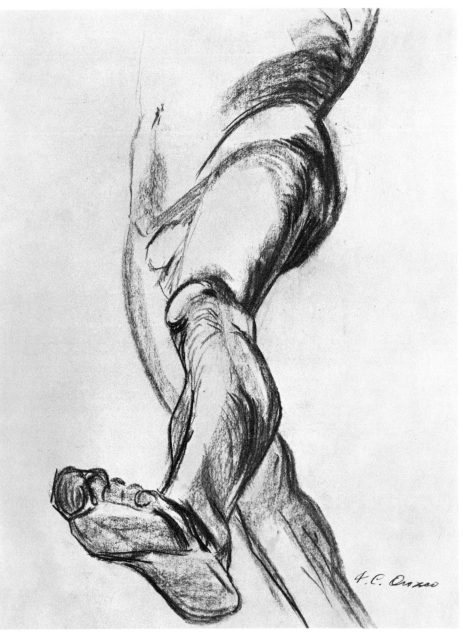

75. José Clemente Orozco
(1883–1949; Mexican). *Legs.* 1938–39.
Charcoal, $25\frac{7}{8} \times 19\frac{5}{8}''$.
Museum of Modern Art, New York
(Inter-American Fund).

Project 10 *Select a large, not too flat leaf that is fairly rigid, preferably with undulating edges (a magnolia or calla lily leaf is excellent). Study it full face and analyze its general shape and its proportions of length to width. Draw it full face, about life size, in the medium of your choice. Next, turn the leaf backside to you and repeat the performance. Some of the edges will appear very different, while the general proportions may or may not be the same. Try to be equally aware of the general shape and the undulations of the edge. Place the leaf in a flat, sideways position so that you see its full length but not its width, which disappears through foreshortening. In this position you may be sharply aware of its undulating edge, since you may see parts of the top and the bottom of the leaf at the same time. Now turn the leaf so that its end comes directly toward you. Notice how its length disappears, while at the same time you become aware of the twistings and turnings of the edges (Fig. 78). Sketch the leaf in any other positions that intrigue you, noticing the constantly varying relationships of shape, size, and proportion of parts.*

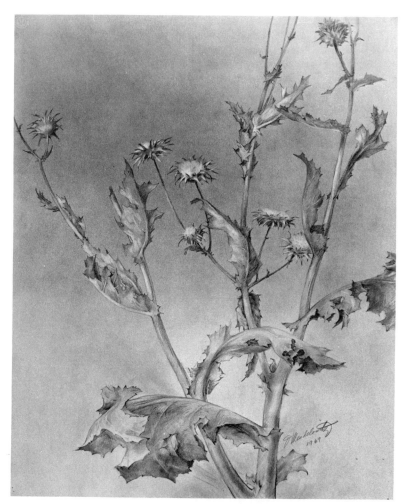

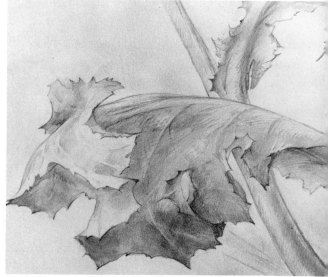

left: 76. Daniel M. Mendelowitz (1905– ; American). *Thistle.* 1969. Rubbed graphite and pencil, 30 × 22″.

above: 77. Detail of Figure 76.

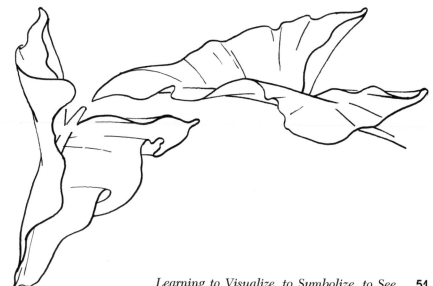

78. Foreshortened side and end views of a calla lily leaf.

Take a branch with three or four leaves on it and draw the cluster. Make a similar sequence of drawings of a fairly large, solid, organic object—a bone, a squash, a large, firm cabbage with one leaf turned out from the head. Most important in this and subsequent projects is to look repeatedly at what you are drawing. It is easy to become absorbed in the act of drawing and gradually draw from the idea rather than from visual analysis.

Foreshortened Geometric Forms

Beginners frequently find foreshortening easier than the more exacting perspective that applies to geometric forms. Perhaps this is because the draftsman has a more exact idea of the actual form a geometric object possesses and therefore does not have to look so continuously to determine its appearance. Drawing this book will provide an introductory exercise in the foreshortening of simple rectangular forms.

Project 11 *Place the book directly in front of you and slightly below eye level. Study its appearance carefully, then try to draw it in simple outline. The result should look like Figure 79.* However, you may find it difficult to represent the lengthened rectangle of the page by means of a nonrectangular horizontal shape, because you know the proportions of the form to be like Figure 80. In other words, your factual knowledge influences your visual perception.

Place the book to one side of you and slightly below eye level. Again trying to estimate the exact shapes you see, make a simple outline drawing. If you draw the receding edges of the pages parallel to one another, as beginners frequently do, you will approximate *isometric perspective* in your treatment of space (Fig. 81). In isometric perspective, parallel lines going into the depth of the drawing do not converge, so objects do not get smaller nor do their

79–81. Drawing this book provides an introductory exercise in the foreshortening of simple rectangular forms.

below: 79. The book seen in foreshortened view, close to eye level.

right: 80. The closed book, viewed without foreshortening.

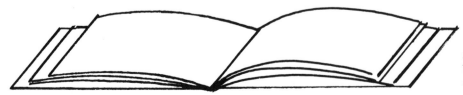

81. The open book, placed below eye level and to one side, drawn in isometric perspective.

widths narrow as they recede into space. If your lines representing the receding edges of the pages tend to converge, you will be suggesting space by means of conventional Western perspective, or *linear perspective. Draw the book in a number of positions from varying viewpoints.*

We have been working with relatively simple forms to acquaint the beginning student with habits and concepts involved in representational drawing. The next drawing project involves more complex forms and introduces certain mechanical aids and procedures useful in determining relationships of size and shape. Although the ultimate goal is to develop eye, mind, and hand coordination, one should be familiar with any simple mechanical aid that can help ascertain exact shapes and relationships. Sometimes such devices help to guide initial judgments at the start of a drawing; sometimes they help identify mistakes. A more systematic development of perspective will be undertaken later (see Chap. 6).

Mechanical Aids to Perception

Project 12 *Place a wooden chair in front of you in a number of positions: facing you, with its back to you, sideways, upside-down, and at a tilted angle. Study it carefully in each position, mentally preparing to draw it. Note how the size and shape relationships between the parts alter with each changed position.* Before you begin to draw the chair in the various suggested positions, let us examine the mechanical aids that may be of assistance.

The pencil as a plumb line, held in a vertical position, can be helpful in ascertaining certain relationships and alignments (Fig. 82). Notice how the position of the pencil clearly reveals that the chair's front leg rests on the floor far left of the seat. If the pencil is moved so that it forms a plumb line on the right side of the chair, it will show that the back rests far to the right of the outermost point of the farther rear leg.

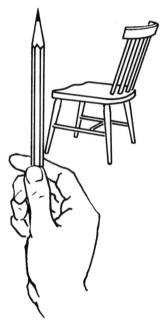

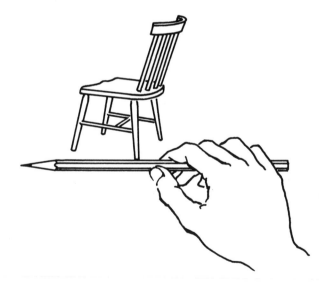

82, 83. Any drawing instrument can be a useful aid in perceiving alignments.

above: 82. Held in a vertical position, a pencil serves as a plumb line to determine vertical alignments.

left: 83. Held as a true horizontal, a pencil helps to determine horizontal alignments.

The pencil held in a true horizontal position is equally useful in determining relationships of above and below. For instance, in Figure 83 see how the forward position of the left front leg, as well as the placement of the other three legs, is revealed by the horizontal position.

The pencil as a measuring device serves as a guide to relationships of shape and proportion. For example, taking a frontal view of the chair, one might have difficulty in determining the proportion of height to width. *Holding the*

84, 85. A drawing instrument
can also serve as a measuring device
in assessing proportions.

right: 84. A pencil held horizontally
at arm's length permits optical
measurement of the chair seat.

below: 85. The pencil held vertically
measures the height, which can be
compared with the width
to estimate the chair's proportions.

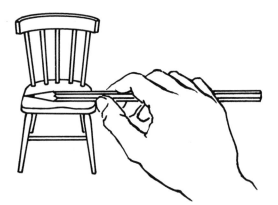

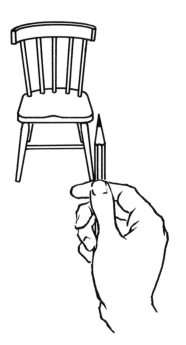

pencil at full arm's length and allowing the tip of the pencil to optically "touch" the left edge of the seat, mark with your thumbnail on the pencil length the right edge of the seat (Fig. 84). (The seat has been selected for measurement because it is one of the largest and most easily observed parts of the chair.) *Turn your pencil vertically, being certain to keep your thumbnail in place on the pencil, and estimate the proportion of height to width marked on the pencil* (Fig. 85). Using the pencil thus to compare width and height provides only general relationships. Figures 84 and 85 suggest that the height of the chair seat is about one and a quarter times greater than the width of the seat in this view. When using the pencil to determine such relative proportions, be certain always to hold it at full arm's length, since any change in the distance between the pencil and the eye destroys the accuracy of the measurement.

A *square viewer* enables the draftsman to see vertical, horizontal, and proportional relationships. *Cut a 1-inch square from a piece of light cardboard or stiff paper. Look at the chair you intend to draw through this hole, keeping the paper at a distance that permits the entire chair to be seen through the aperture while filling the square as completely as possible. The negative spaces—the areas left between the edges of the square and the contours of the chair—help to delineate the shapes you see* (Fig. 86). *Observe the chair in a number of positions through the viewer, and then proceed with the drawing assignment outlined below. Be certain to hold the viewing square in a true vertical plane.*

86. A simple viewing square
cut from cardboard or stiff paper
locates an object in space
and thus enables the draftsman
to see vertical, horizontal,
and proportional relationships.

87. EGON SCHIELE (1890–1918; Austrian).
Organic Movement of Chair and Pitcher. 1912.
Pencil and watercolor, $18\frac{7}{8} \times 12\frac{1}{8}''$.
Albertina, Vienna.

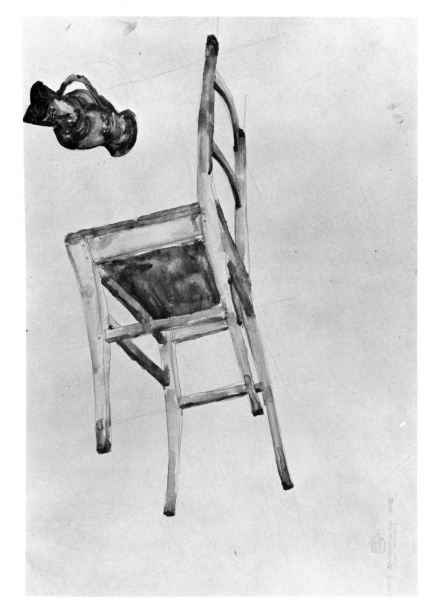

Project 13 A simple wooden chair provides an excellent exercise in drawing, since it consists of a number of parts of extremely varied shapes. Its forms are not strictly geometric, nor are they as subtle as anatomical or organic forms, and the legs, stretchers, and spindles provide excellent baffles through which other parts can be seen. *Place the chair in the first position of your choice and study it carefully, consciously noticing any foreshortening of seat, back, legs, rungs, and so on. When you feel you understand the relationships, proceed to draw the chair rather rapidly, not worrying about accuracy in the depiction of thickness, taperings, or straight edges, but simply attempting to describe the shapes and sizes of the main parts. Study the negative areas—the shapes you see between the rungs, legs, stretcher-bars, and other parts. These often provide new insights about the accuracy of your drawing. For additional drawings arrange the chair in as many different ways as possible, tipping it at an angle, turning it upside down, and otherwise drastically changing your view of it.* It is difficult for the inexperienced artist to perceive the potential of interesting forms inherent in very familiar, commonplace objects. Notice how Egon Schiele studied a simple chair from an unusual viewpoint to create a very interesting drawing (Fig. 87).

opposite above: 88. Johan Barthold Jongkind (1819–91; Dutch). *Cranes.* c. 1848. Pencil and brown wash. Louvre, Paris.

opposite below: 89. Agostino Carracci (1557–1620); Italian). *Nine Heads and a Torso.* c. 1590–92. Pen and ink. Private collection.

right: 90. Ivan Majdrakoff (1927– ; American). *Page from a Sketchbook.* 1959. Pen and India ink, 16 × 11″. Collection the author.

When drawing, it is necessary to observe your subject continuously. Most mistakes occur from drawing without looking at the model. The use of your pencil as a line and of the cutout square as a viewer should be employed only as preliminary steps to drawing, or to clarify a relationship of parts as you are working. Overreliance on such aids can impede the development of independent judgments and of eye-hand coordination.

Project 14 *Use your sketches of chairs for the following assignment to the degree that it is necessary. In a rectangle approximately 5 by 7 inches compose two, three, or more chairs floating in space. Overlap parts of the chairs to establish a strong sense of depth. Try arranging the chairs so they appear to have been carried away by a cyclone.*

Sketchbook Activities

Form the habit of observing and sketching something every day. The regular practice of sketching is essential to continuous development. In time, the response of the hand to the eye becomes spontaneous. *Carry a small sketchbook and set aside ten minutes each day to draw whatever you see around you: people, automobiles, buildings, trees, shrubs, typewriters, your own hand or foot* (Figs. 88–90). Frequently, objects that do not seem promising prove

91. RICHARD PARKES BONINGTON (1801–28; English).
Page from a Sketchbook. Pen and brown ink, $9\frac{3}{4} \times 13\frac{1}{2}''$.
National Galleries of Scotland, Edinburgh.

intriguing to draw. *Do not confine your sketchbook activities to recording what you see. Draw from memory and imagination, doodle and tap whatever artistic resources you have; each ability supplements others in the fully rounded artist.* An artist's sketchbook provides a continuous source of motifs and ideas for compositions, as well as an entertaining record of the past—a kind of diary of visual impressions (Figs. 90, 91).

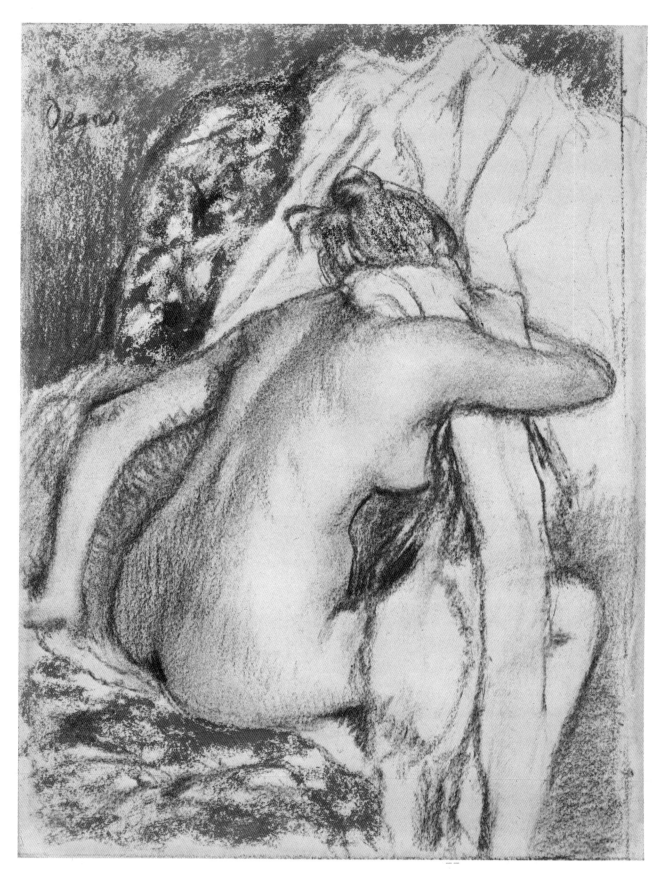

Plate 3. EDGAR DEGAS (1834–1917; French). *Woman Bathing*. 1885.
Pastel and charcoal on paper, $13\frac{1}{2} \times 10\frac{1}{4}''$.
Nelson Gallery-Atkins Museum, Kansas City, Mo.

Plate 4. HYACINTHE RIGAUD (1695–1743; French). *Study of Hands and Drapery*. 1735. Pencil heightened with white chalk on blue paper, $11\frac{3}{4} \times 17\frac{3}{4}''$. Achenbach Foundation for Graphic Arts, The Fine Arts Museums of San Francisco (gift of Mr. and Mrs. Sidney M. Ehrman).

three

The Art Elements

Line, defined in the dictionary as "a long thin mark frequently made with a pencil . . ." does not exist in nature. As a device invented to describe and circumscribe, it provides the basis for the simplest kinds of artistic expression. At the same time, line serves in the creation of the most complex and sophisticated works of art.

Value, the quality of relative darkness or lightness, provides for greater emotional impact—one might almost say for drama. We relate light and dark to untold avenues of experience: right and wrong, day and night, sunshine and shadow, even intelligence and stupidity. Dark and light seem to parallel many of our emotional and intellectual experiences.

Form is the most fundamental of the art elements. We experience form in our earliest stages of awareness and continuously thereafter; we sense it in everything we handle. Round, square, organic, geometric, and numberless other descriptions of form are known to us consciously or unconsciously. Geometry, a fundamental mathematical discipline, was born from the desire to describe form rationally. In its negative aspect, we know form as *space*. Space surrounds us always, and we perceive it even in complete darkness.

Texture and color are the surface attributes of form. *Texture* is unique in that we experience it through more senses than sight alone. Roughness, smoothness, and many other textural qualities can be experienced through the sense of touch and are even an important part of taste, since qualities like grittiness, slipperiness, wetness, and dryness all enhance the pleasure of eating.

Color is the art element that probably gives us the most pleasure. Form and color impinge upon a baby's earliest consciousness. It is color that first attracts the infant as it reaches for the bright rattle and becomes aware of a world beyond Mother.

The art elements—line, value, form, space, texture, and color—provide the basis for our artistic expression. Just as in learning to write one can profit from dissecting a sentence to study the parts of grammar separately, so in drawing, the interrelationships of parts to the whole can best be perceived by understanding the various elements and developing resourcefulness in their manipulation. Let us now examine these elements in more detail.

Line

The simplest line suggests direction; divides space; has length, width, tone, and texture; and may describe contour. As soon as the line begins to change direction—to move in a curved or angular fashion, to fluctuate in width, and to have rough or smooth edges—its active and descriptive power increases many times (Fig. 95). The beginning student, learning to draw, soon discovers what is involved in assuming command over so powerful a tool. With line one can describe, suggest, evoke, and imply an endless variety of experiences, observations, conceptions, and intuitions. Every mark made on paper, whether a thoughtful line or a careless scribble, will inevitably convey something of the maker to the sensitive observer.

The Contour Line

Lines that delineate the edges of forms, separating each volume or area from neighboring ones, are termed contour lines. In its simplest and most characteristic aspect, the contour line has unvarying width, is not reinforced by graduated values of shading, and does not seek to describe the modulations of surface within the edges unless they constitute relatively separate forms (Figs. 92, 93). At its most expressive, the contour line appears to follow the draftsman's eye as it perceives the edges of a form. To develop sensitivity and skill at contour drawing, the draftsman tries to master an exact and almost

unconscious correspondence between the movement of the eye as it searches out the exact indentations and undulations of edge and the movement of the hand holding a pencil or pen. This faculty of eye-hand coordination is invaluable in all drawing activities, and for this reason pure contour drawing has great importance in training draftsmen.

Project 15 A soft pencil is best for beginning contour drawing, since it produces a firm, relatively unmodulated line. *Place in front of you a solid, nongeometric, irregular form—a squash, a not-too-compact pillow, a hat, a work shoe, or a catcher's mitt. Start drawing at some clearly defined point, such as the closest corner of the pillow. If the object you are drawing is not more than 12 or 15 inches across the largest dimension, try to make your drawing about life-size or slightly smaller. Without glancing back at your drawing any more frequently than is absolutely necessary to keep your bearings, let your eye move slowly along each contour and keep your pencil moving in pace with the movements of your eye. Try to respond to each indentation and bulge of edge with an equivalent hand movement. When you come to a point where the surface you are drawing disappears behind another or flattens and disappears, stop, look back at your drawing, and commence with the adjoining surface. After completing your outline, study the drawing in relation to the model and add any internal details that are necessary to make the drawing fully comprehensible.* Much of the effectiveness of contour drawing results from its economy, so remember this when adding details. Contour drawings done with minimum reference to the paper often grow wildly out of proportion, but this should not discourage beginners. The primary concern is sensitivity of edge rather than accuracy of proportion. *Change the position of your subject and repeat the performance. Draw other irregular objects in the same way.*

Project 16 *Do a contour drawing of a fairly complex form or group of forms: a basket of vegetables; a paper bag with bananas, oranges, and apples pouring from it; a potted succulent or cactus plant with large fleshy leaves; a still life containing many objects of a not too symmetrical nature.* (Strictly symmetrical objects are not good, because beginners are likely to be disturbed by the inevitable sharp deviations from symmetry that occur in contour drawing.) *Begin with the closest form or the most forward part. Try to draw all around each form or part without glancing at your hand or the drawing. Exaggerate the characterizing aspect of each object or part to achieve a maximum sense of difference.* When executed by a sensitive artist, a contour drawing of even the simplest forms acquires great distinction and elegance through disciplined purity of line (Fig. 93).

Whenever possible, make a contour drawing of life models, clothed models, heads, plaster casts, shoes, hats, vegetables, or other previously mentioned objects. From time to time practice contour drawing in your sketchbook, establishing the habit of looking at the subject rather than at your drawing.

A comparison of the drawings reproduced in Figures 92 to 95 reveals that the latter two show a more expressive line. This increase in expressive power results from two factors: first, a careful study and consequently a more subtle perception of form; and second, a sensitive linear expression of these subtle perceptions as evidenced in the variations of line width. By changing pressures of the hand in response to the importance of a detail, a shift of direction in a contour, or an overlapping of forms, the artist produces a sensitivity of line deriving from and evocative of a complex set of associations. Sometimes a thicker line suggests the darker value created by a shadow, which by virtue of its darkness makes a strong impact upon the observer's consciousness. In

below: 92. Gaston Lachaise (1882–1935; French).
Standing Nude. 1922–23. Pencil, $17\frac{3}{4} \times 11\frac{3}{4}''$.
Whitney Museum of American Art, New York.

right: 93. Ellsworth Kelly (1923– ; American).
Apples. 1949. Pencil, $17\frac{1}{8} \times 22\frac{1}{8}''$.
Museum of Modern Art, New York
(gift of John S. Newberry, by exchange).

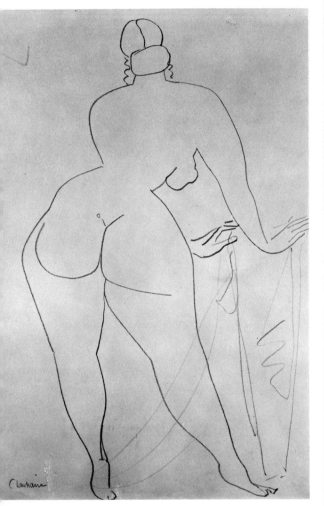

below: 94. Pablo Picasso (1881–1973; Spanish-French).
Head. c. 1905. Brush drawing, $21\frac{1}{2} \times 16''$.
San Francisco Museum of Art (Harriet Lane Levy Bequest).

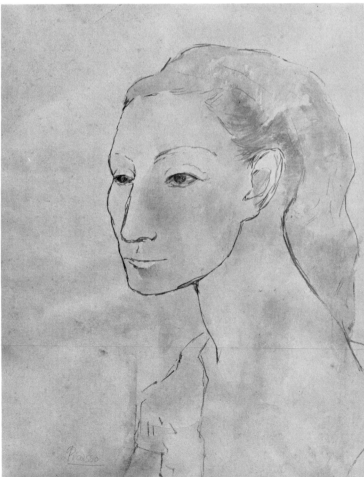

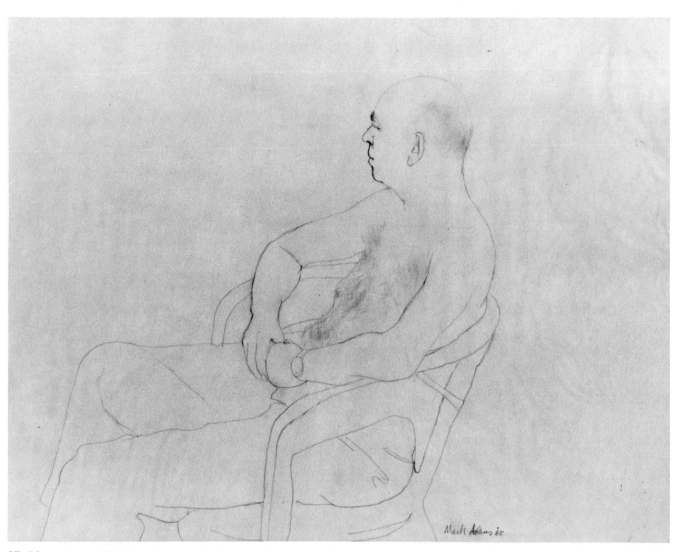

95. MARK ADAMS (1925– ; American). *Portrait of Daniel*. 1965.
Pencil, $18\frac{1}{4} \times 23\frac{1}{4}''$. Collection the author.

a sense these varying line widths function in a manner analogous to the way
that degrees of emphasis in speech reflect the different values a speaker places
upon words.

Adams' *Portrait of Daniel* is worth thoughtful examination (Fig. 95). The
fact that the heaviest lines appear in the face reflects the artist's interest in
the features as the focal point of the portrait study. Interestingly enough, the
ear has been drawn in lighter line, since it seems less crucial in establishing
the character of the sitter. The weighty handling of the profile also suggests
that the far side of the face may be in partial shadow while the ear appears
in full light. Firm and heavy lines stress the upper contours of the arms to
differentiate these muscular surfaces from the flaccid edge of the underarms.
We might suppose that surface texture was of less interest to the artist than
form, since head and body hair is indicated with a fleeting touch. The contour
line that defines the entire upper length of the forward arm merits particular
study. Such changes in line width are not consciously calculated by the artist
but represent a spontaneous response to visual and motor stimuli, for the very
act of drawing, involving as it does such factors as varying directions of
movements or modifications in hand position, produces thicker and thinner

lines. In carrying out the project suggested below, you should not deliberately attempt to change line widths but rather allow pressure on the drawing instrument to vary in accordance with your instinctive appreciation of the importance of each contour.

The Outline of Varied Width

Project 17 *Draw subjects similar to those in Projects 15 and 16. This time, alter pressure on the pencil to describe overlapping planes, darkness of shadow, or other aspects of form that can be implied by changes in the width and darkness of line. Such a method of drawing demands more continuous reference and cross-reference to the subject than did the previous contour drawings. Do not hesitate to look back and forth from drawing to subject as often as you feel necessary, but remember that it is better to keep your eyes on the subject than on the drawing.*

The Delineating Edge

The Broken Line and Repeated Line

Project 18 *Select as a subject a solid form with complex contours—a cabbage with several leaves that have undulating edges, a catcher's mitt, the cast of a hand, or a human head. If you have a large mirror and good light, you might attempt a self-portrait. Using a pencil and drawing a little less than life-size, attempt a slightly broken line such as that in the Picasso Head (Fig. 94). When an edge seems ambiguous and you have difficulty defining it, see if two or three lines will serve better than one.*

Linear Clusters

Project 19 *Again choose a complex subject such as the ones suggested for the previous project, and draw it in freely flowing lines like those in Figures 46 and 96. Allow your hand to move easily, so that the lines are not rigidly parallel to one another or the edge of the form. Be certain to observe the form carefully as you draw; you will find that your perception of roundness, flatness, and meeting of surfaces as they approach the contours will determine the spread or convergence of the clustered contour lines. Remember that the primary purpose of these bundles of lines is to describe the forms within the mass as fully as possible along the boundaries.*

The Modeled Line

Throughout the ages artists have felt the need to reinforce pure outline with suggestions of modeling, for many subtleties of form cannot be revealed by the single line, even one of varying thickness. There is a natural tendency when drawing to amplify differences of line width by means of additional lines, hatchings, or other graduated values to help describe the complexities of form perceived in the model. A good illustration of this tendency to extend and enhance outline can be seen in the *Head* by Picasso (Fig. 94). Here the outline often breaks its movement and changes direction to suggest overlapping planes at the edge of the form. Occasionally, most noticeably in the nose, this broken line is amplified by additional strokes that suggest complexities of form beyond the implications of the single outline.

An extension of this idea is provided by Renoir's *Bathers* (Figs. 96, 97) in which the outline consists of loosely applied lines that follow the form in an easy, flowing rhythm. These lines enrich the sense of three dimensionality,

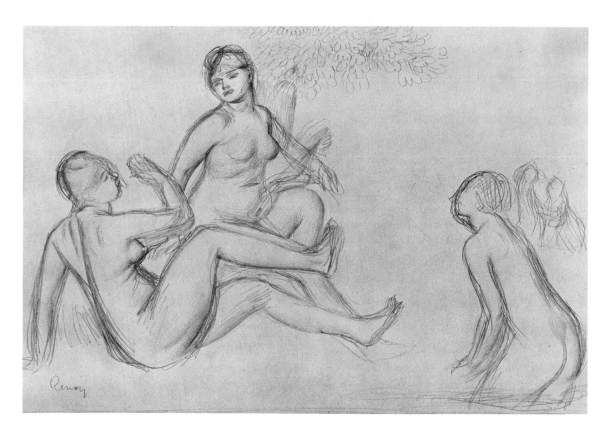

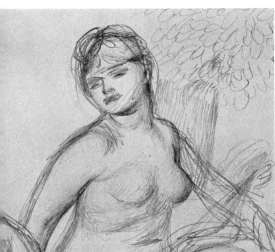

suggesting the movements of a bathing figure as well as the relaxed and joyous act of drawing.

The drawings in Figures 98 to 100 embody further departures from simple outline. Oldenburg's zestful and dynamic *Pat Standing, from Side—"Monkey Woman"* (Fig. 99) provides a striking contrast to the Ingres drawing in Figure 98. Like Ingres, Oldenburg used diagonally moving lines that work with the outline to enlarge the sense of form, but here the execution is brusque and rapid, implying a spontaneous response to the observed facts rather than the painstaking analysis of subtleties that distinguish the Ingres drawing. Both extremes are valid, as are the innumerable possibilities between them.

Project 20 *Select any of the subjects listed for Project 19. Shade the form near the contour with groups of light parallel lines that curve according to the direction the form seems to take. Study the edges carefully, and modify the curvature of the shading lines in any way that seems to describe the form more fully. If the curved shading lines separate from the outlines, making the*

opposite above: 96. Auguste Renoir
(1841–1919; French).
The Bathers. 1887. Pencil, $9\frac{3}{8} \times 13\frac{7}{8}''$.
Wadsworth Atheneum, Hartford, Conn.

opposite far left: 97. Detail of Figure 96.

opposite below: 98. Jean Auguste Dominique Ingres
(1780–1867; French).
Study for the "Grande Odalisque." c. 1814.
Pencil, $4\frac{7}{8} \times 10\frac{1}{2}''$.
Louvre, Paris.

right: 99. Claes Oldenburg (1929– ; Swedish-American).
Pat Standing, from Side—"Monkey Woman." 1959.
Crayon, $35 \times 23\frac{1}{2}''$. Courtesy the artist.

below: 100. Henri Matisse (1869–1954; French).
Reclining Woman. c. 1919. Pencil, $14\frac{3}{8} \times 21\frac{3}{16}''$.
Yale University Art Gallery, New Haven, Conn.
(bequest of Edith Malvina K. Wetmore).

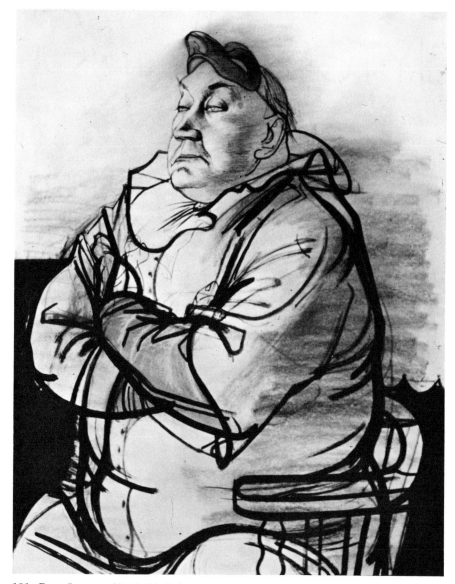

101. RICO LEBRUN (1900–64; Italian-American).
Seated Clown. 1941.
Ink and wash, red and black chalk, 39 × 29″.
Santa Barbara Museum of Art, Calif.
(gift of Mr. and Mrs. Arthur B. Sachs).

*two seem unrelated, see if lines drawn parallel to the edges of the form and
merging into the outline will bind them together. In a subsequent drawing,
try to amplify the sense of form with a bold, scribbled hatching similar to
that in the Oldenburg drawing (Fig. 99).*

*Draw as many objects as you can, following the previous suggestions for
amplifying outlines that delineate form. Do not try to capture the full play
of light and shadow, but merely add supplementary lines, tones, and textures
to reinforce the contours and thereby create a fuller sense of form than can
be achieved by pure outline.*

The Calligraphic Line

Calligraphy is defined as "beautiful writing," and when the beauty of line
that emerges from the flourish of execution becomes a major aesthetic aim,

the result is a true calligraphic line. Study the drawings in Figures 59, 101 and 295—three splendid examples of calligraphic virtuosity. Each of these masterpieces of draftsmanship drew upon the lifetime of experience necessary to achieve a personal style, mature in its assured execution. The beginner cannot hope to do more than become aware of the factors involved.

In drawing, line has not only a descriptive function but also an expressive function. We have seen how variations of thick and thin describe perceptions of form, overlapping edges, and light and shadow. But variations of line width also relate to the gesture by which a line is made. For example, a sweeping stroke—made rapidly, commenced while the hand is in motion in the air, and finished by lifting the hand—usually creates a tapered line that reveals the action by which the line was drawn. In the work of an experienced and excited draftsman, such gestures, far from being self-conscious and deliberate, result naturally from the action of drawing. A glance at the figure of a man from a page in Forain's sketchbook (Fig. 102) reveals the kinds of tapered lines that evoke a hand in motion—starting with a light moving touch, bearing down more heavily in the main part of the line, then lifting.

Beyond the gesture of execution, the character of a tapered line results from the medium used, for the medium, to a degree, controls the gesture. A pointed brush with ink permits wide variation in line widths, as can be seen in a detail from the drawing of *Mother and Child* by Rivera (Fig. 57). Pencil, charcoal, and chalk (Figs. 28, 47) also respond to differing emphasis and reflect the movement of the hand in changes of both width and value; as one presses down, the lines become progressively fuller and darker.

Varying Line Widths

Project 21 *Throughout this project practice using alternately a well-sharpened pencil, and a 1-inch piece of charcoal held between the thumb and first two fingers of the hand (Fig. 39). As noted in Chapter 2, this position encourages maximum facility in modulating line width.*

Pick up the pencil or charcoal as if you were extracting a thumbtack from a surface. Keeping arm and wrist relaxed, make free, swinging, wavy lines, spirals, and gently curved shapes. Hold the pencil or charcoal so that the point of pressure varies from the tip to the side, thus creating a line that ranges from thin to wide. (The charcoal will provide greater variety of line width.) When you hold pencil or charcoal parallel to the direction of your line, it will make a narrow mark; as you move the tool at right angles to the direction in which the line moves, the line will increase in width. Since charcoal serves for making relatively large drawings, use sweeping movements of the arm, so that your lines cover an entire sheet of newsprint. On a full sheet of newsprint, make large, rapid drawings of simple objects, working for a great assortment of line widths.

With a brush dipped in ink, draw a freely curved line. Begin the line in the air, then allow the brush gradually to touch the paper; finally, lift the brush as you complete the line. This should produce a gracefully tapered line. After an initial period of practice, copy the lines of the Forain sketch (Fig. 102) or a detail from Rivera's Mother and Child *(Fig. 57). In copying these, do not try for exact duplication; instead, aim for flexibility of line and free execution.*

Simple Objects

Project 22 *Execute this project first in soft pencil, chalk, charcoal, or a combination of these (Fig. 103); then in brush and ink (Fig. 104). Choose a simple subject with undulating contours: a wide-brimmed hat, a hiking boot*

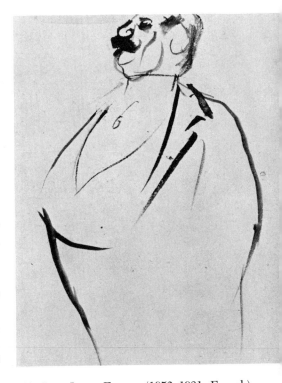

102. JEAN LOUIS FORAIN (1852–1931; French).
Sketch of a Man,
detail of a page in a sketchbook. 1887.
Black crayon, watercolor with brush
and black ink, $11\frac{5}{8} \times 8\frac{1}{2}''$ (entire page).
Art Institute of Chicago
(gift of Frank B. Hubachek).

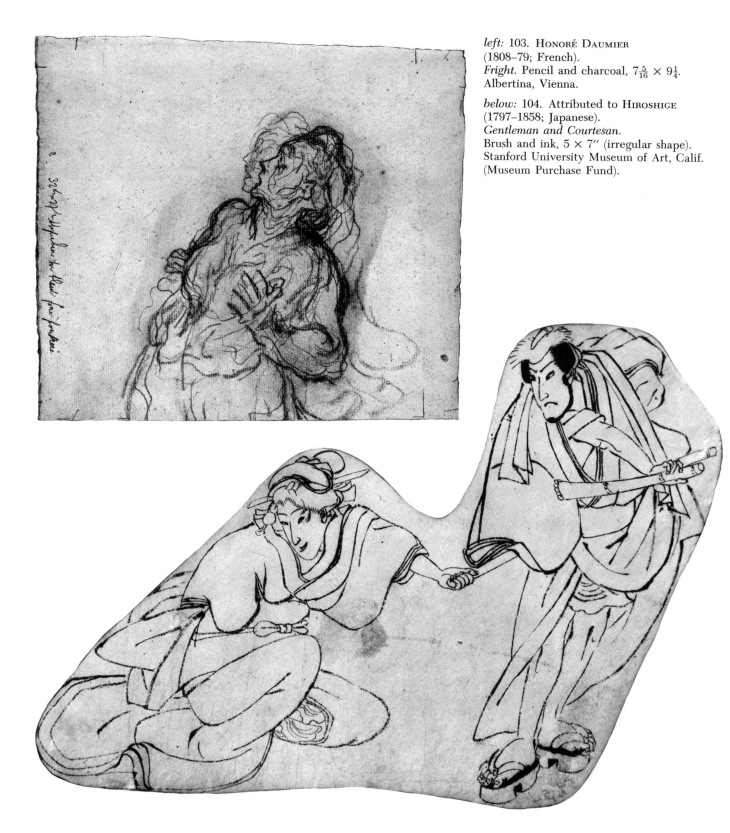

left: 103. Honoré Daumier
(1808–79; French).
Fright. Pencil and charcoal, $7\frac{5}{16} \times 9\frac{1}{4}$.
Albertina, Vienna.

below: 104. Attributed to Hiroshige
(1797–1858; Japanese).
Gentleman and Courtesan.
Brush and ink, $5 \times 7''$ (irregular shape).
Stanford University Museum of Art, Calif.
(Museum Purchase Fund).

or work shoe, a cluster of large leaves, a potted succulent or cactus, or a few large vegetables. Draw them freely, trying for definite variations in line width that seem to grow from the act of drawing. Keep your drawing sufficiently large so that your gestures can be free and unconstricted. Since drawings of this type should be executed quite rapidly, repeat each a number of times and finally select and keep the drawings you think have the most linear character.

Refining the Calligraphic Line

Project 23 *Select a subject and sketch it lightly in pencil, so that you can concentrate on execution rather than on problems of size, shape, and relationship of parts. Proceed with brush and ink, using variations of pressure that correspond to the relationships of form you see or that grow naturally from the act of drawing. Do not try to follow your pencil lines exactly, for this will tend to inhibit the freedom of your strokes. Rather than trying to imitate the effects you see in master calligraphic works, strive for a drawing that expresses the character of the subject, the nature of brush and ink, and the act of drawing.* As you develop assurance of performance and an appreciation of characterful rendering, your own personal calligraphy will emerge.

Experiencing Different Line Qualities

The preceding projects of this chapter were designed to demonstrate the functions of line. Those that follow provide some initial explorations in the expressive qualities of line. An artist does not consciously practice a certain type of line to convey a particular attitude. Instead, the attitude and line character inhere in the artist's temperament—so much so that the artist need not be aware of their existence to express them. Self-discovery is nonetheless most important. This occurs not on a conscious and verbal level, but rather when the artist finds ways of working that are satisfying, comfortable, exhilarating, and "right."

The qualities of line that distinguish individual drawings have been somewhat arbitrarily described as *lyric* (Fig. 105), *emphatic* (Fig. 106), *flowing* (Fig. 107), *crabbed* (Fig. 108), *meandering* (Fig. 109), and *encompassing* (Fig. 110). Such a classification merely attempts to isolate a few of the infinite possibilities of line quality that distinguish artists' work.

Project 24 *Using the medium of your choice, doodle freely in the kinds of line movements you have observed in these illustrations. You may feel the character of the line more sharply if you copy small sections of drawings, but do this loosely, avoiding a cramped, self-conscious copying of your model. Accuracy is not as important as getting the "feel" of a way of working. If you like certain kinds of line movement and they seem to come naturally to your hand, draw in that particular manner. Try to select subject matter*

below: 105. RAOUL DUFY (1877–1953; French). *The Artist's Studio*, detail. Brush and ink, $19\frac{5}{8} \times 26''$ (entire work). Museum of Modern Art, New York (gift of Mr. and Mrs. Peter A. Rübel).

bottom: 106. VINCENT VAN GOGH (1853–90; Dutch-French). *The Bridge at L'Anglois*, detail. 1888. China ink, $9\frac{1}{2} \times 12\frac{1}{2}''$ (entire work). Los Angeles County Museum of Art (Mr. and Mrs. George Gard De Sylva Fund).

right: 107. PAUL KLEE
(1879–1940; Swiss-German).
Play on Water. 1935. Pencil, $7 \times 10\frac{9}{16}''$.
Paul Klee Foundation,
Museum of Fine Arts, Bern.

below left: 108. GEORGE GROSZ
(1893–1959; German-American).
Workmen and Cripple. 1921.
Ink, $15\frac{5}{8} \times 11\frac{3}{8}''$.
Courtesy Richard L. Feigen & Co., Inc.,
New York.

below right: 109. JEAN EDOUARD VUILLARD
(1868–1940; French).
Portrait of Madame Vuillard.
Pencil, $8\frac{1}{6} \times 4\frac{5}{8}''$.
Yale University Art Gallery,
New Haven, Conn.

110. HENRY MOORE (1898– ; English).
Madonna and Child, study for stone sculpture for
the Church of St. Matthew, Northampton, England.
Pen and India ink, wash, and pencil on white paper,
$8\frac{7}{8} \times 6\frac{7}{8}''$. Cleveland Museum of Art
(Hinman B. Hurlbut Collection).

that appears appropriate to each way of working. For instance, you might find
the *lyric* line appropriate for a pencil drawing of one of the following subjects:
a still life of flowers, an imaginative or symbolic visualization of an amusement
park, a mountain stream, or children at play. The *emphatic* line might seem
better suited to a charcoal or brush-and-ink drawing of a battered work shoe,
a stratified rock, or a section of cordwood; the same media and type of line
might intensify an expression titled "Nightmare" or a symbol of "Explosion"
(Fig. 66). The *flowing* line conforms naturally to such subjects as reflections
in quiet water or the rendering of sinuous, naturalistic forms. Erratic move-
ments—the flight of a butterfly or the uncertain gait of a drunkard—suggest
the *meandering* line; the contorted, tight, nervous character of this type of
line applies equally well to the depiction of themes involving tension or
conflict (Fig. 103). Developing easily from continuous circular hand motions,
the *encompassing* line seems particularly well adapted to voluminous objects
and rounded forms—large pumpkins, billowing clouds, or fleshy human con-
tours (Fig. 46). A visualization of objects to be modeled in clay or other weighty
plastic material might also be projected with a strong sense of bulk by the
encompassing line (Fig. 110).

Whenever you commence drawing an object or idea, think about the kind
of line that seems equally right for you, for the medium, and for the subject.
It is productive to think about such factors when one is discovering the world
of drawing in relation to one's own artistic temperament. However, the most
important goal is to work freely, experimentally, even playfully, realizing that
impulse and feeling remain the catalyst for creative activity.

Value

In the visual arts the term *value* denotes relationships of light and dark. White under brilliant illumination is the lightest possible value, black in shadow the darkest—with the range of shades constituting a host of intermediate grays (Fig. 111). Pure black, white, and gray seldom occur in the natural world, for almost every surface has some local coloration, which is in turn influenced by the color of the source of illumination. However, every colored surface—whether red, yellow, or blue—possesses a relative degree of lightness or darkness the artist can analyze and record as value. The systematic use of black, white, and the intervening grays in drawing is then, like line, a convention of visual representation that we accept as an interpretation of perceptual experience (Fig. 112).

While line adequately represents the contours of an object, subjects as a rule display characteristics and suggest moods that cannot be described fully by contour alone. Values clarify and enrich the space defined by simple line in four readily identifiable ways:

1. Three-dimensional form and relationships of form and space become apparent through the play of light and shadow, represented by shading.
2. Value provides a fundamental element for creating pattern, for modulating and describing surface texture.
3. The pervasive mood of a drawing—dark and ominous, light and cheerful—derives from the artist's emphasis on tones at one or the other end of the value scale.

4. Value contrasts convey dramatic power. Strong contrasts of light and dark can, for example, be manipulated to create points of accent in a composition and so draw attention to areas in terms of their importance.

A beginning artist must learn to see relationships of value before attempting to produce convincing visual imagery. Perception of value depends upon a number of factors: (1) the actual coloration of the subject; (2) its lightness or darkness relative to its surroundings; and (3) the degree to which the subject is illuminated or in shadow. Beginners tend to see color (pp. 119–130) as distinct from lightness or darkness and are most aware of value when color does not intrude upon judgment of a subject. Similarly, the novice often thinks of an entire white form as light, although certain areas of it are in shadow and consequently of medium or even dark value (Fig. 113); and of a black surface as dark even when it is brilliantly illuminated. Only with experience can the artist attain a sharply analytical sense of values as they are affected by such factors as color and lighting.

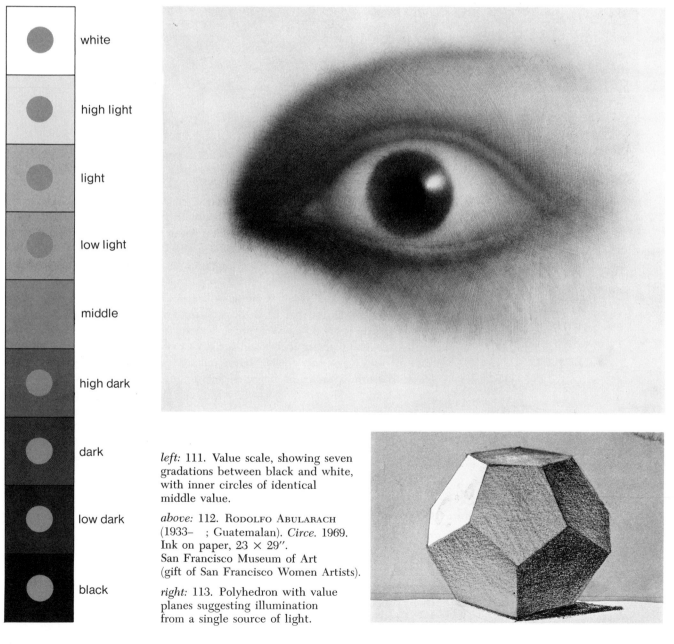

white

high light

light

low light

middle

high dark

dark

low dark

black

left: 111. Value scale, showing seven gradations between black and white, with inner circles of identical middle value.

above: 112. RODOLFO ABULARACH (1933– ; Guatemalan). *Circe.* 1969. Ink on paper, 23 × 29″. San Francisco Museum of Art (gift of San Francisco Women Artists).

right: 113. Polyhedron with value planes suggesting illumination from a single source of light.

114. G. A. FROST
(19th century; American).
Still Life of Casts.
Charcoal, 14 × 21".
Collection the author.

The Value Scale

Traditional French Beaux-Arts academic training stressed the use of charcoal to obtain delicate gradations of value in which almost all suggestion of the method of application was carefully obscured (Fig. 114). In making such drawings, the student carefully pointed a charcoal stick by rubbing it on sandpaper, then built up even gray lines with lightly applied parallel lines. Each set of parallel lines was rubbed with a paper stump or *tortillon*, reinforced with another set of lines, and again rubbed. This procedure would be repeated until tones of the desired intensity and smoothness had been established.

Project 25 For the projects using charcoal, you may wish to add white charcoal paper to the list of beginners' materials (p. 23). Charcoal paper affords greater texture than newsprint, is more durable, and so permits a more finished drawing. *Using a tortillon (or if this is difficult to procure, a rolled piece of paper or paper towel), build up a smooth gradation from white to black.* Because a vigorous range of lights and darks can be created with charcoal, the medium will prove convenient for many of the activities suggested in this section. Students may wish, however, to experiment with other materials. Rodolfo Abularach's fine pen-and-ink drawing *Circe* (Fig. 112) exhibits a wonderfully rich range of values from the heavily cross-hatched, deep black pupil to the gleaming white central highlight provided by the exposed paper ground.

Form and Space

Every object has a specific three-dimensional character that constitutes its *form.* The simplest forms are spheres, cubes, and pyramids. The character of a more complex form, such as a human head, cannot be conveyed fully by a simple word like sphere or cube, since words cannot portray its three-dimensional complexity. We are made aware of the unique aspects of particular forms by light and shadow. As light flows across the surface of a three-

dimensional form, it catches on projecting surfaces and illuminates them, while recessed areas that are hidden from the direct rays of light fall into shadow. Thus, a continuous change of values reveals form to our eyes.

Space is the infinite, uniform component of our world. Artists conceive of space not as an empty void, but rather as a plastic element to be shaped and demarcated by *forms*. The space inside a building or an environmental sculpture, for example, is not merely a hole but a deliberately formed expanse. As such, space can be understood as the negative aspect, or complement, of form. Without forms to indicate spatial intervals, space cannot be perceived. Conversely, without space to articulate forms, those forms would merge into an undifferentiated blur.

Project 26 *Place a white or very light-colored geometric form (a cube or other polygonal shape) so that it receives strong light from above and to one side.* You can easily see how the form of a polygon is revealed, since the angular edges dividing its planes will create sharp changes of value. *Using any suitable technique, build gradations of value, leaving the white paper for the lightest surface and creating the darkest value you can for the deepest shadow, which might well be the cast shadow* (Fig. 113). *If you do not have access to white geometric forms, a cardboard carton with the open flaps propped at varied angles or a covered cardboard box—such as a stationery box with the cover removed and leaned against the bottom at an interesting angle—is also suitable. Observe your geometric object and its cast shadows carefully. Draw the objects as large as is practical for the medium you have chosen.* (Students have a tendency to draw too small, partly from habits derived from elementary and high school paper sizes and partly because smallness seems easier to encompass.) A pencil drawing is too big when it is difficult to build values of even texture; a charcoal drawing is too small when the stick of charcoal seems clumsily oversize.

Chiaroscuro and Form

Since the Renaissance, artists have employed *chiaroscuro*, systematic changes of value, to describe the way light and shadow elaborate form. Figure 115 shows a sphere under strong illumination, and in this uncomplicated form the elements of the system can be identified easily. They are highlight, light, shadow, core of the shadow, reflected light, and cast shadow. *Highlights*, the lightest values present on the surface of an illuminated form, occur upon very smooth and/or shiny surfaces. They are the intense spots of light that appear on the crest of the surface facing the light source. *Light* and *shadow* are terms for the broad intermediate values between the more defined areas of highlight

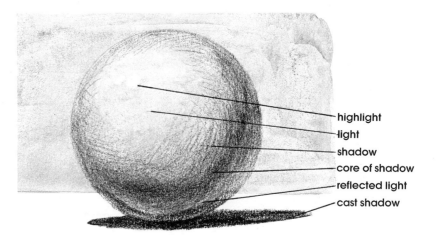

highlight
light
shadow
core of shadow
reflected light
cast shadow

115. Sphere showing the value gradations of traditional chiaroscuro.

and *core of the shadow*, the most concentrated darkness. *Reflected light*—light bounced back from nearby surfaces—clarifies the shadowed portions of a form, especially the core of the shadow. Shadows thrown by objects on adjacent planes are known as *cast shadows*.

Saint Bartholomew by Lorenzo di Credi (Fig. 116) provides an excellent illustration of how Renaissance artists worked chiaroscuro to describe a complex form with broadly established areas of light, shadow, reflected light, and cast shadows. In particular, the core of the shadow functions effectively in many parts of this drawing to delineate the broad division between "light" and "shadow." Notice that the drawing displays no real highlights.

Project 27 *Place a sphere, preferably white although any light color will do (a beachball works well), under strong light. Study the form carefully before you begin to draw, observing how the shadow becomes intensified in the areas of the sphere most removed from the source of light. Also look for the reflected*

116. Lorenzo di Credi
(1459–1537; Italian).
Saint Bartholomew. c. 1510.
Pencil, white and red chalk
on brown paper, $15\frac{3}{16} \times 10\frac{5}{8}''$.
Louvre, Paris.

lights cast into the shadow areas from illuminated nearby surfaces. These values play an important part in placing the sphere in tangible space. *Keep in mind that if the sphere is not shiny, there will be no highlights. Proceed with your drawing, using the method you prefer to create the dark values. If you have a light-gray background, the sense of brilliant illumination will be intensified.*

Project 28 In George Biddle's portrait of Edmund Wilson (Fig. 117) broad areas of light and shadow are separated by a clearly defined core of shadow. There are no highlights, but the small areas of cast shadow under the nose and chin help to define the form. *Try a portrait head (if you are self-conscious about asking a friend to pose, do a self-portrait). Do not strive for a likeness, and try to remain unconcerned with details of features, but work for a solid head (Fig. 118). Concentrate on the play of light and shadow as this clarifies the projections and recesses of the form.*

above: 117. GEORGE BIDDLE (1885–1973; American).
Edmund Wilson. 1956. Charcoal, 13 × 11¼″.
Collection Mr. and Mrs. Benjamin Sonnenberg, New York.

right: 118. FRANCISCO DE ZURBARÁN (1598–1664; Spanish).
A Monk. Charcoal, 10⅞ × 7³⁄₁₆″. British Museum, London.

Sketchbook Activities

In your sketchbook, draw with masses of dark and light to convey light and shadow (Fig. 119). Try blocking in the shadow shapes without any preliminary contour lines (Fig. 120). Continuous practice of this type of drawing develops a kind of shorthand for indicating form and a strong sense of pattern.

Pattern

Flat, unmodulated surfaces of dark and light function as pattern rather than as form. We see the shape of an area and are conscious of its silhouette, but the sense of volume is minimized. Accompanying an increased consciousness of pattern is an awareness of decorative qualities. When a pattern serves decorative purposes, its chief role is to embellish rather than to represent or symbolize. Most textile patterns have this decorative function; the essential role of the design is to enrich the surface of the cloth. A silhouette, whether black on white or white on black, provides the greatest possible value simplification (Fig. 121). It is not, however, sufficiently complex to be very entertaining. We can see how pattern acts to enhance a composition in a drawing by Aubrey Beardsley (Fig. 18). Beardsley's work reveals far greater complexity than a pure silhouette, with a consequent increase of visual interest. In the lower third of the composition the patterns are white on a black ground; the central and upper right areas have black patterns and lines on a white ground; then the upper left again reverses the order. Some elements in the drawing, such as the faces of the two principals and Salome's robes, are outlined so that an effect of white pattern on white ground provides a still further enrichment of the decorative scheme. In the upper left corner, thin white lines on a black ground create an effect of black-on-black pattern.

Patterns in Black and White

Project 29 *Choose a subject or select one of your previous drawings that has decorative pattern potentialities and plan a composition. Sketch your composition in light outlines. With soft pencil, indicate where you will place the black masses and white masses, where you will use black outlines on white and*

119. LOUIS MICHEL EILSHEMIUS
(1864–1941; American).
Old Saw Mill. After 1900.
Pencil, 4½ × 6″.
Amherst College, Mass.

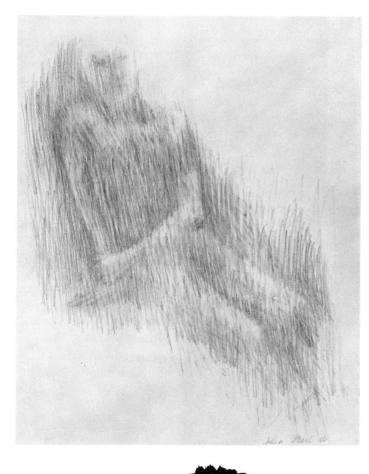

left: 120. JULIA PEARL (1928– ; American).
Seated Figure. 1956. Pencil, $8\frac{3}{4} \times 7''$.
Collection the author.

below left: 121. Anonymous.
Silhouette. Ink, $4\frac{1}{4} \times 3\frac{1}{8}''$.

below: 122. MATT KAHN (1928– ; American).
The Doorbell. 1955. Ink and charcoal, $23 \times 14''$.
Courtesy the artist.

*leave white outlines on black. Finish the study using brush and ink. If you
want a more refined drawing than your present equipment allows, try Bristol
board and a metal pen point; Bristol board provides a brilliant white, takes
the ink well, and permits fine pen lines of even width.*

Patterns in Black, White, and Gray

Intermediate values of gray bring additional enrichment to a black-and-white
decorative pattern. In *The Doorbell* (Fig. 122) the soft grays make the black
and white seem even more vivid, sharp, and dramatic. The fact that *The
Doorbell* is symbolic and expressive in no way diminishes its decorative value;
actually, the two factors are mutually supportive.

Project 30 *For the ensuing problems adapt a previous drawing or choose a new subject. Since the gray you will use can have a strong textural character, you might work with a material such as velvet, satin, or driftwood to develop an abstract-symbolic pattern that expresses in visual terms the textural and physical character of the material. Make a preliminary sketch with pencil or charcoal on newsprint, planning first the shapes and then the placement of black, white, and grays. Draw your composition in light pencil. For the grays crush a bit of compressed charcoal and apply it to paper with a soft cloth or a piece of paper towel, rubbing it gently into the paper until you have smooth gradations of the desired values. Use India ink for the black. If, on completion of the assignment the white areas have lost their brilliance because of smudges, clean them with a soft eraser.*

In *The Doorbell* (Fig. 122) grays blend into the white surfaces, but the black portions remain in silhouette. *Mosaic II* by M. C. Escher (Fig. 123) adds another level of interest. Although it is a lithographic print, the composition was drawn on stone with a lithographic pencil, so it can be legitimately discussed as a drawing. In this work darks modulate the white areas and lights modify the black, thus increasing the visual complexity. *Mosaic II* also achieves a fascinating play of positive and negative areas. The viewer's eye is entertained constantly by the way in which dark forms command attention, only to give way to the figures that emerge as light-colored shapes. The grotesque and imaginative creatures that swarm over the page add to the general fascination, but if one squints one's eyes to the point where detail disappears, the rich pattern of dark and light shapes predominates.

Project 31 *In an area the size of this text compose a group of black-and-white forms—representational, symbolic, or abstract. Paint in the black sections with India ink. Proceed to modulate the white surfaces with charcoal, the black with white chalk. If possible, create a pattern in which positive and negative shapes vie for attention, with the dominance of each group constantly giving way to the other.* This is a difficult feat to achieve, so if you are even partially successful you should be pleased.

123. M. C. ESCHER (1898–1972; Dutch). *Mosaic II.* 1957. Lithograph, $12\frac{1}{2} \times 15\frac{1}{2}''$. Escher Foundation, Gementemuseum, The Hague.

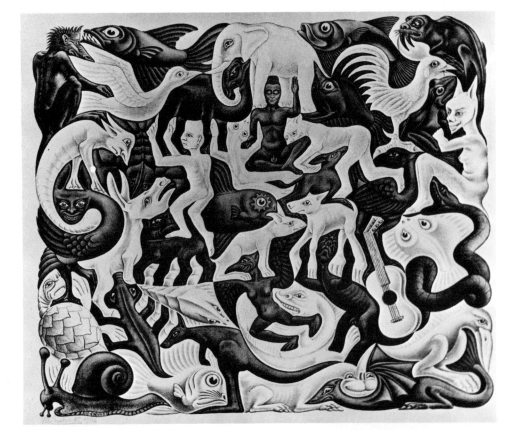

Closely Related Values

The drawings in Figures 18, 122, and 123 exploit full contrasts of value with vigor. But value schemes limited in their range of dark and light can also be effective. Compositions in which close value relationships dominate while contrasts are minimized may create a sense of quiet, soothing restfulness or of introspection and brooding subjectivity (Figs. 120, 124). Predominantly dark compositions often suggest night, darkness, mystery, and fear; Redon's *Human Rock (Idole)* (Fig. 125) projects a powerful combination of all these elements. On the other hand, compositions predominantly light in value carry a sense of illumination, clarity, and perhaps a rational, optimistic outlook (Fig. 4).

Project 32 *Select a theme that seems appropriate for a study in close value relationships, such as "Twilight," "Gray Day," or "Contemplation." You may find it interesting to choose one of your previous compositions and see how a limited tonality, which is the goal of this exercise, can change the mood and expressive character of the study. Depending on your preference, use either crushed charcoal or powdered graphite obtained by rubbing a soft pencil lead on fine sandpaper. With a piece of cloth or paper towel as an applicator, rub on an even tone of medium-light gray over the extent of an enclosed rectangle. Develop your composition by adding darker lines and tones of gray and erasing lighter areas and lines. Avoid intense black areas and pure white lights, so that a gray effect prevails.*

left: 124. MAX ERNST (1891– ; German). *Maternity,* study for *Surrealism and Painting.* 1942. Pencil heightened with white chalk on orange paper, $18\frac{7}{8} \times 12\frac{1}{8}''$. Museum of Modern Art, New York (gift in memory of William B. Jaffe).

right: 125. ODILON REDON (1840–1916; French). *Human Rock (Idole).* c. 1890. Charcoal and red crayon, $20\frac{1}{2} \times 14\frac{3}{4}''$. Art Institute of Chicago (The David Adler Collection).

Dark Values

Project 33 *Select a theme that will lend itself to a predominantly dark composition. Night subjects are, of course, ideal, but a wide variety of less obvious representational or symbolic concepts can be given a special character by combining extended areas of dark with small amounts of accent in light- or middle-value gray (Fig. 126). Plan your composition for either charcoal or charcoal and ink. If you use only charcoal, you may wish to do a full-page composition. An ink-and-charcoal work might better be contained within a smaller rectangle (Fig. 187). Should your lights or whites become smudged, they can be erased clean when the drawing has been completed or can be reinforced with white chalk. To combine ink and charcoal, first develop the charcoal composition to its maximum richness, then add India ink blacks over the darkest charcoal areas. The ink may appear to separate visually from the charcoal areas due to its intense blackness, in which case you might use a textured or dry-brush application of ink to provide a smoother transition from ink to charcoal. For dry-brush effects, partially fill your brush with India ink and then remove the excess by drawing the brush over newsprint paper or a blotter. When the amount of ink is such that a little swipe of the brush against paper leaves a granular texture (Fig. 56), add a transitional tone between the solidly inked masses and the darkest charcoal areas.*

Light Values

Drawings done on white paper in hard pencil—in fact, most line drawings irrespective of medium—carry as essentially light in value. It is only through the extensive application of light grays or through strategic placement of a few very dark accents—as in Thiebaud's *Standing Figure* (Fig. 127)—that the predominantly pale tone of a drawing makes a strong impression.

Project 34 *As in previous projects, determine a subject suitable for expression in the intended value range—for example, a sunlit landscape or strongly illuminated still life devoid of extensive shadow areas—or treat one of your previous drawings as a composition in light values of gray. Frame a rectangle, then rub in a small amount of powdered graphite until you have an even tone of pale gray. Using a fairly hard pencil (2H or 3H) to delineate your composition, add middle-value pencil accents and erase out lights. If you need a few darks for emphasis, draw them in soft pencil. Hard pencil makes a pale*

126. JEAN BAPTISTE CAMILLE COROT (1796–1875; French).
Landscape (The Large Tree). c. 1865–70.
Charcoal, $9\frac{1}{2} \times 16\frac{1}{4}''$.
Collection Victor Carlson, Baltimore.

gray line. Effects of great elegance can result from a pale tonality (Fig. 313), especially when the ground is a very white, fine paper such as the Bristol board previously recommended for pen and ink. Notice the increased power of the whites when seen against a gray background.

Value Contrasts for Emphasis

Variation in degrees of dark and light provides one of the most effective means for accenting areas in a composition. Strong contrasts of dark and light, along with the linear movements, create focal points that can direct the viewer's attention to parts of the composition according to their relative significance. Emphasis through dramatic value contrasts works equally well whether a composition is representational or abstract, as can be observed by comparing Figures 128 and 129. In *Arrival of the Rich Relation* (Fig. 128), value contrasts focus attention on the actors in the narrative according to their degrees of importance. The abstract *Ritual* (Fig. 129) demonstrates an ascending sequence of darks silhouetted against light values and of lights flashing out against dark to create a visually dramatic pattern of satisfying complexity.

Project 35 *Define an area and divide it into rectangles of varying sizes so that you have an abstract composition with three focal points (Fig. 130). In each case, the focus might be a small rectangle encased within the larger ones. Using compressed charcoal fill in the rectangular areas with different values of gray, black, and white; the boldest contrasts should occur where you have planned your focal points. The strongest contrasts could logically be created by small black rectangles on a white ground, or the reverse. Compose a second abstract composition featuring geometric, biomorphic, or organic shapes, and*

127. WAYNE THIEBAUD
(1920– ; American).
Standing Figure. 1964.
Pencil, 10 × 8″.
Courtesy the artist.

128. DAVID WILKIE (1758–1841; English).
Arrival of the Rich Relation.
Ink on paper, $9\frac{3}{4} \times 12\frac{3}{8}''$.
Achenbach Foundation for Graphic Arts,
California Palace of the Legion of Honor,
San Francisco (Collis P. Huntington
Collection).

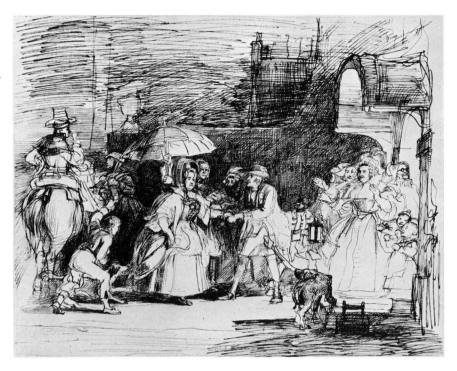

plan one major center of interest and two minor ones. Again place the contrasts of value to direct attention on parts of the composition according to their importance. A change of medium frequently provides a fresh stimulus. Either of the two preceding assignments can be effectively executed in cut and pasted paper using black, white, and various gray papers. Finally, draw a composition that will exhibit a single clearly established center of interest and other minor centers of interest. Carry to completion in the medium of your choice.

left: 129. CALVIN ALBERT (1918– ; American).
Ritual. 1954. Charcoal, $29 \times 23''$.
Art Institute of Chicago
(Art Institute Purchase Fund).

below: 130. Composition of shaded rectangles,
with focal points defined by value contrast.

Perspective

Systems of perspective, in varying degrees of sophistication, have existed in the art of many cultures. The ancient Egyptians suggested space by placing levels of action one above another, each on its own ground line. The lowest band of action in a composition was read as the frontal plane, the highest as the most distant (Fig. 131). This constituted a perspective that not only had intellectual logic but to a certain extent conformed to visual experience, inasmuch as, beginning with the ground in the forefront, one's eyes move up as one looks into the distance. From very early times Oriental artists employed *isometric perspective,* a system still frequently used by architectural draftsmen, industrial designers, and others to indicate the exact measurements of surfaces projected into depth. In isometric perspective, parallel lines going into the depth of a drawing do not converge; that is, objects do not get smaller as they recede into space. The effect is a kind of bird's-eye view of objects and areas depicted, since the lack of convergence creates the illusion of a very high eye level (Figs. 22, 132). It was not until the Renaissance, however, that artists formulated the principles of *linear perspective*—now considered very traditional—in conjunction with those of *aerial* or *atmospheric perspective* (see p. 249) to describe the forms and spaces of the external world upon a two-dimensional picture plane (Fig. 133).

While the fundamentals of linear perspective are disarmingly simple, the rigorous and exact science developed in 15th-century Italy presents a complex

above: 131. *Separation of the Sky from the Earth,* from a *Book of the Dead*
found in the Tomb of Inhapi, Western Thebes. c. 1000 B.C.
Brush drawing in red and black on papyrus, $10\frac{3}{8} \times 19\frac{1}{2}''$. British Museum, London.

left: 132. *Kumano Mandala: The Three Sacred Shrines,*
Japanese hanging scroll, detail. c. 1300. Color on silk, $4'4\frac{3}{4}'' \times 2'\frac{3}{8}''$ (entire scroll).
Cleveland Museum of Art (John L. Severance Fund).

study—one that, in fact, extends beyond our purposes here. Foreshortening
and the simpler aspects of perspective were introduced on pages 48 through
53 by some basic exercises involving overlapping forms, diminishing sizes, and
layered space. The intent of projects in this chapter is to elaborate upon
simpler exercises and to supply the beginner with sufficient familiarity and
working skill in perspective to handle all general sketching requirements.
Throughout this chapter, except where specified, the general term perspective
refers to linear perspective.

Forms in Space

One simple and fundamental concept relates all the complexities of perspec-
tive: objects appear to diminish in size as they recede into the distance.
Diminishing persists until, given enough unobstructed space, all objects disap-
pear. This illusion occurs with absolute regularity, so that a series of objects
of uniform size, such as telephone poles, placed equidistant and in a straight
line on a common plane, appear progressively smaller in a mathematically
determinable progression as they move into deep space, as do all of their parts
and the distances between them. It follows, then, that a plane of uniform width
appears to diminish as it moves into the distance, eventually passing out of the
range of vision at a *vanishing point.* In the terms of traditional perspective,
we generalize this phenomenon as: Sets of parallel lines converge to a vanish-
ing point as they move into the distance. Such convergence is easily observed
in railway tracks, highways, or any regularly shaped and spaced objects that
extend beyond one another into deep space (Fig. 134). Vanishing points at
which parallel lines meet in the distance always occur on a line, called the

133. Leonardo da Vinci (1452–1519; Italian).
Perspective Study for an "Adoration of the Magi." c. 1481.
Silverpoint, then pen and bistre, heightened with white on prepared ground, $6\frac{1}{2} \times 11\frac{1}{2}''$. Uffizi, Florence.

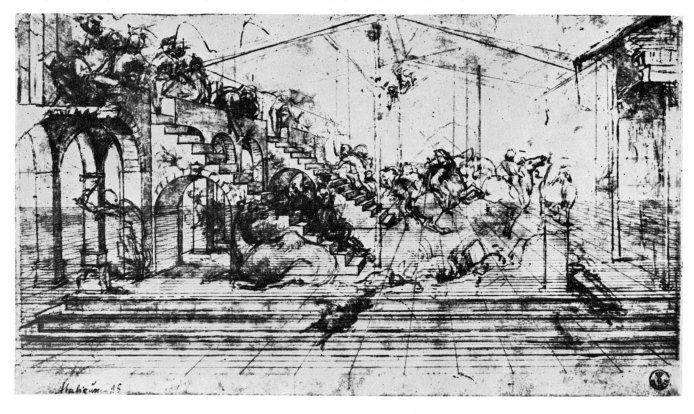

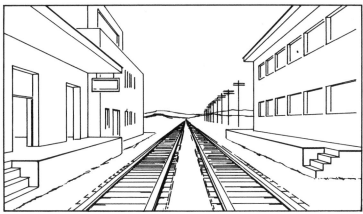

134. An infinite number of parallel lines
can be projected to a single vanishing point.

horizon line, that corresponds to eye level—in other words, the actual eye
height of the viewer-artist in relation to the object or scene being viewed
or drawn (Fig. 147).

While vanishing points and horizon lines can be construed with compara-
tive ease in a few situations—when a road, railway tracks, or telephone poles
cross a vast flat plane in a straight line—such instances are relatively rare.
More often one is confronted with much more complex interrelationships of
form, which are difficult for the eye (and mind) to assess. The following
exercises deal with simple forms that demonstrate the perspective concepts
just introduced—vanishing points, horizon lines, and foreshortened planes—in
order to sharpen the beginner's ability to discern spatial depth as well as render
it on a two-dimensional surface.

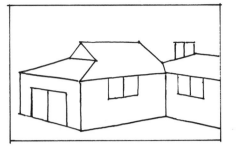

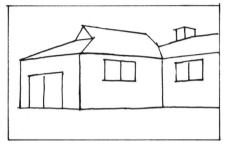

135, 136. The surface of the paper on which a drawing is made constitutes a *plane of vision*.

top: 135. A sketch of a house viewed through a neighboring window.

above: 136. A sketch of the same house viewed through a different window.

137. Five cubes seen from various eye levels.

Viewpoint

Traditional perspective theory rests upon two premises: first, that the eye of the observer is in a fixed position; and second, that the surface of the paper upon which the drawing is done constitutes a *plane of vision*. The term plane of vision may need explanation. If you look straight in front of you through a pane of glass parallel to the plane of your face, this pane of glass represents a plane of vision. If you were to draw on the pane, delineating the edges of objects seen through the glass without moving your head, this act would correspond to doing a perspective drawing.

Project 36 *Place a piece of translucent tracing paper on a pane of window glass and draw around the outlines of an object seen through the glass. An automobile or house provides ideal subject matter, since elements of perspective and foreshortening are reasonably simple and well-defined. Keep your head in one position, and do not modify its distance from the glass. Remove the paper from the window and study the results; identify evident perspective and foreshortening. Repeat this performance, drawing the same object from another viewpoint (Figs. 135, 136).*

Eye Level

Project 37 *Study Figure 137 and determine what each drawing implies about the position of the viewer-artist in relation to the cubes.* If you have observed the drawings carefully and analyzed the full implications of their varying shapes, you should come to several conclusions. First, since you see an equal amount of the two visible faces of each cube, all of the cubes have been sketched from a vantage point directly in front of their forward corners. The position of cube *1* suggests either that the viewer is below the cube (because the bottom face is visible) or that the cube is tilted to reveal this bottom face. Cube *2* lies below the viewer—the same distance below, in fact, as cube *1* was above the viewer—so that its top face is visible. (If cube *2* is tilted, it is tilted in the opposite direction from cube *1.*) Since we cannot see the top or bottom faces of cube *3* and the perspective of both top and bottom edges is equally acute, the viewer's eye level is midway between the top and bottom of the cube. The viewer's eyes are level with the top of cube *4*, because the two edges receding from the forward corner form a straight line. Cube *5*, like cube *3*, implies an eye level halfway between the top and bottom of the cube, but since the angles formed are much sharper than in cube *3*, it appears that the viewer is much closer to this cube.

We can draw these conclusions without formal knowledge of perspective. General familiarity with perspective concepts enables the viewer to interpret

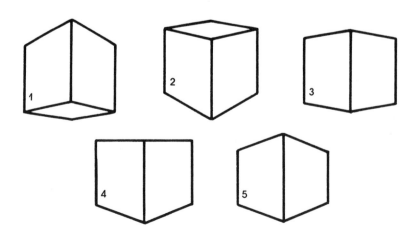

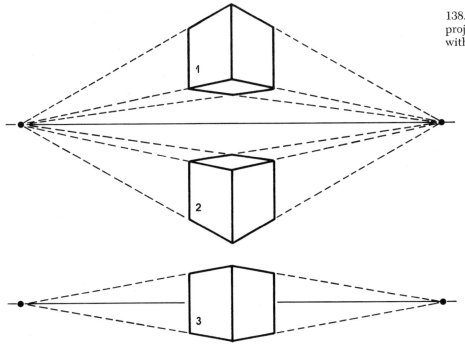

138. Cubes *1, 2,* and *3* from Figure 137
projected into perspective
with horizon lines and vanishing points.

the drawings according to the intent of the draftsman. However, an analysis
of the theoretical basis for these drawing techniques provides insight into the
working of perspective. Figure 138 elucidates the perspective concepts im-
plicit in cubes *1, 2,* and *3* of the previous illustration. We see that cube *1*
and cube *2* share a common horizon line, or eye level—each equally distant,
one above and the other below this line—so that the perspective of one mirrors
that of the other. The horizon line for cube *3*, on the other hand, bisects the
cube.

*Draw a sequence of cubes at various eye levels in heavy pencil lines. With
light lines project the perspective of the cubes to vanishing points and indicate
horizon lines.*

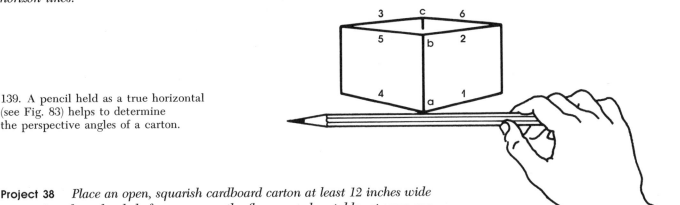

139. A pencil held as a true horizontal
(see Fig. 83) helps to determine
the perspective angles of a carton.

Project 38 *Place an open, squarish cardboard carton at least 12 inches wide
at a series of eye levels before you—on the floor, on a low table, at your eye
level, and considerably above your eye level (to do the last, it is frequently
easiest to thumbtack the empty carton to the wall). Keep the forward corner
of the carton directly in front of you to minimize complexities of perspective.
Observe the varying shapes of the open top and the diminishing amounts of
interior evident as the box approaches eye level. As the box moves above eye
level, notice how an increased area of the bottom becomes visible. Sketch the
box with an easy, free outline in the different positions. If you have difficulty
ascertaining the perspective angle, hold your pencil in a horizontal position
and allow the pencil to touch point a (Fig. 139). You can then judge the angles*

of perspective more objectively (*see* pp. 53–54). The same procedure can be followed in relation to points *b* and *c*, except that at point *c* the pencil should be held above the corner. If your sketches are accurate, you can extend lines *1, 2,* and *3* in each sketch to discover the vanishing point for the right side of the carton; extending lines *4, 5,* and *6* will establish the vanishing point for the left side of the carton. A line drawn between the two points should be horizontal.

When sketching freehand, one seldom achieves an accuracy sufficient to make the projected lines meet in an exact point, and often the horizon line derived from the vanishing points deviates from a true horizontal. This is relatively easy to correct. As you increase sketching facility, your eye will tend to pick out gross inaccuracies. In all sketching exercises you should strive to develop visual sensitivity and place only minimum reliance on theoretical procedures and mechanical aids. Vanishing points and the use of the pencil as a plumb line should serve merely as checks for accuracy.

Project 39 *After sketching the carton, try drawing a series of essentially rectangular forms ranging in size from furniture (a chest, table, or desk) to buildings. Study your sketches carefully to see whether they suggest correct eye-level relationship between you and the subjects.* Frequently, beginners show all objects in bird's-eye perspective—that is, as though the artist were looking down upon the subject matter. Remember that if you are drawing an object whose top is above your eyes, the horizon line containing the vanishing points will be below the top of the object.

Vanishing Points

Project 40 Figure 140 presents another series of cubes. *Study them and again decide what is implied about the position of the viewer in relation to the cubes.* Your analysis of the six cubes should reveal the following information:

1. The hypothetical viewer stands slightly to the right of the cube's foremost edge and sees more of the right face of the cube than of the left. Eye level is at about the middle of the cube, so that the bottom edges rise toward the horizon line at the same angle that the top edges descend.
2. The viewer again stands to the right of the front corner but closer to it, and consequently sees even more of the right and less of the left face of the cube. Eye level is fixed somewhat below the base of the cube.
3. Here the viewer is positioned well to the left of but even closer to the cube's front corner than in either cube *1* or cube *2*. By standing closer

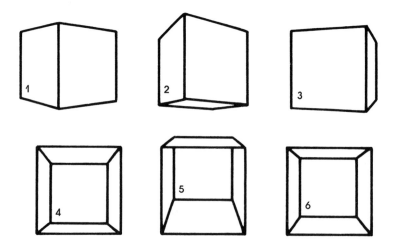

140. Six hollow cubes viewed from different positions.

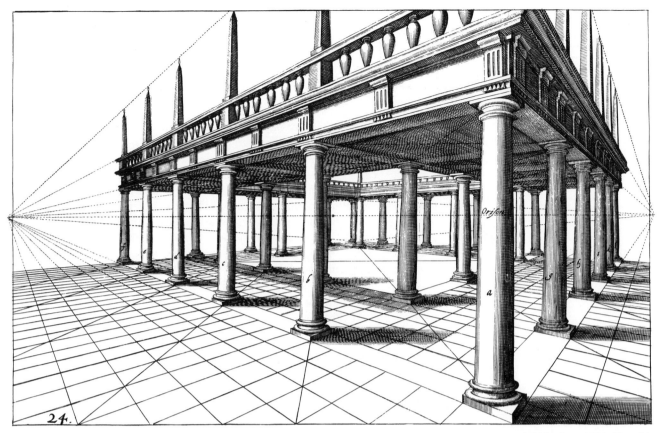

141. Jan Vredeman de Vries (1527–after 1604; Dutch). Perspective study. From *Perspective* (Leiden, 1604).

to the crucial edge, the viewer sees very little of the right face, which is in acute perspective, but most of the left cube face is visible. Eye level rests between the bottom and top of the cube, but nearer to the bottom; hence, the perspective lines of the bottom edges slant up at a lesser angle than the top lines slant down.

4. Here one appears to be looking into an open cube from directly in front of it. The eye level is about one-third up from the bottom of the cube.

5. The viewer is still looking into an open cube from directly in front, but the eye level is now slightly above the top of the cube.

6. Again, one stands directly in front of the cube, but this time with eye level about one-third down from the top of the cube. In cubes *4* and *6* the planes may seem to reverse themselves, so that what at one moment is seen as the back of the cube changes to project forward into the front plane. When this happens, one ceases to see a cube and instead views a truncated pyramid, larger in back than in front. Such phenomena occur readily when more than one reading of a drawing is equally logical. This shift cannot occur in cube *5* because the top plane overlaps the sides, locking them into fixed spatial relationships.

An architectural study by Jan Vredeman de Vries, a Dutch 16th-century student of perspective theory, puts the viewer's eye level, and consequently the horizon line, half-way between the base of the columns and the top of the entablature (Fig. 141). The viewpoint is from just to the left of the front corner of the structure, and its closeness results in a rather acute perspective. The perspective approximates most nearly that of cube *3* in Figure 140.

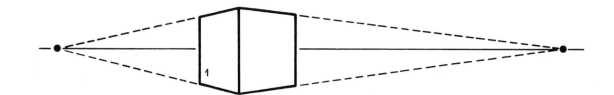

142. Cubes *1* and *4* from Figure 140 projected into perspective with horizon lines and vanishing points.

Place a piece of tracing paper over each of the cubes in Figure 140. Trace the cubes and continue the lines of the edges until they meet at vanishing points. Use heavy lines to outline the cubes and the horizon lines, light lines for the projection as in Figure 142. You will notice that cubes *1, 2,* and *3* have two vanishing points each, while *4, 5,* and *6* each have only a single vanishing point. This can be explained as follows: Each set of parallel lines one sees receding into the distance has its own vanishing point. In the sketches of Figure 140 for cubes *1, 2,* and *3,* the two visible sides of each cube are at right angles to each other, presenting two separate sets of parallel lines; hence, they require two vanishing points. Since cubes *4, 5,* and *6* are centered before the viewer, all four edges of each set of receding interior planes are parallel. In each instance, then, the four lines that describe these edges meet at a common vanishing point directly in front of the viewer.

1. *Draw a series of solid cubes as though you were standing to the left, to the right, high above, and below the cubes. Project the perspective of the cubes to the horizon lines, as in Figure 142, then correct the drawing of the cubes until the projected lines meet at vanishing points on a horizontal horizon line.*

143. Jan Vredeman de Vries (1527–after 1604; Dutch). Street scene, with one-point perspective. From *Perspective* (Leiden, 1604).

2. *Assume a series of open cubes have been placed directly in front of you. Draw them as through they were in varying positions below and above your eye level. Project the perspective, and if the lines do not meet at one central vanishing point, make the necessary corrections.*

One-Point Perspective

An infinite number of sets of parallel lines can meet at one vanishing point, as Figure 134 shows. Here warehouses, loading platforms, doors, windows, tracks, and so on—all rectangular forms that parallel one another—form right angles to the picture plane. Their perspective lines meet at a common vanishing point directly in front of the viewer, in this case in the center of the drawing. The same phenomenon of *one-point perspective* can be observed in a study by Jan Vredeman de Vries (Fig. 143) as well as in Leonardo's study for *Adoration of the Magi* (Fig. 133).

Project 41 *Select a complex grouping of rectangular structures and project them into one-point perspective. Any long corridor such as one sees in the typical school, with doorways opening from it, lockers lining the walls, and so on, provides such a subject. Draw the subject from a central position, placing your vanishing point in the center of the horizon line.*

An interesting variation of this perspective scheme occurs in Dominique Papety's *Via Gregoriana* (Fig. 144), which depicts a simultaneous view down two streets that do not parallel one another. The façades of the buildings lining each street are composed primarily of rectangular forms with a multiplicity of parallel lines. Thus, the sets of parallel lines for each street converge toward separate vanishing points, the one on the left being slightly more central than that on the right. This illustrates in a most vivid way that there can be more than a single vanishing point in a perspective composition.

144. DOMINIQUE PAPETY
(1815–49; French).
Via Gregoriana. 1838.
Graphite pencil with blue ink wash
on gray paper, 13 × 17¾″.
Musée Fabre, Montpellier.

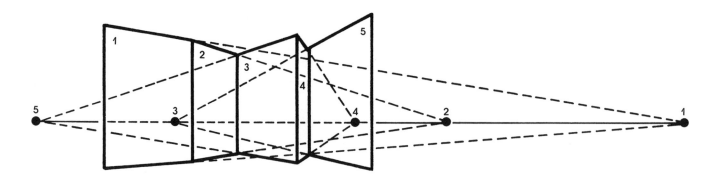

145. A five-faceted screen
with five vanishing points.
The more closely a plane approaches
being perpendicular to the picture
plane, the closer is the vanishing
point. Conversely, the more closely
a plane approximates being parallel
to the picture plane, the farther away
is its vanishing point.

Multiple Vanishing Points

Project 42 In Figure 137 we observed a series of cubes from directly in front of their forward corners, so that an equal amount of the two visible sides of each cube could be seen. This results in two vanishing points, one for each of the sets of parallel lines receding into space, and the two vanishing points are equidistant from the center of the drawing. In Figure 140, cube *1* reveals uneven amounts of its two visible sides, indicating that the viewer is not directly in front of the forward corner of the cube. Therefore, the vanishing points for the two sides are not equidistant from the center of the drawing. The more closely a plane in a drawing approximates being at right angles to the picture plane, the closer is its vanishing point to being directly in front of the viewer. Remember that when a plane is at right angles to the picture plane, its vanishing point occurs directly in front of the viewer; conventionally, though not always, this means in the center of the drawing. The more closely a plane in a drawing approximates being parallel to the picture plane, the farther is its vanishing point from the center of the drawing. A plane exactly parallel to the picture plane would have no vanishing point. The illustrated drawing of a five-faceted screen employs five vanishing points, since no two facets of the screen parallel one another (Fig. 145). You will notice that vanishing point *4*—the vanishing point for the plane (*4*) that is closest to being at right angles to the picture plane—is nearest to center (the viewer is standing slightly to the left of center). Vanishing point *1*, the vanishing point for the plane most nearly parallel to the picture plane, is the farthest from center. *Draw a multifaceted screen and project each facet to its vanishing point.*

Project 43 Study Figure 146. In this sketch we see two sets of vanishing points (four points in all): one set for the group of skyscrapers in the back plane, another for the lower buildings in the foreground. All the left planes in the back range of buildings vanish at point *a*, located on the left border of the drawing. The vanishing point for the right planes of this set of buildings (the faces shaded with diagonal lines) would be located far out of the picture to the right. The vanishing points for the left faces and top planes of the front range of buildings is located at point *b*, almost in the center of the drawing; the other set of vanishing points for the shaded faces of the front buildings would be even farther to the right than that for the back range of buildings, since the front planes come even closer to paralleling the picture plane. Therefore, because the two sets of rectangular forms pictured are neither parallel nor at right angles to one another, this drawing requires four vanishing points, even though only two are apparent within the frame.

Place two large cartons or boxes before you so that the sides are parallel neither to the picture plane nor to one another, and draw them. When you have completed the drawing, project the major planes into perspective to ascertain whether your vanishing points have been correctly placed. If you have made mistakes, correct the drawing.

146. Two groups of buildings not parallel to one another have two sets of vanishing points.

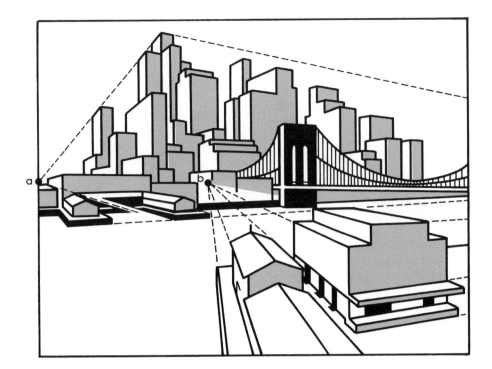

The Horizon Line

We have found that the horizon line upon which vanishing points are placed corresponds to eye level, or the actual eye height of the viewer-artist in relation to the object being drawn. If an artist is drawing an 11-foot-high wall that stands on the ground level with the artist, and the artist's eyes are $5\frac{1}{2}$ feet above the ground, the horizon line will be in the middle of the wall, and the lines that define the top and bottom of the wall will converge at the same angle (Fig. 147).

Project 44 *Trace the edges of this book to provide a frame for the following exercise. In an imaginary landscape setting similar to Figure 148, draw a series of walls projecting into the distance. Assume a constant eye level, and include one wall that is half the height of your eye level, one equal to your eye level, one twice your eye level. Add walls of other heights, and place fence posts, telephone poles, and other objects in the landscape. Draw in distant hills to suggest the landscape setting. Remember that the bottom of the walls and objects cannot be placed arbitrarily. If, as in Figures 147 and 148, an 11-foot wall extends an equal amount below and above the horizon line, a 22-foot-high wall would be placed one-fourth below, and three-fourths above the horizon line. The proportion will remain the same no matter where in the composition the 22-foot-high wall is placed. For instance, the top of a $5\frac{1}{2}$-foot object will always be at the horizon line, if the artist's eye level is $5\frac{1}{2}$ feet. Add some human figures to your landscape.*

left: 147. An 11-foot screen viewed from an eye level of $5\frac{1}{2}$ feet above the ground.

right: 148. The perspective horizon line and the actual horizon are seldom identical.

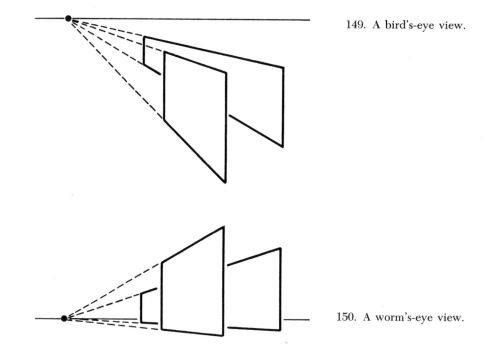

149. A bird's-eye view.

150. A worm's-eye view.

Project 45 As stated before, the horizon line is determined by the actual eye level of the viewer-artist in relation to the object being drawn. If the high walls in Figure 149 were viewed from an eminence far above the top of the walls, the eye level, horizon line, and vanishing points would be raised correspondingly. The same walls viewed from a seated position, with the eye level $2\frac{3}{4}$ feet from the ground, would have the eye level, horizon line, and vanishing points considerably lowered, as in Figure 150. A high eye level is frequently described as a "bird's-eye" view, a low eye level a "worm's-eye" view. *Redraw the group of walls and objects of Project 44 from a bird's-eye view. Repeat from a worm's-eye view.*

Multiple Horizon Lines

So far in our discussion it has been implied that all vanishing points are on the horizon line. This is true only of vanishing points for those sets of lines that define edges parallel to the ground plane. Most of the forms discussed in this study of perspective, being rectangular and resting flat on the ground plane, converge to vanishing points on the horizon line.

Project 46 Figure 151 introduces vanishing points that are not located on the horizon line. Of the six vanishing points used in drawing the carton with open flaps, only vanishing points *a* and *b* are located on the horizon, for they are the vanishing points for those edges of the carton and flaps that parallel the ground plane. However, each of the open flaps *1, 2, 3,* and *4* moves into space at an angle not parallel to the ground plane, so each of these flaps has vanishing points above or below the horizon line. *Study the relationship between each open flap and its vanishing point; you will see that the more vertical the plane, the higher the vanishing point.* We must then amend a previous statement to the effect that sets of parallel lines drawn in perspective converge as they recede into space to meet at vanishing points on a horizon line. Instead, let us say that all sets of parallel lines drawn in perspective converge as they recede into space to meet at vanishing points in the distance.

151. An open carton in correct perspective, with vanishing points for ascending and descending planes.

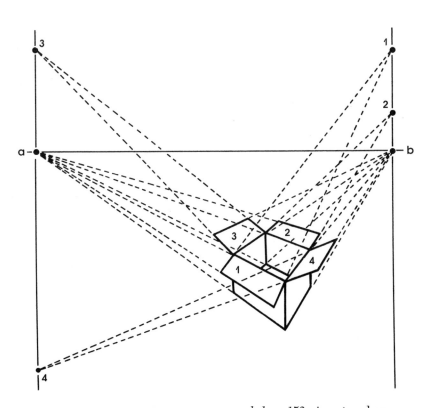

While the exact location of each vanishing point can be determined by scientific perspective, this involves more elaborate theories and skills than are necessary for general sketching.

It is more important for our purposes to develop the ability to observe convergences that occur as planes pitched at various angles move into space than to ascertain the exact vanishing points for various planes. *Compare Figure 152 with the previously discussed Figure 151.* In Figure 151 the flaps of the carton were drawn in perspective to converge at points *1, 2, 3,* and *4.* In Figure 152, which is drawn contrary to the laws of perspective, the flaps cease to appear as true rectangles but seem to be irregular trapeziums. Beginners frequently draw slanting roofs so they appear wider in back than in front. *Compare Figure 153, where the roof plane converges as it goes into the distance, with Figure 154, in which the roof is incorrectly drawn.*

Place on the floor a large open carton with flaps extended at various angles, and make a freehand drawing of it in perspective. After you have finished your sketch, project the perspective to vanishing points and correct any mistakes. Change the angles of the open flaps and draw the carton in another position, profiting from any previous mistakes. Make a drawing of a small house with a pitched roof and gables, and project the sides of the roof into perspective. Be certain to observe the roof areas carefully, and do not show surfaces you cannot see. It is most important to integrate perspective theory with drawing habits.

below: 152. A carton drawn in incorrect perspective. Convergences and vanishing points are inconsistent.

far left: 153. A pitched roof drawn in correct perspective.

left: 154. A pitched roof incorrectly drawn.

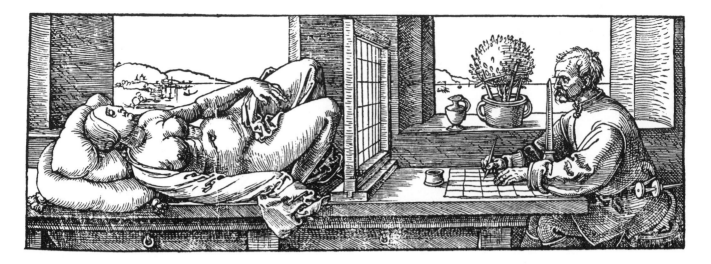

Three-Point Perspective

All of the material on perspective discussed up to this point has been based on a convention wherein the viewer is looking straight forward and the picture plane is vertical, at right angles to the horizontal ground plane (Fig. 155). However, neither in actual experience nor in theory need this be true. One can look up at a tall building or down from a height, in which case one vanishing point will be directly in front of the viewer, in deep space either above or below. Renaissance perspective theory recognized this fact, as can be seen in a perspective study by Jan Vredeman de Vries (Fig. 156). The drawing relies upon one-point perspective, with the vanishing point just slightly off center. The only convergence occurs toward the one established vanishing point; none can be found in the systems of rectangular forms that parallel the picture plane.

above: 155. ALBRECHT DÜRER
(1471–1528; German).
*Draughtsman Making Perspective
Drawings of a Woman.* 1525.
Woodcut, $2\frac{15}{16} \times 8\frac{1}{2}''$.
Metropolitan Museum of Art, New York
(gift of Felix M. Warburg, 1918).

below: 156. JAN VREDEMAN DE VRIES
(1527–after 1604; Dutch).
Perspective of an interior court.
From *Perspective* (Leiden, 1604).

Three-point perspective is a relatively recent concept, brought to the modern consciousness by the camera, the skyscraper, and the airplane, as can be seen in the aerial photograph of skyscrapers in Atlanta (Fig. 157). The three-point perspective system evident in Figure 157 is analyzed in a diagram view loosely based on the photograph (Fig. 158). In this drawing, vanishing point *a* lies on the baseline, far below the tops of the buildings. Vanishing points *b* and *c* are on a horizon line far above eye level—*b* to the left and *c* on the same horizon line and far to the right.

Typical three-point perspective employs three vanishing points in just this manner. Two of the vanishing points function for those sets of converging lines parallel to the ground plane on which the viewer stands. These vanishing points rest on a horizon line established by the eye level of the viewer. The third vanishing point is at right angles to the picture plane, a picture plane that parallels the tilt of the head as the viewer looks up or down, either far overhead or far below.

above: 157. Aerial view of downtown Atlanta.

right: 158. Diagrammatic rendering of a view similar to that in the photograph above.

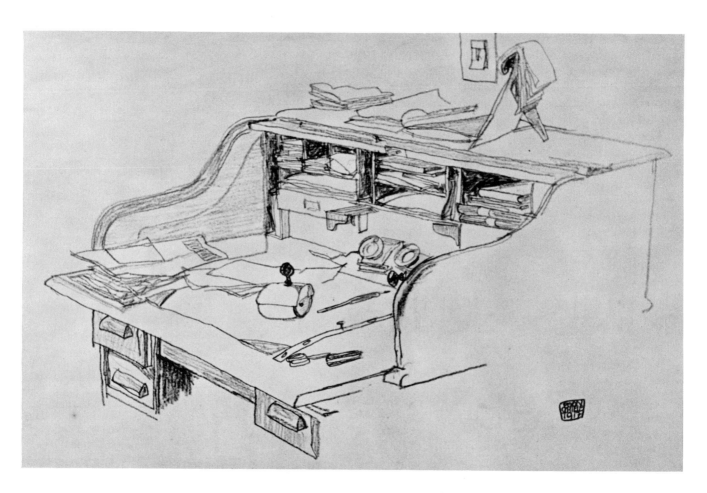

159. EGON SCHIELE
(1890–1918; Austrian).
Desk. 1917.
Black chalk, $11\frac{5}{8} \times 18\frac{1}{8}''$.
Collection Dr. H. Rose,
Douglas, Isle of Man.

Project 47 While three-point perspective grew from viewing experiences that were confirmed by aerial photographs or by looking up at tall buildings, it is frequently used to give an effect of looking down on a relatively small object, such as a piece of furniture (Fig. 159). *After studying some familiar household objects from several viewpoints, make a number of drawings that, by means of three-point perspective, suggest looking sharply up or down.*

Curvilinear Forms

So far our study of perspective has concerned itself with the disposition of rectangular forms. Circles, ovals, and other curvilinear forms demand separate consideration. The circle provides the basic curvilinear form for our study here, since an understanding of the perspective of circles will develop fundamental knowledge for later sketching of more complex curves.

160. A circle viewed in perspective
takes the form of an ellipse,
whose exact shape can be determined
by inscribing the circle within a square
and projecting both into perspective.

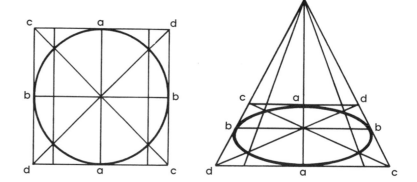

161. A drinking glass with circular edges drawn in faulty perspective.

Project 48 When a circle extends into space, it assumes the form of an ellipse. The exact form of an ellipse can best be visualized if the circle is lodged within a square that is then projected into perspective, as in Figure 160. To establish a relationship between circle and square, it is necessary first to draw a circle in a square as seen full-face (left). *Notice the location of lines a-a, b-b, c-c, and d-d, for these provide guidelines that enable us to foreshorten the circle accurately. Now study Figure 160 carefully, and you will realize that the circle on the left has been drawn in correct perspective on the right. Observe the elliptical form created, and note that its edges as they touch the sides of the square are not pointed but rounded. Note also that the front half of this circle in perspective is larger than the back half, producing a fuller front curve.* The most frequent mistakes made in drawing ellipses freehand are: (1) to draw the more distant curve larger than the nearer, and (2) to depict the ellipse ends as too pointed (Fig. 161). *Project two or three circular forms in squares to varying degrees of perspective; then draw some ellipses freehand.*

Ellipses in Varying Perspectives

If a cylindrical drinking glass is held upright in a sequence of positions from far below eye level to high above, the circle formed by the rim will appear fully round only when the glass is directly above or directly below the eye. As it approaches eye level, the circle manifests itself as a sequence of increasingly closed ellipses, reduced finally to a straight line at actual eye level (Fig. 162). The same progression occurs when a circle is rotated about a vertical axis (Fig. 163).

Project 49 *Place a cylindrical object on the floor in front of you, then gradually raise it until it is at eye level. Draw the changing ellipses. Continue, placing the object above your eye level, and draw the circular shapes of the top as you look up at them. Draw a wheeled object going into perspective—a bicycle, car, child's wagon, or any other convenient source of circular shapes.*

right: 162. The circular rim of a glass, viewed in perspective as it moves from directly below to directly above the eye of the observer.

below: 163. Successive views of a circle rotated about a vertical axis.

Ellipses in an Architectural Setting

A number of perspective problems involving ellipses arise when one is sketching traditional architecture of any complexity. Arches, circular windows, the capitals and bases of columns, round turrets and towers—all involve the perspective of circles and partially circular forms. These curvilinear elements usually appear along with rectangular forms, and if the two are not handled consistently, the drawing will be weakened. It is often wise to use bisected squares as a basis for making elliptical forms (Fig. 160), particularly when drawing a series of arches extending into perspective, as in a long arcade. Master drawings again prove illuminating. In Figure 164 de Vries describes a series of arches extending into deep space with each ellipse centered on a square rectangle. Piranesi's *Monumental Staircase Leading to a Vaulted Hall* (Fig. 165) projects a wide variety of arched and circular forms into planes at varied eye levels with unusual power and conviction.

Sketchbook Activities

Continuous practice in perspective drawing sensitizes the eye, so that one unconsciously sees in perspective and can readily perceive errors. *In your sketchbook draw subjects from both theory and observation involving judgments of perspective: books, boxes, furniture* (Fig. 159), *room interiors, buildings, street scenes, automobiles, boats, machines, and so forth.* When you draw objects such as automobiles or boats, it may be helpful to place them in theoretical "boxes" and then modify the rectangular into ovoid forms; *in other words, first draw the forms as though they were encased in rectangular blocks and then "chip" away to reveal the rounded contours of these encased forms.* In drawing complex architectural subjects, you will sometimes be hard put to tell whether the edges of walls and roofs appear to rise or fall as they go into the distance. Even using your pencil as a horizontal line to judge the

164. JAN VREDEMAN DE VRIES (1527–after 1604; Dutch).
Perspective study. From *Perspective* (Leiden, 1604).

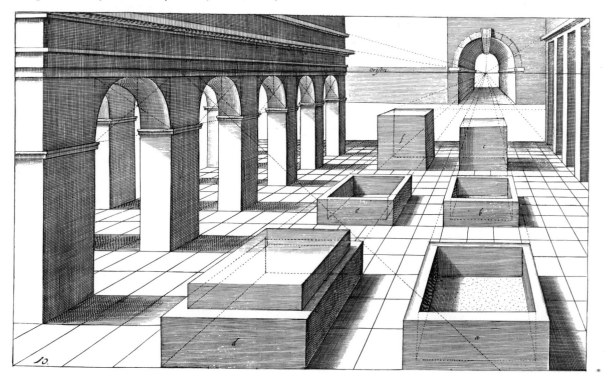

165. GIOVANNI BATTISTA PIRANESI
(1720–78; *Italian*).
*Monumental Staircase Leading
to a Vaulted Hall.* c. 1755.
Pen and brown ink over red
chalk, with brown wash,
$15 \times 10\frac{1}{2}''$.
British Museum, London.

degree and direction of angle will not always reveal the proper cues. In such cases, ask yourself whether the confusing edge is in reality above or below your eye level. If your eye is 5 feet from the ground, a roof line 8 feet above the ground, and the ground on which you are located approximately level with that on which the building rests, the roof edge must descend toward the horizon as it goes from you into the distance. With much drawing and much looking, uncertainties become less frequent and drawing more accurate.

Accuracy in itself is no great virtue in drawing, and mechanical modes of procedure that inhibit freedom and instill habits of undue timidity and caution are more harmful than the faults they are meant to correct. *Draw*

frequently, vigorously, and freely, always looking at the subject of your drawing. After you have drawn an object, study the drawing and ask yourself whether it conveys properly your position in space and your relation to the object. If not, check the implied horizon line as well as the location of your implied vanishing points, and make necessary corrections. The most common mistakes are (1) drawing as though from a bird's-eye position so that converging perspective lines meet high above the buildings; (2) not having related sets of converging perspective lines close enough to meet at common vanishing points; and (3) drawing ellipses with pointed corners and having the fuller curve of an ellipse on the farther rather than the closer side.

Perspective Distortion

Although our subject at this moment is accuracy, many fine drawings purposely violate conventional perspective concepts. In Ben Shahn's *Brownstone Front* (Fig. 166) the fact that both main contours and details of the building are depicted in incorrect perspective stresses the building's decorative qualities rather than its spatial depth. The pedimented door reveals this with particular force. Shahn realized that our eye is accustomed to seeing architectural forms presented in correct perspective and so consciously used distortions to jar the observer from complacent looking to an increased awareness.

Texture

When we look at the world about us, we are conscious not only of form, space, color, dark and light, but also of tactile qualities, a sense of the feel of surfaces, of roughness and smoothness, hardness and softness. Our perception connects many associations with these tactile experiences. For instance, smoothness may suggest refinement, luxury, expert craftsmanship; roughness tends to evoke vigor, heartiness, crudity, and careless finish. In our industrial age, smoothness also implies machine finish as opposed to the less regular and less mechanical surface created by the workman manipulating handcraft tools. Traditionally, feminine and masculine qualities have been linked with the attributes of smooth and rough. We term this multitude of tactile sensations and associations *texture,* and its representation is fundamental to the aesthetic strength of any drawing.

Textural Character

Three factors determine the textural character of a drawing. First, in works concerned with picturing objects, there is the surface quality of the objects represented. The artist of *Two Monkeys in a Wu-T'ung Tree* has created a textural complexity as rich and subtle as the finest Chinese cuisine (Fig. 167). Second, there are the textures inherent in the artist's materials—for example, coarse chalk on rough paper as contrasted to fine pencil on smooth paper.

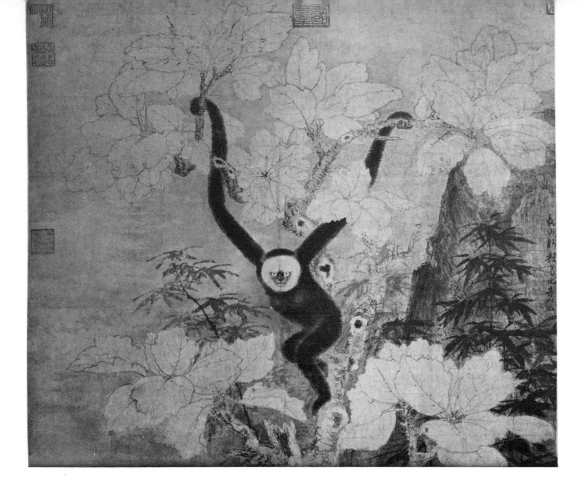

167. Anonymous (Chinese; 17th century). *Two Gibbons in a Wu-T'ung Tree*, detail. National Museum, Stockholm.

Third, there is the suggestion of roughness or smoothness that results from the artist's manner of work. In Goya's *The Little Prisoner* (Fig. 168) the impetuous use of ink, evident in both the crinkly contour lines and the briskly applied hatchings, creates a sense of vitality less related to the surfaces being described or medium being used than to Goya's excited execution. These elements—the surface portrayed, the medium and ground, and the method of application—unite as the textural character of a drawing. Drawings that do not convey a decisive sense of texture tend to appear flaccid and weak.

Familiar Surfaces

The minute moldings of a surface's structure are often so fine that textural character is difficult to perceive. Too, many surfaces are so familiar that we take them for granted and fail to be objective about the particulars of their textures. Enlarging the scale of a surface provides an excellent means of becoming aware of its exact character (Fig. 169). Upon close examination the texture of many a familiar surface—a sponge, a slice of bread, or the skin of a cantaloupe—proves fascinating.

Project 50 *Select a textured surface. Light the surface sharply from above and to one side (a "raking" light) in order to emphasize and clarify its texture. Fill a small rectangle with a pencil rendering of the surface magnified many times, using dark and light values to create a maximum sense of its texture.*

Textures of the Artist's Media

Project 51 For this project you will need to acquire a much greater assortment of materials than you have worked with heretofore: *Gather papers of varying roughness, smoothness, and type of surface grain (see p. 133). Small*

right: 168. Francisco Goya
(1746–1828; Spanish).
The Little Prisoner. 1810–20.
Pen and brown ink, with wash, $4\frac{5}{16} \times 3\frac{1}{8}''$.
Prado, Madrid.

below: 169. A section of natural sponge,
$\frac{3}{4} \times 1\frac{1}{4}''$, drawn on a scale
four times natural size.
Pencil, $3 \times 5''$.

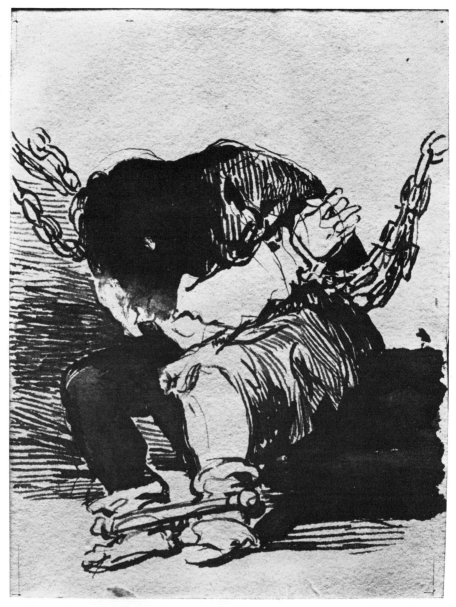

pieces with a total area of only 9 or 10 square inches will suffice. Collect chalks, crayons, pencils; felt-, nylon-, and ball-point pens; brushes, sponges, and other equipment for applying inks. Experiment with applying the different media to the papers. Use both the sides and points of dry media; cross-hatch and stipple in both dry and wet media; combine all types of pens, sponges, brushes, and so forth. Cut out even-size areas of the textures you consider most interesting and mount them side-by-side on heavy paper or mat board to emphasize their differences.

Comparative Renderings

Project 52 *Set up a simple still life of little textural variety—smooth vegetable or fruit forms and a bowl on a table, or a plaster cast. Select two contrasting combinations of media and paper from the previous experiment, and render the subject in each combination. Study the two drawings when they are completed and try to determine which method of working seems most satisfying to you, in terms of both the activity and its end result.*

Rendering Multiple Units as Texture

Modern students of the psychology of perception have observed that we see similar things as comprising a unit. Thus, when we look at a tree, we are not aware of the hundreds of leaves that make up the tree, but rather fuse

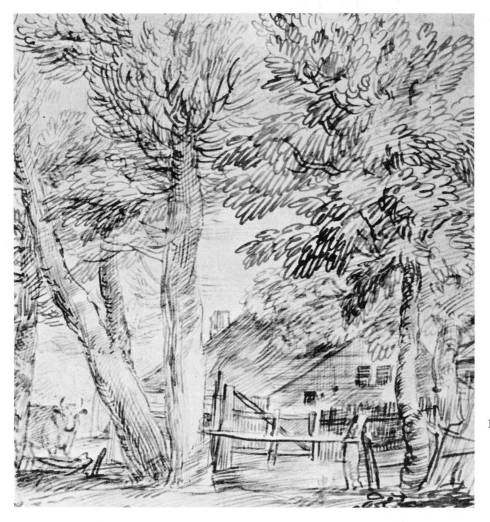

170. JAN LIEVENS (1603–44; Dutch). *Rural Landscape with Milkmaid*, detail. Reed pen and brown ink on Indian paper, $8\frac{11}{16} \times 14\frac{1}{16}''$ (entire work). Metropolitan Museum of Art, New York (Rogers Fund, 1961).

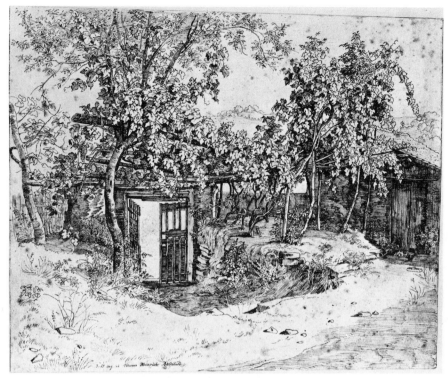

left: 171. HEINRICH REINHOLD
(1788–1825; German).
Vineyard, Olevano. 1822.
Pen and ink, with pencil, $10\frac{1}{4} \times 12\frac{7}{16}''$.
Staatliche Graphische Sammlung, Munich.

below: 172. Detail of Figure 171.

them into a single visual entity; a cluster of leaves becomes a tree. When we look at a tree, we see its multiple surface units as a texture, and in rendering the surface an artist tends to suggest that textural character by wiggling the hand, stippling, making lines or splotches, or using any other measures that appropriately suggest the surface quality of the object. Such movements of the hand become almost automatic in time, the hand responding to the visual perception of texture as unconsciously as it responds to changes of direction when one is doing contour drawing.

Project 53 An interesting illustration of the ways in which different artists respond to similar stimuli can be seen in the following sequence of illustrations and the accompanying details (Figs. 170–178). The artists were representing

173. ALEXANDER H. WYANT
(1836–92; American).
Landscape, detail.
Charcoal, $11\frac{3}{4} \times 17''$ (entire work).
Los Angeles County Museum of Art
(gift of Dr. and Mrs. F. W. Callmann).

Texture **113**

left: 174. SCHOOL OF SESSHU (EITOKA ?)
(16th century; Japanese).
Panel of a six-fold screen. c. 1590.
Sumi on rice paper, 5′3″ × 1′9″.
Stanford University Museum of Art, Calif.
(Ikeda Collection, gift of Jane L. Stanford).

right: 175. Detail of Figure 174.

various trees and using different media; their drawings reflect a variety of traditions and divergent temperaments. *Study the drawings, analyzing all the ways of suggesting foliage. Select two or three trees from nature with sharp differences in the character of their foliage. Before you start to draw, analyze the elements that give each tree its particular character—the shapes of the foliage masses; the size of leaves, whether they hang, radiate from a central joint, or lie in horizontal or vertical strata; the size and shape of the areas of sky seen through the masses of foliage; the character of branch patterns, where branches are seen, and so forth. After you have analyzed these qualities, develop textures that communicate the character of the foliage masses, using the medium of your choice. Select the texture you consider most satisfactory, and draw a full tree. Draw another tree of very different character.*

above left: 176. RODOLPHE BRESDIN (1822–85; French).
Bank of a Pond. Pen and India ink, $6\frac{7}{16} \times 6\frac{11}{16}''$.
Art Institute of Chicago (gift of the Print and Drawing Club).

above right: 177. Detail of Figure 176.

178. VINCENT VAN GOGH
(1853–90; Dutch-French).
In Saint-Remy. 1889–90.
Black chalk or charcoal
and white chalk
on tan paper, $11\frac{3}{4} \times 15\frac{3}{8}''$.
Formerly collection
Mrs. Ruth Lilienthal,
Hillsborough, Calif.

Uniform Texture

Some artists prefer that the texture of a drawing assume an abstract character, not determined by the subject being portrayed but rather by the mode of applying the medium. This method tends to emphasize the formal aspects of a drawing and seems best suited to stylized modes of expression, where a uniform texture frequently prevails throughout a drawing (Figs. 179, 180). Such uniformity enhances the patternlike qualities of texture (see also Figs. 119, 120). In *The Thought Which Sees* (Fig. 181) Magritte has employed vivid texture patterns to add visual complexity to the drawing, to differentiate parts, and to suggest the visual experiences that inspired the drawing—wood grain, waves, a garden at night, and so on. The result is a drawing of subtlety and unusual evocative power.

Project 54 *Enclose five rectangles, roughly 2 inches wide by 3 inches high, and fill them with textures of uniform character created in ways suggested by the drawings just observed or by methods of your own devising. Work for an even texture that graduates imperceptibly from very dark in one corner to very light in the opposite corner. To create a texture of uniform character, pencil, hard chalk, or ink applied with brush and/or pen is preferable to charcoal, since charcoal, being soft, is apt to blur as you work over it. Gradations of value can be achieved through both the darkness of individual marks and the varied spacing of these marks. Some suggested ways of working are: (1) scribble in curved and circular movements; (2) scribble in angular and straight-line movements; (3) use straight lines at right angles to one another to create cross-hatched texture; (4) use dots, taking care to eliminate all linear*

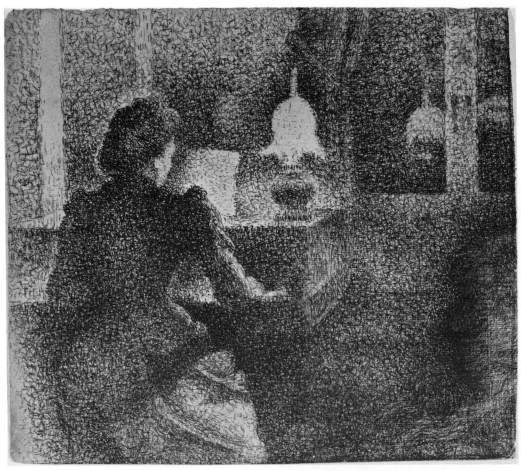

179. THÉO VAN RYSSELBERGHE (1862–1926; Belgian). *Maria van der Velde at the Piano.* 1891. Conté crayon, $12\frac{1}{2} \times 14\frac{1}{8}''$. Art Institute of Chicago (John H. Wrenn Fund Income).

trailings, or consciously use commalike marks; (5) combine or modify one or more of the above methods.

Project 55 *Select an appropriate subject or plan a simple composition to be developed in dark and light, using one or more textures.* If you have difficulty in deciding upon a subject, it might be interesting to adapt one of your earlier value studies for this project (see pp. 79–88). The size of your drawing should be influenced by the scale of the texture you are rendering. A coarse brush or soft pencil texture inevitably demands a much larger composition than a fine, precisely applied pen-and-ink or hard-pencil texture.

Studied and Free Rendering

The freedom or caution with which a medium is applied to paper, the degree to which hands and body are relaxed, expressions of inner tension or harmony, as well as intellectual convictions and aesthetic tastes—all these work together to form an artist's mature style (Pl. 2, p. 26). Each artist's style has its textural character. The beginner frequently shows conscious preferences that take the form of admiration for some particular master's way of working, and very often the beginner gives legitimate expression to these preferences by following the manner of the master. Very gradually, as the young artist matures, the way of working gains assurance and independence from admired models, and a unique style evolves.

Project 56 *Study a number of drawings or good reproductions, and select ways of working that achieve an appealing textural character. Using the media*

180. FERNAND LÉGER (1881–1955; French). *Study for "The Divers."* 1941. Pencil, pen and ink, with ink wash, $12 \times 17\frac{2}{3}''$. Art Institute of Chicago (gift of Tiffany and Margaret Blake).

you feel you handle most effectively, draw simple objects in ways derived from the admired manner. It is important to work with similar if not identical materials. Do not attempt to copy the admired techniques, but instead try to feel the mood of the style and the manner in which it was carried out, whether slowly and methodically or rapidly and impulsively, whether with small finger strokes or large hand movements. After you have made a number of drawings, study them in relation to the master drawings that inspired them. Try to discern where your methods and results deviate from your model and to what degree you prefer your deviations. When you find a way of working that appeals to you, either because you feel comfortable in it or because you like the results, continue to practice it in your sketchbook and elsewhere. It is important to discover the most satisfying ways of working and those you can use with a minimum of self-consciousness.

181. RENÉ MAGRITTE (1898–1967; Belgian).
The Thought Which Sees. 1965. Graphite, $15\frac{3}{4} \times 11\frac{3}{4}''$.
Museum of Modern Art, New York (gift of Mr. and Mrs. Charles B. Beneson).

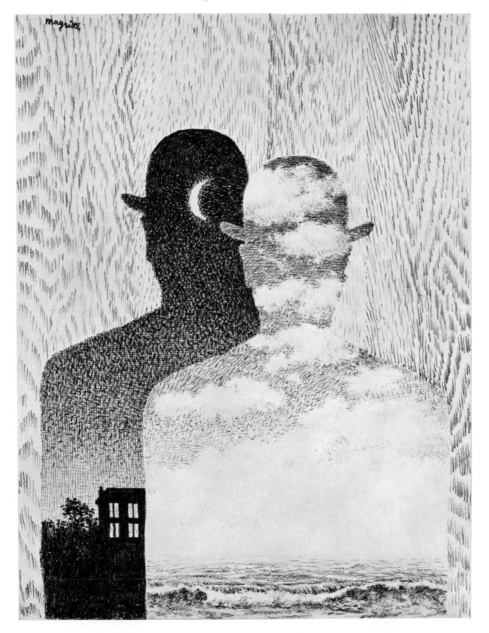

Color

The distinction between drawing and painting is an arbitrary one, particularly when drawings have color applied. In general, drawing is conceived as employing less than full modulations of color and omitting the varying degrees of fluidity and viscosity that characterize painting. *The Abduction* by Gabriel de Saint-Aubin is truly a colored drawing (Pl. 15, p. 195). Pen and ink provides the dominant linear element, although traces of black chalk can be discerned. A bistre wash and watercolor highlights interplay with the linear elements. As is the case with many old master drawings, little concern was expended on retaining the "purity" of the medium of execution. Instead, almost any material that would contribute to the desired effect was considered valid.

The introduction to color provided in this chapter has been designed with the limited aim of familiarizing the beginner with the nature of color to the extent of exploring its potential to enrich drawing. Almost every beginning student working in black and white at some time feels the limitation of colorlessness and longs to discover the beauty and excitement of color. Under this stimulus, students frequently introduce color in their drawings by adding touches of watercolor, colored ink, or chalk to a black-and-white sketch. These legitimate attempts to expand experience can do three things: they can introduce students to the realm of painting, provide a means of expanding the expressive potential of drawing (Pl. 3, p. 59)—and make students realize anew the power and beauty of black and white.

Media

To explore the use of color in drawing, you must enlarge your supply of materials. You should purchase media similar to those you have heretofore employed most effectively and that will mix well with them. Colored chalks, pastels, colored pencils, colored ball-point and felt-tip pens, colored inks, and watercolors (either transparent or opaque) are all readily available, inexpensive, and easy to use; they will equip the beginner for a comfortable introduction to color. Wax crayons and oil paints do not mix with water-soluble or dry media, so they are not recommended for beginners.

If watercolor is your choice for initial experimentation in color, watercolor paper of good quality or illustration board provides the most satisfactory type of ground (see p. 133). Illustration board can be thumbtacked to your drawing board; watercolor paper is best mounted. To mount watercolor paper, wet it on both sides, lay it on the drawing board for about five minutes or until the water has been absorbed, smooth out slightly, and fasten the edges of the paper with butcher (not masking) tape. Allow the paper to dry thoroughly, so the buckling disappears. This procedure keeps the watercolor paper flat, prevents swelling, and minimizes the pooling of washes.

When purchasing color materials, beginners frequently select an unduly elaborate array. It is wise to commence with a small range of basic colors and learn to mix and modify them. A minimal set of colors could consist of the three primary pigments, red, yellow, and blue, plus the three secondaries, orange, green, and violet. These, together with black and white, will make an entirely adequate palette for the beginner.

A package of colored construction paper will also prove very useful. As background or in pieces pinned to compositions for intermediate stages, colored paper allows an artist to test the effectiveness of intended color combinations. In fact, problems of color scheme and composition can be assembled easily and rapidly in flexible collages of cut paper.

Today there exists an unparalleled abundance of colored drawing materials. This abundance further lessens the previously mentioned distinction between drawing and painting, a distinction that in earlier times was closely related to the ease with which a free range of color could be an intrinsic part of the drawing process. In earlier times one might draw in black or brown on colored paper and then perhaps add a second color for an occasional accent (Pl. 4, p. 60; Pl. 13, p. 161). Today one can draw with as great a range of hues, values, and intensities as that available for painting (Pl. 14, p. 162), with the additional comfort of knowing that many of the colors, although certainly not all of them, are fairly permanent.

Manufacturers have devised three classifications to describe pigments and their power to resist fading: (1) *permanent*—will not fade except with much exposure to direct sunlight; (2) *durable*—safe for most paintings kept indoors, in normal light, and glassed; (3) *fugitive*—fade with little exposure to light. Many artists freely employ durable colors except in murals or similar situations where extreme exposure demands maximum permanence. Fugitive colors are used when brilliance of color is of prime importance and permanence of little consequence, as in posters and other types of advertising art. To guard against unfortunate surprises, an artist should test colors by controlled exposure before committing them to an important work.

Color Theory

The layman uses the word "color" and the names associated with it in ways that are vague and subjective, although adequate for everyday communication. One describes familiar color experiences as brown, tan, taupe, magenta,

turquoise, pink. Such words, however, lack sharp definition. Pink, for instance, encompasses a number of shades from near red to the palest blush. For a genuine understanding and accurate control of color, the artist requires the terms of a more precise analysis.

Color is an optical sensation produced by the various wavelengths of visible light that form a narrow band on the known spectrum of radiant energy. White (or apparently colorless) light, such as that emitted from the sun at noon, contains all of the colors of the spectrum—violet, blue, green, yellow, orange, red, and their innumerable intermediate gradations—so balanced and blended that they become isolated only when a beam of white light is passed through a prism. A prism *refracts* or bends the constituent elements at different angles according to their varying wavelengths. This phenomenon occurs in nature as a rainbow, where raindrops act as minute prisms to refract the white light. When light strikes an object, some of the component rays are absorbed and others reflected. The reflected rays determine the color we perceive. Thus, a lemon absorbs almost all light rays except those for yellow, which reflected to our eyes give the lemon its characteristic color. Leaves reflect mostly green rays, and therefore we say that leaves are green.

Color theory in relation to those sensations we perceive from surface reflections—like the yellow of a lemon or pastel or tempera—differs significantly from color theory as it applies to light. Artist's colors represent a translation of the transparent colors of light into the opaque medium of pigment, and as such behave differently in combination. Color in the visual arts for the most part means reflected color, and for purposes of simplicity our discussion here explores only this aspect—that is, the properties of color as exhibited by the artist's media.

Full description of a particular color sensation demands the identification of the three dimensions of color: *hue, value,* and *intensity. Hue* refers to location on the spectrum. While in actuality the spectrum consists of a series of light vibrations that merge imperceptibly into one another, an artist working with colors sees this continuum of vibrations as divided into intervals named violet, blue, green, yellow, orange, and red (Pl. 5, p. 125). These basic hues are then further distinguished as primary, secondary, or tertiary.

> *Primary colors*—red, yellow, and blue—are so-called because they cannot be obtained by mixing together any other hues.
> *Secondary colors*—orange, green, and violet—are the derivative hues produced by primary mixtures (orange by combining red and yellow, green from yellow and blue, and violet from red and blue).
> *Tertiary colors,* the intermediate steps between the six basic hues, carry hyphenated names. A color between blue and green would be called blue-green, one between red and orange, red-orange. (One ordinarily names first the primary, then the secondary hue. If the convention is reversed, as in "orange-red," the implication is that the hue contains a good deal more orange than red.)

The lightness or darkness of a hue, its approximation to white, black, or one of the intermediary grays, is indicated by the term *value* (see Chap. 5). Pink then represents a light value of red; navy blue a dark value of blue (Pl. 6, p. 125). Violet as it appears in the spectrum is dark in value; yellow is light. Light, medium-light, medium, medium-dark, and dark describe degrees of value.

Intensity refers to the saturation of a hue, its purity or brilliance. A color of high intensity is pure, vivid, unmodulated by gray, black, white, or another hue that might diminish its impact; a low-intensity color is conversely dull, grayed, carrying little vitality. High, medium-high, medium, medium-low, and low are the adjectives commonly used to characterize intensity.

A brief analysis of the color brown will elucidate the concepts of hue, value, and intensity and their interdependency. Brown is a dark value and low intensity of the hue orange. If you add a dab of black paint to bright orange, the black will darken the value of the orange and lower the intensity, producing brown. If you add much white to this mixture of orange and black (or if you are using watercolor and add water), you will get a light value, low intensity of orange called tan. The brilliance or purity of the orange (its intensity) will have been reduced, or we sometimes say grayed, by the addition of black and white (Pl. 7, p. 126) or its complement, blue (Pl. 8, p. 126).

Only knowledge, experience, and conscious analysis will enable one to progress from thinking in terms of familiar color names like brown and tan to identifying color experiences by the relationships of their constituent parts—hue, value, and intensity. This does not mean that the artist should eliminate common terms from everyday speech but that in perceiving and using color the artist should employ precise terminology. One can learn to translate such conventional color names as maroon or leaf-green into objective observations—for example, by defining maroon as a medium-dark value, medium intensity of red and leaf-green as a medium-light value, medium-high intensity of yellow-green.

Identifying Color

Project 57 *Take all of your colors, one at a time, and to each add black, white, and black and white (gray). Observe what the additions do to each color and name the results accurately.* If you are using a dry pigment such as chalk, value can be lightened either by adding white chalk or applying a thin granular layer of color to permit the white of the ground to show through (thus also producing a lesser degree of intensity).

From color reproductions (magazines provide a good source), cut out single-color areas no smaller than 1-inch square. Using whatever medium you prefer, mix your own colors to match the samples. Cut out squares of equal size and pair them with the magazine samples. Mount these pairs, and below each identify the colors in terms of hue, value, and intensity.

The Color Wheel

The color wheel is a conventional device whereby the progression of hues in the visible spectrum is presented in circular format. A number of color theories or systems have been formulated, each with its own special color wheel. Plate 5 (p. 125) shows a standard, broadly accepted version that functions well in practical use. Here yellow and violet face each other across the circle, permitting a smooth transition from the lightest hue at the top to the darkest at the bottom. Twelve hues compose this wheel—the primaries, the secondaries, and the tertiaries. Counter-clockwise, the names read: yellow, yellow-orange, orange, red-orange, red, red-violet, violet, blue-violet, blue, blue-green, green, and yellow-green.

Project 58 *Make a color wheel, using whatever medium you wish. To be effective the colors should be of the highest intensity possible.* Opaque, water-soluble media such as poster paint offer the simplest solution, since they are available as high-intensity colors and dry with an even, mat surface. Watercolor demands great care to maintain full color intensity, and chalks may not provide a sufficient range of intense hues. A successful color wheel is distinguished by the consistent high intensity of all hues and the regular progression from hue to hue around the wheel. For watercolor samples, it is simplest to paint large patches of color and then cut out swatches from the

best areas, subsequently mounting them on a piece of illustration board. If you are using chalks or pastels, you might apply your colors directly to illustration board or paper, allowing them to overlap at the edges and thereby producing a continuous band of fused color.

Warm and Cool Colors

The color wheel, although an arbitrary bending of the spectrum, is a functional arrangement. A few of its practical applications will be explored in the following projects.

The hues on one side of the color wheel—yellow, orange, red, and their neighboring tertiaries—are called warm colors; the hues on the opposite side of the wheel—green, blue, violet, and the intermediate tertiaries—are termed cool. Yellow, orange, and red are aggressive colors. They seem to project forward in space; suggest among other things sunlight (yellow), heat (orange), and blood (red); and are psychologically arousing and stimulating. The cool colors, relating to sky, water, distance, and foliage, tend to recede in space, seem quiet and more restful. Human responses to color have probably been conditioned through the ages by our environment. The landscape is predominantly cool in color. Vast areas of medium-intense blue and green in sky, water, and foliage surround us. While warm colors occur frequently in nature also—in sand, rocks, and earth—most that are present in large quantities are of low intensity. Intense warm colors seem to appear in nature primarily as accents (flowers, feathers, and so on) and relate to the perpetuation of the various species of living things.

When applying color the artist, consciously or unconsciously, employs warm and cool, aggressive and recessive tendencies to create the emotional and spatial effects desired. Color intensity, too, has its psychological and spatial impact. A color of high intensity is more aggressive and stimulating than the same color in a low intensity (Pl. 7, p. 126). Intense orange commands more attention and moves forward in space more than does tan (a light value, low intensity of orange) or brown. In the same way, a high-intensity blue is more active compositionally than a grayed blue.

Project 59 *Select one of your earlier black-and-white compositions for the following experiment with color.* Abstract compositions provide a better vehicle for color experiments than representational works, since naturalistic considerations tend to restrict color in the representational drawing while abstraction encourages greater freedom in the selection of hue, value, and intensity. *Make color samples on separate pieces of paper and pin them to various parts of the composition so they look as though you had planned to include color as a compositional element.*

Experiment with a number of colors in varying values and intensities to see which combinations reinforce the impact and mood of your drawing most effectively. Also, study the effect of different colors on the space relationships established by the drawing. If a color comes forward or recedes too much, modify it to function effectively. When you have settled on the color that works best, add it to the black-and-white drawing. When color is introduced to a drawing, not only must the medium be compatible with the original work but the texture and method of application must be similar.

Complementary Hues

Hues situated opposite one another on the color wheel are termed complementaries. Yellow and violet are complementary, as are red and green, blue and orange. Complementary tertiary hues also face each other across the color

wheel; thus, the complement of yellow-green is red-violet, of blue-green, red-orange, and so forth. Complementary hues play two roles: they can either nullify or intensify each other (Pl. 8, p. 126). Mixed together, complementary pigments neutralize or lower the intensity of one another. True complements combined in the proper proportion will, at least in theory, produce a neutral or colorless gray. In practice it is usually difficult to find pigments that are exact complementaries, so when one mixes blue and orange, the result will most likely be either brown (low-intensity orange) or a blue-green hue of low intensity.

Project 60 *Mix pairs of complementary colors together to determine their effects upon one another.* You will undoubtedly notice that the intensity of a hue rapidly lessens with the admixture of its complement. For this reason, when one mixes paints or colored chalks and wishes high-intensity colors, one must avoid combining complementaries. However, it is important to remember that a touch of the complementary can selectively reduce a color's intensity. *Explore fully the effects of complementary mixtures.* To handle color effectively, one must have an almost intuitive command of the full gamut of color interaction.

Placed in juxtaposition, complementaries increase the apparent intensity of each other, or truly "complement" one another. A spot of low-intensity orange pigment upon a field of high-intensity blue will appear distinctly more intense. A high-intensity orange spot on a high-intensity blue field almost vibrates, its brilliance augmented by interaction with the intense blue to the point that the eye can barely discern the precise edges of the orange spot.

Project 61 *Select or paint a sequence of colored papers that are of a single hue but vary greatly in intensity. These will serve as backgrounds and should be at least 4 by 6 inches in size. Pin them on the wall. Cut out small spots (not more than 1 inch in diameter) of a single low-intensity complementary color and pin them on the backgrounds.* You will notice that the spots seem hardly to be from the same piece of paper. Spots on the high-intensity backgrounds will appear much brighter than those pinned on the low-intensity backgrounds. If your backgrounds vary in value, you will observe another interesting reaction. The spots pinned on dark backgrounds will appear much lighter than those on light backgrounds, for the light backgrounds will make the spots look darker than they are. Pursue this experiment thoroughly and you become aware of a very interesting aspect of color—its dynamic character. Colors are not static; what we see depends upon the interaction of many factors—the size and shape of the color mass, amount and color of the light and its clarity or diffusion, the character of surrounding colors, and even the temperament of the viewer.

After exploring these suggestions, do a drawing on a colored paper of low intensity. Add accents of a complementary hue, varying the values and intensities according to the degree of emphasis you wish various parts to project.

Color Schemes

Students of color theory have formulated many systems, called color schemes, for achieving satisfying relationships of color in a work of art. The three most widely recognized are the monochromatic, analogous, and complementary color schemes. While few mature artists adhere religiously to any formal scheme of color in their work, an understanding of the different color systems gives the beginner a point of departure for selecting and combining colors when venturing into this new area of artistic expression.

Plate 5. The color wheel shows a sequence of *hues* in the following (counter-clockwise) order:
yellow, yellow-orange, orange, red-orange, red, red-violet,
violet, blue-violet, blue, blue-green, green, and yellow-green.
The numeral *1* indicates the primary hues, *2* the secondary, and *3* the tertiary hues.
Complementaries face each other across the center of the wheel. (See pp. 121–123.)

Plate 6. Color *value* refers
to the lightness or darkness of a hue,
color *intensity* to its saturation
or purity. Thus, pink is a light value,
low intensity of red; navy blue
is a dark value, low intensity of blue.
(See pp. 121–122.)

125

Plate 7. Intensity affects the psychological impact of color
—its tendency to advance or recede in space.
High-intensity orange is more aggressive than the same hue
in a low intensity, such as tan or brown (*above*).
Warm hues are generally more aggressive than cool hues,
but a low-intensity tan or brown may appear to recede
when compared to an intense cool hue, such as bright blue.
Overlapping contours (*above right*) also affect
the relative impact of color areas. (See p. 123.)

Plate 8. When mixed together,
complementary hues neutralize each other,
as at the centers of the swatches (*right*).
But juxtaposed complementaries intensify
one another (*below left*). Surrounding
a spot of intense green with intense red
causes both colors to be reinforced.
Four squares of the same grayed orange
(*below right*) seem to vary in intensity
when set against different intensities
of orange and blue. (See pp. 123–124.)

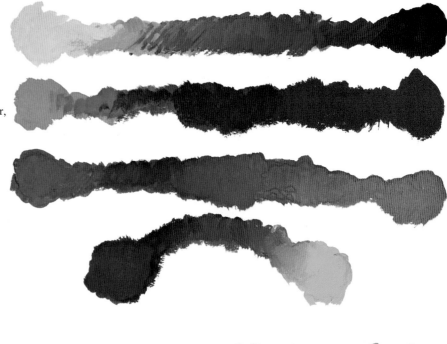

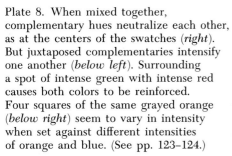

Plate 9. A *monochromatic* color scheme
is one that employs various values
and intensities of a single hue.
The prevailing hue (in this case, green)
establishes an overall mood. (See p. 129.)

Plate 10. An *analagous* color scheme employs a limited range
of neighboring hues, usually in a variety of values and intensities.
As in the monochromatic scheme, an overall mood results
from the predominance of closely related colors. (See p. 129.)

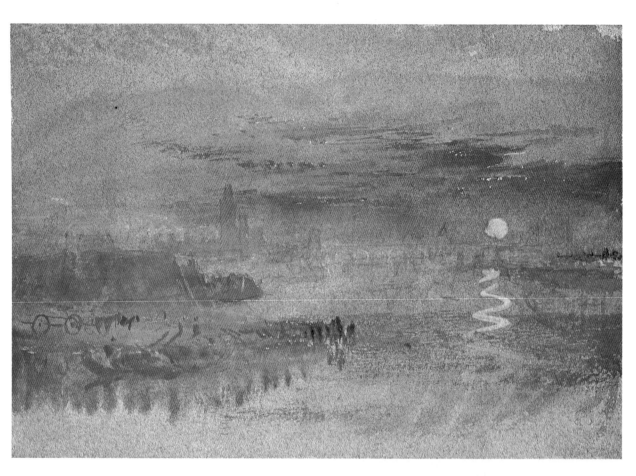

left: Plate 11.
EDVARD MUNCH (1863–1944; Norwegian).
The Scream. c. 1892–93.
Oil on cardboard, $32\frac{7}{8} \times 26''$.
Munch Museum,
Kommunes Kunstsamlinger, Oslo.

below: Plate 12.
J. M. W. TURNER (1775–1851; English).
Sunset: Rouen. c. 1829.
Body color on blue paper, $5\frac{5}{16} \times 7\frac{1}{2}''$.
British Museum, London.

The Monochromatic Color Scheme

As the name suggests, a monochromatic color scheme involves only a single hue. This is the simplest type of scheme—one in which mood is established by the omnipresent hue and interest achieved through varied values and intensities of that hue (Pl. 9, p. 127). Black and white, not being colors as such, supply modulation in the scheme without violating the one-hue limitation. Accented and subordinate areas of a composition are distinguished respectively by bright and subdued intensities of the prevailing hue.

Project 62 *To familiarize yourself with the monochromatic color scheme, select or prepare a background paper of a single hue at medium-light value and low intensity. Partially develop your composition in black and white, then add color in varying values and intensities. (Do not, of course, depart from the original hue of the background.)* You may wish to refer to one of your earlier studies as subject matter for this project. Symbolic themes and emotional states provide excellent vehicles for monochrome depiction, since we all carry distinct associations with, for example, the cool, recessive nature of a blue or violet, or the vibrancy of hot orange or radiant yellow.

The Analogous Color Scheme

An analogous color scheme employs unlimited values and intensities of neighboring hues on the color wheel, the range not to exceed the bounds of two consecutive primary colors. Analogous character is most emphatic when a single primary hue forms the base for all of the colors used. Thus, a typical scheme might include varying values and intensities of yellow-green, yellow, yellow-orange, and orange (the common denominator being yellow); or a second scheme might employ modulations of red-violet, violet, blue-violet, and blue (the common denominator being blue, as shown in Plate 10, p. 127). Though more animated than a monochromatic color scheme, the analogous scheme can also create a harmonious and quiet mood, due to the close relationship of its component hues. Again, small areas of high-intensity color provide for dynamic accents, while the lower intensities and the middle values can foil the more aggressive, high-intensity areas.

Project 63 *Create a composition in analogous colors. You might follow the same general procedure suggested for Project 62.* Analogous color schemes provide an effective means for creating a mood. Seasonal themes—spring, summer, and so forth—can inspire abstract or naturalistic compositions seen as related color groupings. Visualizing concepts of hot, cold, warm, cool, sun, shadow, arctic, or tropical might also prove stimulating.

Complementary Color Schemes

For the two previously discussed color schemes, the criteria are relatedness of hue and a limited range. The *complementary color scheme,* on the other hand, combines contrasting hues, such as blue and orange (Pl. 17, p. 229). A complementary scheme will also admit the addition of other hues, as long as they do not overwhelm the requisite pair of complementaries. (Any color scheme is defined only by the hues that predominate.) Blue and orange plus red and green and supplementary colors would compose a *double-complementary scheme.* A composition based on such a plan might express tension between equally dynamic elements, or one pair of complements could dominate while the other pair supplies visual counterpoint. In the latter case, a scheme can achieve further subtlety and strength when one of the complements at high

intensity illuminates strategic areas and its opposing hues are subordinated by lesser intensity—as in Edvard Munch's *The Scream* (Pl. 11, p. 128), in which areas of intense red and orange complement passages of less intense blue and green to create a strident, disturbing color scheme appropriate to the painting's nightmarish subject. A *split-complementary scheme* poses one hue against the two hues flanking its complement; an example would be yellow combined with red-violet and blue-violet (Pl. 12, p. 128).

Variety, domination, and subordination are principles as vital in the use of color as for other compositional elements. Good color schemes should avoid equal quantities of constituent colors, and these should not be too similar in value or intensity. A satisfying relationship among the components of a color scheme frequently results from greater quantities of middle-light to middle-dark values and of medium-high to low intensities. Very light, very dark, and particularly very intense colors should be used sparingly and primarily as accents to focus attention on strategic areas.

Project 64 *Plan a complementary color scheme.* Gaiety, celebration, conflict, energy, and exuberance are excellent themes. Sports events, parades, street scenes, markets, flower studies, and fruit or vegetable still lifes also provide apt subjects.

We must again emphasize the dynamic nature of color. Colors are never static. The mood of the viewer; the relationship of a color to its surroundings; the color, clarity, and diffusion of the light; and the temperament of the observer—all influence what is seen and the response to it.

four
Drawing Media

Exploration is the first step toward discovery, and it is essential that the young artist discover the medium best suited to his or her temperament and talents. A feeling for media, sensitivity to their intrinsic beauty and expressive potential, a delight in manipulating them, are part of the make-up of most artists. Since pleasure in the craft is an important component of the artistic temperament, the joyful savoring of the particular qualities inherent in each material and each surface contributes to the total effect. The velvety blackness of India ink or compressed charcoal, the pale silvery gray of hard pencil, the grainy vigor of dry-brushed tempera—all these add to the pleasure of drawing, and this is reflected in the full and sensitive exploitation of each medium.

There are as many kinds of artistic personalities as there are differences in people, in their tastes and abilities. Some very talented individuals are by nature craftsmen. They enjoy working patiently and methodically to conquer a challenge. A medium that intrigues them and demands the most precise control, the most disciplined exercise of manual dexterity, and the most careful manipulation of difficult tools, affords such an individual deep inner satisfactions. Pencil techniques requiring very hard leads and a delicate hand, intricate and refined manipulations of pen and ink, painstaking academic charcoal techniques, and certainly silverpoint and scratchboard methods—all might appeal to an artist of exacting sensibility.

At the other extreme is the artist who cannot put ideas down on canvas or paper with sufficient speed, who may awaken in the middle of the night with an inspiration that must be made concrete. Working intensely with complete absorption for a few minutes or hours may enable this artist to formulate and express an idea. The ideal medium facilitates this rush of enthusiasm, demanding neither great precision nor any extensive preparation of materials. Charcoal and chalk come readily to mind, since they can be applied to large areas with the free movements of arms, shoulders, and torso that help provide release from tension. These two substances erase easily and can be worked over, smeared, rubbed, and otherwise modified without seeming to imply a lack of technical facility. They encourage rapid visualization of a concept. A half-dozen alternate arrangements of a composition can be explored while the burst of energy still flows. Once the idea has been captured, the artist can formulate a more refined and highly developed version of the composition.

Between the two extremes lie a host of intermediate talents and temperaments, all of which can be accommodated by the range of available media. Wash, for instance, might prove flexible enough to satisfy persons who are sometimes methodical, sometimes more free. Pencil can act in dozens of ways, as can brush and ink or conté crayon. In truth, any attempt to define or limit the use of a medium to one type of temperament suggests a categorizing inherently false to the need for experiment, self-discovery, and self-definition that are integral to the artistic drive and its demand for satisfaction through achievement.

Chapter 2 introduced the media most commonly employed in drawing by beginning students—pencil, charcoal, ball-point and felt-tip pens, brush and ink, and perhaps pen and ink. This section will explore a fuller range of drawing materials, some more sophisticated and requiring greater skill in the draftsman. While the following projects have been designed to encourage students to experiment with a wide range of materials, there has purposely been an avoidance of what the author considers esoteric methods and recipes. A large body of fascinating literature deals with the procedures of past masters for coating paper, for making plume and reed pens, iron gall ink, chalks, pastels, brushes, and other tools and materials. Many of these recipes render very beautiful and unique results and can be rewarding for the occasional mature artist who finds it impossible to obtain the desired effects from commercially available materials. But the time spent on such activities cannot be justified for the beginning student, who should devote full time and energy to the major problems of artistic development and self-discovery.

Unduly detailed directives about the use of media, tools, and materials have also been avoided. Restrictive directions telling how to hold tools and step-by-step instructions for working can encourage self-conscious and mechanical procedures, inhibiting rather than furthering the direct and vigorous expression of native capacities. No two individuals are temperamentally alike, and, in general, after accepting certain fundamental and very general procedures, artists work out their own methods. One should play freely with media before embarking upon their use, for only by a free and inventive manipulation of materials do artists discover and develop their personal preferences and ways of working. It is suggested that you first read through this entire section and then select those media and exercises that sound interesting. When you fix upon a medium or method of working that seems particularly satisfying, it is wise to emplore it rather fully before moving to another. An extended series of single cursory encounters with a wide variety of materials and methods can disperse energies and result in confusion. The production of works that satisfy the artist remains the greatest encouragement and stimulus toward further development.

Papers

Before we begin to explore the categories of dry and wet media, a brief survey of the standard papers employed in drawing will afford the student a basic reference. *Newsprint* is the cheapest paper and comes in pads of various sizes. It has a smooth surface and yellows badly, and hence is used chiefly for quick sketching in pencil, charcoal, conté, and chalk. *Charcoal paper* has considerably more "tooth" (roughness created by printed texture plus some very fine sand) and is available in white and a number of gray tones for use with charcoal, chalk, conté crayon, and pastels. *Soft sketching papers* are manufactured for use with soft pencils, ball-point and felt-tip pens, and colored crayons. *Rice paper,* the traditional surface for Oriental brush-and-ink drawing, provides a soft and very absorbent type of ground. *Bond papers* are smooth, hard, lightweight papers designed for use with pencil or pen and ink. *Bristol board,* a very fine, hard-surfaced paper, is manufactured in two surfaces: *kid finish* facilitates fine pencil work and rubbed pencil-and-graphite combinations by virtue of its very slight "tooth"; *smooth finish* encourages delicate and elegant studies in pen and ink or very hard pencil. When layers of variously surfaced papers are mounted on a cardboard backing, the result is termed *illustration board.* While expensive, illustration board tends to justify its price in its durability and resistance to wrinkling when wet. *Watercolor papers,* as the name indicates, are used primarily for wash and watercolor. The heavier the weight of the paper, the more absorbent, free from wrinkles when wet, and expensive it will be. There are three standard finishes: *rough,* a surface produced in the best papers not by mechanical graining but as the result of a hand-manufacturing process, and which is best adapted to splashy, spontaneous ways of working; *hot press,* richly though not as heavily and coarsely textured as the rough finish; and *cold press,* the smoothest of fine watercolor papers and excellent for very refined, controlled techniques.

Dry Media

9

The dry media consist of those materials that leave granular deposits when they are drawn across a surface. Usually (though not always) in stick form, the dry media include charcoal, chalks, pastels, conté crayon, wax crayons, pencil, stick and powdered graphite, silverpoint, and scratchboard (Fig. 182).

Charcoal

Charcoal is a crumbly material that readily leaves a mark when rubbed against any but a very smooth surface. With it, tentative lines can be put down and subsequently erased; the same piece of charcoal can with ease serve for line drawing or—turned on its side—produce broad tonal masses. Charcoal is equally suited to sketches (Fig. 183) and rapidly executed preliminary compositional plans (Fig. 184) as to fully developed, large-scale value studies (Fig. 185). One disadvantage of charcoal is that it is rather dirty. Also, because marks are not deeply imbedded in the ground surface, careless movements of the hand or arm across a drawing can almost eradicate it.

The two most popular types of charcoal are stick and compressed. *Stick charcoal* is made by heating sticks of wood about $\frac{1}{4}$ inch in diameter in closed chambers or kilns until the organic materials have evaporated and only dry carbon remains. Stick charcoal comes in varying thicknesses, the finest quality (called *vine charcoal*) made in very thin sticks of an even, soft texture. Manu-

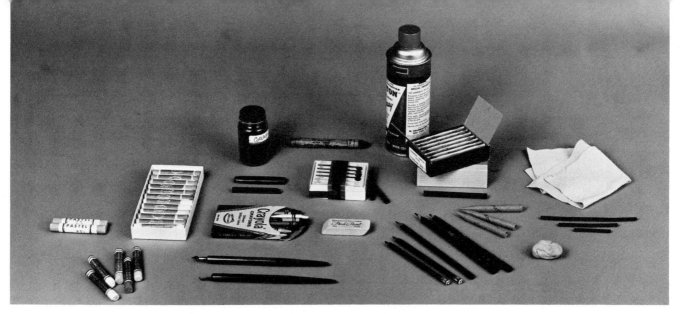

182. The dry media include the following materials (left to right): soft and semihard pastels, chalk (in box), scratchboard instruments, wax crayons, stick and powdered graphite, grease crayon, conté crayons (in box), pencil eraser, graphite and charcoal pencils, fixative (in pressurized can), compressed charcoal (in box), tortillons, chamois, kneaded eraser, and stick charcoal.

183. HENRI DE TOULOUSE-LAUTREC (1864–1901; French). *The Model Nizzavona.* Charcoal, $23\frac{7}{8} \times 18\frac{5}{8}''$. Art Institute of Chicago (gift of Carter H. Harrison).

184. Henri Matisse (1869–1954; French).
Reclining Woman with Flowered Robe.
1924. Charcoal, 19 × 24½″.
Baltimore Museum of Art
(Cone Collection).

facturers classify charcoal in four degrees of hardness: very soft, soft, medium, and hard. *Compressed charcoal* (also called *Siberian charcoal*) results from grinding the charcoal to powder and compressing it into chalklike sticks about ¼ inch in diameter. Compressed charcoal is also labeled according to hardness, ranging from 00, the softest and blackest, through 0 to 5, which contains the most binder and is consequently the palest and hardest. In general, compressed charcoal produces less easily erased lines and tones than stick and so is not as well adapted to beginners' needs as regular stick charcoal. It is most effective for very large-scale quick sketches or when rich darks are desired (Fig. 186).

Charcoal pencils are made by compressing charcoal into thin rods and sheathing them in paper or wood. They range in degree of compression from 6B (extra soft) through 4B (soft) and 2B (medium) to HB (hard). The chief virtues of the charcoal pencil are its cleanliness and maneuverability, but these also constitute its chief liabilities. The pencil lacks the flexibility of stick charcoal because only the point can be used effectively.

Method

There are three common methods of working with stick or compressed charcoal. The direct free attack, using both the point and side of the charcoal

185. Gustave Courbet (1819–77; French).
Self-Portrait. 1847.
Charcoal, $10\frac{7}{8} \times 8''$.
Wadsworth Atheneum, Hartford, Conn.

stick, offers maximum flexibility of stroke and tone without the time-consuming fussiness of more finished modes (Fig. 185). An alternate process, involving a disciplined and relatively "pure" application of charcoal, is to build value relationships through systematically cross-hatched lines drawn with a pointed stick of charcoal (Fig. 186). Many enthusiasts consider most desirable a clearly grained texture without any of the soft fluidity of tone that accompanies

186. Robert Baxter
(1933– ; American).
One, Two, Three, Infinity. 1963.
Compressed charcoal, $30 \times 40''$.
Courtesy the artist.

187. GEORGE BELLOWS
(1882–1925; American).
The Cliff Dwellers.
Charcoal, black crayon, brush
and India ink, with touches
of watercolor, $21\frac{1}{4} \times 27\frac{1}{8}''$.
Art Institute of Chicago
(Olivia Shuler Swan
Memorial Collection).

rubbing. A third manner of applying charcoal produces carefully developed value studies of even, graduated tone through repeated applications of charcoal rubbed into the paper with either the fingers or a tortillon (a pencil-shaped roll of soft paper). This last method, the standard academic technique of the 19th century (Fig. 37), is little used today, since most contemporary artists prefer a livelier surface.

Charcoal can be applied to many kinds of drawing paper. Newsprint suffices for quick sketches and studies that do not demand erasing or the careful building up of smooth tones. Manila and coarse drawing papers also provide acceptable grounds for quick sketches with stick or compressed charcoal or charcoal pencils. Regular charcoal paper is best for sustained studies, for it will take repeated erasures and rubbing without losing its grain. Cheap, soft charcoal papers lack tooth, and so do not hold the flaky charcoal; consequently, it is difficult to get extended areas of rich dark tones on such papers. Compressed charcoal can be used effectively on relatively smooth bond papers to produce rich darks, but these materials demand certainty of execution.

In charcoal work the chamois acts as an eraser to wipe out unsatisfactory lines and tones. The kneaded eraser can serve to eliminate small areas of tone, to clean away smudges, and to pick out small light accents. Charcoal drawings can be "fixed" by spraying them with fixative (shellac or a transparent plastic material dissolved in solvent); artists who use charcoal for elaborate studies with carefully graduated values often fix the drawing in its successive stages of development so that the initial steps do not get lost through smudging.

Quick Sketching

Project 65 Quick sketching of the kind ordinarily done in the life drawing class develops the capacity to put down rapidly the essential elements of a composition without becoming distracted by minor details. In figure drawing

the artist learns to identify the characterizing aspects of a physique, a gesture, an action, or a typical posture. Forcing oneself to make the same kinds of rapid summaries of the characterizing aspects of buildings, trees, vehicles, animals, people on the street, and any other subject is equally important. *Make a group of such drawings in charcoal, striving for the essential character of a form in one-minute, five-minute, and ten-minute periods.*

Finished Composition

Project 66 *Select a subject—a complex still life, an abstraction, a landscape, a cityscape, or a self-portrait—that encompasses a wide range of value relationships.* Before embarking upon a highly finished charcoal drawing, it is wise to establish a preliminary visualization of the full linear and tonal pattern as rapidly as possible. *Plan your composition on a piece of newsprint, drawing and redrawing until the arrangement satisfies you. Using the side of a short piece of charcoal, lay in the darks. Once you have determined the full value pattern, pin your preliminary study to the wall where you can refer to it and, on charcoal paper, proceed with the finished drawing. Employ any one of the three methods described above for making fully developed, large-scale, dark and light charcoal studies.* While it is entirely possible to combine these techniques to create further variations of texture, in so doing you must take care to achieve consistency of handling throughout the drawing (Fig. 187).

Chalk

Chalk, like charcoal, is an ancient drawing material, traces of which can be found in the Old Stone Age cave paintings in France and Spain. Natural deposits of richly pigmented earths were discovered in prehistoric and Neolithic times, and pieces of this matter could be employed for drawing and coloring. Natural carbons provided black, iron oxides reds, ochres dull yellows, umbers a range of browns, and chalk and talc whites. These materials—used either directly as they came from the earth or ground into fine powder, mixed with an adhesive material, and shaped into rounded or rectangular sticks—came into common usage in 15th-century Italy. They have remained popular ever since.

The term *chalk* covers a wide variety of materials that range in texture from coarse to fine, from hard to soft and crumbly, and from dry to greasy. It is impossible to establish the point at which chalk becomes crayon or pastel, and the dividing line between chalk and compressed charcoal is equally tenuous. (Compressed charcoal might, in fact, be considered a black chalk made from carbon.) Since the early 19th-century the manufacture of chalk has been standardized to ensure regularity in the sizes of the sticks, the degrees of softness and hardness, the color range and intensity, and the dryness or oiliness. Most familiar are the regular blackboard chalks, which are inexpensive and come in bright but not necessarily permanent colors. These lack any oily binder and consequently are very dry, dust off easily, and are serviceable only for projects of a crude or temporary nature.

Chalk affords the artist a technical versatility similar to that of charcoal. Because it adheres firmly to paper, chalk, like compressed charcoal, is more difficult to erase than stick charcoal, but it offers ample compensation in the potential for richer, darker lines and solid masses. The possible effects are numerous and satisfying, from open, energetic sketching (Fig. 188), through solidly developed but nonetheless freely executed studies (Fig. 189), to carefully finished drawings (Fig. 190). The medium's chief advantage is of course color, permitting enriched tonal and compositional relationships as well as charming decorative effects (Pl. 13, p. 161).

188. MARSDEN HARTLEY (1878–1943; American). *Self-Portrait.* Black chalk, 12 × 9″. Collection Mr. and Mrs. Benjamin Sonnenberg, New York.

Dark and Light on Toned Paper

Project 67 Using black and white or dark and light colored chalks on a middle-value paper ground facilitates the rapid visualization of tonal relationships (Fig. 191). The technique has also produced highly finished master drawings of great beauty (Figs. 192, 193). *Select a subject that will allow a full extent of darks and lights—a well-lighted nude, costumed model, or head—and a toned charcoal paper of middle value.* The subject should be posed against

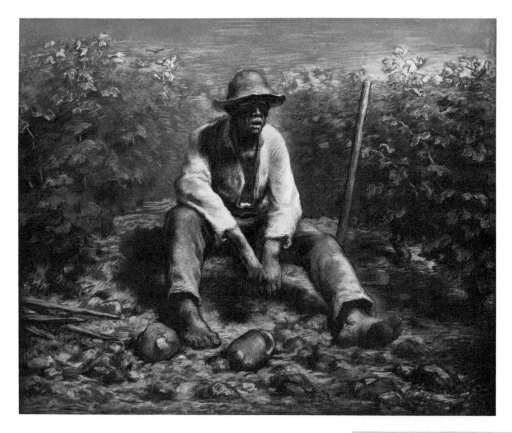

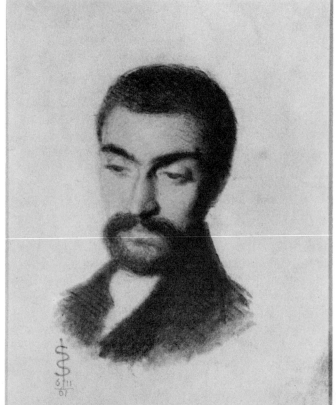

above: 189. JEAN FRANÇOIS MILLET (1814–75; French).
Peasant Resting. Black chalk on white paper.
Mauritshuis, The Hague.

right: 190. SOLOMON SIMEON (1840–1905; English).
Bearded Man. 1861. Black chalk, $11\frac{1}{2} \times 8\frac{1}{2}''$.
Collection Mr. and Mrs. Benjamin Sonnenberg, New York.

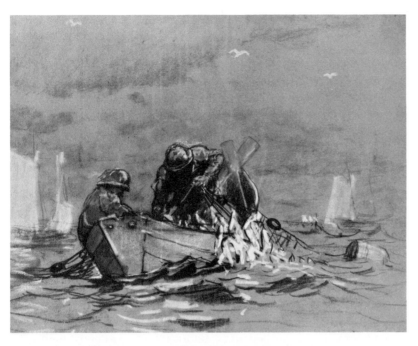

191. WINSLOW HOMER (1836–1910; American).
Banks Fishermen (Herring Net). c. 1885.
Black and white crayons
on bluish-gray paper, $16\frac{5}{8} \times 20\frac{5}{8}''$.
Cooper-Hewitt Museum of Decorative Arts
and Design (Smithsonian Institution),
New York (gift of Charles W. Gould).

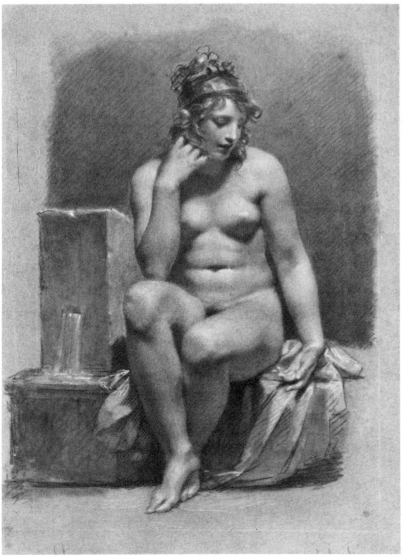

left: 192. PIERRE PAUL PRUD'HON
(1758–1823; French).
La Source. c. 1801.
Black and white chalk, $21\frac{3}{16} \times 15\frac{5}{16}''$.
Sterling and Francine Clark Art Institute,
Williamstown, Mass.

above: 193. Detail of Figure 192.

a background comparable in value to the toned paper. *Execute your composition in dark chalk and a very light chalk, allowing the ground to carry as a middle value. Avoid excessive smearing of the dark and light chalks together, for the paper should serve as the fusing element* (Fig. 193). This exercise can also be done with compressed charcoal and white blackboard chalk.

If you have completed the immediately preceding project in black and white on gray paper, you might enjoy redoing the exercise with colored paper and colored chalks. The most successful effects are obtained with monochromatic or analogous color schemes (see p. 129). The paper and chalks should be closely related in color without strong differences in intensity and, using Figure 111 as your guide, only about one or two value "steps" apart. *Select, for example, a medium tan paper for use with light cream and dark brown chalks, a blue-gray for pale and very dark blue chalks, and so forth. For further interest, add accents in black and white* (Fig. 191).

Pastels

Pastels are high-quality chalks of fine, even texture, available in a wide range of hues of graduated value and intensity. *Soft* pastels—long popular in France and traditionally called French pastels—consist of dry pigment mixed with an aqueous binder, usually compressed into cylindrical form. Soft and crumbly in nature, this type of pastel is nonadhesive and thus requires both a paper of decided tooth and a fixative to assure a measure of permanence. Oil added to the binder causes *semihard* pastels to adhere more readily to paper. Manufactured most commonly as rectangular sticks, semihard pastels possess a number of advantages over ordinary pastels: the oily texture and smooth sides render them less crumbly; the flat planes provide for rapid coverage of broad areas; and the sharp corners make them effective for detailing and accenting. *Hard* pastels, a more recent development, share the basic characteristics of the semihard variety but are distinguished by an even firmer texture. Both semihard and hard pastels are difficult to erase, so it is wise to make a small preliminary color sketch before commencing on a large-scale composition. Pastels offer a full complement of colors and values to permit what might be termed "drawn paintings" (Pl. 14, p. 162). Any of the exercises in the sections on chalk and conté crayon afford practice in the use of pastel.

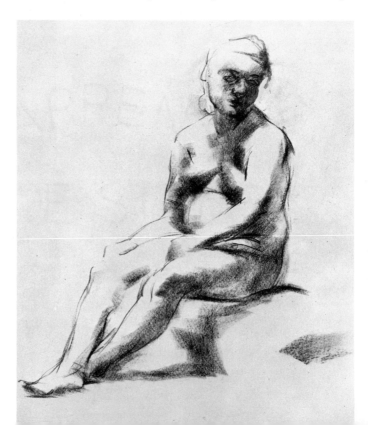

194. A twenty-minute life drawing in conté crayon. The broad areas of dark were built up with the side of the crayon; the sharp corners were used for linear accents.

195. CHARLES SHEELER
(1883–1965; American).
Feline Felicity. c. 1934.
Conté crayon on white paper, $14\frac{1}{8} \times 13\frac{1}{4}''$.
Fogg Art Museum, Harvard University,
Cambridge, Mass. (Louise E. Bettens Fund).

Conté Crayon

Conté crayon is a semihard chalk of fine texture containing sufficient oily material in the binder to adhere readily and more or less permanently to smooth paper. Conté, in sticks about $\frac{1}{4}$ inch square and about 3 inches in length, comes in three degrees of hardness—No. 1 (hard), No. 2 (medium), and No. 3 (soft). It offers a limited number of colors—usually white, black, sepia, and sanguine (a Venetian red, and the most popular of conté colors). In sketching, conté crayon takes full advantage of a rectangular format, its flat sides creating broad strokes of graduated tone, its corners capable of drawing elegant, sharply accented lines (Fig. 194). Conté erases with difficulty and consequently best serves the needs of the sure, experienced draftsman.

Project 68 *Break a stick of conté into two or three pieces and do fairly rapid drawings of posed figures, buildings, trees, vehicles, animals, or any subject that appeals to you. Work for a broad representation of essential forms and movements. Build your darker values by using the side of the crayon rather than by cross-hatched lines.* The lines created by the corners of the square crayon provide energetic contrasts.

Fully Developed Drawing

Conté's fine texture is particularly appropriate to the creation of carefully finished drawings with a full value range (Fig. 195). The chalk is greasy enough that it does not rub off readily, and yet its softness allows smooth gradations of dark to light. Modeling can be further reinforced by swipes of the kneaded eraser, which lifts out whites almost in the manner of white chalk marks.

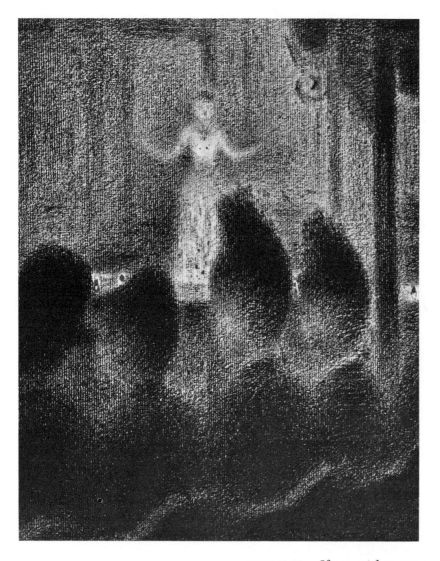

196. Georges Seurat (1859–91; French).
At the "Concert Européen." c. 1887.
Conté crayon, $12\frac{1}{4} \times 9\frac{3}{8}''$.
Museum of Modern Art, New York
(Lillie P. Bliss Collection).

Project 69 *If you wish to attempt a highly finished drawing, select a smooth, firm paper, decide upon a subject, and plan your composition on newsprint paper until you are fairly certain of its arrangement. Lay in your initial lines lightly, and then proceed to develop the drawing to full value. You may wish to strengthen drawings done in brown or red conté by the addition of black accents and/or white highlights.*

Conté on rough paper produces an interesting granular quality, as evidenced by Georges Seurat's composition (Fig. 196) in black and red conté accented with white. Seurat intended his drawing to suggest the precise pointillist style (color systematically applied in tiny dabs) of his painting. By very even pressure on soft conté, he filled the grain of the paper according to the degree of desired darkness in each area, so that only in the darkest passages does the white grain of paper completely disappear. The even texture of conté crayon as it is used here, without variations in size of the grain or in direction of stroke, contributes a somewhat impersonal surface to the drawing that, in combination with the simplified and generalized form, builds an abstract and monumental quality.

Wax Crayons

Inexpensive sets of brightly colored wax crayons manufactured for children are familiar to all. The waxy substance adheres firmly to most paper surfaces

and so presents a relatively clean medium to handle. The hardness of wax crayons, however, makes them inflexible, and it is difficult to obtain deep, rich tones, since the waxy strokes do not readily mix or fuse. For artists, such materials have a limited usefulness in planning color schemes, but they seldom produce handsome finished drawings.

A number of other hard, greasy chalks and wax crayons exist for those who desire media capable of yielding strong, deep tones that do not rub or smear. Grease crayons and lithographic crayons suit these criteria and, when applied to grained papers, yield vigorous, clearly defined textures (Fig. 197). Corresponding disadvantages of these crayons are that they do not erase nor allow lines or tones to be fused or blurred easily. Students wishing to experiment with any of the hard, greasy crayons can follow the general instructions for quick sketching with conté, charcoal, or chalk.

Pencil

The pencil is probably one of the most familiar tools in our culture, inasmuch as we learn to handle pencils in early childhood, if not for drawing, certainly for writing. Our familiarity may lead us to take the pencil for granted and discourage objective recognition of the medium's actual potentialities and limitations. In addition, habits contracted at school for learning how to write, do arithmetic, and so on, frequently work against the free and expressive use of the medium. Despite these obstacles, pencil remains a very important and versatile drawing medium.

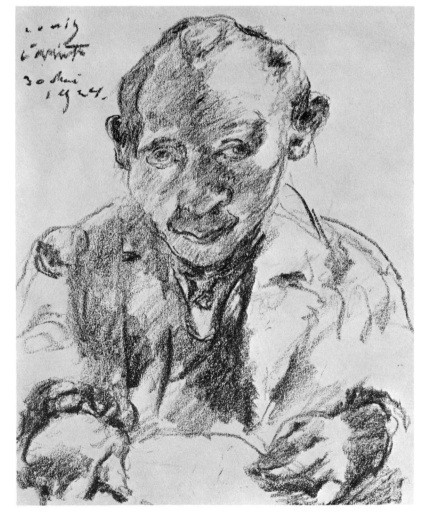

197. LOVIS CORINTH (1858–1925; German).
Self-Portrait. 1924.
Black lithographic crayon, 12¼ × 9¼".
Fogg Art Museum, Harvard University,
Cambridge, Mass.
(gift of Meta and Paul J. Sachs).

A glance through the catalogue of any art supply house reveals an astonishing variety of pencils—graphite, carbon, charcoal, wax, conté, lithographic (grease), and a wide range of color pencils, both soluble and insoluble (Pl. 2, p. 26), each offering a particular quality that renders it valuable for certain effects. The common, so-called "lead" pencil, our concern in this section, is actually composed of graphite, a crystalline form of carbon having a greasy texture. Early graphite pencils were soft and smudgy, but at the end of the 18th century the Frenchman Nicolas Jacques Conté developed the process of mixing viscous graphite with clay to create leads of varying consistencies. Suppliers now manufacture graphite pencils in hexagonal, round, and flat shapes, and in as many as seventeen degrees of hardness, from 6B, the softest for possessing the highest graphite content, to 9H, the hardest for containing the greatest proportion of clay.

All pencils, regardless of content, share the definitive characteristic of their common design: a narrow lead sheathed in wood or rolled paper and coming to an exposed sharp or blunt point. Pencil is a determinedly linear medium. In general, to seek other than a primarily linear form of expression with pencil, whether hard or soft, is to force the medium beyond the bounds of its effectiveness. Students attempting to build extended masses of dark tone will discover that such overworked areas assume a shiny, mottled surface, sometimes marked with indentations from repeated pressures of the lead.

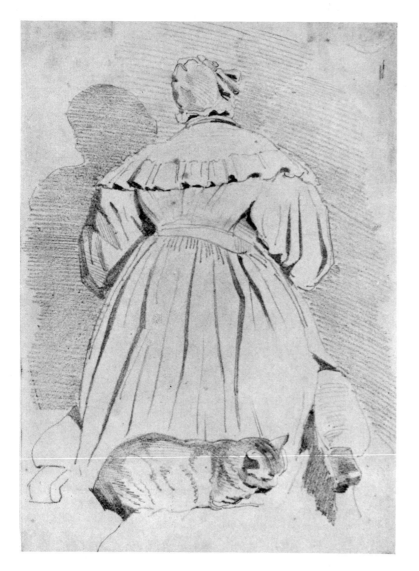

198. JEAN IGNACE ISIDORE GÉRARD
(called Granville; 1803–47; French).
Femme de Dos (*Woman Seen from the Back*).
Pencil, $7\frac{1}{2} \times 5\frac{1}{8}''$.
Stanford University Museum of Art, Calif.
(Mortimer C. Leventritt Fund).

Soft Pencil

Soft pencils (6B to 2B) used in a fairly large format (at least 15 by 12 inches) are particularly well suited for contour drawing or other similarly free, linear types of notation (Fig. 92). The soft lead also lends itself to informally applied parallel hatchings (Fig. 198) and loosely executed cross-hatching (Figs. 199, 200). Applied lightly and in overlapping strokes, cross-hatching can build a soft, light gray tone to suggest the shifting directions of complex forms and

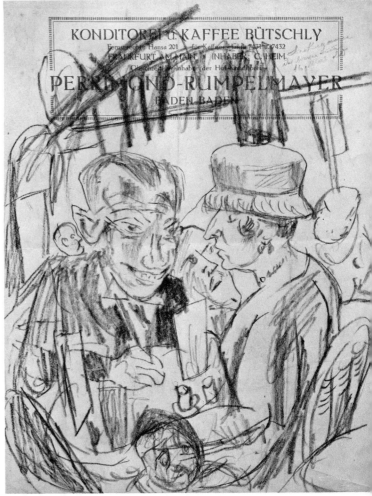

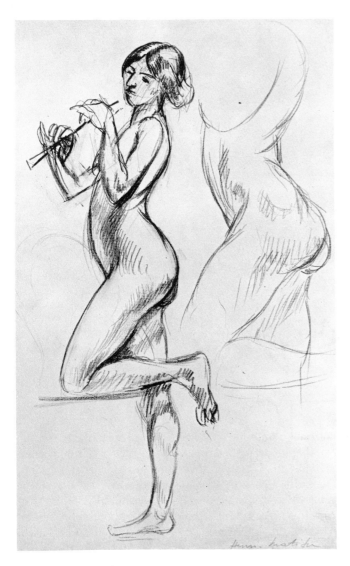

left: 199. Henri Matisse (1869–1954; French).
Two Sketches of a Nude Girl Playing a Flute. c. 1913.
Pencil on white paper, 13¾ × 8½".
Fogg Art Museum, Harvard University, Cambridge, Mass.
(gift of Mr. and Mrs. Joseph Kerrigan).

above: 200. Max Beckmann (1884–1950; German).
Coffee House. 1920. Pencil, 11¼ × 8¾".
Courtesy Richard L. Feigen & Co., New York.

right: 201. MARK ADAMS
(1925– ; American).
Still Life: Chair and Towel. 1965.
Pencil, 14 × 17″.
Collection Duncan and Cynthia Luce,
Laguna Beach, Calif.

below: 202. JEAN EDOUARD VUILLARD
(1868–1940; French).
Interior of the Artist's Studio. c. 1897.
Pencil, 4½ × 7″.
Courtesy Richard L. Feigen & Co.,
New York.

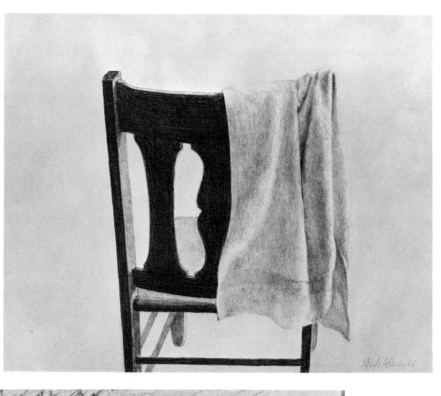

to further define important contours (Fig. 201). Great vitality marks the
scribbled notes that perhaps correspond to a darting eye recording some
complex visual experience too temporary to permit more orderly notation.
A room interior by Vuillard (Fig. 202) displays a free, very open style of
soft-pencil sketching, in which a meandering line moves in all directions to
establish the main forms. In a more controlled style than that of the Beckmann
drawing (Fig. 200), Vuillard has introduced into the matrix of middle-dark,
sketchy lines more precise darks that define forms and avoid ambiguity.

203. Richard Parkes Bonington
(1801–28; English).
View of Rouen. c. 1824.
Pencil on paper, $10\frac{1}{8} \times 7\frac{11}{16}''$.
Stanford University Museum of Art, Calif.
(gift of the Committee for Art at Stanford).

Project 70 *Scribble with a variety of soft pencils ranging from 6B to 2B. Select the degree of softness most pleasing to you, and make free notations of any subject you choose.* Frequently, a drawing of whatever happens to be within your field of vision has a fresh interest lacking in the arranged or selected subject. If your environment at the moment does not interest you, a pair of old boots or shoes, a friend lounging in a chair, or a coat and hat tossed on a bed provide apt subject matter for this kind of drawing.

Soft Pencil: Formalized Patterns

Soft and medium-soft pencils (6B to B) are commonly used in combination and in a rather formalized manner for depicting architectural subjects. Board, shingle, brick, and stone patterns, doors, windows, and moldings, all show lively patterns, while the shadows under eaves and in recessed doorways, built up from simple hatchings, provide contrasting darks (Fig. 203). In *Old Saw Mill* (Fig. 119) by Louis Eilshemius, the board and shadow notations combine with diagonal line shading and formalized suggestions of foliage to create an animated landscape. The distinctive sense of decorative patterning that pervades the drawing results from the rather large scale of the detail, the clear articulation of pencil lines, and the careful, even distribution of white areas.

Project 71 *Do a pencil drawing of a gingerbread Victorian house, a street scene, or a landscape in which trees and foliage configurations suggest a variety of lively pencil patterns. Avoid too much detail, fine-scale patterns, and extended areas of dark.*

Hard Pencil: The Modeled Line

Hard pencil (H to 6H) drawings evince a distinctive character quite unlike that of renderings in soft pencil. The clean-cut line and silvery tone of hard pencil can yield effects of great elegance. Hard pencil is well adapted to a style of drawing in which light shading blends with line to convey a fuller sense of form than can be suggested by outline alone (Fig. 204). Some of the most beautiful drawings are pencil renderings by skilled draftsmen of complicated subjects treated in great detail. Jean Auguste Dominique Ingres, the acknowledged master of pencil drawing, has left a magnificent legacy of figure studies, portraits, and architectural subjects (Figs. 4, 205, 275, 313). Amedeo Modigliani's *Portrait of Leon Bakst* also illustrates, in a vastly different style, the incisive strength of hard pencil (Fig. 206).

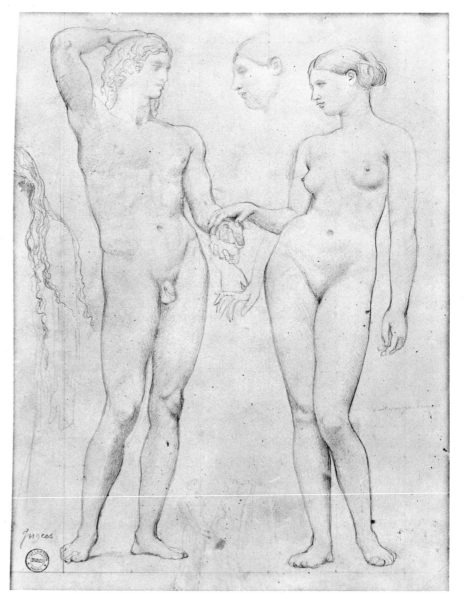

above: 204. Anonymous.
Yellow Rose. 1968.
Pencil, $5\frac{1}{2} \times 7''$.
Collection the author.

right: 205.
Jean Auguste Dominique Ingres
(1780–1867; French).
Two Nudes, study for *The Golden Age.*
c. 1839–43. Pencil, $16\frac{3}{8} \times 12\frac{7}{16}''$.
Fogg Art Museum, Harvard University,
Cambridge, Mass.
(bequest of Grenville Winthrop).

150 *Drawing Media*

206. AMEDEO MODIGLIANI (1884–1920; Italian-French).
Portrait of Leon Bakst. 1917.
Pencil, 22½ × 16½″.
Wadsworth Atheneum, Hartford, Conn.

Project 72 Precise delineation of intricate, interlacing forms is pleasing not
only because it projects an air of verisimilitude and technical virtuosity, but
also for the fascinating visual patterns that result. *Select a complex subject,
sketch it lightly in medium-hard pencil, and, once the boundaries of principal
forms have been established, proceed to render the detail as freshly and
distinctly as possible.* Drawings in hard pencil are best kept small, for if they
are too large the pale lines and tone do not carry well. Life drawing, portraits,
costumed figures, and in fact almost any subject suits this medium, provided
the artist concentrates on outline with slightly modeled reinforcement. Since
some pressure is necessary when using hard pencil, a firm, not too thin paper
such as kid Bristol board is advised for this project, in order to avoid an
excessively engraved surface.

Stick and Powdered Graphite

Graphite is available in other than the familiar pencil form. Stick graphite
(about ¼ inch square and 3 inches long) comes in gradations labeled in the
same manner as pencils (B to 6B). The stick can be manipulated like conté
or square chalks: the point of the stick producing soft, rich lines, the flat sides
depositing broad areas of gray, while the corners create sharp, dark accents.
Finely ground, powdered graphite is packaged in squeeze tubes for purposes
of lubrication and can be purchased in hardware stores. Harder than stick
graphite, it produces a paler gray. When rubbed onto a kid-finish Bristol board
with a soft cloth or paper towel, powdered graphite produces an even silvery

tone of great beauty. Drawings can be developed upon this toned background using medium-hard and hard pencil lines with white highlights recovered through erasure (Fig. 207).

Numerous variations and combinations of the two graphite forms are possible. Graphite drawings worked over with a bristle brush dipped in turpentine have a painterly richness of tone and texture (Fig. 208); they neither smear nor show a disturbing shine—faults that often mar works in dry graphite. Graphite in either stick or pencil form can be powdered on sandpaper and applied with a finger, soft cloth, or paper towel. Used in conjunction with a pointed pencil or stick, rubbed powdered graphite provides a smoothly textured tone that contrasts effectively with sharp outline—a combination particularly apt for describing the meltingly soft shadows of the nude figure (Fig. 209).

Project 73 *Experiment with dry stick and powdered graphite as suggested above. After you have explored the dry possibilities, moisten a bristle brush in turpentine and rework the drawings with the dampened brush. If you desire richer darks, dip your damp brush into powdered graphite and apply the mixture to your study. When you have discovered the effects most satisfying to you, apply the technique to a landscape, still life, figure study, or abstraction.*

Using a soft cloth or paper towel, rub powdered graphite into kid Bristol board until you have a smooth tone of light gray. Draw with light pencil lines and then add darker shading. Erase out whites. If you want small areas of white, cut a firm eraser to a fine edge and this will lift out narrow white lines. Since all marks, whether penciled darks or erased lights, show on the gray background, select a subject that will permit improvisation rather than one demanding great exactitude. Leafy plants (Fig. 210), a tangle of bare branches, or an organic-style abstraction might prove workable.

207. DANIEL M. MENDELOWITZ (1905– ; American).
Portrait of Annie. 1963.
Rubbed graphite pencil and eraser, 16 × 12″.

208. Daniel M. Mendelowitz
(1905– ; American).
Flooded Orchard. 1970.
Pencil, graphite, and rubber cement,
brushed with turpentine, $7 \times 11\frac{1}{2}''$.

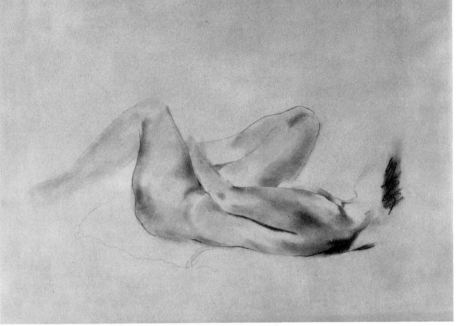

right: 209. Fritz Wiegele
(1887–1944; Austrian).
Female Nude, Reclining. c. 1921–22.
Rubbed pencil, $11 \times 15\frac{1}{8}''$.
Collection Count Antoine Seilern,
London.

below: 210. Daniel M. Mendelowitz
(1905– ; American).
Wild Radish. 1965. Hard pencil
and rubbed graphite, $15\frac{1}{2} \times 21\frac{1}{2}''$.

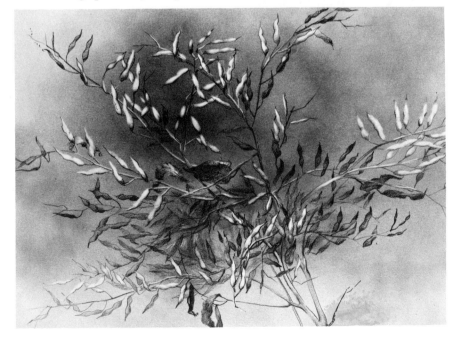

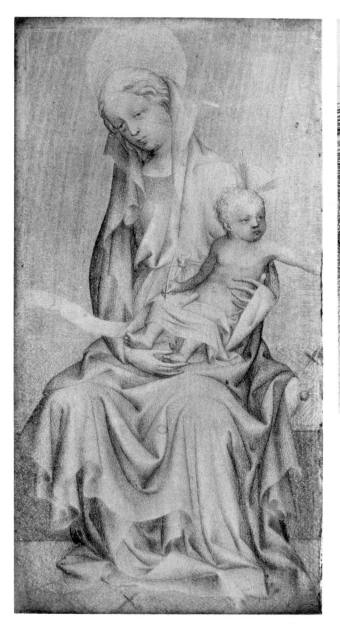

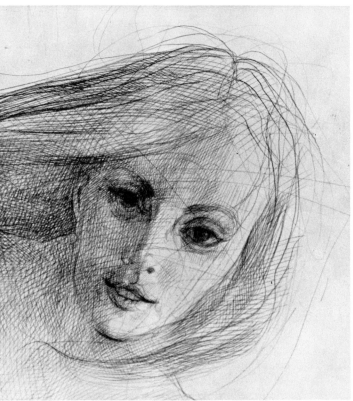

Silverpoint

Metal points preceded actual pencils as drawing implements. Over the ages silver has seemed to provide the most satisfactory metal point, its lovely gray color oxidizing to a gray-brown with the passing of time. A silverpoint drawing by Jacquemart de Hesdin of the *Virgin and Child* (Fig. 211) offers an excellent sample of the use of silverpoint in the later Middle Ages. The drawing was executed on boxwood, and the barely perceptible grain of the wood adds textural interest. Considerable solidity of form, as evidenced in the folds of the skirt, has been built up by infinitely fine cross-hatching.

A stout wire (preferably silver and available at any jewelry or craft supply store) not more than 1-inch long and pointed by rubbing on sandpaper provides a satisfactory silverpoint. For ease of handling, the wire can be inserted into a regular drafting pencil holder, a mechanical pencil, or a wooden stylus. Any smooth, heavy paper—again, Bristol board is excellent—surfaced with white poster paint or tempera makes an adequate ground for the beginner. Robert Baxter, a master professional who works in silverpoint, mounts two-ply Bristol

board on a drawing board and coats the paper with thin applications of warm *gesso*—a white, fluid paste made by mixing gypsum or chalk with glue and water. When a smooth opaque surface has accumulated and the gesso has been burnished with a soft cloth, the surface is ready for silverpoint (Fig. 212).

Silverpoint yields a thin gray line of even width, like that of a hard pencil, and like hard pencil it is best adapted to making relatively small drawings of exquisite finish. Since silverpoint does not erase, before you attempt a silverpoint drawing, you should do a preliminary practice study in hard pencil, perhaps 4H. Lines executed in silverpoint will not blur; hence, gradations of value must be achieved through systematic diagonal shading, clusters of lines, or cross-hatching (Fig. 213). Silverpoint, like the scratchboard method discussed next, is most rewarding to individuals with the craftsman's temperament who enjoy methodical procedures and painstaking workmanship.

Scratchboard

Project 74 Scratchboard technique reverses the familiar dark-on-light relationship to one of white lines on a black ground. *To produce the ground, coat heavy poster board smoothly with white gesso. When it is dry, the gesso should be surfaced with an even coat of India ink or fine black tempera paint.* A substitute form of scratchboard can be made by coating a hard-surfaced paper with white poster paint and covering it with black wax crayon. *Then, with a sharp, pointed instrument—a knife blade, scalpel, or ice pick—scratch lines through the black surface to reveal the white undercoating* (Fig. 214). Optimum results for the medium obtain in small drawings executed with precision in

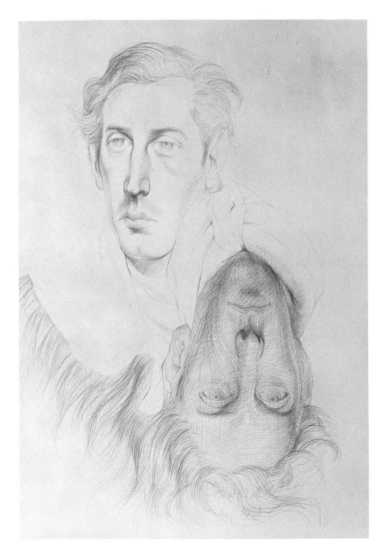

left: 213. Pavel Tchelitchew (1898–1957; Russian-American). *Portrait of Frederick Ashton.* c. 1938. Silverpoint on prepared white paper, 20 × 12½″. Fogg Art Museum, Harvard University, Cambridge, Mass. (gift of Meta and Paul J. Sachs).

below: 214. Scratchboard technique: (*top*) White gesso covered with an even coating of India ink or fine black tempera comprises the traditional scratchboard ground, on which clean, sharp lines can be incised with a pointed instrument. (*bottom*) A substitute form of scratchboard can be made with black wax crayon over a coating of white poster paint.

Dry Media **155**

an essentially linear technique. Furthermore, uncovering large areas of white reduces the effective character of scratchboard, and the technique thus tends to encourage rich, dark, sometimes somber drawings (Fig. 215). Unlike the silverpoint method, however, scratchboard can be adapted to free, sketchy modes, as evidenced by Claude Monet's *Two Men Fishing* (Fig. 216). In an interesting deviation from full scratchboard technique, Monet has drawn on the white-surfaced paper with grease crayon and then etched through the crayon lines with a sharp instrument to reveal clean white accents.

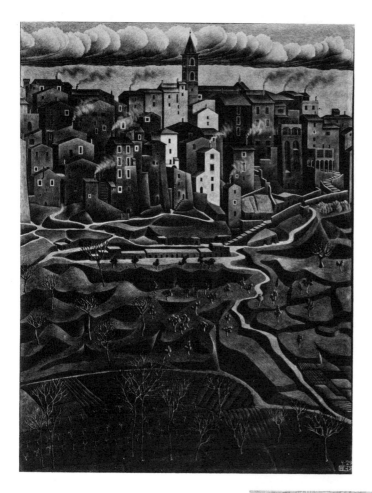

left: 215. M. C. Escher (1898–1972; Dutch).
Genazzano, Abruzzi. 1929.
Scratchboard with lithographic ink, $23\frac{3}{4} \times 18''$.
Escher Foundation, Gementemuseum, The Hague.

below: 216. Claude Monet (1840–1926; French).
Two Men Fishing, detail.
Black crayon on prepared white ground,
with scratched light accents, $10 \times 13\frac{1}{2}''$ (entire work).
Fogg Art Museum, Harvard University, Cambridge, Mass.
(Meta and Paul J. Sachs Collection).

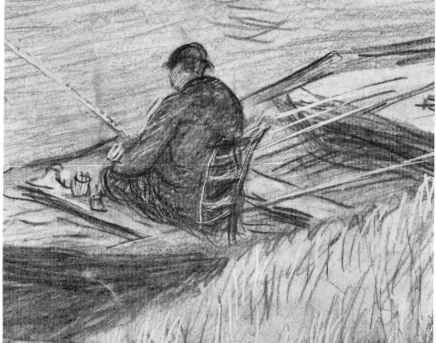

Wet Media

Any fluid preparation an artist chooses to employ could conceivably be termed a "wet" medium (Fig. 217). For instance, artists sometimes draw in brush and oil (Fig. 240), or in printer's ink (Fig. 58). Our interest here, however, will be such wet media as *inks*—full strength or diluted for *wash*—and those types of paint commonly associated with drawing—watercolor, tempera, acrylics, and gouache.

Ink

Inks, applied with pen or brush, were used for writing and drawing in Egypt, China, and elsewhere long before the beginning of the Christian era. Contrary to common impression, inks can take paste or solid form as well as fluid, but the quality most generally distinguishing ink from paint is fluidity. The *Oxford Universal Dictionary* defines ink as "the colored fluid ordinarily employed in writing with a pen on paper, parchment, etc., or the viscous paste used in printing." Inks are further identified by their purpose (lithographic, printing, writing); by special qualities (indelible, soluble, transparent); by color; and also according to their place of origin (India, China, and so on). Many adapt well to artistic use, although the commonest types of writing inks tend to be too thin and pale to be highly prized as artistic media.

above: 217. The wet media include the following: watercolors opaque (in tray) and transparent (in tubes); India and colored inks; pens; acrylic, oil, and gouache paints (in tubes); brushes (stiff oil type, Oriental, No. 10 sable, and small sable); *sumi* ink stick and mixing well; sponge; turkey quills; felt-tip and ball-point pens.

below: 218. A selection of pen nibs and the lines they produce (top to bottom): turkey quill; reed pen; bamboo pen; two drawing pens with metal points; two lettering pens, with flat and round metal nibs; "crow quill" pen; rapidograph pen; nylon-tip pen; felt-tip marker and pen; ball-point pen.

Pen and Ink

For its elegance and clarity, the medium of pen and ink is unexcelled. It serves with equal success as the vehicle for sharp, detailed observation (Fig. 224), for monumental sweep (Fig. 227), or for cryptic amusement (Fig. 223). By definition a linear medium, and one that does not indulge mistakes, pen and ink demands precise and subtle control. The beginning student will probably have to tolerate initially clumsy results before achieving expertise.

Pen Types

The requirements of a pen are that it be tubular and pointed, with sufficient capacity in the tubular body to hold a fair amount of liquid that can flow from the body of the pen through the point to the paper (Fig. 218). Two types of pen, quill and reed, have been in use for both drawing and writing from ancient times up to the modern era. *Quill* pens are cut from the heavy pinion feathers of large birds and shaped to a sharp or angular, coarse or fine point, depending upon the taste of the draftsman. These quill points soften after some use and have to be recut from time to time. As a result of their lightness and pliancy, quill pens respond readily to variations of touch and pressure, and consequently draw a responsive, smooth, and flexible line.

Reed pens are hewn from tubular reeds or the hollow wooden stems of certain shrubs; they too are cut to suit the user's taste. In general, reed pens are stiff and their nibs, or points, thick and fibrous. The lack of supple responsiveness results in a harsh, almost angular line of bold character (Fig. 219). Because the reed pen does not slide easily across the paper surface, it contributes to a deliberate or even awkward strength of handling that tends to challenge the artist and thus inhibit overfacility and technical display. Today, bamboo pens, a type of reed pen, are still imported from the Orient for contemporary artists who value the strong, brittle quality of line they impart to drawings.

The *metal* pen point as we know it today appeared at the end of the 18th century, and by the early 19th century had largely supplanted the earlier reed

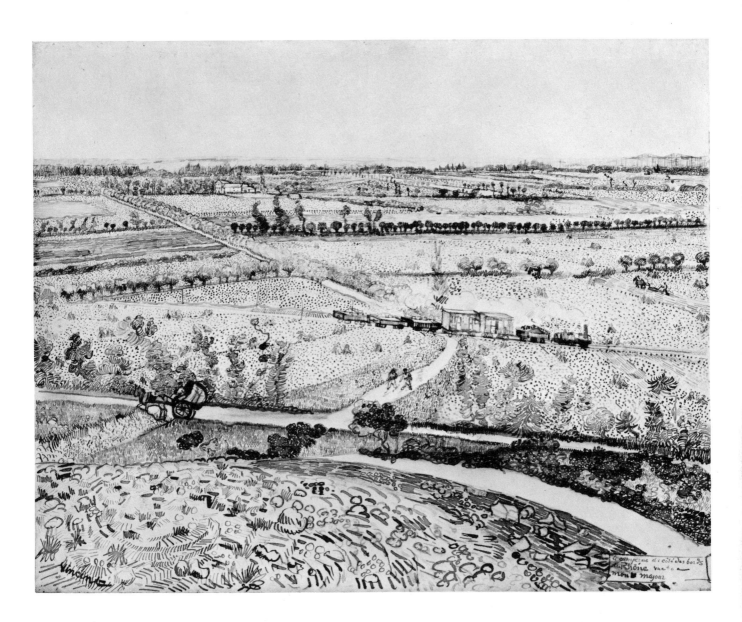

and quill types. Used on very smooth, partially absorbent paper, the steel pen can be more completely controlled than either of its precursors and can be handled with nearly infallible accuracy by a sufficiently skilled draftsman. Nibs of varying sharpness, pointedness, and angularity permit almost any desired effect, once the artist discovers the pen best suited to his or her purposes.

The multiplicity of steel pens available to artists for drawing in fact demands much experimentation and exploration. For general sketching purposes, many artists prefer a pen holder and interchangeable nibs. (An added benefit of pen and ink is that lines do not smear or smudge in the notebook as do pencil and other dry media.) Lettering pens come with round, straight, or angular nibs ranging in width from $\frac{1}{10}$ millimeter to more than $\frac{1}{4}$ inch. Certain of the straight-nibbed lettering pens yield a line that in its stiff angularity recalls the reed pen. Fountain pens are perhaps more convenient for sketchbook drawing, since once filled they eliminate frequent recourse to a bottle of ink (which is always a risk, especially when transported). Two general fountain-pen types are specially manufactured for sketching and drawing: *quill-style* pens, which will dispense India ink for an extended period of time without clogging or dripping; and *stylus-type* pens, generally termed *rapidograph* pens, with a central cylindrical point that enables the user to move

219. VINCENT VAN GOGH (1853–90; Dutch-French).
La Crau from Mont Majour. 1888.
Reed and fine pen with light brown ink over black chalk, $19\frac{1}{8} \times 23\frac{13}{16}''$.
British Museum, London.

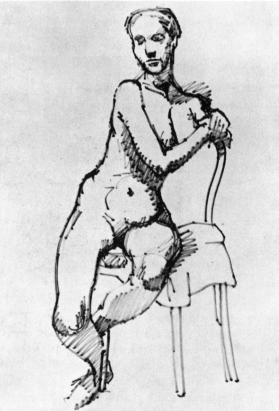

above: 220. Mark Adams
(1925– ; American).
Rocky Landscape, Death Valley. 1960.
Rapidograph pen and India ink,
$18\frac{1}{2} \times 23\frac{3}{8}''$. Collection the author.

right: 221. A twenty-minute life drawing.
Felt-tip pen, 24 × 18″.

the pen in all directions without varying the line width (Fig. 220). Thorough cleaning of pens—their nibs and reservoirs—after usage greatly prolongs the effective life of these tools. Rapidograph pens in particular should be flushed out frequently in accordance with the manufacturer's instructions to prevent irreparable clogging of their delicate internal mechanisms.

In recent years nylon, felt-tip, and ball-point pens, as well as commercial marking pens such as laundry pens, have been adopted as convenient substitutes for traditional pen and ink for sketching purposes. Although they do not dispense a fluid with the rich, opaque darkness of India ink nor have the flexibility of a metal pen, their bold, simple lines have a special character of their own (Figs. 51–54, 218, 221).

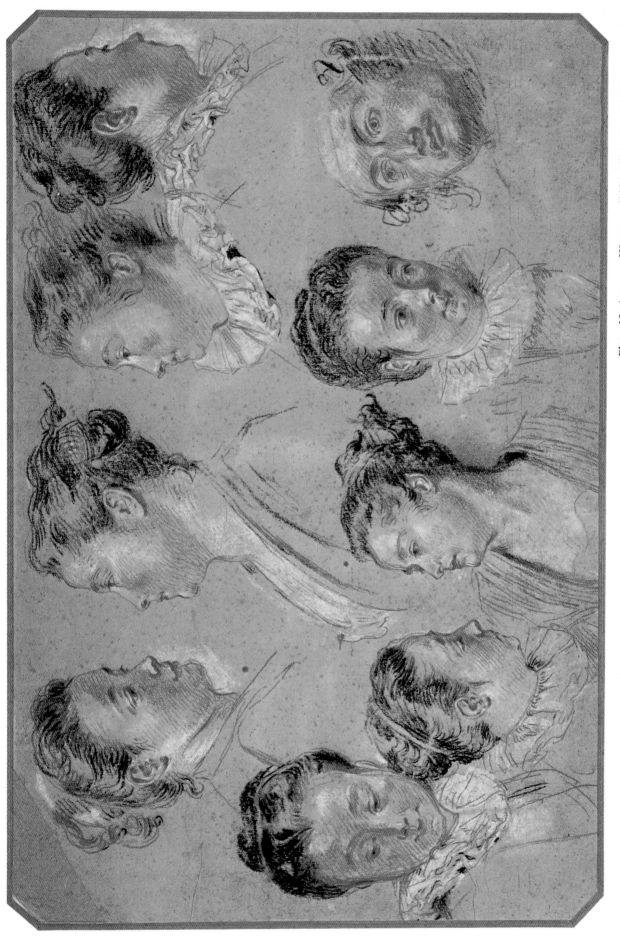

Plate 13. ANTOINE WATTEAU (1684–1721: French). *Page of Studies.*
Red and black chalk, heightened with white chalk on beige paper, $9\frac{7}{8} \times 15''$. Louvre, Paris.

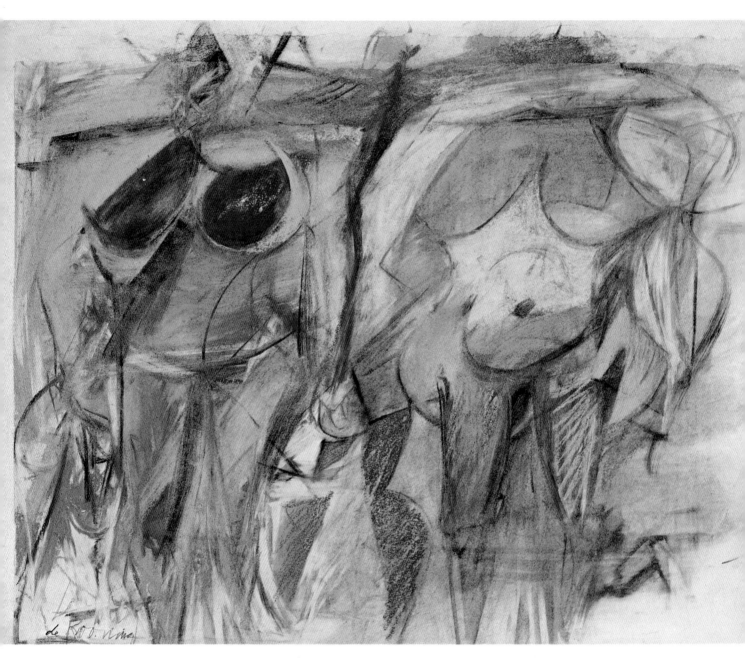

Plate 14. WILLEM DE KOONING (1904– ; Dutch-American).
Two Women. 1952. Pastel and charcoal, $18\frac{1}{2} \times 24\frac{5}{8}''$.
Art Institute of Chicago.

Simple Line Drawings

A black ink line done with pen on a white page carries with incisive brilliance
and energy. Hard, pure, and abbreviated, the simple line drawing creates a
kind of shorthand impression of reality by recording only what the artist
considers absolutely essential, eliminating all distracting details. Stark though
it may be, the pen-and-ink line displays remarkable elasticity in terms of
expressive possibilities. The pen line of unvarying width, for example, conveys
an impersonal quality reflecting little of the gesture of drawing. Alexander
Calder found it particularly appropriate for depicting the characters of his
Circus, conceived to be executed in wire (Fig. 222). Saul Steinberg's *Benjamin Sonnenberg*, on the other hand, reveals a very simple and direct use
of the more conventional flexible pen (Fig. 223). Lines vary slightly in width,

above: 222. ALEXANDER CALDER
(1898– ; American).
The Circus. 1932.
Pen and ink, 20¼ × 29¼″.
Courtesy Perls Galleries,
New York.

right: 223. SAUL STEINBERG
(1914– ; American).
Benjamin Sonnenberg. 1950.
Pen and black ink, 13 × 10″.
Collection Mr. and Mrs.
Michael Tucker, New York.

left: 224. JEAN COCTEAU (1892–1964; French).
Jean Desbordes. 1928. Pen and ink, $16\frac{3}{4} \times 13\frac{3}{8}''$.
Art Institute of Chicago
(gift of Mrs. Gilbert W. Chapman
in memory of Charles B. Goodspeed).

opposite: 225. EUGÈNE DELACROIX
(1798–1863; French).
The Sultan on Horseback. c. 1845.
Pen and ink, $8\frac{1}{8} \times 6''$. Louvre, Paris.

with heavier lines in the hat, neck, and elsewhere providing both emphasis and enough inflection to give the portrait a strong sense of the art collector's intriguing personality.

Project 75 A drawing such as the Steinberg is often inked over a lightly penciled sketch. *Do a pencil drawing from memory or imagination and trace over it freely in pen and ink. When the ink dries, erase the faint pencil guidelines. Remember that pen and ink is most effective in a small format.*

The profile portrait of Jean Desbordes by Jean Cocteau represents still another type of simple pen-and-ink technique (Fig. 224). It is obvious that the artist has drawn directly from the model; the contour line meanders in discontinuous movements that reflect the artist's sequential observations. Where a mistaken judgment has been modified, as at the back of the head and neck, the correct line has been doubled for greater weight. A simple back-and-forth scribble and light smudging around the eyes and at the back of the collar provide soft touches of value and a suggestion of texture.

Project 76 *Make a series of line drawings of forms that are not too symmetrical or regular.* Organic forms, vegetables, fruits, leaves, or flowers make logical subjects, since barely perceptible deviations in contours from those of the actual model will not ruin the drawing. Portraits and figure studies present greater difficulties than do still lifes for this reason, but they compensate with increased interest. *If you wish, sketch your subject in light pencil*

lines before proceeding with ink. In this case, do not try to follow the pencil lines so closely that all freedom of movement is curtailed, but, using the pencil lines as a general guide, draw in ink directly from the model. Take care not to overload the pen with ink. When this does occur, wipe the pen point against the side of the bottle before commencing to draw, or the pen may deposit a large drop of ink when it first touches the paper. Should you have an accident with a drawing you like that has been done on good-quality Bristol or illustration board, it is best to allow the ink to dry, gently scrape the excess ink off with a razor blade, and then with an ink eraser remove any remaining vestiges of the spot. Do not attempt to draw again over the scraped portion, for the ink will undoubtedly bleed freely into the disturbed surface.

Project 77 *The Sultan on Horseback* by Delacroix was executed rapidly, with a flourish that is reflected in the general exuberance of the drawing and in decided variations of thick and thin that mark individual lines (Fig. 225). In making drawings of this sort one must be careful to avoid angular tails on lines as one applies or lifts the pen. This problem can be overcome by commencing line movement while the hand is still in the air and continuing that movement while lifting the hand. *Practice making sweeping motions, pen in hand, gradually bringing down and lifting the pen until you can render a line beautifully tapered at both ends. Sketch a subject that does not demand exact contours, perhaps a figure or animal in action like Delacroix's rider and horse.* Preliminary guidelines in hard pencil can be followed if they are reassuring, but they should not be permitted to be restrictive.

above: 226. ABRAHAM BLOEMAERT (1564–1651; Dutch).
Young Man with Back Turned Holding Stick. c. 1600.
Fine pen and brown ink, $4\frac{9}{16} \times 3\frac{3}{8}''$.
Christ Church, Oxford.

below: 227. Attributed to PIETRO TESTA (1611–50; Italian).
Compositional Study. Pen and brown ink, $11\frac{1}{16} \times 16\frac{1}{2}''$.
Achenbach Foundation for Graphic Arts,
Palace of the Legion of Honor, San Francisco.

right: 228. Detail of Figure 227.

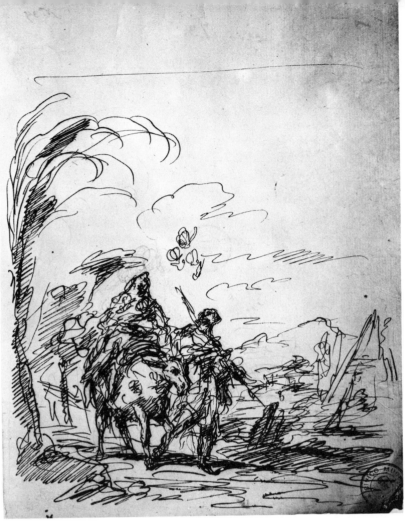

above: 229. GASPARE DIZIANI (1689–1767; Italian).
The Flight into Egypt. 1733.
Black pencil and pen with sepia on yellowish paper, $11\frac{5}{8} \times 8\frac{1}{2}''$.
Museo Correr, Venice.

right: 230. HENRI MATISSE (1869–1954; French).
Femme Nue Vue de Dos (Female Nude Seen from the Back). 1923.
Pen and black ink, $10\frac{5}{8} \times 7\frac{15}{16}''$.
Musée des Beaux-Arts, Grenoble.

Cross-Hatching

Because pen and ink is essentially a linear medium, dark values must be built up line by line and dot by dot. There are two standard methods for building pen-and-ink values: *hatching,* a system of carefully applied parallel lines; and particularly *cross-hatching,* criss-crossed patterns of parallel lines. Innumerable methods exist for applying cross-hatching, among them: painstaking, evenly spaced lines (Fig. 226); boldly executed angular lines that move in many directions (Figs. 227, 228); freely looping curved lines that interlace wildly (Fig. 229); tightly crimped scribbled lines (Fig. 230); and scribbled cross-hatched lines interspersed with spots, bold splashes, and other textural accents (Fig. 99).

Initial attempts at pen-and-ink cross-hatching inevitably seem stilted, but the beginner should not be unduly concerned with blotches and mistakes. In time, each artist develops a personal style of cross-hatching; fluent, consistent, unmarred pen-and-ink lines come only with much experience. It is important to have a fine-quality smooth paper for cross-hatching, lest the surface tear from repeated applications of the pen or become so absorbent that the ink lines lose their sharpness and become blurred.

Project 78 *Practice cross-hatching until you can maintain some measure of control, then sketch a simple subject and proceed to model it in dark and light. At the beginning, draw brightly illuminated, simple forms with clearly defined areas of shading and a minimum of surface texture.* When you are ready to attempt a more complex essay, you might find it profitable to translate some of the pencil drawings done for earlier projects into pen and ink.

Stippling and Pattern Textures

In drawing, and especially in scientific drawings or other highly detailed studies, stippling and formalized patterns serve to describe the very smooth gradations of value that define form, texture, or color modulation. In *Antennarius Tagus* (Figs. 231, 232) lines and dots have been combined with great skill and ingenuity to capture form, texture, and surface patterns. Even the sharpest photograph would not reveal the details of form with the clarity of this drawing, for in a photograph reflected lights, shadows, and imperfections of surface occasioned by handling the specimen could provide distracting or irrelevant elements. Though the purpose of this drawing departs from fundamentally artistic expression—entailing an almost compulsive discipline to the representation of actuality—its clarity and virtuoso production are in themselves worthy of visual appreciation.

Project 79 *Repeat in pen and ink the introductory exercise for texture in Chapter 7 (p. 110), working to delineate form and texture in as disciplined a manner as possible and avoiding extended areas of dark tone.* A laboratory specimen from a biology or natural science class can supply excellent subject matter for your practice here.

Project 80 Pen and ink is also well adapted to drawings in which clearly defined patterns are desired for their expressive and decorative values, rather than to describe form or surface texture. Aubrey Beardsley remains an un-

left: 231. CHLOE LESLEY STARKS (1866–1952; American). *Antennarius Tagus.* c. 1900. Pen and ink, $5\frac{1}{4} \times 9\frac{1}{4}''$. Formerly collection Dorothy Rich, Menlo Park, Calif.

right: 232. Detail of Figure 231.

challenged master at using pen and ink to achieve unique and original decorative effects. In *J'ai Baisé Ta Bouche, Jokanaan* (Fig. 18), dots, lines, and other devices unite in an imaginative scheme of richly patterned surfaces. Beardsley's *Third Tableau of "Das Rheingold"* (Fig. 233), unlike most of the drawings reproduced here, displays an almost solid black background, but white dots and clusters of narrow white lines have been allowed to penetrate the ground to elucidate forms and suggest movement in the darkness. The wraithlike forms and movements are remarkably evocative of both the mythological spirit world of Wagnerian music and its texture. In Figure 234, freely drawn triangular and curvilinear patterns have been extended, compressed, bent, and twisted to create the mobile pattern effects. *With combinations of dots and linear pattern as the basis of your texture, develop an imaginative illustration or design a simple mask or fantastic head.*

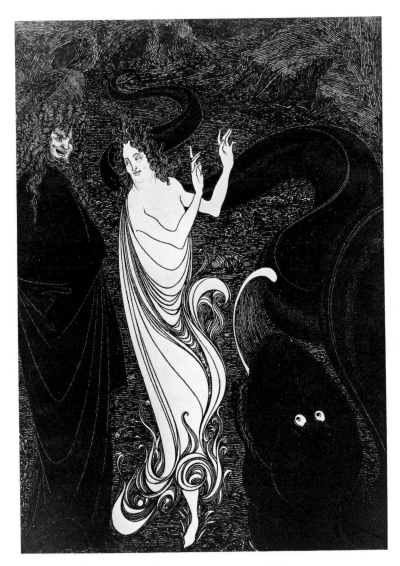

above: 233. Aubrey Beardsley (1872–98; English). *Third Tableau of "Das Rheingold."* 1896. Pen and India ink, $10\frac{1}{16} \times 6\frac{7}{8}''$. Museum of Art, Rhode Island School of Design, Providence.

right: 234. Ivan Majdrakoff (1927– ; American). *Head.* 1961. Pen and ink 10 × 7″. Collection the author.

235. GEORGE GROSZ (1893–1959; German-American). *The Survivor*. 1936. Pen and India ink, 19 × 25″. Art Institute of Chicago (gift of the Print and Drawing Club).

Project 81 In *The Survivor* by George Grosz (Fig. 235), a rich array of texture patterns has been employed both to characterize form and the nature of surfaces and for expressive effects. These pen-and-ink patterns reveal many varied uses of the pen, and some textures appear to result from pressing fabrics or other materials dampened with ink against the paper. *Experiment to see how many different textural patterns you can invent. Once you have evolved an interesting group, carry out a finished composition involving them.*

Pen, Brush, and Ink

Pen and ink amplified by brush provides an obvious transition from pure pen-and-ink to brush-and-ink drawing. Brush strokes logically facilitate the production of more extended areas of dark or lines of greater width modulation than can be obtained with the relatively less pliant pen nib.

Project 82 A delicate example of pen drawing supplemented by brushed-ink masses is Eugène Delacroix's *Madame Pierret* (Fig. 236). Delacroix has maintained consistency of texture between the two media through simple linear transitions relating the black and white. Furthermore, he has retained highlights within the dark locks of hair. The strategic placement of dark-toned areas causes the drawing to carry far more forcefully than if it were strictly linear. *Select a subject with bold contrasts of dark and light—perhaps a self-portrait illuminated by strong light to one side—and develop it in pen outlines and brushed-ink masses, using both tools to create the transitional values and textures.*

left: 236. Eugène Delacroix (1798–1863; French). *Madame Pierret.* Pen, brush, and ink, $8\frac{11}{16} \times 7\frac{3}{16}''$. Louvre, Paris.

below: 237. Jean Edouard Vuillard (1848–1940; French). *Young Seamstress.* 1891. Brush and ink, $14\frac{1}{8} \times 11\frac{15}{16}''$. Stanford University Museum of Art, Calif. (Mortimer C. Leventritt Fund).

Brush and Ink

The narrowness of line produced by a pen point gives it its bite and energy and at the same time limits its degree of flexibility and painterliness. When artists wish to expand the scope of line, they pick up a brush, as did Diego Rivera when he drew *Mother and Child* (Fig. 57). The brush encourages the expansion of line width and thereby promotes an eloquence and richness that a pen line lacks. Because Rivera used a pointed brush fully loaded with a not-too-viscous fluid on a fairly smooth paper, the lines here have clean edges and, where the artist so desired, swell from a fine point to a full line and back again. A page of sketches by Jean Edouard Vuillard (Fig. 237) reveals an unpretentious but expressive use of a small pointed brush dipped in India ink. While the line of this drawing certainly exhibits greater flexibility than an ordinary pen line, it still lacks the rich and dramatic effects we normally associate with brush and ink: linear strength and bold masses of dark and light (Fig. 238). Emil Nolde's *Landscape with Windmill* (Fig. 58) conveys an almost frenzied vehemence, as though the somber landscape of Schleswig aroused such powerfully depressing emotions that the artist could barely control his expression. A stiff, rather broad bristle brush, slightly dampened with heavy black printer's ink, yielded the grainy textures (or "dry-brush" effects) and the harsh, awkward shapes that so effectively express the grim mood.

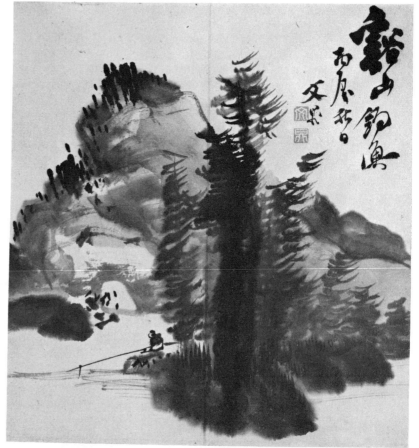

left: 238. HENRI MATISSE (1869–1954; French).
Dahlias and Pomegranates. 1947.
Brush and ink, $30\frac{1}{8} \times 22\frac{1}{4}''$.
Museum of Modern Art, New York
(Abby Aldrich Rockefeller Fund).

below: 239. BUNCHŌ TANI (1763–1842; Japanese).
Fishing in the Melting Mountain. 1818.
Brush and ink, $10\frac{15}{16} \times 9\frac{13}{16}''$.
British Museum, London.

240. HANS HARTUNG
(1904–ं ; German-French).
D-52-2. 1952.
Charcoal, brush and oil, 19 × 25″.
San Francisco Museum of Art.

All kinds of brushes—from the pointed instruments of China and Japan, to the flat bristle brush employed in oil painting, and the sable or oxhair brushes intended for watercolor—can be used with ink, and each brush imparts its particular character to a drawing (Fig. 217). The long, very pointed Japanese brush, for instance, is most responsive to pressures of the hand and so creates lines of unusually varied widths. A stiff bristle brush produces brusque, angular lines, often with heavily dry-brushed edges. Chisel-shaped lettering brushes draw lines with abrupt differentiations in width, depending upon whether the narrow or wide edge of the brush touches the paper. Frequent and thorough rinsing of such wet media tools, as well as careful storage (especially important so that brush fibers are not disarrayed) ensures the continued quality and dependability of the materials.

Papers also have much to do with the quality of line in brush-and-ink drawing (see p. 133). Soft, absorbent papers like rice paper or blotting paper soak up the ink the moment the brush touches and so create lines whose width and edge character vary considerably (Fig. 239). Hard-surfaced papers, on the other hand, absorb a minimum of ink from the brush, and this contributes to continuity of line and clean-cut edges. A dry-brush effect inevitably occurs in limited areas when a very rough, textured paper is used; conversely, it is almost impossible to achieve an interesting dry-brush quality on very smooth paper. Striking effects can be obtained by drawing with brush on wet paper. The ink creeps over the wet surface leaving curious veiny paths or pools in unusual blobs, and the very fact that the movements of the ink cannot be predicted forces the artist to be inventive in relation to what appears on the paper in the course of carrying out a drawing (Figs. 249, 250).

Media other than ink can serve for brush drawings. Black watercolor, tempera, poster paints, and oils are all good possibilities. Here, as with inks, the color, opacity, and viscosity of the media determine applicability to certain situations. Many experienced painters like to draw with the tools and materials they use for painting, since this practice facilitates developing a drawing into a painting. In such cases, it becomes impossible to tell when drawing ceases and painting begins (Fig. 240).

Oriental Calligraphy

Among the most sophisticated and beautiful brush-and-ink drawings are those of the Oriental masters (Fig. 241). The brush is as commonplace in the Orient as the pen is in Western cultures. There has always been a particularly close connection between the art of writing and drawing in China and Japan, since the techniques involved in manipulating the brush are the same, and in both the ornamental character of the line produced by skillful brush handling has been highly prized. Long years of copying the works of acknowledged masters and learning the exact strokes of a conventional artistic vocabulary constituted an arduous apprenticeship for the Oriental artist (Fig. 242). This strict and careful training supplied the basis for a virtuosity of performance that at best produced magnificent drawings, but frequently was stultifying. While in the work of such masters as Hokusai technical skill remained in the service of expression, more often one is aware of the pure virtuosity of technique and decorative charm.

Most Oriental brush masters employ *sumi*, a stick of carbon ink that the artist grinds and mixes with water on a shallow stone or ceramic block (Fig. 217). This procedure permits great control over the density of tones. The brush itself is held in a vertical position above a flat ground, neither hand

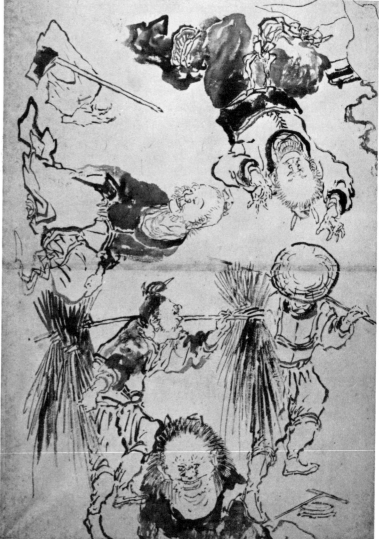

above: 241. KAWANABE KYŌSAI (1831–89; Japanese).
Man with a European Hat. c. 1870.
Ink and color on paper, $6\frac{11}{16} \times 5\frac{5}{16}''$.
Rijksmuseum voor Volkenkunde, Leiden.

right: 242. HOKUSAI (1760–1849; Japanese).
Model figures for pupils to copy,
arranged to enable several pupils
to work from the sheet simultaneously.
c. 1835–40. Brush and sumi, $17 \times 11\frac{3}{4}''$.
British Museum, London.

243. Antonio Canaletto
(1697–1768; Italian).
An Island in the Lagoon.
Pen and brown ink, with carbon ink wash
over ruled pencil lines, $7\frac{13}{16} \times 10\frac{15}{16}''$.
Ashmolean Museum, Oxford.

nor wrist being allowed to touch the paper or table support. By raising and lowering the hand and loading the brush in different ways—using the side or the tip alone, or combining heavy black ink in the tip with very thin, watery ink in the body of the brush—artists can regulate an extensive repertoire of strokes. Since the traditional rice paper and silk fabric grounds are very absorbent, lines cannot be altered or deleted, and a skilled craftsman never repeats a line.

Project 83 A good-quality watercolor brush, blotter or rich paper, regular India ink, a saucer, and water provide substitutes for the standard materials of Oriental calligraphy for those students wishing to explore the technique without purchasing special equipment. *For an initial exercise, copy on an enlarged scale portions of Figure 242.* Chen Chi's *Winter* illustrates a contemporary interpretation of traditional Oriental brush drawing (Fig. 347).

Wash Drawing

A wash drawing is a painted drawing and as such stands halfway between drawing and painting. Unlike brush-and-ink drawing, which depends for its effectiveness on a more-or-less solid black contrasting with white, in wash drawing the medium is freely diluted with water for a wide range of grays. Both the brush and the diluted medium are extremely flexible vehicles; they encourage an unusually fluid play of lines, values, and textures (Figs. 243–245). Wash has long been a popular drawing medium, especially in periods when painterly effects were highly valued.

Wash commonly refers to black ink or watercolor that has been thinned with water to various value gradations. It can also encompass water and tempera, gouache, or the new acrylic polymer paints, although these media tend to be less fine-grained than ink or watercolor. Stretching the term still further, wash can include oil paints thinned with turpentine or paint thinner. Whatever the pigment, it is the principle of dilution that characterizes wash drawing.

Many students have found wash to be an instructive transition from drawing to painting. Equipment needs are modest: brush, ink, black watercolor

or tempera, and a not-too-thin, absorbent paper. Regular watercolor paper of a good quality and illustration board will not wrinkle or buckle when wet, and so they present satisfactory grounds for wash. Illustration board can be thumbtacked to your drawing board; watercolor paper is best mounted according to the directions given on page 120. In addition to the equipment and materials indicated above, you will need a quantity of clean water close by your work table and a supply of absorbent paint rags. A sponge will also prove helpful for wetting the paper or for picking up areas of wash that appear too saturated. A white saucer, plate, or watercolor palette can serve as a container in which to mix your pigment.

Flat Washes

Project 84 *For your first wash drawing, select a subject with clearly defined planes of dark and light—perhaps a small house, a garage, or a tool shed—and sketch firm, preliminary outlines in pencil. Keep to a modest scale—no more than 8 by 10 inches. Plan the distribution of your values, leaving the pure white paper for the lightest areas. Place a couple of tablespoons of water in your saucer or palette, and add enough ink or paint to make a light gray. Load your brush with this tone, and spread it over all portions of the drawing that you intend to be other than white. When this first application has dried, add a second wash of gray to the next darkest areas of your composition. Continue in this manner until you have built your areas of deepest tone. As you progress toward the darks, you may wish to intensify your gray puddle, because this enables you to achieve deep tone more rapidly. Never try to lay a wash over a partially dry surface, for this produces an ugly, mottled result. While the*

244. Honoré Daumier (1808–79; French).
The Connoisseurs. c. 1863.
Black chalk, wash, and watercolor, $10\frac{1}{4} \times 7\frac{5}{8}''$.
Cleveland Museum of Art
(Dudley P. Allen Fund).

medium encourages free, spontaneous handling, a rather cautious and systematic procedure is best for those with little experience in wash or watercolor.

Modulated Areas: Wash with Other Media

Wash is particularly suitable for free, fluid effects. Whether applied directly to paper without preliminary drawing (Fig. 245), or combined with pencil (Fig. 246), pen and ink (Fig. 247), charcoal, chalk (Fig. 244), or almost any

above: 245. CLAUDE LORRAIN
(Claude Gellée; 1600–82; French).
The Tiber Above Rome, View from Monte Mario.
c. 1640. Brush and bistre wash, $7\frac{3}{8} \times 10\frac{5}{8}''$.
British Museum, London.

left: 246. CASPAR DAVID FRIEDRICH
(1774–1840; German). *Quarry.* 1813.
Pencil and wash, $8\frac{1}{4} \times 6\frac{13}{16}''$.
National Gallery, Berlin.

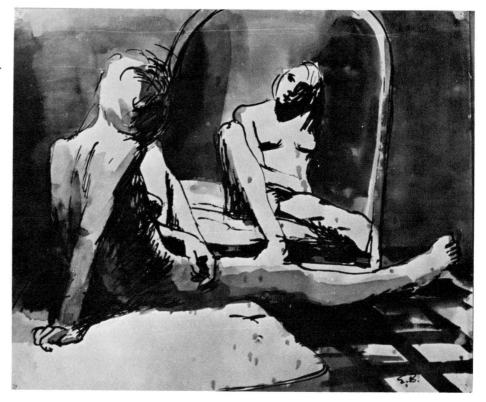

right: 247. Elmer Bischoff
(1916– ; American).
*Seated Figure Reflected
in a Mirror.* 1962.
Pen and ink with wash, $14\frac{3}{4} \times 17\frac{7}{8}''$.
San Francisco Museum of Art.

below: 248. Auguste Rodin
(1840–1917; French).
Nude. c. 1900–05.
Pencil and watercolor, $17\frac{5}{8} \times 12\frac{1}{2}''$.
Art Institute of Chicago
(Alfred Stieglitz Collection).

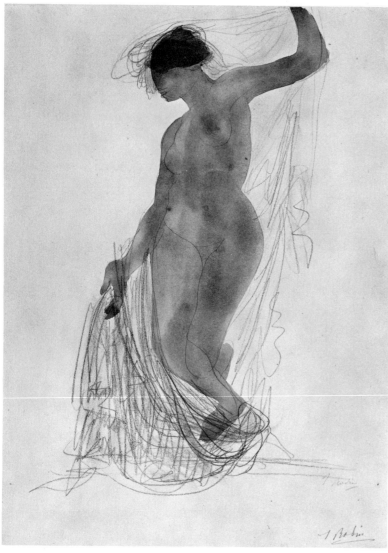

nongreasy drawing medium, wash reveals a distinctively casual air. When blending wash with other media, it is the artist's option whether the wash precedes or follows the pencil, pen, or charcoal lines. The artist can also control the amount and strength of linear elements in a wash drawing.

In the drawing illustrated as Figure 248, Auguste Rodin has washed in an almost flat tone of gray to separate a dancing figure from the penciled drapery masses and the background. There is little evidence of any systematic attempt on Rodin's part to vary the value of the wash to give form to the figure, but the seemingly accidental changes of tone within the wash inevitably suggest the volumes of the body, partly because they are reinforced by such firm contour lines. The casual nature of wash seems right for the almost scribbled indication of the draperies and suggests that Rodin made the drawing as a note with no other thought in mind than to record the graceful gesture of the dancer.

Project 85 *Select a subject that calls to mind a somewhat splashy, spontaneous effect—a landscape or perhaps a life drawing. In contrast to Project 84, try for free and natural painterly effects (Fig. 245). Sketch your subject in the medium of your choice. Keep your concentrated ink or paint accessible, and mix a fair-sized puddle of middle-value gray in your palette. Proceed to paint, adding water to your middle-value gray when you want lighter tones and concentrated pigment to yield darker tones. Do not try for flat washes or smooth effects, but permit the brush strokes and gradations of paint to show. Once the washes have begun to dry, allow surfaces to become completely dry before you add additional layers of wash. Lastly, add your most concentrated accents of black. If you wish to recover some small areas of white, you can retouch with opaque tempera white or scratch out with a razor blade. For clearly defined edges, apply wash to a dry surface; for softened contours (as in drawing clouds), wet the paper with a sponge and apply the wash to the wet surface.*

Project 86 Wash frequently provides a convenient means of unifying a composition that lacks cohesiveness. In fact, in many master drawings the function of wash appears to be a fusing of the component parts—pencil, pen, or brush lines in conjunction with cross-hatching, stippling, dry-brush textures, and so forth—into a painterly unity (Pl. 15, p. 195). *If you have evolved a method of using pen and ink or brush and ink that is particularly to your liking, start a composition in that technique, planning to combine it with wash.* Let us assume you settle on cross-hatched pen and ink plus wash as in Figure 247. *Develop your composition partially in pen line and then add wash. Return to pen and ink for additional cross-hatched lines where they will strengthen form and volume. Continue altering pen and wash until you have achieved a pleasing richness and coherent unity. If your light areas become obscured, reintroduce highlights either by scratching with a razor blade or through dabs of white tempera paint.*

Project 87 An interesting variation of traditional wash drawing can be worked with ink or concentrated paint on wet paper. The resultant veined effects, unpredictable runs, blobs, and granular deposits create textures and lines quite unlike the limpid fluidity of typical wash drawing (Fig. 249). An unusual drawing by Paul Klee looks as though the ink lines had first been drawn with a pen and, while wet, touched with a watery brush (Fig. 250). In this way, the artist managed to control the direction and extent of the ink spread. (If you apply much-diluted paint to a completely wet surface, the paint sinks into the saturated background too thoroughly to yield interesting effects.) *Choose a finished line drawing that satisfies you, and experiment with the methods described here to amplify its effect.*

right: 249. LIONEL FEININGER
(1871–1956; German-American).
Mellingen IV. 1916.
Watercolor, opaque watercolor, and ink
on paper, $9\frac{1}{4} \times 11\frac{15}{16}''$.
Pasadena Art Museum, Calif.
(Galka E. Scheyer Blue Four Collection).

below: 250. PAUL KLEE
(1879–1940; Swiss-German).
Canal Docks. 1910.
Pen and ink over hard pencil,
with wash, $3 \times 9\frac{13}{16}''$.
Albertina, Vienna.

Project 88 Of course, drawings coordinating wash and other media need not be confined to black and white. Colored wash reinforced by colored inks, pencils, chalks, or other tinted media offers an excellent vehicle by which students can make the transition to painting. A monochromatic color scheme provides a simple step into using color (see p. 129). *Select a medium adaptable to dilution, such as colored ink, watercolor, felt-tip pen, or poster paint. Decide on your subject and composition, sketch it in lightly, and then proceed to paint with pigment and water, diluting according to the desired value. Enhance your drawing with chalk, pen and ink, or the medium of your choice, being careful to confine yourself to the inflections of a single hue, preferably dark in value. After you have experimented with a monochromatic color scheme, attempt an analogous or complementary scheme (see pp. 129–130).*

Mixed Media: Exploration of New Materials

Some artists are purists by temperament and take the limitations of a medium as a challenge. They delight in bending the medium to their respective aesthetic wills and making it do what seems impossible. We have seen Ingres

accomplish this with pencil (Figs. 4, 98, 205, 275, 313) and Sheeler with conté crayon (Figs. 195, 366). Other artists care only to achieve a certain effect, and they freely combine media to realize their goals. Many drawings by both old and modern masters were not undertaken with clearly defined plans with respect to media, but instead developed through improvisation (Pl. 15, p. 195). Such drawings frequently were begun in an exploratory medium, perhaps charcoal or chalk. At a later stage wash or ink may have been added to intensify the darks and, subsequently, white tempera dabbled on strategically to strengthen the lights. If the accents in black ink or white tempera seemed discordant, a gray wash may have been stroked on to soften transitions. A small amount of colored chalk may have provided a final enrichment.

Project 89 *Study your previous works to find a drawing you feel did not attain its full potential. Enrich by blending with another medium: colored ink, wash, and tempera can be added to charcoal and pencil, and so forth.* You might also profit from starting a drawing in pencil on illustration board with no preconceptions about how you will complete it, and then proceed to develop it with whatever materials seem appropriate.

Each year the manufacturers of art materials introduce new products. Felt-tip, ball-point, and nylon-tip pens have been mentioned as capable of offering a wide range of line widths in many colors. Rubber emulsions—recently offered as masking devices to protect areas of white paper from washes, inks, and other water-soluble pigments or from soiling—are now exploited for their brilliant "stopped out" possibilities (Fig. 208). Wax crayon or rubber cement laid under wash gives similar effects, but the consistency of the rubber cement creates a very different and unique line quality (Fig. 251), while the mottled coating of crayon raises interesting granular surfaces, as in the lower right-hand corner of Figure 252.

above: 251. Abstract design created from ink, wash, and rubber cement. 2 × 4½″.

below: 252. HENRY MOORE (1898– ; English). *Figures in a Shelter.* 1942. Black chalk, crayons, and India ink, 14¾ × 21$\frac{1}{16}$″. Formerly collection Mrs. Ruth Lilienthal, Hillsborough, Calif.

above: 253. ANDRÉ MASSON
(1896– ; French).
Battle of Fishes. 1927.
Oil, sand, and pencil on canvas,
$14\frac{1}{4} \times 28\frac{3}{4}''$.
Museum of Modern Art,
New York (purchase).

below: 254. Ink applied to paper
with corduroy. 5 × 6″.

Inventiveness in the use and combination of materials is of great impor-
tance, for it encourages the artist to avoid clichés. Even the most traditional
materials, in the hands of an imaginative person, take on fresh and original
dimensions. André Masson drew his *Battle of Fishes* on canvas in pencil and
oil and then added masses of sand, creating a suggestive textural variety (Fig.
253). Drawings done in chalk, charcoal, or pencil, in which the lights are erased
rather than achieved by reserving white paper, have a fresh and interesting
character (Fig. 207). Ink applied to paper with a piece of corduroy produces a
curious sort of cross-hatching (Fig. 254).

Project 90 More will be said about the inventive use of media in Chapter
15, but for the present a few simple experiences may encourage the habit
of exploration. *Select from the following the experiments that appeal to you:*

1. *Roll a small piece of heavily textured cloth into a compact ball. Wet it
 slightly with ink, and press it against a piece of paper. Make a dark and
 light drawing using only the fabric ball dampened with ink to build your
 value and contour patterns.*
2. *Rub a middle-value coat of powdered charcoal into a piece of paper. Do
 a drawing in erased lights, adding darks and erasing lights until your
 drawing is completed.*
3. *Make a drawing on firm white paper with rubber cement and whatever
 implement works best. Rubber cement is viscous and stringy, so do not
 attempt to achieve smoothly modulated lines, but accept its unpredictable
 irregularities. Lay a wash of mottled gray over the entire drawing, and
 when this has dried, rub off the rubber cement. If the resulting white pattern
 pleases you, consider the drawing completed. Should you feel it necessary,
 add darks that will complement the white pattern.*
4. *Do a large drawing with a felt-tip pen or commercial laundry marking
 pen, using cross-hatching or some other technique for which you ordinarily
 employ a fine pen point. Dramatize the bold scale of the line (Fig. 99).*

*Above all, doodle and play on paper with media you find intriguing. Develop a
drawing from something that evolves in the course of playful explorations.*

five

Traditional Areas
of Subject Matter

Figure Drawing

The forms depicted in the earliest drawings were the animals on which primitive hunters relied for sustenance. The walls of Paleolithic caves abounded with bison, deer, and other animals they preyed upon (Fig. 255). In this initial attempt to control the unpredictable forces of the universe, the hunter-artist tried to capture the images of the hunt in the belief that this in turn would ensure the capture of the living animals. Next to appear in the drawings of primitive people were images of themselves; later, in Neolithic times, schematic and formalized human figures appeared with increasing frequency on potteries, woven into fabrics, chiseled into rocks, or painted and drawn upon whatever other surface the artist chose to decorate (Fig. 256). As civilization evolved, the representation of the human figure became synonymous with the degree of cultural advancement in different areas. In the kingdoms of Egypt (Fig. 131), Assyria, China, India, Greece (Fig. 257), and Rome, artists displayed remarkable skill in depicting this extremely difficult and complex form as they gradually mastered the proportional relationships of parts, principles of foreshortening, and visual sophistication in this demanding art.

Anatomical Drawings

In the years of the European Renaissance, artistic activity and scientific inquiry went hand in hand, since both pursuits represented an attempt to expand the fields of knowledge and come to an understanding of natural phenomena and

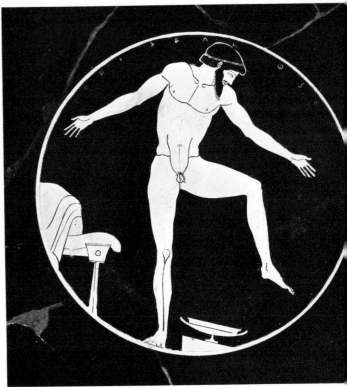

above: 255. *Bison*, prehistoric cave painting.
c. 15,000–10,000 B.C. Pigment on natural rock.
"Salon Noir," Niaux Cave, Ariège, France.

below: 256. *Monsters*. Moche (Mochica) culture, Peru
(c. A.D. 300–850). Brush drawing on pottery (reconstruction).
British Museum, London.

right: 257. DOURIS (active c. 500–475 B.C.; Greek).
Reveler Balancing on One Leg. c. 490 B.C.
Interior of an Attic red-figured kylix, approx. 8″ diam.
Museum of Fine Arts, Boston (H. L. Pierce Fund).

their interrelationships. Until this time, artists had for the most part contented
themselves and their audiences with carefully observed descriptions of surface
appearance. Amid the Renaissance atmosphere of expanded intellectual curi-
osity about the nature of the physical world—and in particular the human
organism—an increased concern with the structure underlying the surface
features permeated the artistic community. By the 15th century, the study
of anatomy—entailing the dissection of cadavers and consequent analyses of
bones, muscles, tendons, nerves, and the functioning of these various parts—
had begun to command the serious, though clandestine, attention of artists.

258. Attributed to Raphael
(Raffaello Sanzio; 1483–1520; Italian).
The Virgin Supported by the Holy Women, anatomical
study for the Borghese *Entombment.* c. 1500–07.
Pen and brown ink with traces of black chalk, $12\frac{1}{16} \times 7\frac{15}{16}''$.
British Museum, London.

Raphael's study is evidenced in a preliminary sketch entitled *The Virgin Supported by the Holy Women* (Fig. 258), where the skeletal forms project the correct disposition of the figures for subsequent more fully developed drawings.

An understanding of the forms of muscles, bones, and tendons as they interlock and combine below the surface to create the projections and hollows that meet the eye gives Renaissance drawings a power that is absent from the lovely but (in comparison) naive drawings of earlier times (Fig. 211). Only meticulous study of anatomy could have made possible the superhuman figures with which Michelangelo peopled his world (Fig. 259). These powerful, muscled bodies—with their small heads, hands, and feet, their great torsos, thighs, and arms—are completely convincing because they are based on a profound knowledge of bone and muscle structure. The musculature clearly articulated in these drawings is less evident when one looks at a living nude figure. Nonetheless, the grandeur of Michelangelos' figures was such that they established a stylistic ideal that was perpetuated throughout the Baroque period and into modern times (Fig. 260).

Renaissance attempts to codify the proportioning of the body departed from the newly acquired anatomical familiarity with the human form. This systematic approach to the proportions of the human body coincided with the desire to find universal relationships governing all fields. Leonardo da Vinci's famous drawing relates the male body to the perfect geometric forms of the square and the circle (Fig. 261). A figure of idealized proportions, eight

259. MICHELANGELO BUONARROTI
(1475–1564; Italian).
Figure Study. Louvre, Paris.

heads high (the normal male stands about seven heads high), is subdivided into even parts. The groin is halfway between the top of the head and soles of the feet, the knees halfway between the groin and the feet, and so forth.

Project 91 *Study the Leonardo drawing to familiarize yourself with the main divisions of the body. Have your model take a standing pose, feet slightly apart, one arm hanging at the side and the other with hand on hip. Measure optically with a drawing implement (see p. 54) the distance from the chin to the crown*

above: 260. WILLIAM RIMMER
(1825–79; American).
Call to Arms. c. 1870–76. Pencil.
From *Art Anatomy* (Boston, 1877).

right: 261. LEONARDO DA VINCI
(1452–1519; Italian).
Study of Human Proportions
According to Vitruvius. c. 1485–90.
Pen and ink, $13\frac{1}{2} \times 9\frac{3}{4}''$.
Accademia, Venice.

right: 263–265.
BERNHARD SIEGFRIED ALBINUS
(1697–1770; Dutch).
Anatomical drawings from *Tabulae
Anatomicae* . . . (Leiden, 1747).

263. Skeleton walking.

264. Musculature (front).

265. Musculature (rear).

262. ANDREAS VESALIUS
(1514–64; Belgian).
Anatomical drawing: skeleton.
From *De Humani Corporis Fabrica*
(Brussels, 1543).

*of the head, and calculate the number of units or "head heights" comprising
the total height of the figure. Use the unit measurement to determine as well
the placement of nipples, groin, knees, elbows, and so on. Draw the figure
in charcoal or soft pencil to facilitate erasures and changes.*

The study of anatomy remained an integral part of life drawing classes
into the 20th century and, in occasional instances, prevails today. Charts,
diagrams, and class lectures, in which the professor drew upon the blackboard
while an obliging model tensed his muscles so they bulged and revealed their
relationships to the bony protrusions of the body (ribs, knees, ankles, and so
forth), helped students analyze what they saw when they observed a model.
You might enjoy looking at one of the standard artist's anatomy books while
drawing from a live model, in order to gain a clear understanding of the
coordination of bulges and indentations one cannot always easily perceive.

Anatomical drawings have frequently gone beyond the reference purposes
of artists or anatomists to become artistic works in and of themselves. A
comparison of an anatomical drawing published by Andreas Vesalius, a 16th-
century Belgian anatomist, with some by Bernhard Siegfried Albinus, an
18th-century Dutch anatomist, gives interesting illustration of the breadth
of possibility. Vesalius' drawings are handsome and informative (Fig. 262).
Those of Albinus, however, are highly finished works whose aims far exceed
straightforward communication and the needs of medical or art students (Figs.
263–265). The exquisite refinement of finish, the handsome backgrounds, the
idealized proportioning of parts—small heads, elongated bodies, delicately
tapered extremities—all are far from purely factual rendering and as such
are meant to appeal to the collector of works of art.

Another group of anatomical studies deserves our attention for their
unusual charm. In the 19th century Japanese artists became interested in
European artistic concepts. A page of block prints of skeletons by Kyosai
entertains us with its whimsical fantasy and humor (Fig. 266). Although the

TAB. II. TAB. V.

below: 266. KAWANABE KYOSAI (1831–89; Japanese).
Skeletons. 1881. Woodblocks, each 7 × 4$\frac{15}{16}$″.
British Museum, London.

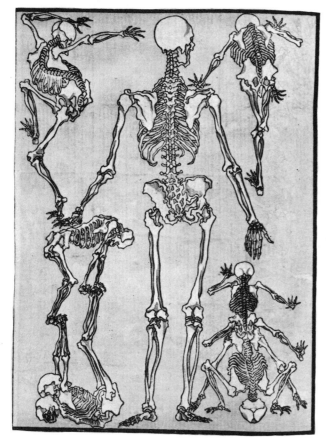

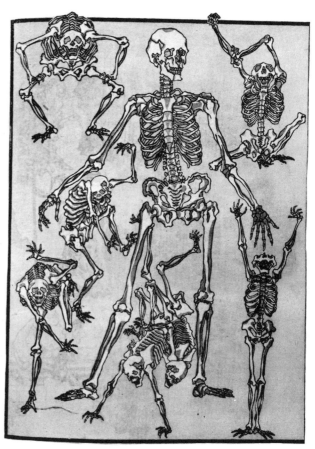

skeleton symbolizes death for many, and consequently seems a rather macabre artistic form, Kyosai finds it an unparalleled vehicle for the depiction of exaggerated human antics.

Project 92 *Draw a series of skeletal forms engaged in entertaining antics. If your knowledge of skeletal configurations is scant, begin with stick figures and then, referring to the Vesalius and Albinus drawings, enrich your straight lines to resemble bony structure.*

left: 267. Life drawing from one-to-five-minute poses.

below: 268. Life drawing from twenty-to-thirty-minute poses.

Life Drawing—The Nude Model

Drawing the human figure from a living model—"life drawing" as we call it today—serves as the principal discipline whereby students acquire knowledge of and sensitivity to the intricacies of the human form. In most life drawing sessions the model commences with quick static poses held for one to five minutes. This provides the student with a warming-up period. Quick sketches are best executed on newsprint paper in charcoal or very soft pencil (Fig. 267). One or two twenty-minute or half-hour poses usually follow the quick-sketching period. This permits more fully developed drawing with some modeling of forms in dark and light masses and an indication of anatomical details (Fig. 268). Fritz Wiegele's drawing of a model in two successive poses coupled close together on one page is hardly distinguishable from a skillful student's twenty-minute sketch (Fig. 269). After the longer sketching period, the model assumes a pose that has been designated as the long-study pose of the week. The student can then complete a fully developed drawing and refine it over a period of days (Fig. 270).

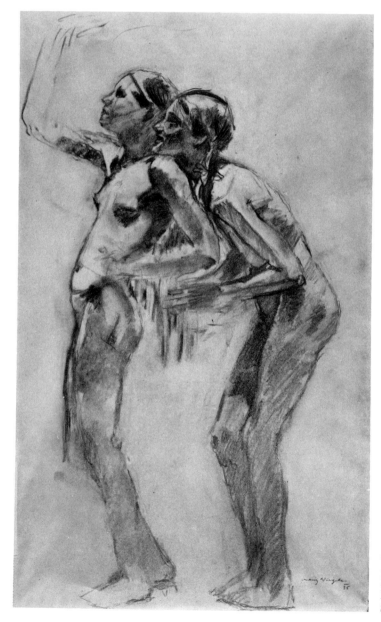

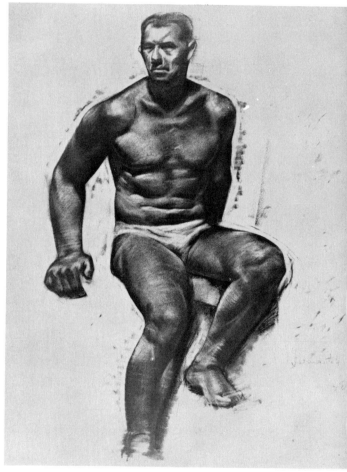

left: 269. Fritz Wiegele (1887–1944; Austrian).
Two Young Girls. 1935.
Rubbed pencil, $21\frac{3}{8} \times 12\frac{3}{8}''$.
Collection Count Antoine Seilern, London.

above: 270. Victor Arnautoff (1896– ; Russian-American).
Study of a Model. 1928.
Red and black conté crayon, $25 \times 19''$.
Department of Art and Architecture,
Stanford University, Calif.

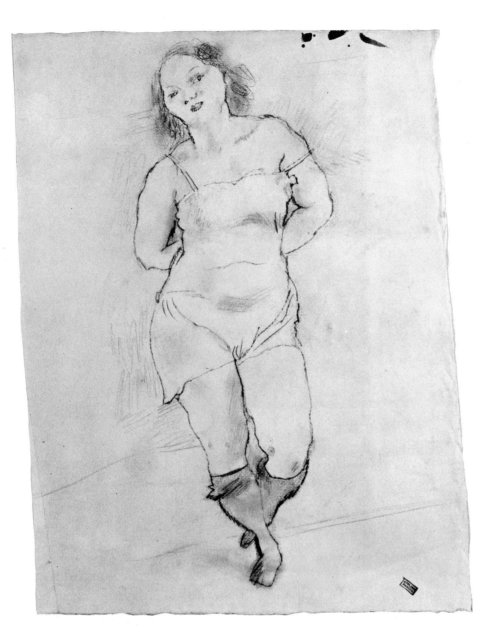

271. JULES PASCIN
(1885–1930; Bulgarian-American).
*Jeune Fille Debout (Young Woman
from Above)*. c. 1920–30.
Black conté crayon,
$18\frac{11}{16} \times 13\frac{7}{8}''$ (irregular).
Stanford University
Museum of Art, Calif.
(Mortimer J. Leventritt Fund).

Project 93 *Sketch a nude life model in one-minute, five-minute, and ten-minute poses. For your initial attempts, use a short stick of compressed charcoal (an inch or an inch-and-a-half length usually works well). Keep the flat side of the charcoal against the paper and rapidly build broad areas of dark with a back-and-forth motion. As you sketch, pay as much attention to the shapes of the dark and light areas as you do to contours.*

Many mature artists have adopted as their special province the fully developed life drawing. From Renaissance times on, artists have taken delight in beautiful drawings of the human figure. Michelangelo, Raphael, and a host of other Renaissance artists made such drawings, sometimes as studies for figures in projected paintings, but just as frequently for their own sakes (Figs. 24, 61). In subsequent centuries innumerable drawings of this type were produced, enough to fill many handsome books with infinite variations on "the human figure." A superb charcoal study by Jules Pascin, *Jeune Fille Debout*, in this artist's sensitive, personal manner, communicates with particular subtlety the voluptuous quality of a female body (Fig. 271). In the mid-20th century, the

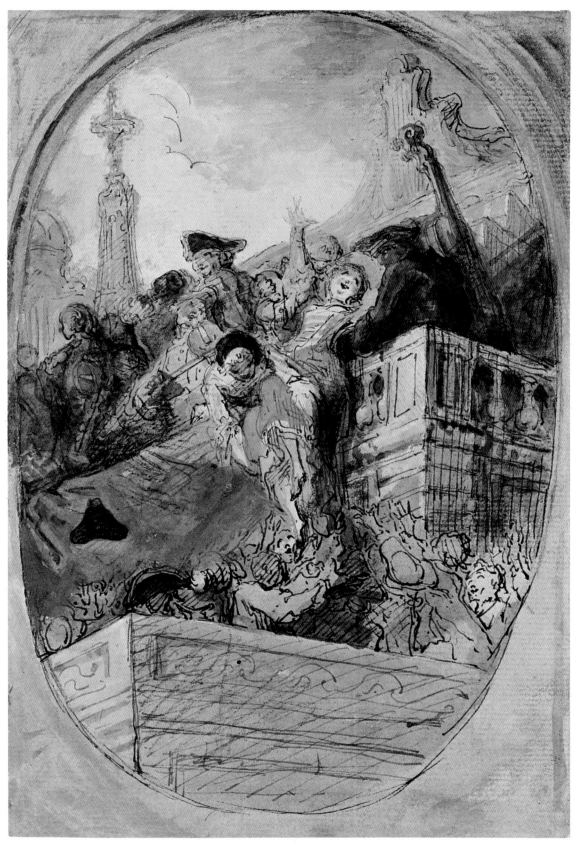

Plate 15. GABRIEL DE SAINT-AUBIN (1724–80; French). *The Abduction.* c. 1760–70.
Pen and ink, with black chalk, gouache, watercolor, and touches of graphite on cream paper, $7\frac{13}{16} \times 5\frac{5}{16}''$.
Achenbach Foundation for Graphic Arts,
The Fine Arts Museums of San Francisco (Georges de Batz Collection).

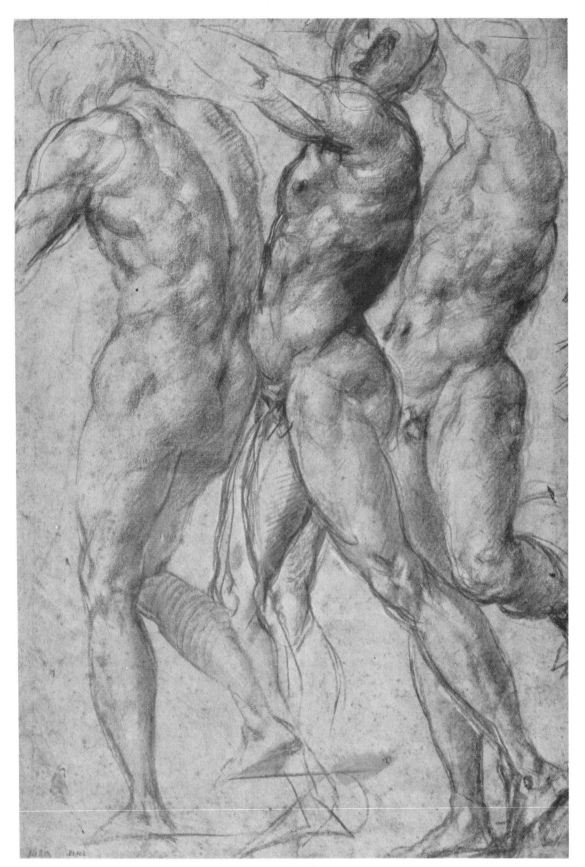

Plate 16. Jacopo Pontormo (1494–1556; Italian).
Three Walking Men, study for the *Story of Joseph* series. c. 1517.
Red chalk, 15¾ × 10½″. Musée des Beaux-Arts, Lille.

American artist Philip Pearlstein continued this tradition with a pitiless realism augmented by a forceful sense of composition (Fig. 272).

Project 94 Undertake this project only after you have been drawing nudes for some months; the novice in life drawing cannot work profitably for more than twenty minutes to half an hour on a single pose. As you become more skilled, you can benefit from increasing the time spent on a drawing, perhaps working in a medium, such as conté crayon, that does not smear readily and thus permits the reworking of a fully developed study. *Observe the drawing in Figure 270. Have your model assume the same pose for at least three two-hour sittings. Illuminate your subject with a strong light to reveal the anatomical forms in high relief. Study the model carefully, and build a sense of form through the use of traditional chiaroscuro (see pp. 79–81). If you have difficulty developing one of the forms in a satisfactory manner, make studies of that detail in the margins of your paper; then resume work on the main drawing.*

Even seemingly academic sketches and studies display remarkable beauty when executed by a sure and skillful hand. Over an earlier study for an Annunciation, Agostino Carracci sketched an instructional page of drawings

272. PHILIP PEARLSTEIN
(1927– ; American).
Seated Female Model, Leg Over Armchair.
1971. Pencil, $18\frac{7}{8} \times 23\frac{7}{8}''$.
Courtesy Allan Frumkin Gallery,
New York.

left: 273. Agostino Carracci (1557–1620; Italian).
Feet, over an earlier sketch for an *Annunciation.* c. 1595.
Pen and brown ink, $10\frac{3}{16} \times 6\frac{3}{8}''$.
Royal Library, Windsor Castle, England (reproduced
by gracious permission of Her Majesty Queen Elizabeth II).

below: 274. Eleanor Dickinson (1931– ; American).
Study of Hands. 1964. Pen and ink, $13\frac{7}{8} \times 10\frac{1}{4}''$.
Stanford University Museum of Art, Calif.

below: 275. Jean Auguste Dominique Ingres (1780–1867; French).
The Dead Body of Acron, study for *Romulus, Victor over Acron.* c. 1808–12.
Lead pencil, $7\frac{3}{4} \times 14\frac{3}{8}''$. Metropolitan Museum of Art, New York (Rogers Fund, 1919).

276. LUCA CAMBIASO (1527–85; Italian).
Martyrdom of St. Lawrence.
Pen and brown ink,
with brown wash, $9\frac{3}{8} \times 12\frac{1}{2}''$.
National Gallery of Canada, Ottawa.

of feet (Fig. 273). The feet are drawn from many angles with an amazing certainty and knowledge. Carracci depicted ankle forms, the ball of the foot, the arch, the toes, and the heel with a clarity that makes contemporary draftsmen envious. Nonetheless, a modern page of foreshortened hands by Eleanor Dickinson (Fig. 274) provides an exciting comparison with the feet by Carracci and proves that skill and certainty still work together in our less disciplined age.

Project 95 *Do extended studies of hands, feet, heads, and other body details to amplify your knowledge of the figure.* Foreshortening is always difficult, and hands and feet are perhaps the most complex and problematic parts of the body to draw. *If no model is available, draw from your own anatomy with the aid of a mirror.*

Project 96 *Observe the foreshortened top figure of Ingres' studies for the dead body of Acron (Fig. 275). Instruct your model to approximate as closely as possible the pose of the legs, but turn the torso more toward you and extend the arms above the head to achieve maximum foreshortening. Draw in pencil or charcoal, first with some modeling, then using pure outline.*

Schematic Form

In figure drawing one of the greatest problems is getting a sense of solid, three-dimensional form. Translating a solid body onto the flat, two-dimensional paper ground demands both familiarity with the subject and knowledge of how to proceed to create the illusion of form. Artists continually seek techniques for rendering a convincing sense of form. Among the many schemes that have evolved over the ages are the various perspective and foreshortening systems (see Chap. 6 and pp. 48–53), chiaroscuro (see pp. 79–81), and also certain diagrammatic methods for indicating structure. Luca Cambiaso, an Italian artist active during the 16th century, simplified the complex anatomical shapes into blocks, spheres, and other geometric forms, as can be seen in his *Tumbling Men* and the *Martyrdom of St. Lawrence* (Figs. 276, 277). Cambiaso

left: 277. Luca Cambiaso
(1527–85; Italian).
Tumbling Men.
Pen and ink, with wash, $13\frac{3}{4} \times 9\frac{5}{8}''$.
Uffizi, Florence.

right: 278. H. Kofi Bailey
(1931– ; American). *Birth.*
Conté, wash, and oil, $40 \times 30''$.
Courtesy Contemporary Crafts,
Los Angeles.

reinforced his simplifications of form with an equally economic version of chiaroscuro. *Birth* by H. Kofi Bailey (Fig. 278) displays a "modern" interpretation of Cambiaso's treatment of form.

Project 97 *Using pencil or charcoal, draw a figure from either a cast or a live model. If neither of these subjects is available, do a self-portrait. Have your subject well lighted from above and to one side, so that the planes of the form are clearly revealed. Using firm outlines, translate the complexities of your subject into geometric forms expressed by flat planes in the manner of Cambiaso. To strengthen and clarify form relationships, shade the underlying planes and those on the side away from the light.*

One of the great life drawing teachers of the 20th century, George B. Bridgman, developed a fine method for blocking out the masses of the body that both conveys a sense of weighty form and, by emphasizing the opposition of masses, projects a vigorous sense of action (Fig. 279).

Project 98 *Drawing from a live model, block the form into geometric entities, and then incorporate the more tapered, complex body parts. Work for convincing solidity and three-dimensionality, planting your figure firmly on the ground plane. In a subsequent drawing, refine the squared edges of the figure and the relationship of body parts.*

Perhaps the most influential diagrammatic method developed in modern times to indicate form was that devised by Paul Cézanne. A detail from *Study after Houdon's Ecorché* reveals the method with particular clarity (Fig. 280). Cézanne felt that to convey the facts of form it was necessary to simplify nature's complexities into somewhat geometric components, but his simplifications are less arbitrary and more subtle than those employed by Cambiaso

279. George Bridgman
(1864–1943; American).
Blocking the figure. Charcoal.
From *Bridgman's Complete Guide to
Drawing from Life* (New York, 1952).

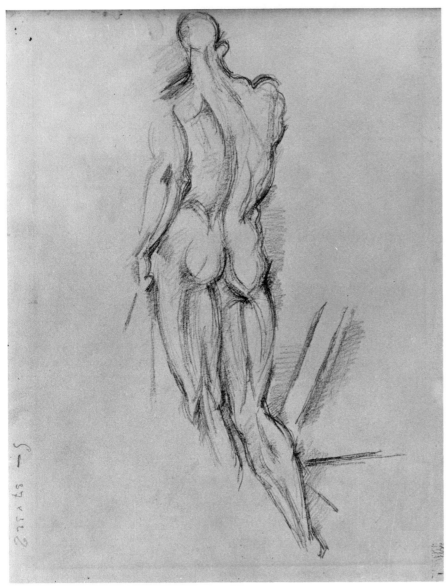

280. Paul Cézanne (1839–1906; French).
Study after Houdon's Ecorché. c. 1888–95.
Lead pencil, $10\frac{3}{4} \times 8\frac{1}{4}''$.
Metropolitan Museum of Art, New York
(Maria DeWitt Jesup Fund, 1951;
from the Museum of Modern Art,
Lillie P. Bliss Collection).

Figure Drawing **201**

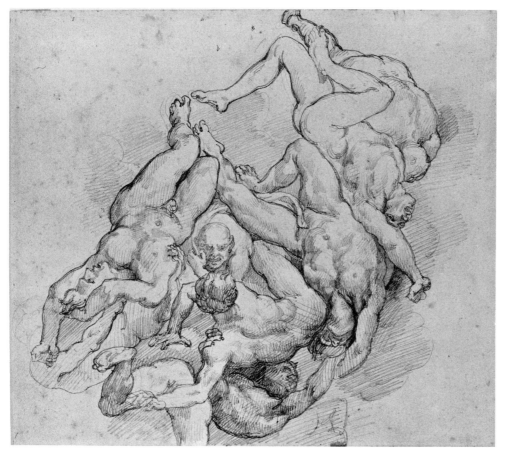

281. Théodore Géricault
(1791–1824; French).
Fall of the Damned. c. 1817–18.
Pencil, $8\frac{1}{16} \times 9\frac{1}{16}''$.
Stanford University
Museum of Art, Calif.
(gift of the Committee
for Art at Stanford).

(Figs. 276, 277). In the *Ecorché,* human anatomy has been translated into spherical, cylindrical, and conical elements in interpenetrating relationships with clusters of lines used to further define the forms.

Project 99 *If one is available, draw an "écorché" (a plaster cast showing the muscles of a human figure); otherwise, again draw from one of the subjects suggested for the previous two projects. Try to define the elements of the form in a manner similar to that employed in Cézanne's study* (Fig. 280). This can best be accomplished by a somewhat spontaneous and intuitive analysis of form. *Work freely, trusting your eyes and hand rather than attempting a too stringent, intellectual (verbal) analysis.*

Perception of Form

It is easy to settle into certain pleasing habits of drawing the human figure and neglect many avenues for perceiving and recording this rich and complex form. Contour drawing sensitizes the eye to the subtle undulations of edges and helps to establish eye-hand coordination (Fig. 92). Gesture drawing, in simple lines or clusters of lines, conveys a suggestion of action (Figs. 3, 96). The use of rotary, enveloping clusters of lines lends a sense of roundness and helps the draftsman perceive bulk and describe the weight mass of the figure Figs. 46, 47).

Project 100 *Exploit the devices detailed above and any others you might think of or invent to help you describe form, movement, contour, gesture, and the sense of a figure's weight and mass.* Exaggeration is likely to be more

descriptive than a restricted and literal portrayal of what you see in the model. Students often get into the habit of drawing figures of a standardized size determined by the dimensions of the paper they most commonly employ. *Try doing details of the figure that cover the full extent of the paper. To further expand your sense of scale, tack a piece of wrapping paper on a wall, stand before a full-length mirror, and do a life-size self-portrait.*

Figure Groups

Drawing groups of related figures is an important part of the artist's education. Students may become skilled at depicting single figures but remain unable to compose a successful group of related ones. Gericault's *Fall of the Damned* (Fig. 281) represents an amazing tour de force in its intricately intertwined falling bodies. Such a drawing might well be beyond the capacities of many skilled contemporary figure draftsmen, largely because the problem is addressed so infrequently. Equally impressive are the interrelated, foreshortened figures of Tiepolo's *Three Studies of Bacchus* (Fig. 282), in which one looks up at a standing Bacchus while the two foreshortened figures of the foreground seem to be sliding down billowing clouds. See also Plate 16 (p. 196).

Project 101 *Study Figure 281, and pose two nudes in semireclining positions so that the bodies intertwine. Record the poses in light charcoal outline. Now have one model assume a standing pose and the other a reclining, foreshortened pose. Add these poses to your sketch so that the upright figure stands behind the first group and the reclining figure rests in front. Check the proportions, erase confusing overlappings, and proceed to develop the solidity of forms. If you can find a child to add to your group, the changed proportions of a young person can add considerable interest.*

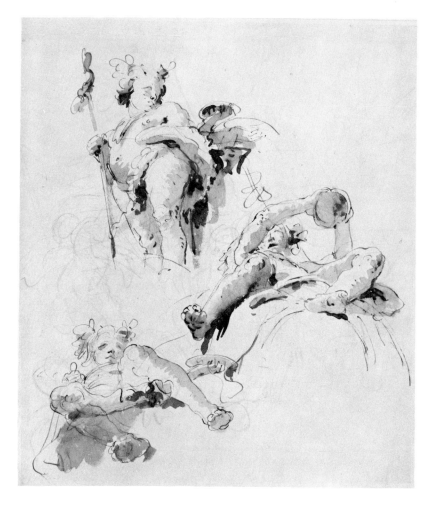

282. GIOVANNI BATTISTA TIEPOLO
(1696–1770; Italian).
Three Studies of Bacchus.
Pen and brown ink, with brown wash
over black chalk, 13 × 10$\frac{13}{16}$″.
Pierpont Morgan Library, New York.

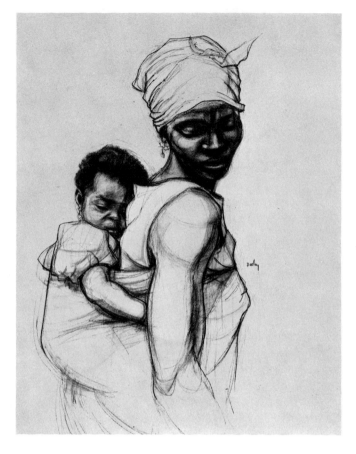

283. H. KOFI BAILEY (1931– ; American). *African Series.* Charcoal, 30 × 26″. Courtesy Contemporary Crafts, Los Angeles.

Drawing the Clothed Figure

Project 102 Mastery in drawing the clothed figure equals in importance the depiction of the nude form but is often neglected in the training of beginning artists. *Draw clothed figures as often as you can, both in the studio and elsewhere.* You will gain an excellent opportunity to draw clothed figures when seated in a car parked on the street in a business district. *Sketch the people walking or standing, singly or in groups, and choose people of all ages. Notice that the proportion of head to body varies with sex as well as with age.* The average man measures approximately seven to seven-and-a-half heads in height. Women typically stand about seven heads high. Children's heads are larger in proportion to their bodies; in a young baby, the head may constitute a third of the entire body length (Fig. 283). With age, the body shrinks while head size stays constant, leaving the old person's head large in comparison to the remainder of the body. Too, the old person characteristically does not stand erect but is likely to be bent or may even stand in a lopsided manner.

Solid background in anatomy gave a particular authenticity to the Renaissance treatment of costumed as well as nude figures. We have already referred to Raphael's skeletal underpinning for his *Virgin Supported by the Holy Women* (Fig. 258). Pieter Brueghel drew a page of *Beggars and Cripples* (Fig. 284) so that one is continuously aware of bony shoulders, knees, and elbows, as well as of paunchy bellies and fat buttocks. Clothes and bodies cohere with convincing unity. A 17th-century Dutch artist, Gerrit Andriaensz Berckheyde, clothed his *Standing Woman* so voluminously that one would think all sense of the underlying body would be obscured (Fig. 285). Miraculously, her full hips, broad shoulders, and sharp elbows can be felt through the clothes, and the woman stands firmly on her feet.

The less formalized techniques of later centuries yield equally impressive if expressively different results. Despite their loose, shapeless clothes, Jean François Millet's peasants display a remarkably solid body form (Fig. 286). Millet is said to have asked his peasant models to wear the same garments unlaundered for long periods of time, so that the clothes would have the sculptural richness of anatomical forms. A powerful seated figure by Alberto Giacometti (Fig. 287) emerges in bundles of loose lines that, by providing a transition from underlying body structure to external clothing, achieve a satisfying continuity. The flow of lines extends into the surroundings, composing body, clothes, and background into a coherent unit.

below: 284. Attributed to
PIETER BRUEGHEL THE ELDER (c. 1525–68; Dutch).
Beggars and Cripples. Pen and brown ink, $10\frac{7}{16} \times 7\frac{7}{8}''$.
Bibliothèque Royale, Brussels.

right: 285. GERRIT ADRIAENSZ BERCKHEYDE (1638–98; Dutch).
Standing Woman. Black chalk, $7\frac{3}{4} \times 4''$.
Rijksmuseum, Amsterdam.

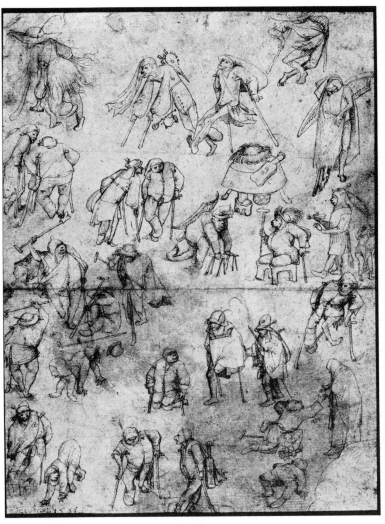

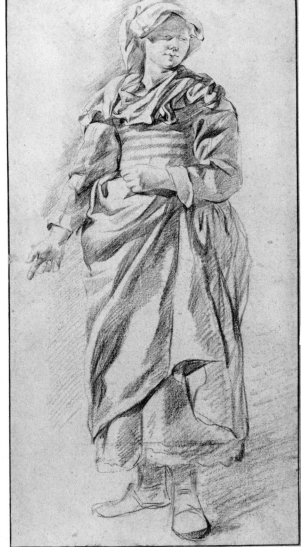

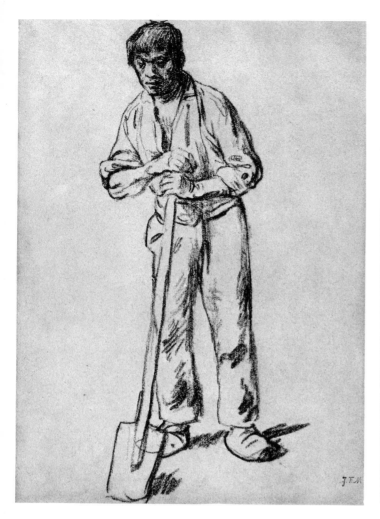

left: 286. Jean François Millet
(1814–75; French).
Peasant with Shovel. c. 1859.
Pencil, $9\frac{1}{16} \times 8\frac{11}{16}''$.
Louvre, Paris.

right: 287. Alberto Giacometti
(1901–66; Swiss).
Seated Man. 1953.
Pencil, $19\frac{13}{16} \times 12\frac{13}{16}''$.
Wallraf-Richartz Museum, Köln.

The Figure in Action

The Drunk (Fig. 288), an anecdotal drawing by George Bellows, provides a transition from our discussion of the clothed figure to the subject of figures in motion. The handling of the woman on the left reveals her tensed, rounded body forms. The flimsy nightgown drapes and reveals the woman's body in the manner of ancient Greek statuary. Two children cowering in the background emphasize by their reaction the violent forward thrust of the drunk's body. Needless to say, the dynamics of the drawing, partially created by the substantial body forms, are amplified by the bold diagonal design and stark value contrasts. Bellows has also left a number of life drawings that exhibit his comprehensive knowledge of the body in action and in repose.

Life drawing presupposes a model holding a pose without moving, if only for a short time. To suggest action is, however, a desire that at some time usually emerges in the artist's consciousness. Many an artist, skillful at depicting static figures, cannot communicate a sense of movement. The solution, of course, is to draw figures in action as often as possible and develop a personal technique for so doing. No two artists share the same method, but observing a few master drawings may suggest how to approach the problems involved in representing figures in action.

Eugène Delacroix loved turbulent motion; he remains one of the great masters at suggesting it. Particularly vital is the artist's *Mounted Arab Attacking a Panther* (Fig. 289). The marvelous sense of action—projected through the flowing contour lines of head, arms, and leg, the frenzied horse's head,

the scribble of attacking panther, and the overall economy of detail—indeed represents the accomplishment of a master.

Henri Matisse's fine drawing of a full-length figure *Le Guignon* (Fig. 290) entails a very different approach to the suggestion of action. Sweeping lines implying at once motion and transparent draperies carry the eye through generalized body forms in an unbroken flow of visual movement; the easy, unlabored curves of the body progress smoothly from the dancer's ankles to her upraised arms.

Project 103 *Draw figures walking, running, or bending. In doing quick sketches, lay in a few lines of action to indicate movement of arms, legs, torso, and head, and then rapidly suggest the contours of the forms. Once you have developed a successful method for depicting relatively simple, repetitive motions, undertake more dynamic movements. Do not worry at first about accuracy of shape or proportion, but sacrifice all to achieve a sense of action.*

below: 288. GEORGE BELLOWS (1882–1925; American).
The Drunk. Charcoal, 16 × 13″.
Addison Gallery of American Art,
Phillips Academy, Andover, Mass.

right: 289. EUGÈNE DELACROIX (1798–1863; French).
Mounted Arab Attacking a Panther. c. 1840.
Graphite pencil, $9\frac{1}{2}$ × 8″.
Fogg Art Museum, Harvard University, Cambridge,
Mass. (Meta and Paul J. Sachs Collection).

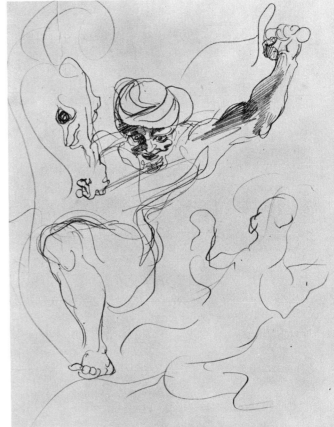

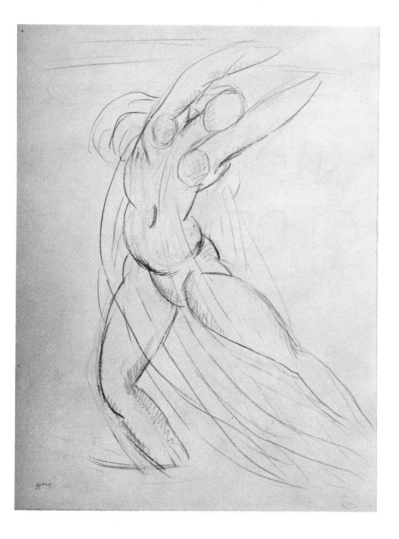

290. Henri Matisse (1869–1954; French).
Dancer, illustration for Mallarmé's *Le Guignon*.
c. 1930–31. Pencil, 13 × 10⅛″.
Baltimore Museum of Art (Cone Collection).

Abstraction and the Human Form

Our discussion of figure drawing so far has stressed an essentially realistic approach. However, the use of distortion and abstraction lend zest and variety to modern interpretations of the figure. The forms of Paul Klee's *Naked Woman* create a curiously mannikinlike impression (Fig. 291). The oblique eye, sharply profiled head, triangular breast, dislocated arms and legs fascinate us and suggest some enigmatic being. Three cloudlike horizontal forms at the upper right balance the upraised right leg. Overall, the exquisitely hatched ink lines give this evocative figure a precise delicacy.

The Abstract Expressionist Willem de Kooning departs even further from a traditional depiction of form (Pl. 14, p. 162). His drawing entitled *Woman*, executed in pastel and pencil on white paper (Fig. 292) distorts the female figure both in shape and in the proportions of parts. Great eyes, voluminous breasts, and heavy thighs contrast sharply with jagged fingers and edges elsewhere in the composition. The figure is drawn with an angry violence that, along with the distortions, projects a mood of pessimism and disillusionment with modern life.

Project 104 *Stand with your weight on one leg, shoulder drooped, head down, emotionally depressed, physically relaxed. Feel the pose in every part of your body. Attempt to draw your pose; if you lose the feel of any part, resume the pose for a short time. Do not work slowly or strive for technical finesse, but express the feeling of the pose and your emotional tone.*

Marcel Duchamp's pencil-and-watercolor *Virgin No. 2* (Fig. 293) has the intellectualized geometry of Cubism but manages to suggest movement in the head area and through dislocated and abstracted body parts. One can identify the profile of a breast at right. Other lines and forms imply bone and socket-pivoting forms; elsewhere the patterns in themselves intrigue the eye, providing pleasure as pure abstract shapes in a fine composition.

right: 291. PAUL KLEE
(1879–1964; Swiss-German).
Naked Woman. 1926.
Pen and ink, $10\frac{1}{8} \times 11\frac{3}{4}''$.
Solomon R. Guggenheim Museum,
New York.

below: 292. WILLEM DE KOONING
(1904– ; Dutch-American).
Woman. 1952.
Pastel and pencil, $21 \times 14''$.
Collection Mr. and Mrs.
Stephen D. Paine, Boston.

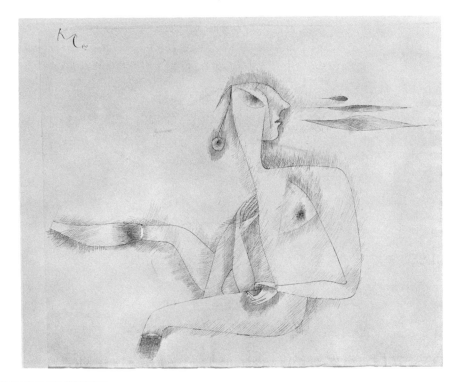

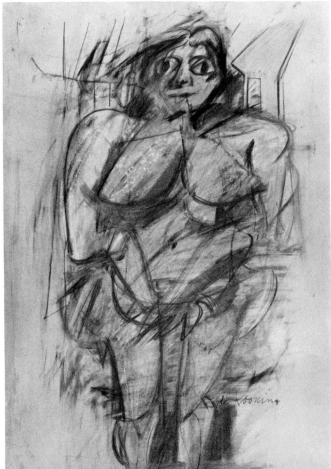

Also in the Cubist manner, Alexander Archipenko creates a dynamic *Figure in Movement* (Fig. 294) using cut and pasted paper, crayon, and pencil. Anatomical forms are boldly simplified into large geometric entities that have been given a semblance of three-dimensional weight and solidity by light shading. Opposing rhythms convey a formalized sense of action in direct contrast to the unpremeditated, impulsive effect seen in the Delacroix sketch reproduced as Figure 289.

Project 105 *Analyze the stylizations of form underlying the works by Duchamp and Archipenko (Figs. 293, 294). Avoid copying the style of these drawings; rather, see what elements and relationships in the form and pose of your model lend themselves to a Cubist interpretation. A series of drawings on tracing paper recording a succession of simplified forms can help evolve meaningful abstractions.*

The human figure continues to supply vital subject matter for artists. Certainly any student wishing to make a career of graphic art or illustration will be working with the figure, and even architects include human beings in their renderings, both for a sense of scale and as a reminder of the warm pulse of life. Serious painters and sculptors find in the form strength, beauty, and above all human values. Artists of all persuasions, realists and abstractionists alike, come to this form for inspiration, for it is truly the fountainhead of life and aesthetic expression.

left: 293. MARCEL DUCHAMP (1887–1967; French-American). *Virgin No. 2.* 1912. Watercolor and pencil, $15\frac{3}{4} \times 10\frac{1}{8}''$. Philadelphia Museum of Art (Louise and Walter Arensberg Collection).

right: 294. ALEXANDER ARCHIPENKO (1887–1964; Russian). *Figure in Movement.* 1913. Cut and pasted papers, crayon, and pencil, $18\frac{3}{4} \times 12\frac{3}{8}''$. Museum of Modern Art, New York (gift of the Perls Collection).

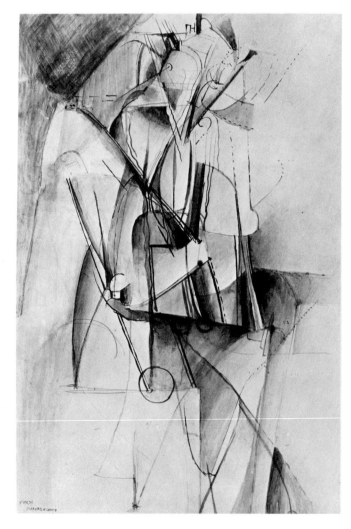

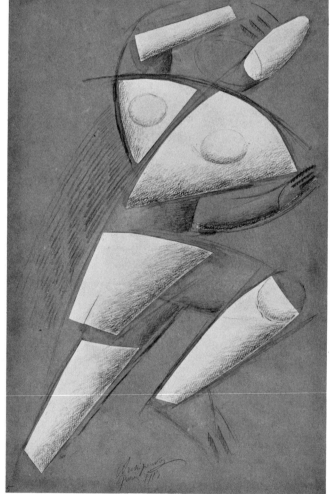

12 The Portrait

Much artistic expression has grown from our desire to arrest the hurried passage of experience and immobilize its images for later study and appreciation. The face, more than any other part of the body, has long been an object of scrutiny for artists, because through its myriad expressions pass all the fleeting thoughts and emotions of human experience. From earliest times the making of portraits has been a means whereby human beings have tried to evade the common destiny of all living creatures and to achieve some degree of immortality. The ancient Egyptians, the Chinese (Figs. 295, 296), Indians (Fig. 297), and Europeans (Figs. 298, 312) from medieval and Renaissance times on, all recorded in portraiture, whether sculpted, painted, or drawn, the appearance of the few who had attained sufficient eminence to command a greater measure of immortality than was the lot of commoners.

A look at the illustrations of this section and elsewhere in the book reveals the tremendous variety of approach to portraiture by individual artists. A page of drawings from a 13th-century French album by Villard de Honnecourt (Fig. 299) represents an attempt to work out a system for proportioning the facial features in relation to the mass of the head—a medieval recipe to reduce the complexities of the head and face to a geometric essence. Some portraits strive for exact replication of every bump and hollow in the face (Fig. 12). In others, there is a telling selectivity or stylization which at times becomes caricature, at others idealization (Fig. 300). Arguments frequently question whether the

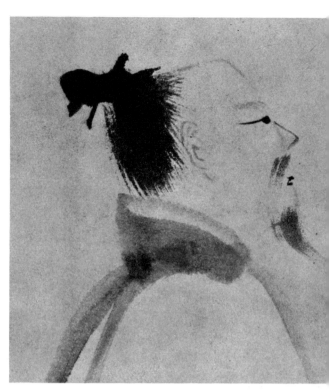

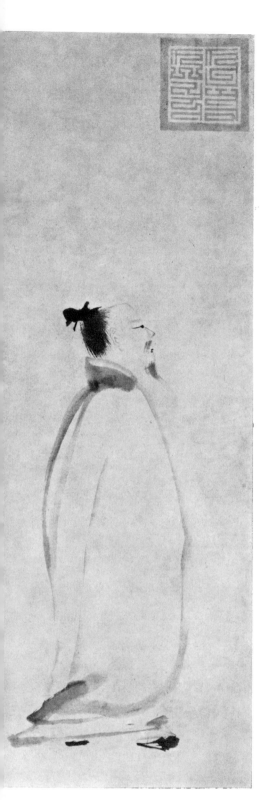

left: 295. Liang K'ai
(c. 1160–1246; Chinese).
*Ideal Portrait of
the Poet Li T'ai-Po.*
Ink on paper, 32 × 12".
Tokyo National Museum.

296. Detail of Figure 295.

portrait involves psychological perceptions made and incorporated in the work by the artist, or whether the telling irregularities of feature that constitute the "psychological" element—particularly those irregularities that convey tension, strain, and lack of inner quietude—are "read into" the drawing by the viewer almost irrespective of the draftsman's intent. For this reason and because of the inordinate complexity and expressive potential of the subject matter, no field of drawing is more demanding, and perhaps rewarding, than the portrait.

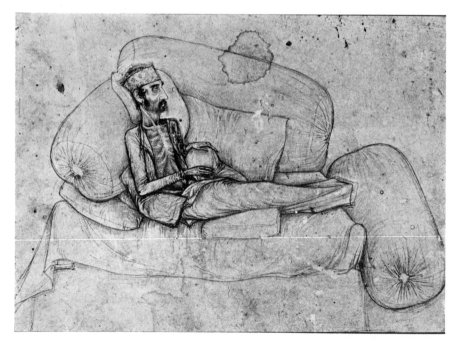

297. Anonymous (17th century; Indian).
Death of Inayat Khan,
preliminary drawing for a miniature.
1618. $3\frac{3}{4} \times 5\frac{5}{16}$".
Museum of Fine Arts, Boston
(Francis Bartlett Donation of 1912
and Picture Fund).

212 *Traditional Areas of Subject Matter*

below: 298. JAN VAN EYCK (1390–1441; Flemish).
Portrait of Cardinal Albergati. c. 1431.
Silverpoint on grayish-white prepared paper, $8\frac{3}{16} \times 7''$.
Kupferstichkabinett, Staatliche Kunstsammlungen, Dresden.

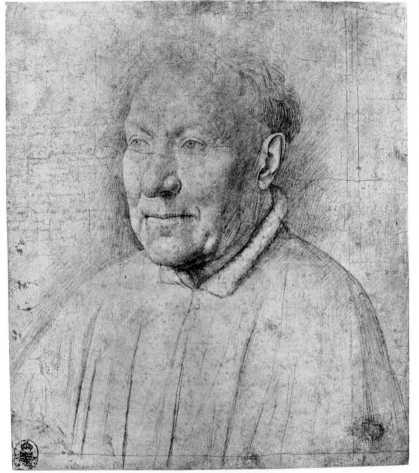

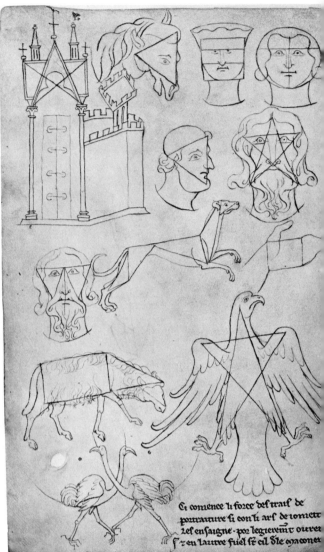

above: 299. VILLARD DE HONNECOURT
13th century; French).
Geometrics, page from a sketchbook. c. 1240.
Pen and ink, $9\frac{7}{8} \times 6''$.
Bibliothèque Nationale, Paris.

left: 300. JACOPO BELLINI (c. 1400–70; Italian).
Profile of a Man.
Silverpoint on bluish prepared vellum.
Louvre, Paris.

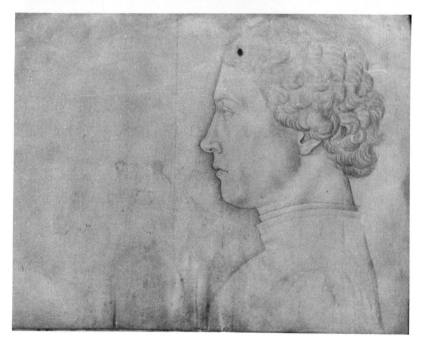

left: 301. How to draw a head. General proportions (*a*) are as follows: The eyes are halfway between the crown of head and the chin; the base of the nose is halfway between the eyes and the chin; the mouth is at one-third the distance between the nose and chin. In drawing three-quarter views, keep eyebrows, base of nose, and mouth perpendicular to a line through the center of the face (*b*) in order to avoid distortion (*c*).

above: 302. When the head tilts, the base of the ear acts as a stationary fulcrum.

below: 303. WILLIAM RIMMER (1825–79; American) *The Forms of the Head and Neck.* c. 1870–76. Pencil. From *Art Anatomy* (Boston, 1877).

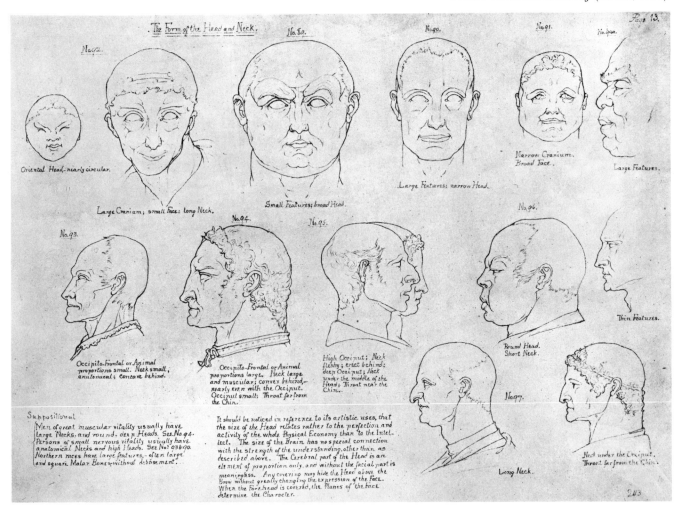

The impersonal, idealized portrait in which distinctive aspects of appearance are sacrificed to a bland, generalized version of the sitter has long been the accepted standard for "official" portraiture. Bankers, college presidents, chairmen of boards, and famous personalities offer both subject matter and livelihood for the financially successful portrait artist. The drawings reproduced here belong to another sphere of human activity, having been chosen for their aesthetic interest rather than commercial acceptability. Each work by a great portrait artist manifests a characteristic emphasis. It is this personal touch that constitutes the artist's genius and distinguishes such work from thousands of adequate but merely routine likenesses that predominate in conventional portraiture.

Form and Proportion

Portraiture demands both a rigorous analysis of form and empathy for the sitter. Acquiring the analytical powers comes with practice and experience. Empathy appears to be a deep-seated psychological trait, a part of the emotional make-up of the artist, and whether it can be deliberately developed is open to question.

Before commencing your own portraits, you might profit by studying general head and feature relationships diagramed in Figures 301 and 302, as well as the varied head and facial studies of William Rimmer (Fig. 303), all of which will assist you in seeing, assessing, and drawing a head. An extremely complex form, the head is the focus of attention as we move about and meet people. Despite the fact that we are constantly observing faces, most of us have surprisingly little knowledge of the general proportions and the relationships between parts of the face. Almost anyone can sense when a head is incorrectly drawn, but it is for the most part only the portrait artist who knows why. As illustrated in Figure 304, the most common faults in unskilled drawings of the head are:

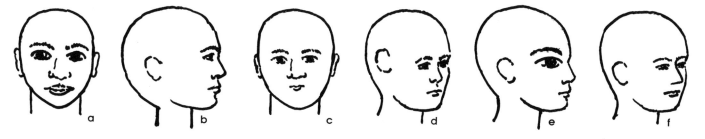

304. Common errors in drawing the head.

1. The features too large in relation to the entire area of the face (*a*). Eyes and features occupying most of the head, rather than the bottom half.
2. An almost round head placed on top of a vertical, tubelike neck, like a pumpkin on a post (*b*).
3. The mouth drawn too small (*c*).
4. The ears drawn too far back and too low, or too high (*d*).
5. The eyes not foreshortened in profile and three-quarter views (*e*), thus resulting in frontal, Egyptian-style eyes (Fig. 131).
6. The nose not foreshortened in a three-quarter view (*f*) or not projecting enough in a profile view.
7. The eyes, nose, and mouth not at right angles to each other and not properly aligned with the facial plane—common faults when the head is drawn in a tilted position or in three-quarter view (Fig. 301, *c*).

Project 106 A plaster head, strongly lighted from above and to one side, provides an excellent vehicle for studying general proportions of the head and relationships between its parts. *Begin by assessing the form optically. Determine with your pencil or stick of charcoal the proportion of head width to height. Sketch these dimensions lightly on your paper. Then measure vertical distances between the major divisions—top of head to hair line, hair line to eyes, eyes to bottom of nose, bottom of nose to lip line, lip line to chin. Do the same for the relationships of width—the dimensions of eyes, mouth, nostrils, the space between eyes, and the distance from nose to ear. Add indications of each of these proportions to the overall dimensions marked on your paper. As you refine and develop the drawing, emphasize bony structure, cheekbones, turn of the forehead from frontal plane to side plane, bony protuberances in the nose, and so forth.* The forms in a plaster cast are likely to be generalized and weak compared to those in a human being, but the plaster head has the virtue of remaining absolutely motionless, thus permitting leisurely and accurate observation.

Once correct relationships of form and feature are firmly settled in the beginning artist's perception, features themselves may still tend to be idealized and generalized. Remember that for few individuals are the two sides of the face identical: eyes differ in size and shape; the mouth is not the same on both sides, and so on (as in Raphael Soyer's self-portrait, Fig. 305). Faces vary greatly according to whether they are meaty or bony, loose- or tight-skinned, or have heavy or light eyebrows and lashes. Also, an individual's characteristic head posture, the angle the head most commonly assumes, has much to do with a "likeness."

Project 107 *As an exercise in developing sensitivity to the peculiarities of likeness, draw an interesting sitter—preferably someone with a distinctly unusual face. Stress all departures from regularity: differences between eye shapes, the length and structure of the nose, mouth, lips, and chin. Notice wrinkles, muscularity or flabbiness of the flesh, tilt of the head, hair style. Be mean and merciless; a kind draftsman creates a flaccid likeness.*

Project 108 Developing the power to conceptualize and project your concepts in drawing is an important step in attaining a degree of independence from direct, constant observation of a subject. *Study the illustrations of this chapter and then examine your own face in a mirror, carefully observing as many different angles as possible. Now draw your profile. Next, tilt your head back while again looking in a mirror. Study the relationship of eyes, nose, mouth, chin, hairline, ears. Leave the mirror and draw your tilted head. Use as little chiaroscuro as possible, making overlapping contour lines describe the form. Resume the pose and check your drawing for accuracy.* The foreshortened features may prove difficult to assess and reproduce, but persevere until you achieve a reasonable facsimile.

The Self-Portrait

Classification of the various types of portraits is difficult, for almost none of the possible categories is very sharply defined one from another or mutually exclusive. Perhaps the most obviously distinct type is the *self-portrait*, but as a glance at the following group of self-portraits will evidence, this form too spans a considerable range of disparate styles and approaches.

Raphael Soyer's drawing (Fig. 305) reveals a most subtle study of himself accompanied by his father. The self-portrait's thoughtful expression, the slight irregularity of eye shape and size, the sensitive mouth and furrowed

brow, all bespeak the introspective artist. The head of his father peering over Soyer's shoulder mimics that of the artist in structure, but is much less well-defined in form and may well have been done from memory.

In a simplified expressive style of unusual power, Käthe Kollwitz portrays herself in a brooding, hunched-over position (Fig. 306). Her deep-set eyes, tremulous mouth, and the heavily boned skull seem almost to suggest a

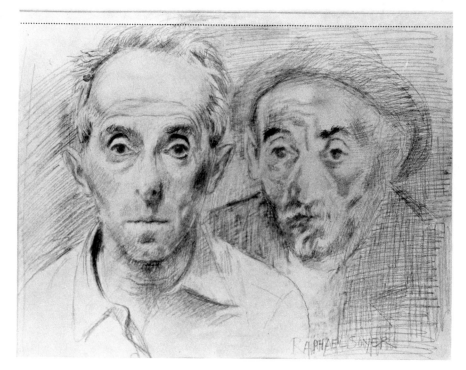

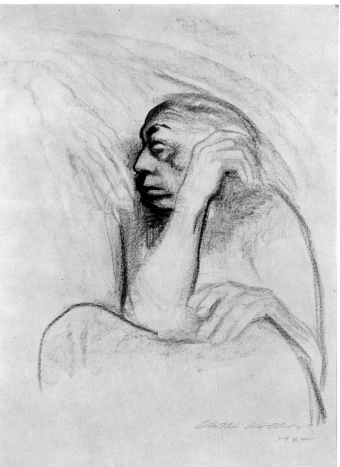

above: 305. RAPHAEL SOYER (1899– ; American).
Self-Portrait with the Artist's Father.
Pencil, $9\frac{3}{4} \times 12\frac{1}{8}''$.
Collection Mr. and Mrs. Benjamin Sonnenberg,
New York.

right: 306. KÄTHE KOLLWITZ (1867–1945; German).
Self-Portrait. 1924.
Charcoal, $23\frac{13}{16} \times 18\frac{13}{16}''$.
Allen Memorial Art Museum, Oberlin College,
Ohio (R. T. Miller, Jr., Fund).

left: 307. Carlo Dolci (1616–86; Italian). *Self-Portrait.* 1674. Chalk, $7\frac{1}{8} \times 5\frac{1}{2}''$. Uffizi, Florence.

below: 308. Hans Holbein the Younger (1497–1543; German). *Portrait of Cecelia Heron.* Colored chalk, $15 \times 11\frac{1}{8}''$. Royal Library, Windsor Castle, England (reproduced by gracious permission of Her Majesty Queen Elizabeth II).

death's-head. Graceless, heavy hands reinforce the general atmosphere of pessimism. A disquieting and powerful work of art, Kollwitz' self-portrait lies at the opposite end of the spectrum from the objective recording of appearances that constitutes one standard of portraiture.

The self-portrait may serve either as an opportunity for serious introspective exploration or merely as a chance to work one's technical prowess upon an obliging model. Marsden Hartley, for example, scrutinized himself with a hypnotic stare, his portrait seeming to suggest that he views himself as an intense, dynamic personality (Fig. 188). In a pencil and gouache color study by Egon Schiele (Pl. 17, p. 229), the artist's almost furtive glance toward the viewer, coupled with the hands clasped protectively in the lap, suggest an uneasiness in the face of self-analysis. Gustave Courbet has drawn himself smoking (Fig. 185). While the delineation is thoughtful, Courbet seems more interested in creating a richly formed dark-and-light study than an introspective analysis of himself.

We end this brief survey of self-portraits with a charming and light-hearted study by Carlo Dolci (Fig. 307). Dolci, a 17th-century Italian artist, drew him-

self in the act of drawing. His open-mouthed concentration on his work as he peers through glasses perched on the end of his nose portrays a modest man who can view himself with humor.

For our purposes, and for any beginning student interested in doing portraiture, the self-portrait has a number of advantages. First, the sitter is always available. Second, there is no need to worry about disturbing the sitter's "self-image," a frequent problem when drawing another person ("Is my nose really that long?"; "I don't squint, do I?"). One can draw oneself as frequently as desired, change media and pose at will, and dispense with the complexities of scheduling sitters. You can and should concentrate first on learning to draw a solid head rather than on striving for an exact likeness. If your aim is to achieve an exact likeness, that can come later, as can any of the other more sophisticated aims of the serious portrait artist.

Project 109 *Whenever possible, study your face to gain familiarity with its structure and expressions. Decide how you can best describe your personality through the way you look. Do a series of self-portraits using various media, lighting effects, and poses.*

The Objective Approach

One fairly standard and broadly accepted ideal of portraiture is pure objectivity. We often equate pure objectivity with "photographic likeness," but the photograph, we know, can be highly selective and in actuality far from a strictly factual statement. For that matter, "pure" objectivity as such exists only as a theoretical state of mind, human perception being a combination of limited experience and acculturation. In terms of artistic endeavor then, we mean a reasonable facsimile of a completely objective approach—one that Andrew Wyeth's portrait of Beckie King exemplifies more succinctly than could any verbal explanation (Fig. 12).

Project 110 *Study Figure 12 and carefully analyze the rendering of minute details. Keeping the techniques observed in mind, view your own model. (For this exercise, you may find the "weathered" face of an older model easier to draw than the smooth features of a young person.) Make your initial sketch in medium-hard pencil, checking frequently for verisimilitude. Work slowly and carefully, developing a form in three dimensions only when you are certain of your outline. Gradually strengthen the forms and add textures. If you do not comprehend the subtleties of some feature, walk up to the model and examine the form closely until your intellectual comprehension of it clarifies what you see. Use softer pencils for the modeling and a very soft, very sharp pencil for the dark accents in eyes, nostrils, hair, and so forth.*

Among the most effective portrait drawings ever produced are the studies Hans Holbein made for oil portraits (Pl. 1, p. 25; Fig. 308). These drawings in pencil, chalk, or charcoal with an occasional bit of color, were made as notations to enable Holbein to paint his portraits with few sittings. Most of his subjects were of the nobility or by some other token individuals of importance, and the less time they had to spend sitting for their portraits the more pleased they were. And yet, in conformity with the character of the culture and the standards of the day, a most exact likeness was demanded. Holbein's portraits have never been surpassed as objective statements of appearance which at the same time seem to provide an insight into the characters and personalities of the sitters.

Centuries later Edgar Degas created sharp and admirable portrait drawings of a very different nature. Here, too, his genius enabled him at one and the

309. EDGAR DEGAS (1834–1917; French).
Study for a Portrait of Diego Martelli. c. 1879.
Black chalk heightened with white chalk on gray-brown paper, $18 \times 11\frac{1}{2}''$.
Fogg Art Museum, Harvard University, Cambridge, Mass.
(gift of Meta and Paul J. Sachs).

same time to seem to record every detail of feature and form and yet introduce a selective emphasis that appeared to reveal the essence of the sitter's personality (Fig. 309).

The technological triumphs of each age provide special problems and special opportunities. One might think that television and photography would eliminate the need for the objective portrait sketch, but this is not entirely the case. Artists skilled at portraiture can provide more incisive likenesses

310. Howard Brodie
(1915– ; American).
Dogface. 1951.
Color pencils, 11 × 14″.
Courtesy the artist.

than the camera; consequently television news broadcasts often use the services of an artist in the courtroom, not only because cameras are not admitted, but also because more lively characterizations sharpen and add variety to the reporting. Howard Brodie is probably far the best known of these portrait journalists. In a few seconds he records the faces of the politicians, judges, criminals, and lawyers in a court of law using a spirited, animated line that records the surface forms and projects a sense of character as well as a feeling of the tension and drama of the courtroom. *Dogface*, drawn during the Korean War, is a more finished drawing and one of Brodie's favorites (Fig. 310). Vigorous and free, it reveals the enviable technical assurance that accompanies talents that have been developed and exercised in the course of doing hundreds, perhaps even thousands, of drawings.

Project 111 *As often as you have the chance, sketch people who are not posing.* A restaurant, classroom or other public gathering place provides many subjects. You can also sketch heads you see on television. News commentators, for example, hold fairly still yet do not actually pose.

The Idealized Portrait

Idealization in portraiture can take many forms but in general means a structuring of features to conform to a concept of perfection and the minimizing of all irregularities. In Pierre Puvis de Chavannes' *Study of a Woman's Head* (Fig. 311), features are simplified and modeled after the head of a classical Greek statue. The two sides of the face are identical, and no furrows, wrinkles, or other attributes of skin texture disturb the stony smoothness. The

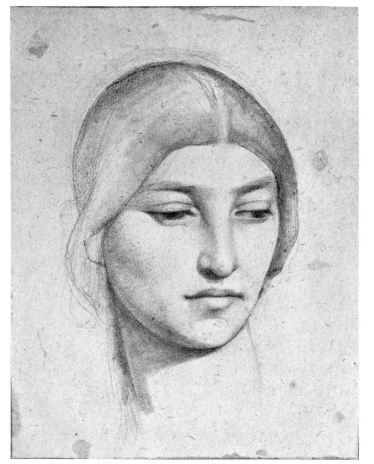

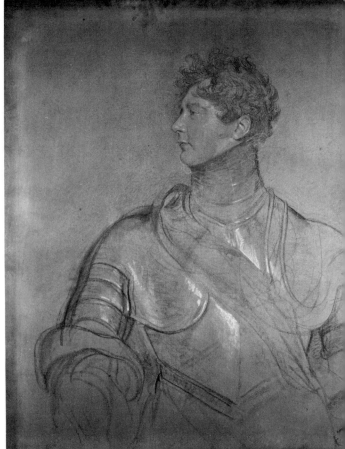

drawing suggests the white colorlessness of marble rather than the ruddy irregularities of healthy skin tone.

The major problem of drawing an idealized portrait involves getting a resemblance that satisfies the sitter with the "likeness," and at the same time ironing out the less ideal aspects of the face. A portrait of the Prince Regent by Sir Thomas Lawrence is idealized in accordance with an aristocratic conception (Fig. 312). The features are handsome and smooth, the skin polished, and the hair picturesquely windblown. The head, held erect on a very long neck, is small in comparison to shoulder width—a proportion which suggests power. The small head on a large body was established in classical sculpture as an attribute of the gods. The large head on a small, solid body has come to characterize the earthy peasant or workman.

One of the marks of genius in idealized portraiture is the ability to fuse and reconcile opposites into a coherent and expressive whole. Ingres had this amazing capacity, as evidenced in his magnificent full-length portrait of Lucien Bonaparte (Fig. 313). The head is characterful and the features incisive; we have the illusion of seeing an objective likeness, exact and precise. Yet careful examination reveals clear idealizations—perfect symmetry of feature, smooth sculptured form, and flawless skin. The elegant clothing, the beautiful rendering of the antique Roman chair on which the figure sits, and the marvelous spaciousness of landscape setting that sweeps to a distant view of Rome, rendered in the most precocious pencil technique—all these elements contribute to an air of aristocratic distinction.

Liang K'ai's exquisite *Ideal Portrait of the Poet Li T'ai-Po* (Figs. 295, 296), although in many ways highly formalized, nonetheless reveals a unique per-

sonality. Such works prove the falsity of the often voiced opinion that, because of the burden of convention and the effete refinement of court tastes, Chinese art lost contact with reality.

Project 112 *Do an idealized self-portrait, or, if you feel particularly adventurous, try drawing three self-portraits: an exact likeness, an idealized head, and a caricature (see pp. 231–234). Better yet, if you have a very sympathetic friend willing to endure the required sittings, draw your friend, for it is easier to view another person analytically. Be certain to use a flexible and easily erasable medium such as soft pencil, charcoal, or chalk. A good size for the beginner to strive for is a head about 9 inches high; a head too large looks clumsy, and drawing too small tends to cramp freedom of hand movement.*

The Symbolic Head

More than any other part of the body, the head frequently symbolizes moral and ethical concepts, and certain facial expressions readily lend themselves to symbolic representation (Do we not commonly speak of an angelic face? a diabolical grin?). Symbolic heads derive from the initial selection of an appropriate type and an emphasis on and exaggeration of certain features

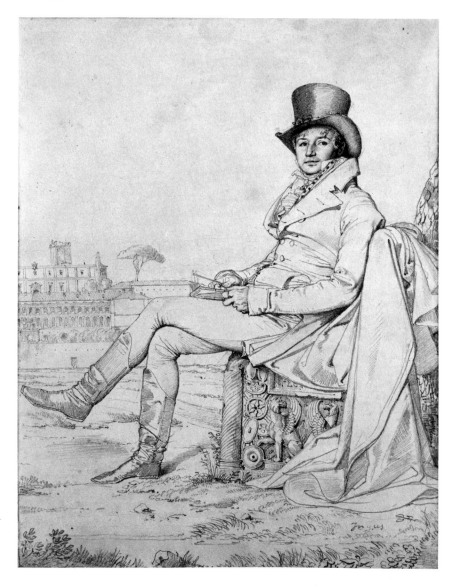

313. Jean Auguste Dominique Ingres (1780–1867; French).
Portrait of Lucien Bonaparte. 1807.
Pencil on white woven paper, $9\frac{3}{8} \times 7\frac{1}{8}''$.
Collection John Goelet, New York.

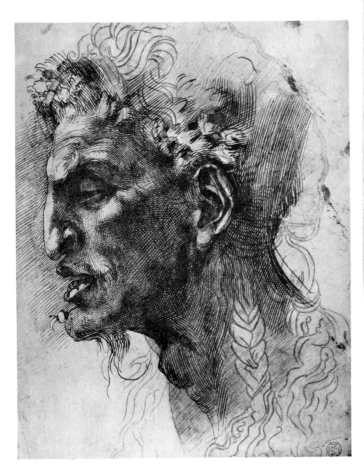

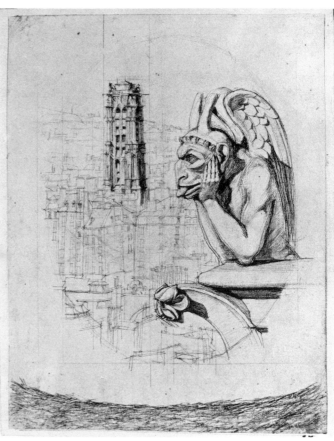

left: 314. MICHELANGELO BUONARROTI (1475–1564; Italian). *Head of a Satyr.* c. 1510–20. Pen and ink over chalk, $10\frac{5}{8} \times 7\frac{7}{8}''$. Louvre, Paris.

above: 315. CHARLES MERYON (1821–68; French). *The Chimera and the Tower of Saint Jacques,* study for *Le Stryge.* c. 1853. Pencil on paper, $7\frac{7}{8} \times 5\frac{7}{8}''$. Sterling and Francine Clark Art Institute, Williamstown, Mass.

and characteristics of that face. Such drawings can thus easily veer toward caricature, an aspect of portraiture that receives special consideration below. A brief survey of masterworks will help to clarify the expressive possibilities of the symbolic approach.

A satyr's head by Michelangelo (Fig. 314) provides a wonderful symbol of the playful half-man, half-goat of mythology—sensual, cunning, and surging with vitality. The brilliant cross-hatching in clear, strong pen lines contributes much to the strength and conviction of the conception.

In the same vein, Charles Meryon made a sketch of one of the gargoyles that guard the towers of Notre Dame in Paris (Fig. 315). Presenting a humorous and playful conception of the devil, the malicious creature sticks out his tongue as, chin on hands, he surveys the sinful mass of humanity that will one day be in his keep. The vivid and imaginative form delights us as we identify with him.

In a *Head of an Apostle* (Fig. 316) Albrecht Dürer created a symbol of sanctity. Virtue normally seems less dramatic than evil, hence Dürer's apostle at first glance strikes us less forcefully than Michelangelo's *Satyr* (Fig. 314). In Dürer's head the eyes are cast heavenward; the handsome features are

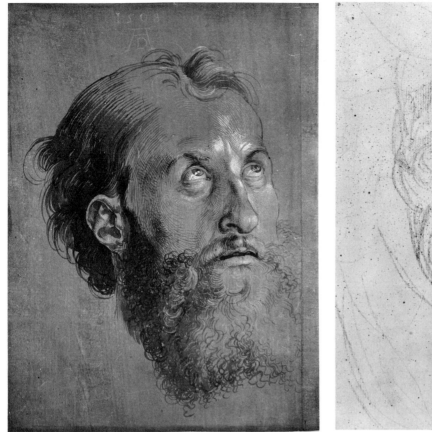

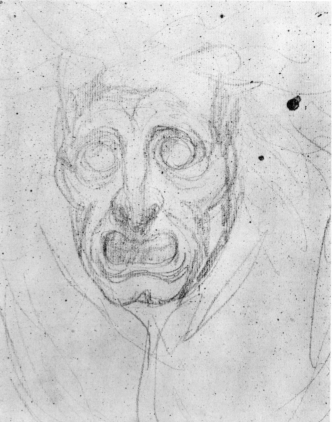

noble, the expression reverent and thoughtful. Here again masterful technique contributes to the conviction of the image. Dürer has used a middle-value toned paper, and then applied dark lines and white highlights to emphasize the full, rounded forms and create an image of unusual solidity.

By contrast, *Head of a Demon* by George Romney (Fig. 317) is as haunting as a wraith in a nightmare. Even the grainy texture of the pencil on rough paper contributes to the head's insubstantial quality.

In *Preacher* Charles White symbolized a moral leader (Fig. 318). Here the selection of a particularly apt type has constituted the initial step. Foreshort-

left: 316. ALBRECHT DÜRER
(1471–1528; German).
Head of an Apostle. 1508. Pen, ink, and wash, heightened with white, $11\frac{5}{16} \times 8\frac{3}{16}''$. Kupferstichkabinett, Staatliche Museen, West Berlin.

right: 317. GEORGE ROMNEY
(1734–1802; English).
Head of a Demon. c. 1780–90. Pencil, $12\frac{1}{8} \times 9\frac{7}{16}''$. British Museum, London.

318. CHARLES WHITE
(1918– ; American).
Preacher. 1952.
Ink on cardboard, $21\frac{3}{8} \times 29\frac{3}{8}''$.
Whitney Museum of American Art,
New York.

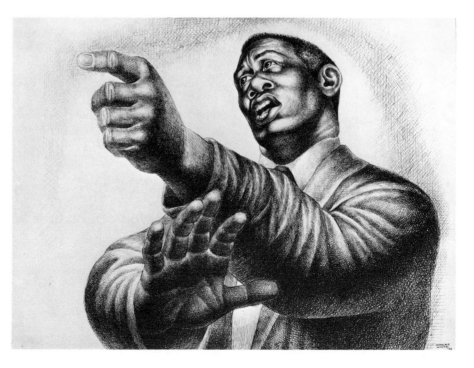

below: 319. WALTER SICKERT (1860–1942; English).
Sir Max Beerbohm.
Pencil on cream paper, 10 × 8″.
Collection Mr. and Mrs. Benjamin Sonnenberg, New York.

right: 320. OSKAR KOKOSCHKA (1886– ; Austrian).
Portrait of Olda. 1938.
Blue crayon, $17\frac{11}{16} \times 17\frac{3}{16}$″.
Allen Memorial Art Museum, Oberlin College, Ohio
(R. T. Miller, Jr., Fund).

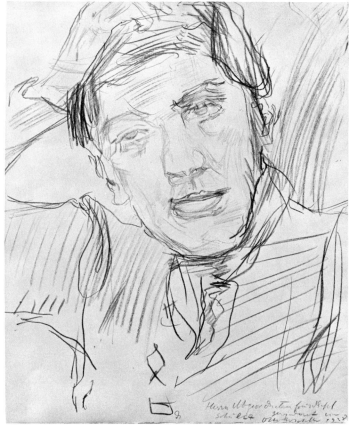

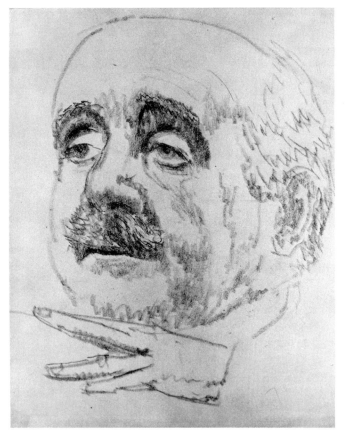

ened enlargement strikingly dramatizes the preacher's hands and conveys the
sense of leadership. The face is reverent, handsome, and strong as the preacher
delivers his ardent, impassioned sermon. The physical strength of the forms
and the solidity with which they are rendered convey the sense that there
is no contradiction between spirituality and full-blooded flesh and bone.

Project 113 *Create a symbolic head, but avoid caricature. If you are at a
loss for subject matter, remember that decadence tends to be more pictorial
than virtue. Consider, for instance, what you see as the salient features of
"evil," "gluttony," "miserliness," and "senility." Thinking in terms of actually
designing a mask helps steer one away from too literal a representation.*

The Psychological Portrait

Early in the discussion of portraits we raised the question of whether psycho-
logical complexities in a drawing resulted from the conscious or unconscious
perceptions of the artist or were read into it by the sensitive observer. Cer-
tainly some drawings seem only to record externals, while others create the

illusion of penetrating the surface and revealing inner aspects of personality—tensions, a withdrawn self-sufficiency, or warmth and sociability.

Walter Sickert has drawn a portrait of the famous English caricaturist Max Beerbohm (Fig. 319). In it we sense a warm, sympathetic observer of life. The raised brows, heavy-lidded eyes, and slightly open mouth all seem to describe the inner life as much as they do external appearances. The raised hand adds an accent as though Beerbohm needed a gesture to give full meaning to his words.

Oskar Kokoschka has drawn his *Portrait of Olda* in scrambled and scattered lines (Fig. 320). The very turbulence of the crayon scribbles creates a disturbing mood, which is intensified by the abstracted look in the eyes, the crooked mouth, and the thoughtful pose. This is a rather unusual combination—a free execution, suggesting the artist's relaxed approach to the act of drawing, and the sense that the subject is a tense, withdrawn personality. The two aspects create a paradox and call to mind the unknown aspects that make every individual an enigma.

Edouard Vuillard was an artist of unusual refinement and sensitivity. His *Seated Girl* (Fig. 321), like many of his works, used the hide-and-seek of pattern

321. Jean Edouard Vuillard
(1868–1940; French).
Seated Girl. 1891.
Brush and ink, with traces
of pencil, $7\frac{1}{8}''$ square.
Museum of Modern Art, New York
(Collection Mr. and Mrs. Alfred R. Stern).

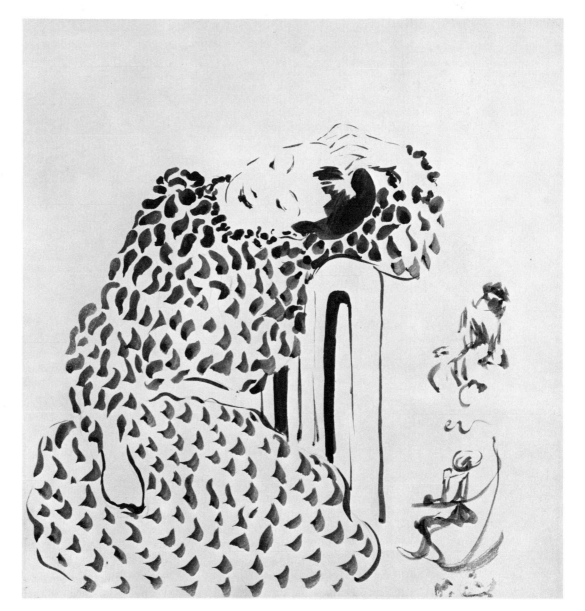

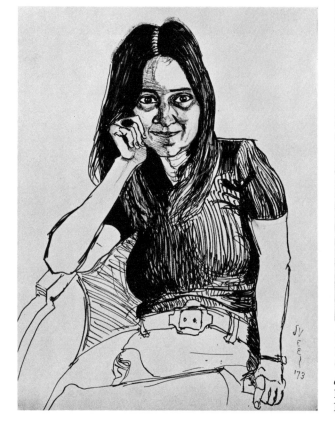

left: 322. Alice Neel (1900– ; American). *Adrienne Rich.* 1973.
Ink heightened with Chinese white, 30 × 22″.
Courtesy Graham Gallery, New York.

above: 323. Paul Klee (1879–1940; Swiss-German). *Portrait.* 1931.
Pen and ink, $12\frac{15}{16} \times 8\frac{1}{4}''$.
Paul Klee Foundation, Museum of Fine Arts, Berne.

to suggest ambiguities of personality. Here the bold pattern of the dress both
obscures and reveals. While it defines the forms of the body, it creates the
feeling of a recessive, contemplative individual who hides behind her clothes.
Where the Kokoschka portrait projects tension, the Vuillard communicates
the essence of a tender, sweet, shy person.

 Alice Neel has pictured introspection with power and subtlety (Fig. 322).
A shadow of a smile provides a clue to the tenor of the subject's thoughts.
The entire pose suggests relaxed bemusement, and the loose, easy rendering
of the drawing reinforces this lack of tension on the part of the sitter.

 More than almost any other late-19th- or early-20th-century artist, Paul
Klee initiated a new sensibility by exploring the world of fantasy and feeling
with almost no dependence on the conventions and disciplines of his day. His
Portrait does indeed describe a person (Fig. 323). The external charac-

Plate 17. EGON SCHIELE (1890–1918; Austrian).
Self-Portrait. c. 1917. Pencil and gouache, $18\frac{1}{8} \times 12''$.
National Gallery, Prague.

Plate 18. ALBRECHT DÜRER (1471–1528; German). *The Great Piece of Turf*.
1503. Watercolor, $16\frac{1}{4} \times 12\frac{3}{8}''$. Albertina, Vienna.

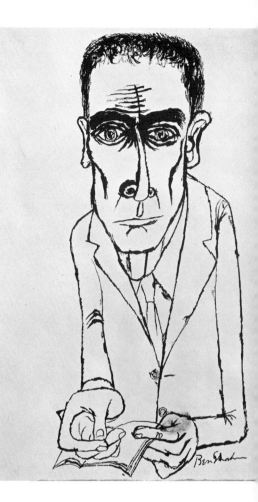

324. BEN SHAHN
(1898–1969; Russian-American).
Dr. J. Robert Oppenheimer. 1954.
Brush and ink, 19½ × 12¼″.
Museum of Modern Art, New York.

teristics—the round face, small eyes, thin nose and mouth, and full chin—are not evident at first glance. One must study the drawing thoughtfully. Perhaps more readily perceived than the features is the sense of the figure's self-questioning bewilderment: the eyes peer; the mouth is nervous; and the arms protectively clasp the soft body.

Project 114 In both Vuillard's *Seated Girl* (Fig. 321) and the Klee *Portrait* (Fig. 323), texture and patterns strengthen the suggestions of very subtle facets of personality. Recognition of such subtleties requires an unusual degree of psychological insight on the part of the artist—equally as important as skill and imagination in depicting them. *Select one of your more objective portrait drawings and invent patterns and textures to amplify expressive possibilities. Also, modify proportions (note the large head and shapeless body of the Klee portrait), and exaggerate the unique aspects of the pose.*

Caricature

Webster's dictionary defines caricature as "a picture in which certain features or mannerisms are exaggerated for satirical effect." While in many kinds of portraits the minor eccentricities and idiosyncratic details of feature and expression are minimized (or almost completely eliminated as in the idealized portrait), such elements provide the essence of caricature. Caricature demands a special talent. The ability to select and sharpen telling details of feature, head shape, posture, and particularly expression seem closely related to a heightened sense of character. Many a fine caricaturist cannot do a "straight" portrait; many a fine portrait artist cannot caricature.

Like all satire, caricature can be humorous and kindly, as in Steinberg's drawing of Benjamin Sonnenberg (Fig. 223), can be mordant and biting as in the portrait of *Dr. J. Robert Oppenheimer* by Ben Shahn (Fig. 324), or can be almost ribald in the gusto with which it depicts its subject (Fig. 326). In the caricature of Dr. Oppenheimer the areas where selectivity and exaggeration occur are easily identified. The heavy eyebrows, the eyes, and the wrinkles and rings around the eyes create an introspective emphasis and communicate tension. The bony cheeks, thin nose, and tight mouth all reinforce this image, as does the hunched-over, shrunken body. It is almost necessary to measure the head and compare it with the body to realize that the distance from the top of the head to the chin is greater than from the chin to the hands. The fact that these distortions of fact contribute to, rather than detract from, the image being projected is a tribute to the power of the drawing. The large, bony hands, not relaxed but cramped and constricted, increase the general impression of tension. Of equal importance to the overall effect are the linear and textural qualities of the drawing. The lines are broken and ragged, like frayed nerves, and the scratchy textures throughout contribute an itchy restlessness.

Caricature goes far back in history. In the 15th century Leonardo gave vivid expression to familiar evils such as smugness, stupidity, vulgarity, gluttony, and cupidity in his *Five Grotesque Heads* (Fig. 325). Through the astute selection and exaggeration of characterizing elements, he created vivid personifications. Leonardo knew human anatomy—bone, tendon, and muscle and their

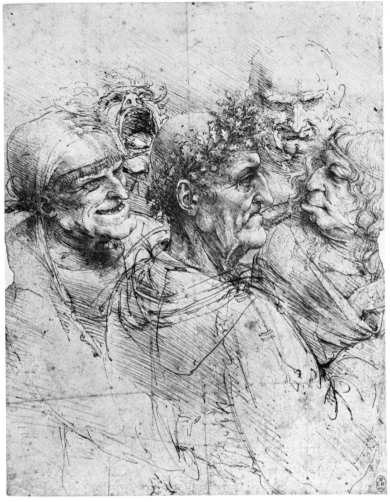

left: 325. LEONARDO DA VINCI (1452–1519; Italian).
Five Grotesque Heads. c. 1506–17.
Pen and brown ink, $10\frac{1}{4} \times 8\frac{1}{2}''$.
Royal Library, Windsor Castle, England
(reproduced by gracious permission
of Her Majesty Queen Elizabeth II).

below: 326. THOMAS ROWLANDSON
(1756–1827; English).
Comparisons between Human and Animal Heads.
c. 1820. Pen and watercolor over pencil, $8\frac{7}{8} \times 7\frac{1}{4}''$.
Courtauld Institute of Art,
London (Witt Collection).

relationships—through clandestine dissection of cadavers, and this knowledge enabled him to create heads of unusual power and conviction.

In 18th-century England, Hogarth, Rowlandson, and many minor artists reveled in making drawings that satirized human ugliness and vulgarity. Rowlandson's zestful caricatures (Fig. 326), while they lack the depth of Leonardo's work, are entertaining, and the artist obviously had a good time doing them.

Rollin Kirby, an American caricaturist, laughed at prohibition and the blue-nosed, hawk-faced minister who esposed it in *Prohibition and Intolerance* (Fig. 327). This symbol of the kill-joy is on a journalistic level designed for a momentary glance and quick laugh. It employs impersonal, journalistic symbols and is executed with professional flair.

The particular genius of the caricaturist has rarely received more brilliant expression than in the drawings of David Levine. Of particular interest are those of the literary celebrities of our day. *W. H. Auden* is a splendid example of Levine's style (Fig. 328). The large head and flowing hair are drawn in clear, sharp, cross-hatched pen lines. The furrowed face with its sharp questioning eyes, full nose, and unsmiling/smiling mouth dominates the drawing, but the body, though it continuously diminishes in size down to tiny feet, is far from unimportant. A rhythmic line carries the eye in a flowing movement from the top strand of hair down to the forward left foot. The fleshy hand holding a cigarette provides a secondary accent, but the literary mind dominates! Careful study of the intriguing face reveals a surprising detachment

left: 327. ROLLIN KIRBY (1875–1952; American). *Prohibition and Intolerance.* Crayon and pencil, $13\frac{1}{8} \times 7\frac{5}{8}''$. Museum of the City of New York.

right: 328. DAVID LEVINE (1926– ; American). *W. H. Auden.* c. 1964. Pen and ink. Reprinted with permission from *The New York Review of Books;* Copyright © 1965 NYREV, Inc.

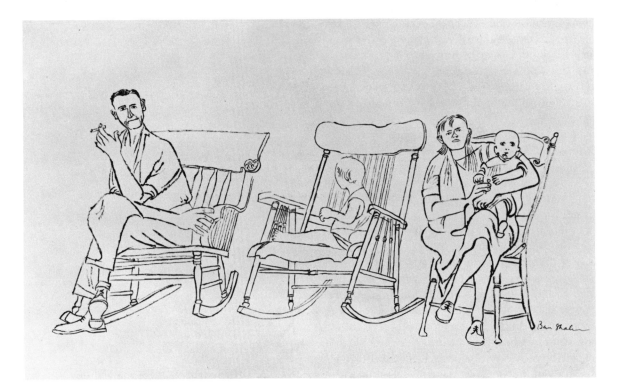

329. BEN SHAHN
(1898–1969; Russian-American).
Southern Family. 1946.
Pen and ink on paper, $11\frac{1}{2} \times 16''$.
University of Nebraska Art Galleries,
Lincoln (F. M. Hall Collection).

on the part of the artist. He laughs neither at nor with his sitter but instead seems to view him with an eye as analytical as that which peers out at us from the drawing. This ability to judge objectively the characterizing features, expressions, and gestures and to picture them in a technique as clear as the perceptions themselves makes Levine the powerful caricaturist he is.

Project 115 *If you have not yet attempted a caricature, do so now. Pick a subject for which you have strong feelings, either of amusement, distaste, or affection, and see if you can communicate these through caricature. Next, caricature yourself. Exaggerate all of your facial characteristics, stressing such irregularities as differences between eyes, unevenness and size of mouth, nose, and so forth. A penalty for being regular of feature is that you may find yourself hard to caricature.*

Group Portraiture

One of the most familiar versions of the group portrait is the family portrait. Ben Shahn revitalizes this old and cherished tradition in his *Southern Family* (Fig. 329). While the drawing may seem at first glance to be a caricature, Shahn has employed none of the somewhat standardized exaggerations we often associate with caricature. Rather, he has based his forms on a scrupulous observation of the postures, gestures, and expressions of the hillbilly family. The sharp, furrowed face of the man, his heavy hands, the awkward angularity of the sitting posture, have all been recorded with an unerring eye (the foreshortened undersole of the raised shoe is particularly telling). The heavy mother, her features squeezed into the center of a round face framed in thin scraggly hair, holds the empty-faced baby in a routine embrace. Rocking chairs and a kitchen chair complete the scene, and one needs no architectural details to visualize the sagging porch and unpainted clapboards of the house. As in his portrait of Oppenheimer (Fig. 324), Shahn again uses a rough, scratchy line so that the texture of the drawing reinforces the sharp commentary.

Project 116 *Draw your own family or draw a group of your friends in a familiar habitat. Stress idiosyncrasies of posture, costume, and facial feature. Include items of furniture, architectural elements of the room, and any other details that will help establish atmosphere. Use a ball-point or felt-tip pen, so that you cannot erase and consequently become overinvolved in a "correct" drawing.*

We have seen that drawings fail to fall into neatly defined categories; that almost any fine portrait does many things. Feliks Topolski's sketch of E. M. Forster and Benjamin Britten (Fig. 330) seems to take the two heads as an excuse for making a spirited drawing in which the lines probe, skirt, describe and circumscribe forms with vehement abandon. The drawing reminds one of a witty conversationalist having fun talking about a mutual acquaintance, revealing some insights into the character being described, and at the same time enjoying his own facility with words.

Project 117 *After studying Topolski's sketch, do a drawing of two friends, more as an opportunity for spirited involvement in the act of drawing itself than as a pedestrian attempt at a likeness. Choose a medium that you feel will encourage spontaneity, while at the same time permitting a satisfying involvement in the quality of line.* You may even achieve a better likeness of your friends in this manner than with more deliberate efforts.

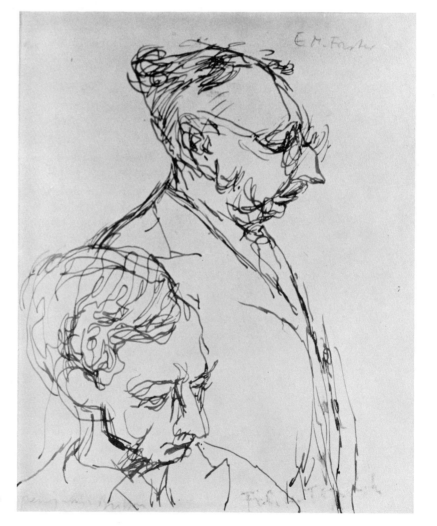

330. FELIKS TOPOLSKI (1907– ; Polish).
E. M. Forster and Benjamin Britten.
Pen and brown ink, 9¾ × 7¾″.
Collection Mr. and Mrs. Benjamin Sonnenberg,
New York.

13 *Landscape*

No body of subject matter equals the landscape in diversity or surpasses it as a resource for artistic expression. When one surveys the drawing and painting of the Orient, Western Europe, and America—whether that of the past or the present—one realizes that landscape has always provided a major stimulus for artistic expression. Its potentialities are infinite: variations of weather, seasonal changes, the thrilling expanse of great stretches of distance—all contribute to the diversity. The patterns and textures revealed by close-up details are frequently breathtaking in their beauty and fascinating complexity.

Landscape has not always been represented primarily for its own sake. Much landscape art of the European Renaissance employed the landscape as a setting for human activity, and a similar viewpoint prevailed in the Orient, where the natural environment was conceived as a matrix against which to portray the narrative of human endeavor. All of these varied aspects of landscape will be seen in the drawings discussed in the following essay.

A view of *The Tiber Above Rome* (Fig. 245), by 17th-century landscapist Claude Lorrain, reveals an intense love of nature and its moods. It is one of the great wash drawings of all time, exhibiting a breathtaking virtuosity in both the handling of wash and the ability to catch a momentary late-day atmospheric effect with certainty and power. The open sweep of the Roman campagna, receding to the distant hills, is recorded in freely brushed wash strokes. In the middle distance a few towers, umbrella pines, and cypresses

particularize the scene. In the foreground the gleaming surface of the Tiber reflects the heightened luminosity of the overhead twilight sky, contrasting with the velvety darks of the heavy tree masses, deep in the shadow of late day. The entire drawing is silent and reverent in tone, resonant with the artist's awe before the grandeur of nature.

In our current age, when industrialization and urbanization encroach upon the natural environment, we must expand our conception of landscape to reflect this change. Hence, our survey here can hardly be limited to the illustration of tranquil, rural scenes. We will begin with the more traditional viewpoint and, once familiar with this, explore the cityscape and, finally, the potentialities for abstract composition.

Needs of the Landscapist

It is most important for the landscape artist to be as comfortable as possible, for landscape drawing can involve many discomforts. Heat, cold, glare, wind, human and animal intruders, insects, changing lights and shadows are only a few of the problems. One of the fine 19th-century landscape artists was John Singer Sargent, also a great portrait painter. Drawing and painting from the landscape provided him with a change from the strain of official portrait commissions. Sargent was able to hire a servant to accompany him and carry a great umbrella, a solid stool and easel, and other pieces of equipment that enabled him to work in comfort.

Few of us today can afford the luxury of servants, so we have to care for our own needs. Dark glasses, gray rather than colored, will help cut the glare of bright sunshine on white paper. A firm stool and lightweight but stable easel are important. A small tool kit provides a convenient carryall for pencils, charcoal, erasers, a small sketch pad, and the like. A portable drawing board is essential (the finest drawing boards are of basswood, which is smooth, almost without grain, and sufficiently soft so that paper can be thumbtacked to it without difficulty).

The most logical media for the landscapist are those that permit one to work rapidly and easily. Charcoal, colored chalks, or soft pencil help the beginner to capture the complex forms of nature and the fleeting effects of light and shadow with a minimum of difficulty. Pen and ink or brush and ink discourage erasures and changes; moreover, they are awkward to transport and handle outside the studio.

Landscape Imagery

Individual Elements

While we tend rather automatically to associate the term "landscape" with a panoramic view, artists have often chosen to focus upon a single facet of the landscape, both as a means of approaching an understanding of landscape texture and composition as a whole, and as a rich source of particularly expressive forms. The miracle that can be achieved when the simplest and most familiar scene is scrupulously rendered with complete fidelity is nowhere more apparent than in Albrecht Dürer's intimate view of *The Great Piece of Turf* (Pl. 18, p. 230). Dürer seems to have undertaken an absolutely faithful transmission of facts about his subject. Through this fidelity to nature he has created a work of art whose beauty is to a large extent a reflection of the artist's humility and honesty.

A handsome drawing of a tree (Fig. 331), until recently attributed to Leonardo da Vinci, also reveals a loving sensitivity to detail. But while the drawing is most certainly accurate, there has been no attempt at a slavish

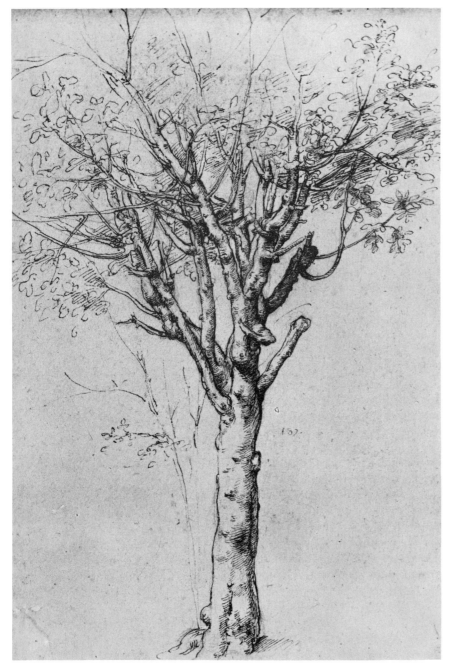

331. Cesare da Sesto (1480–1521; Italian)
or Leonardo da Vinci (1452–1519; Italian).
Tree. Pen and ink over black chalk
on blue paper, 15 × 10⅛″.
Royal Library, Windsor Castle, England
(reproduced by gracious permission
of Her Majesty Queen Elizabeth II).

copying of nature. One feels the selective eye of the artist noting the characterizing joints, bumps, movements, angularity of branches and areas of shadow, stressing and then only suggesting the accompanying masses of foliage and minor branching. In much the same way as another artist would approach drawing a life model, the artist here has sought to define the tree's essence through its form.

A section of a hand scroll (Fig. 332) by Li K'an, a Chinese artist active from about A.D. 1340 to 1360, provides for equally interesting comparison with *The Great Piece of Turf* (Pl. 18, p. 230). Li K'an's scroll shows a deft, masterful handling of the conventionalized Oriental vocabulary of brush-and-ink strokes, conveying a sense of the decorative quite different from the sharp photographic image of Dürer's work. Equally observant and equally skilled, the two examples might be said to represent the West European

332. Lɪ Kʼᴀɴ (Li Hsi-chai; active c. 1340–60; Chinese). *Ink Bamboo,* detail. Handscroll, ink on paper, 1′2¾″ × 18′1″ (entire scroll). Freer Gallery of Art, Smithsonian Institution, Washington, D.C.

scientific viewpoint in contrast to the Oriental aesthetic response to visual experience. It might also be noted that the Oriental drawing conveys a sharper sense of tactile qualities, while the Western emphasis seems more purely visual.

Project 118 *Select a close detail from the landscape around you—a cluster of rocks, a small tree or leafy shrub, a branch with a few meager leaves, a patch of weeds—and study it as an isolated element. Rock formations may suggest a brush-and-ink technique (Fig. 332); a small tree, pen and ink or pencil (Fig. 331). A shrub of interesting texture might be most effectively depicted in wash combined with pen and ink (Fig. 333). A patch of weeds,*

333. Dᴜᴀɴᴇ Wᴀᴋᴇʜᴀᴍ (1931– ; American). *Trees and Foliage.* 1961. Colored inks, wash, sponge, and pen, 9½ × 11″. Collection Richard Sutherland, San Francisco.

perhaps even a detail of a weed, could be strikingly rendered in rubbed graphite and pencil as in Figure 76. Concentrate on the characterizing attributes of your chosen subject, and attempt to convey its uniqueness.

Project 119 You should undertake this project only after completing the previous exercise in direct observation. *Assemble sketches of different leaves. Gradually progress to more complex shapes such as pinnated or lobed types or leaves with serrated edges. Make a composition by combining the different leaf shapes in various sizes. Add stems, branches, and tendrils to build an arrangement expressive of luxuriant growth. By allowing larger leaves to overlap smaller ones, create a sense of space.*

The Total Picture

How the artist perceives and treats individual elements of the landscape obviously has much to do with the overall sense of a landscape drawing. Camille Corot's study in the *Forest of Compiègne, with Seated Woman* (Fig. 334), executed in crayon and pen on white paper, reveals a most attentive consideration of the facts of nature: the slightly undulating movements of the

334. CAMILLE COROT (1796–1875; French).
*The Forest of Compiègne,
with Seated Woman.* c. 1840.
Crayon and pen on white paper, $15\frac{3}{4} \times 10\frac{5}{8}''$.
Musée d'Art et d'Histoire, Lille.

slender trunks of trees formed by their search for sunlight as each tree moved upward over many years; the dark pattern of extended branches seen against the overhead light in contrast to the shine of an occasional branch against the distance; the deep quiet of the shadowy underbrush; the dim mottled light and feathery spurts of foliage—all coupled with a certain gravity of vision. Corot appears happy to transfer the facts of nature onto paper, as Dürer did in *The Great Piece of Turf* (Pl. 18, p. 230), attempting neither to add nor to take from nature, modifying neither the material character of his subjects and their local tone, nor the relationship between parts. The technique in which the drawing is executed is as sensitive, discreet, and controlled as the quality of the artist's vision. Nowhere does the line of the fine hatching take over at the cost of the subject.

On a somewhat grander scale, Pieter Brueghel's *Mountain Landscape with River, Village, and Castle* (Fig. 335) shows a landscape filled with innumerable small forms—human, animal, vegetable, and geological. The drawing is extremely complex, but Brueghel has maintained coherence through a consistency of technique—each form is meticulously rendered by small, sharp pen strokes—and the tight interweaving of details. Lighter in the foreground and darker in the distance, Brueghel's pen lines masterfully convey the sense of deep, panoramic space.

335. PIETER BRUEGHEL THE ELDER (c. 1525–69; Flemish). *Mountain Landscape with River, Village, and Castle.* Mid-1550s. Pen and brown ink, with brown wash, $14\frac{1}{8} \times 16\frac{11}{16}''$. Pierpont Morgan Library, New York.

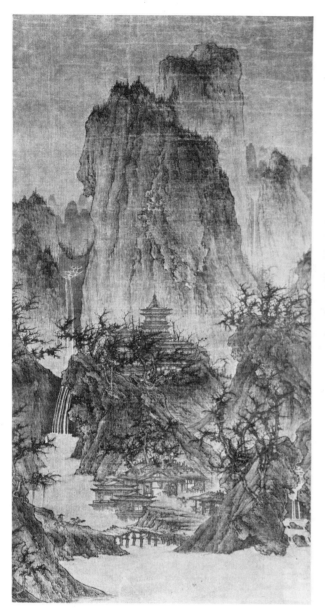

left: 336. LI CH'ENG
(Ying-ch'iu; c. 950–1000; Chinese).
Buddhist Temple Amid Clearing Mountain Peaks.
Ink and slight color on silk, 44 × 22″.
Nelson Gallery-Atkins Museum,
Kansas City (Nelson Fund).

above: 337. Detail of Figure 336.

In a magnificent work such as *Buddhist Temple Amid Clearing Mountain Peaks* (Figs. 336, 337), attributed to Li Ch'eng, landscape assumes a formal elegance and refinement quite different from the European viewpoint illustrated above (Figs. 334, 335). The concern here is basically philosophic, and the natural environment is conceived as a great matrix against which to play the narrative of humanity. Great mist-shrouded mountains rise in the distance behind a foreground of twisting waterways, picturesque trees, stratified rock formations, small buildings and bridges peopled with figures of miniature scale. One must inspect a detail of this handsome work (Fig. 337) to appreciate fully the sharp observation of individual forms and the skill and subtlety with which these observations are made part of a traditional Oriental way of seeing. Li Ch'eng has masterfully coordinated these motifs, impregnating each with his own artistic personality in much the same way that a fine musician, when performing, leaves a unique imprint on an established composition.

Project 120 *Study Li Ch'eng's work carefully* (Fig. 336), *noting in particular:*
(1) *the sequence of diagonal movements from the bottom to the top of the*

composition and their unifying sweep; (2) the decreasing size of all parts as the eye follows the upward recession into deep space; and (3) the consistency of texture and tone, which relates all the diverse elements of the composition. Select a more contemporary version of Li Ch'eng's subject for this exercise— perhaps a college campus with buildings and treelined walks peopled here and there with students. Draw such elements individually, and then combine them in a single composition. Make small "thumbnail" sketches of possible compositions before attempting your final study. Charcoal provides for a variety of textures, darks, and lights, although pencil, wash, or other media may better suit your preferred techniques.

Texture and Pattern

The textures of landscape, and the patterns they compose in conjunction with the play of light, have fascinated a great many artists (Figs. 171, 174, 220). As explained in Chapter 7, the overall textural interest of a drawing derives from both the depiction of actual surface qualities in the subject and the medium employed—that is, the medium's own texture and the way in which it is applied.

A pen-and-bistre drawing perhaps by Giorgione (Fig. 338) shows a sensitive treatment of earth structure. The artist has rendered towers and fortified walls as well as rocky hillocks and graceful trees in precise detail. Forms throughout the drawing are clearly defined and modeled. Shading by means of short, clean lines applied in sets of straight or slightly curved parallels is further enriched by cross-hatching and stippling to yield a drawing of rich and dense texture.

Project 121 *Survey your natural environment, and take an inventory of interesting textures—grass, weedy growths, various tree barks, gravel, hair, shingle, shake, tile, fieldstone, cut stone, brick, and so forth. Using media that seem logical, analyze and reproduce in sketches a small area of each surface. Then, proceed to suggest various surfaces by less deliberate and more spontaneous rendering. Select a landscape in which there is ample opportunity to convey a vivid range of textures* (Fig. 119), *and create a drawing with as much textural character as possible.*

Project 122 Claude Lorrain's *Study of Trees* (Fig. 339), filled with air and light, explores woodland textures in an intimate, fresh, and spontaneous style.

338. Attributed to GIORGIONE
(1478–1510; Italian).
Landscape.
Pen and bistre, $6\frac{5}{16} \times 9\frac{7}{16}''$.
Louvre, Paris.

Splotchy application of wash creates the illusion of filtered light. Sketchy pen lines reinforce the broken tones of wash to create fresh, crisp textures.

Do a quick wash drawing of a cluster of trees with grass underneath. By means of a roughly textured, broken surface and very dark shadows, describe the feeling of light filtering through the trees. Work as well to capture a strong sense of the contrast between the broken pattern of leafy branches and the vertical texture of the grass. Use diluted ink or watercolor.

A powerful empathy with the physical world made Vincent van Gogh feel each surface as a living thing capable of movement. An intense, tragically frustrated man, Van Gogh vented his passions in the vividly animated style of his drawing and painting (Figs. 106, 178, 219). The brusque pen strokes in Figure 340 twist and writhe about forms, creating tangled, complex textures. Visual textures have been rendered as though animated by emotion; surfaces move rhythmically on the page; the great swirling cypresses appear muscled and alive. Roelandt Roghman defined foliage textures in a loose but more traditional manner in a roadside scene (Fig. 341).

After viewing drawings like those by Van Gogh (Fig. 340) and Roghman (Fig. 341), it is important to remember that vitality of texture need not be synonymous with a bold style. As the landscapes reproduced as Figures 342 and 343 so aptly illustrate, very subtle variations in texture and line weight

339. CLAUDE LORRAIN
(Claude Gellée; 1600–82; French).
Study of Trees. 1635–40.
Pen, brown ink, and bistre wash
over traces of black chalk, $12\frac{1}{8} \times 8\frac{3}{8}''$.
British Museum, London.

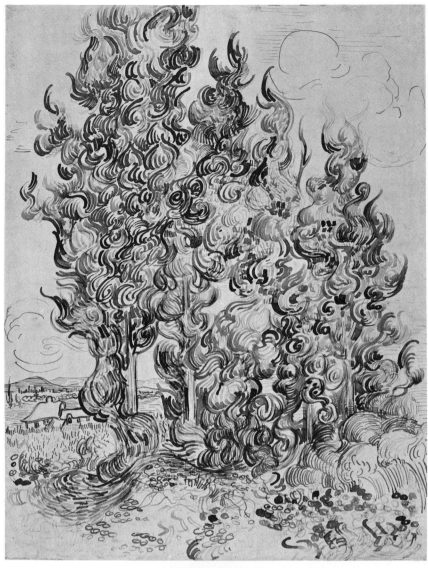

left: 340. Vincent van Gogh
(1853–90; Dutch-French).
Grove of Cypresses. 1889.
Reed pen and ink over pencil, $24\frac{5}{8} \times 18\frac{1}{4}''$.
Art Institute of Chicago
(gift of Robert Allerton).

below: 341. Roelandt Roghman
(c. 1620–86; Dutch).
Landscape with a Road and a Coach.
Pen and light-brown ink with gray
and brown wash, $5\frac{1}{8} \times 7\frac{1}{8}''$.
National Gallery of Canada, Ottawa.

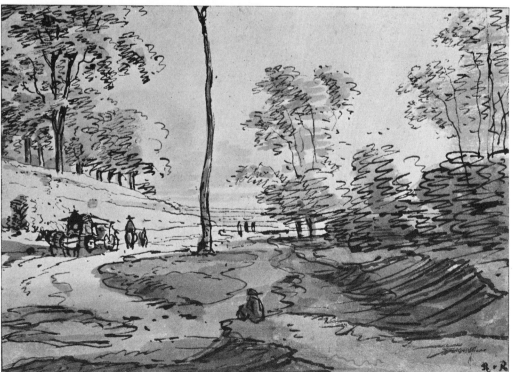

left: 342. Théodore Rousseau
(1812–67; French).
Road Across the Heath. Sepia, $5\frac{1}{16} \times 11''$.
National Gallery of Scotland, Edinburgh.

below: 343. Jules Pascin
(1885–1930; Bulgarian-American).
Figures in a Landscape. c. 1910.
Pen and ink, $4\frac{3}{8} \times 5\frac{3}{4}''$.
Stanford University Museum of Art, Calif.

can serve to establish the character of forms and spaces. While Jules Pascin handles pen and ink with exuberant freedom in *Figures in a Landscape* (Fig. 343), the resulting lines are delicate, through skillful variation in width hinting at surface textures and relationships of forms. Too, the drawing charms us by its humor and sheer joy in life.

When landscape textures combine in relationships that emphasize flat shapes rather than three-dimensional form and space, either as a natural consequence of the play of light and shadow or as a result of the artist's composing eye, landscape patterns evolve. Impromptu patterns frequently arise in the naturally rhythmic or patterned components of the environment such as the sky or a body of water (Fig. 355). An artist may, in turn, be stimulated by such patterns to emphasize their potentialities (Figs. 344, 358). In Jacopo Bellini's *Christ in Limbo* (Fig. 345), the striated rocks and precipitous

above: 344. DAVID HOCKNEY (1937– ; American). *Alexandria.* 1963. Color pencil, 10 × 12½″. Collection John C. Stoller, Minneapolis.

right: 345. JACOPO BELLINI (1400–70; Italian). *Christ in Limbo.* c. 1450. Silverpoint on bluish prepared vellum, 13¾ × 9⅜″. Louvre, Paris.

left: 346.
JOHANN MARTIN VON ROHDEN
(1778–1868; German).
Landscape.
Pencil, $11\frac{7}{8} \times 18\frac{1}{16}''$.
Staatliche Graphische
Sammlung, Munich.

below: 347.
CHEN CHI (1912–; American).
Winter. 1970.
Brush and ink, $13 \times 33\frac{3}{4}''$.
Chrysler Museum
at Norfolk, Va.

bottom: 348.
REMBRANDT VAN RIJN
(1606–69; Dutch).
Winter Landscape. c. 1647.
Reed pen and ink wash
on grayish paper, $2\frac{5}{8} \times 6\frac{5}{16}''$.
Fogg Art Museum,
Harvard University,
Cambridge, Mass.
(bequest of Charles A. Loeser).

cliffs purposefully have been portrayed so that one senses the handsome pattern of the hard stone surfaces. Nearly parallel lines cluster together, stressing formal patterns of light and dark. The rhythms of the main masses create a graceful movement that is, in fact, at variance with the true nature of natural cliff formations.

Project 123 *As Bellini has done, formalize a cliff or rocky mass. Permit abstract patterns to dominate your drawing, remembering that your creative impulses need not be subservient to fact. Confine your composition to a small format, no larger than 5 by 7 inches, and work your patterns in hard pencil.*

Spatial Relationships in Landscape

Forms in Deep Space

Many landscape drawings and paintings display a considerable degree of spatial complexity, and artists have devised the system of *aerial* or *atmospheric perspective* to reinforce the illusion of depth initially mapped out by linear perspective. Atmospheric perspective is based on two observations. The first is that air is by no means completely transparent and, therefore, that a thin but (with distance) ever-increasing layer of obscuring atmosphere gradually interpolates itself between seen objects and the viewer. Second, as objects go into the far distance and become smaller, the eye eventually fails to perceive individual forms and the separate facets of light and dark that make up individual forms. These blend together and cancel out one another, leaving a general prevailing middle value that, in turn, is further obscured by the intervening layer of light-colored air to become a medium-light value. These two factors create the illusion of atmospheric perspective, the principle of which is that *contrasts of value diminish as objects recede into the distance;* the lights become less light, the darks less dark, until all value contrasts merge into a uniform, medium-light tone. Similarly, color contrasts also diminish and gradually assume the bluish color of the air, but this is more a concern of the painter than of the draftsman.

Project 124 *Select a landscape scene encompassing numerous levels of distance, and attempt to delineate clearly a sense of deep space by diminishing the darkness of your lines and their width. Remember that the boldest darks and whitest highlights occur in the foreground. As the scene moves into the distance, the darks become less dark and the lights less light. In the far distance, a neutral gray prevails. For your first attempt, do a line drawing in pen and ink or with pencils of varying hardness.* Johann von Rohden has achieved a masterful result in his landscape (Fig. 346) by eliminating all minor elements that might distract from the sweep of space he describes with an enviable purity of line. *Next, try a brush-and-ink technique using full blacks contrasting with white paper in the front plane* (Fig. 347). *Charcoal, chalk, or pen and ink can serve just as well to create bold textures in the foreground to contrast with paler textures in the distance* (Figs. 219, 335). Rembrandt has used ink and a reed pen to depict a winter landscape (Fig. 348). (A small stiff brush such as is employed in oil painting could provide a contemporary equivalent if you are unable to obtain a reed pen.) With only a few quickly brushed lines and a pale wash, Rembrandt recorded the all-encompassing whiteness of winter, the sharp perspective of fence and road, a faint horizon, and a huddled cluster of trees and farm buildings. It is easy for the observer to overlook the role played by the few dark accents in the foreground in creating the sense of a blanket of snow. Without these accents, we would have merely a pale drawing.

The Horizon Line

When one is sketching outdoors, the *theoretical* horizon line (eye level) seldom corresponds to the *actual* horizon line (Fig. 148). The theoretical horizon line is based on the concept of an absolutely flat plane extending as far as one can see (see pp. 99–100), and this rarely occurs in nature except when the viewer is confronted by a vast body of water. As a consequence, in outdoor sketching situations one usually constructs a theoretical horizon line by observing the perspective in the objects being drawn, rather than by trying to place vanishing points on the actual horizon.

Domenico Fossati has permitted himself considerable license in defining the horizon line in his *View with Villa and a Building at Left* (Fig. 349). Since the placement of the buildings implies various ground levels, however, the discrepancies in perspective logic are not obtrusive. No ground line is shown for the building in the left foreground; the building at the far right tends to float in relation to the others. Fossati's work achieves its effect of consistency by its free assurance and aplomb.

Project 125 *Draw a landscape with one building up close, one placed in the middle ground, and a number of buildings in the far distance. Relate them loosely to whatever horizon line you choose (to the degree that one exists in the Fossati drawing, it is at the bottom). Now sketch each part in very light pencil so that the drawing is consistent within itself. Do a final sketch in a bold, free manner that carries conviction. Soft pencil would be a logical medium.*

Project 126 When first beginning to draw landscapes, artists may overlook the importance of cloud configurations. These too are subject to the laws of perspective, and their representation greatly affects the overall character of a landscape scene (Fig. 176). *Do a series of skies with different cloud types: cumulus, cirrus, stratus, etc. Rub charcoal or graphite into your paper to produce a graduated gray ground, from lighter near the intended horizon to darker as you approach the top of the page. Wipe out cloud patterns with a chamois or eraser. Remember to project the clouds in correct perspective. Clouds tend to appear more rounded overhead, becoming progressively flatter and more horizontal as they near the horizon.*

349. DOMENICO FOSSATI
(1743–84; Italian).
View with Villa and a Building at Left.
Pen and sepia with wash, 8½ × 15½″.
Los Angeles County Museum of Art.

350. Rembrandt van Rijn (1606–69; Dutch). *Panorama of London.* c. 1640.
Pen and brown ink heightened with white, $6\frac{7}{16} \times 12\frac{1}{2}''$.
Kupferstichkabinett, Staatliche Museen, West Berlin.

Cityscape

As has been observed, landscape drawing need not necessarily be limited to
the pastoral and rural—qualities that may indeed be more and more difficult
to experience. Rembrandt's beautiful *Panorama of London* (Fig. 350) gives
evidence of artists' early interest in the cityscape. Richard Parkes Bonington,
an early-19th-century English artist, captured the bustling ambience of an old
market square in his *View of Rouen* (Fig. 203). Many contemporary artists
see in the city an exciting and spacious view that appeals to them in the same
way the rural countryside did to previous generations. Richard Diebenkorn
found inspiration in the semi-industrialized outskirts of a modern urban area
(Fig. 351). The scattered buildings, telephone poles, and empty lots establish
the character of a familiar scene that we usually view cursorily from an
automobile or train window approaching the city. Henry Lee McFee has done

351. Richard Diebenkorn (1922– ; American). *Roadside, Alexandria, Va.* 1944.
Brown ink and wash, $8\frac{1}{2} \times 11\frac{1}{4}''$. Courtesy the artist.

below: 352. HENRY LEE McFEE
(1886–1953; American).
The City. c. 1935. Pencil, 20 × 14½″.
Addison Gallery of American Art,
Phillips Academy, Andover, Mass.

right: 353. LIONEL FEININGER
(1871–1906; German-American).
Incoming Fisher Fleet. 1941.
Watercolor and India ink, 11$\frac{3}{16}$ × 19″.
Allen Memorial Art Museum,
Oberlin College, Ohio (R. T. Miller, Jr., Fund).

above right: 354. CLAUDE LORRAIN
(Claude Gellée; 1600–82; French).
Ship in a Tempest.
Pen and brown ink, with gray wash, 7$\frac{1}{16}$ × 9$\frac{7}{16}$″.
Allen Memorial Art Museum,
Oberlin College, Ohio (gift of Walter Bareis).

right: 355. VIJA CELMINS
(1939– ; Latvian-American). *Untitled.* 1969.
Acrylic and pencil on paper, 32½ × 43½″.
Collection Charles Cowles, New York.

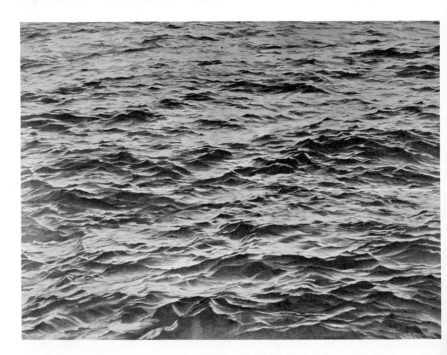

a fine pencil sketch of city rooftops (Fig. 352). Smoke and smog obscure the distant skyscrapers and contribute to a panorama that evokes a sharp sense of the special character of the metropolis.

Seascape

No study of landscape drawing would be complete without the mention of seascape. Throughout time the ocean has fascinated human beings and challenged the expressive powers of artists. All the complexities of water—its unceasing movement (Fig. 353), its reflections and transparency, its colors and moods, the turbulent excitement of its surface in storms (Fig. 354), and its capacity to yield patterns of calm repose or unsettling tension (Fig. 355)—have proved endlessly fascinating to many artists.

Project 127 The ocean, a lake, a stream, a fountain, or, as a last resort, a bathtub—all exhibit the salient features of water, and depicting them involves nearly similar problems. *Analyze the light reflections seen on the facets of waves (in the tub, ripples serve as "waves") and the distortions of form caused by water movements as well as by increasing depth. Soft pencil or charcoal with smeared erasures may offer the most effective means of simulating the smooth, gleaming surface of water.*

Abstraction

The landscape serves as a basic artistic resource even for those artists whose concerns lie in abstracting relationships of form and space. Richard Mayhew's *Nature Solitude I* (Fig. 356) maintains convincing spatial relationships—that is, one can perceive in the changes of light and dark a progression from foreground to distance, and also infer certain relationships between formal groupings. Individual forms, however, are amorphous and largely indistinguishable one from another. Through formal precision, the dense, controlled texture of this artist's pen-and-ink technique masks what is actually a very careful observation of natural phenomena.

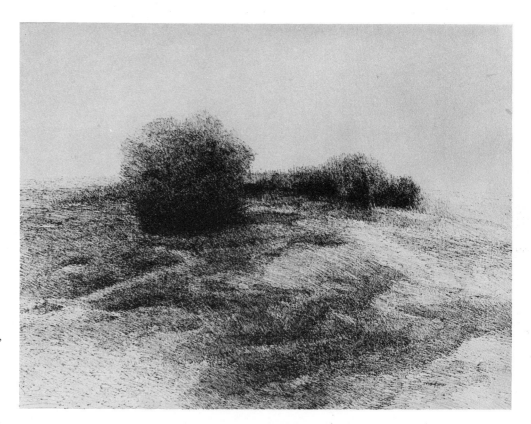

356. RICHARD MAYHEW (1924– ; American). *Nature Solitude I.* 1970. Ink, 17½ × 23½". Courtesy Midtown Galleries, New York.

Project 128 In *Trees Behind Rocks* (Fig. 357), Paul Klee composes triangular rocklike shapes and foliage-inspired textures to create a visually entertaining entity that still "feels" like a landscape. *Choose a landscape free from a multitude of diverse elements—a field of grain viewed under a cloudy sky, or rocks and water at the beach—and reduce your scene to a few contrasting abstract patterns. (Notice how freely Klee has departed from a literal handling of foliage.) Your subject should dictate the medium.*

Jean Dubuffet departs almost completely from recognizable form and space in his *Landscape with Jellied Sky* (Fig. 358). The artist's unique vision fragments the landscape into innumerable puzzle pieces, themselves internally cross-hatched and decorated. And yet, despite its patterned abstraction, Dubuffet's work does adhere to certain landscape conventions. One can discern a definite transition from land to sky, and what might be interpreted as cloud patterns dot the upper corner of the drawing.

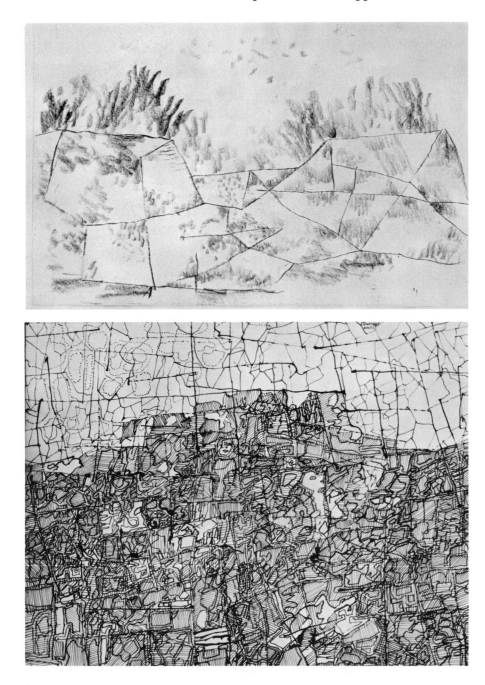

above: 357. PAUL KLEE
(1879–1940; Swiss-German).
Trees Behind Rocks. 1929.
Pencil, $8\frac{1}{4} \times 13''$.
Solomon R. Guggenheim Museum,
New York.

left: 358. JEAN DUBUFFET
(1901– ; French).
Landscape with Jellied Sky. 1952.
Pen and India ink, $19\frac{3}{4} \times 25\frac{3}{4}''$.
Courtesy Pierre Matisse Gallery,
New York.

14 Still Life

From earliest times artists have been intrigued by the myriad forms and surfaces that surround us and have taken great pleasure in rendering them. One charming story tells of a certain artist in ancient Greece who prided himself on the ability to paint fruits so convincingly that birds would peck at them (Fig. 359). With a comparable enthusiasm, Jan van Eyck, Rogier van der Weyden, Hans Memling, and other artists of 15th-century Flanders reveled in the skill with which they could depict glass, ceramics, fabrics, wood, fruits, and flowers (Fig. 360). Throughout the Renaissance and Baroque periods artists repeatedly drew upon still-life materials to create an atmosphere of everyday reality in their works (Fig. 361). The emergence of a bourgeois culture in the 17th century, with its glorification of middle-class values, made the portrayal of material wealth a major thematic concern. In Flanders especially, artists featured tables laden with fruit, vegetables, fish, poultry, and meat in what to our squeamish age seems a gluttonous display. The Dutch masters of this period added flowers to their repertoire, painting splendid arrangements complete with sparkling drops of dew and an occasional insect. Still-life subjects continued to be popular with early 19th-century American painters, who patterned their works after Dutch precedents. The late 19th-century American "trompe l'oeil" artists, most notably William Michael Harnett and John Peto, originated a brilliant style of still-life painting employing very shallow space, clearly defined cast shadows, and a meticulous rendering of surface textures that would have done credit even to Van Eyck (Fig. 362).

360. JAN VAN EYCK (1390–1441; Flemish). *Giovanni Arnolfini and His Wife*, detail. 1434. Oil on wood, 33 × 22½″ (entire work). National Gallery, London (reproduced by courtesy of the Trustees).

359. *Peaches and Glass Jar,* wall painting from Herculaneum. A.D. c. 50. Fresco, 13½ × 14″. Museo Nazionale, Naples.

361. CARAVAGGIO (1573–1610; Italian). *Bacchus,* detail. c. 1590. Oil, 38½ × 33½″ (entire work). Uffizi, Florence.

Unfortunately, preparatory drawings by masters working in the still-life tradition are extremely scarce (Figs. 363, 364). Perhaps these artists were, for the most part, sufficiently assured to attack the task of painting without benefit of the preliminary studies that customarily preceded religious, mythological, and genre works—studies that constitute our body of master drawings. Thus, despite the long popularity of still life and the fascinating solutions devised over the years to problems of composition, we must restrict our discussion largely to 20th-century examples if we are to appreciate the potentialities of this field for drawing.

Advantages of Still Life

Still-life drawing presents a number of advantages. Working in a quiet studio and usually alone, the artist is free from many of the problems that accompany

left: 362. WILLIAM MICHAEL HARNETT
(1848–92; American).
Old Models. 1892. Oil on canvas, 4′6″ × 2′4″.
Museum of Fine Arts, Boston (Charles Henry Hayden Fund).

above: 363. JACOB DE GHEYN II
(1565–1629; Flemish).
Study of Dead Pigeons. Pen and ink, $6\frac{1}{16} \times 8\frac{15}{16}''$.
Rijksmuseum, Amsterdam.

364. ABRAHAM BLOEMAERT
(1564–1651; Dutch).
Studies of Garden Plants.
Pen and ink, $11\frac{3}{8} \times 14\frac{7}{8}''$.
École Nationale Supérieure
des Beaux-Arts, Paris.

portraiture, life drawing, and landscape drawing. There is no need to make the appointments and commitments that are part of scheduling sittings with life drawing models or portrait subjects. Too, the artist can ignore the caprices of weather and work uninhibited by wind, rain, changes in sunshine and shadow pattern, and all the other unpredictables that go with working out of doors; inquisitive horses and cows will not breathe over your shoulder, dogs will not bark at you, nor will suspicious, irate farmers order you off their premises. And the studio demands of the still-life artist are minimal; any quiet room with good light, whether natural or artificial, will serve.

For the novice, still life has yet another advantage. The subject, as the name clearly indicates, does not move. Thus, the beginning student has ample time to observe and learn to portray the tremendous variety of surface qualities that characterize all objects, to learn to see, as it were, and to develop the skills involved in depicting the appearances of what is seen. The rendering of form, light and shadow, texture, color, and such subtle phenomena as lustre and transparency can all be attempted at an unhurried pace. Problems of perspective and foreshortening, often on a rather elementary level, will arise, and these problems can be worked on at the artist's leisure. If the arrangement is placed where it need not be moved for some time, and if the subject is not susceptible to withering or decay (an old boot, for instance, in contrast to fruit or flowers), the student can experiment in as many media as desired.

Finally, still life demands little expense. Every home is filled with potential still-life subjects. One need only glance at the illustrations in this section to see that anything from old clothing to edibles, from tablewares to cooking utensils, from musical instruments to books can serve as subject matter.

A simple carton of eggs, for example, can provide an excellent subject for the artist with imaginative vision and a sense of composition (Fig. 365), for it is the sympathetic observation of familiar objects accompanied by the capacity to project these observations into arresting and revealing works of art that characterizes the true still-life artist.

A second drawing by the same artist again reveals the potentialities of the most humble and familiar household items when seen through a fresh eye (Fig. 201). A towel thrown over the back of a kitchen chair becomes a study of black against white, of soft versus hard, and of geometric forms contrasting with curvilinear. Particularly handsome is the ogee curve in the backsplat of the chair seen as an isolated element in the composition, which throws all the remaining patterns into visual relief.

Project 129 *Arrange a group of stable forms—preferably not fruits, flowers, or other perishables.* Ideal subjects have large, clearly differentiated forms; a pumpkin, for instance, is infinitely preferable to a leafy branch. *Once the objects have been set in an interesting composition, proceed to draw; slightly smaller than life size is best. At the beginning, concentrate upon trying to portray forms and textures, leaving problems of color for later.* Subjects as varied as old shoes, hats, and kitchen or table ware are all suitable. Vases and other symmetrical objects may prove less desirable; the struggle to achieve perfect symmetry can be inhibiting, although this need not be the case as can be seen in Figure 367. *After you have gained some experience, the more intriguing forms of fruits and vegetables will provide stimulating additions. Still later, concentrate on trying to render such subtleties as the transparency of glass and the shine of metal.* Needless to say, good light is essential, and the ideal light comes from above and to one side. Daylight has no particular advantage over artificial light, as long as the artificial light is brilliant. It is equally important that one draw in a relaxed position, using a table of the right height and a comfortable chair. And, of course, the still-life arrangement should be set up where it can stand undisturbed for as long as needed.

Still-Life Forms

Value Study

Much early training in the 19th-century academies of art in Europe and America was devoted to the techniques of rendering form through traditional chiaroscuro, for which still-life compositions provided ideal subjects. White plaster casts like the one depicted in Figure 114 were favored for clear illustration of value gradations. Elements of chiaroscuro—light, shadow, the core of the shadow, reflected light, and highlights (see pp. 79–81)—could easily be observed and analyzed on the smooth, colorless plaster surface.

Project 130 Frost's drawing (Fig. 114) and one by Charles Sheeler (Fig. 366) display an enviable virtuosity of technique and vision. In both, the objects

above: 365. MARK ADAMS
(1925– ; American).
Box of Eggs. 1968. Pencil, $13\frac{1}{4} \times 16\frac{1}{4}''$.
Courtesy the artist.

below: 366. CHARLES SHEELER
(1883–1965; American).
Of Domestic Utility. 1933.
Black conté crayon, $25 \times 19\frac{3}{8}''$.
Museum of Modern Art, New York
(gift of Abby Aldrich Rockefeller).

reveal their forms solely by value changes. *Compose a still-life arrangement containing large, rather simple forms and illuminate with a strong light above and to one side* (Fig. 366). If the objects are all of closely related values, preferably pale ones, the use of chiaroscuro to describe form will not be complicated by differences in color. A still-life of kitchen bowls, potatoes, and squash, or of apples and oranges, works well. Simple vase forms, two or three inflated beach balls or floating toys, or a group of plaster casts also provide good subjects. *Place a simple background behind the still life, preferably close enough so that shadows cast by the objects fall on the background and the background surfaces cast reflected light back into these shadows. Sketch the objects in light outline to ensure satisfying size and shape relationships, then proceed to develop the form in dark and light. Study the shapes of cast shadows very carefully and model them as thoughtfully as you do the actual objects.* To the mature artist, all aspects of the visual experience are significant; the shadows cast by objects provide elements of pattern equal in importance to the objects (Fig. 238).

Schematic Form

Schematizing form is yet another means of grasping the essence of a subject. By simplifying the complexities of form into geometric components, one can more readily clarify the relationship of parts and thus better "see" the overall

form. Schematic form has been discussed in detail in the context of figure drawing, and the student should refer to this section to review basic principles for the following project (see pp. 199–202).

Project 131 *Set up a still life containing objects with clearly structured forms, such as segmented vegetables (pumpkins or squash), large bones, or shells. A partially crunched, large paper bag provides a good subject for this problem. Stratified rocks or large mineral specimens also work well. Use a diagrammatic sketching style to indicate the forms and the interrelationships of parts. Your problem is to simplify and clarify by creating basic forms that will reveal structural relationships.* Certain very literal-minded students will find this exercise too foreign to their temperament to have value. Those with a tendency to abstraction will enjoy and profit from translating nature's organic complexities into formally structured equivalents.

Composition and Treatment

Elements of the still life—fruits and vegetables, pots, plates, bowls, casts, and so on—achieve aesthetic coherence and interest through the artist's sense of composition or viewpoint and the chosen method of treatment. Paul Cézanne composed three skulls in a pyramidal grouping, a traditional compositional device ensuring stability (Pl. 19, p. 263). The textile on which the skulls rest relates to them in its curvilinear patterns, and the tabletop frames and stabilizes the composition. As in all of Cézanne's later works, color serves to build solid forms. This structural use of color allowed Cézanne independence from traditional chiaroscuro. Heavy darks lost their importance, leaving him free to create bright, colorful works predominantly light in value.

A still-life drawing by Henri Matisse further illustrates how relatively unimportant subject matter can become when vitalized by imaginative vision. In *Dahlias and Pomegranates* (Fig. 238), it is the bold brush-and-ink handling and resultant dynamic patterns that create an unconventional drawing from common fruits, flowers, a vase, and a bowl.

Project 132 *As a point of departure, study the Matisse and Cézanne still lifes (Fig. 238; Pl. 19, p. 263). Arrange fruit forms in a bowl with some spilling over and around it. Illuminate the study with a strong light from above to create stark shadow patterns. Execute your drawing in brush and ink, compressed charcoal, or black chalk.*

Beth van Hoesen is a printmaker of distinction whose original viewpoint is evidenced by both her ability to see the potentialities of the most modest and familiar objects and her capacity to project them into arresting forms and patterns. *Paint Jars* (Fig. 367) transmutes studio litter into a rhythmic flow of jars and jar tops, interrupted by an occasional contrasting shape. *Kitchen* (Fig. 368) details a greater variety of shapes, but relates them by a continuous compositional movement that commences at the upper left, moves in a diagonal down to the horizontal tabletop. The artist then repeats the diagonal movement in the progression from the refrigerator-top down to the lower right-hand corner of the drawing.

Project 133 *Make an interesting still-life arrangement of your drawing materials. Rather than rendering the articles carefully, strive for the incisive vigor that distinguishes the two works just discussed.*

Richard Diebenkorn's *Still Life* (Fig. 369) emerged from a very familiar and, at first thought, unprepossessing household subject: a cluttered table

369. RICHARD DIEBENKORN (1922– ; American). *Still Life*. 1964.
Crayon and wash on paper, 12 × 18″. Courtesy the artist.

setting, presumably after a meal. The artist has displayed his compositional insight in the original arrangement that characterizes this drawing. Against a pattern of horizontal stripes, three circular shapes have been distributed—the large, cut-off plate in the upper right corner, the smaller white plate slightly to the left of center, and the small bowl or ashtray at the upper left. Scissors, a napkin, a salt shaker, a spoon, a folder of matches, and several less easily identified objects provide variety and animation. The execution is fresh and lively and contributes to the casual charm of the study.

Project 134 As is so aptly illustrated by the Diebenkorn work (Fig. 369), disorder can be visually exciting. *Make a trip through your own home observing the tops of desks, tables, sideboards, and any other surfaces where objects accumulate, and evaluate the pattern potentialities of each. Should you wish to enhance or formalize a "mess," consider the following suggestions: (1) drop some papers and objects such as small, empty cartons or a worn shoe into a waste basket; (2) rearrange the clutter of an untidy kitchen or your own bedroom. Keep your composition dynamic through the domination of strong diagonal lines and bold tonal contrasts. An unusual combination of media might prove stimulating, such as colored wax crayon and watercolor.*

Another example of the way in which a distinguished handling of a traditional subject can transform it and create a fresh and original effect can be observed in Ellsworth Kelly's *Apples* (Fig. 93). Purity of line combines with the sensitive observation of all departures from absolute spherical shape, and the elimination of distracting peripheral elements (such as table edges) yields a refreshing drawing with no trite overtones.

Project 135 *Place a group of fruits and vegetables on a table without consciously arranging them in a composition. Draw the group with pure, unmodulated contour lines. Observe any deviations from perfect regularity and*

above: Plate 19.
PAUL CÉZANNE (1839–1906; French).
The Three Skulls. 1902–06.
Watercolor and pencil
on paper, $18\frac{3}{4} \times 24\frac{3}{4}''$.
Art Institute of Chicago
(Mr. and Mrs. Lewis L. Coburn
Collection).

left: Plate 20.
FRANCIS PICABIA (1879–1953; French).
Conversation I. c. 1922.
Watercolor, $23\frac{1}{2} \times 28\frac{3}{8}''$.
Tate Gallery, London.

263

Plate 21. Théodore Géricault (1791–1824; French). *Ancient Sacrifice.*
Pen and brown ink heightened with gouache on oiled paper, $9\frac{1}{4} \times 15\frac{3}{4}''$. Louvre, Paris.

describe these with linear exactitude, for they characterize the individuality of each object and differentiate it from its neighbors.

Mu-Ch'i individualized each fruit in his *Six Persimmons* (Fig. 370) through variations of shape, value, and technique—outline for the two at each end, solid areas of ink for the others—and through calligraphic strokes of pure black that make each stem unique. This masterpiece of Chinese art demonstrates the great subtlety of observation that can be attained even in a highly abstract approach to still life.

Meticulous attention to the surface qualities of objects—their rough or smooth texture, their shininess, their transparency—remains one of the prime concerns of many still-life artists. *Oliva and Turitella* by Allan Jones (Fig. 371)

below: 370. Mu-Ch'i (13th century; Chinese). *Six Persimmons.* Ink on paper, 14½ × 11¼″. Daitoku-ji, Kyoto.

right: 371. Allan Jones 1915– ; American). *Oliva and Turitella.* Dry brush ink, 27¾ × 19⅞″. Chrysler Museum at Norfolk, Va.

exploits the beauty of shell forms and the complexities of a glass surface. Subtleties of transparency, sheen, and reflection have been handled with admirable effectiveness through the skillful use of dry brush ink.

Project 136 Shine, transparency, and translucence are perhaps the most subtle of surface qualities—as intriguing as they are difficult to render. *Arrange your own version of one of the following suggested compositions: (1) a half-empty jar of jelly beside a dirty spoon and slice of toast spread with jelly; (2) flower stems seen in a glass bowl of water; (3) a glass jar or bowl containing a mixture of glass objects, marbles, and stones. Analyze carefully the visual attributes of your subject, and attempt to develop personal techniques for rendering these difficult qualities. Rubbed graphite and pencil readily provide the value range required for such a study.*

Expanded Subject Matter

While our conception of appropriate subject matter for still life is apt to be limited to a group of small objects commonly found around the house, it can logically be extended to include larger pieces of furniture and other inanimate or "still" things. Thus, Ben Shahn's *Silent Music* (Fig. 69), which shows a group of music stands and chairs resting in intriguing disarray after the musicians have finished their performance and departed, would certainly qualify as a still-life subject. A desk with a melange of papers and writing materials also illustrates how broad is the range of interesting subject matter (Fig. 159). Even Sheeler's *Feline Felicity* could qualify as a still life, though certainly the cat might move at any moment (Fig. 195).

372. ROBERT SULLINS (1926– ; American). *Tom Ready's Store.* Ink and pencil, 24 × 18″. Chrysler Museum at Norfolk, Va.

373. John L. Doyle
(20th century; American).
War Belt. 1970. Graphite, $28\frac{1}{2} \times 23\frac{3}{4}''$.
Chrysler Museum at Norfolk, Va.
(Irene Leache Memorial Purchase, 1971).

Project 137 *Without changing the position of pieces of furniture in your room, study simple groupings through a rectangular viewfinder. Pick two or three compositions that you find appealing, and sketch in the medium of your choice. Beth van Hoesen's* Kitchen *(Fig. 368),* Towel and Chair *by Mark Adams (Fig. 201), Egon Schiele's* Desk *(Fig. 159) and the same artist's* Organic Movement of Chair and Pitcher *(Fig. 87) suggest some possibilities.*

To limit the field of potential still-life material by any rigid limitations reveals an academic and doctrinaire viewpoint. Despite the presence of Tom Ready, for instance, the drawing of *Tom Ready's Store* remains in essence a still life (Fig. 372). The artist has portrayed a fascinating array of strange objects and achieved great sophistication of surface texture. The shallow space of the composition and the shabby objects included remind one of Harnett's compositions (Fig. 362), but here the rich texture results from the handling of the media rather than through the skillful simulation of real surfaces.

In *War Belt* (Fig. 373) John Doyle has dramatized a vigorous and straightforward drawing by selecting an unusual object for depiction; we see that uniqueness of subject matter can provide as much interest as distinguished treatment of a familiar subject. Every drawing stands on its own merits, so one must indeed be cautious with generalizations about what comprises good still-life material.

Modern Trends

Still life has a conventional sound that suggests it might be impervious to modern trends, but this is certainly not the case. Contemporary artists bring to bear the myriad possibilities of their rich heritage, both past and present, from abstraction to superrealism, on this still vital area of subject matter.

left: 374. Odilon Redon
(1840–1916; French).
Yellow Flowers. c. 1912.
Pastel, $25\frac{1}{2} \times 19\frac{1}{2}''$.
Museum of Modern Art, New York
(bequest of Mary Flexner).

right: 375. Jacques Villon
(1875–1963; French).
Interior. 1950. Pen and ink,
with traces of pencil, $9\frac{1}{8} \times 6\frac{3}{4}''$.
Museum of Modern Art, New York
(John S. Newberry Collection).

Odilon Redon's *Yellow Flowers* (Fig. 374) appears to have been inspired by a bouquet on a table. From the initial real image, however, Redon developed a richly textured abstract pattern by leaving the unfused lines of pastel moving in a variety of directions. The unusual amount of animation in the study is augmented by the circular rhythm that holds the composition together. Jacques Villon's *Interior* is elegant, fresh, and light in mood (Fig. 375). Executed in open, textured cross-hatching, the volumes and forms play against one another in a beautiful, luminous ambience. A "now-I-can-identify-it-now-I-can't" ambiguity enriches the formal beauty of the design.

A *Sheet of Studies* by Picasso (Fig. 376) includes among the other sketches a charming still life of a table top, some fruit, and a bowl. Here distortions of perspective destroy the conventional flavor that such a subject would have if the treatment were more literal. Circular forms in the bowl, fruit, and the spindles of the table legs play against the rectangular shapes with piquant liveliness.

Advancing beyond the simple distortions of form and space illustrated in the Picasso drawing, Georges Braque's *Still Life with Letters* exhibits the strict organization of a true Cubist composition (Fig. 377). In its formal arrangement, three-dimensional space has been almost obliterated except as suggested by overlapping planes. These planes carry texture patterns inspired

above: 376. Pablo Picasso (1881–1973; Spanish-French).
Sheet of Studies. 1909. Pen, brush, and ink, $18\frac{5}{8} \times 19\frac{1}{2}''$.
Museum of Modern Art, New York (A. Conger Goodyear Fund).

below: 377. Georges Braque (1882–1963; French). *Still Life with Letters*. 1914.
Cut and pasted papers, charcoal, and pastel, $20\frac{3}{8} \times 28\frac{3}{4}''$.
Museum of Modern Art, New York (Joan and Lester Avnet Collection).

378. TOM WESSELMANN (1931– ; American).
Drawing Maquette for Still Life #59. 1972.
Pencil on Bristol board, mounted on cardboard, $7\frac{3}{4} \times 14 \times 5\frac{7}{8}''$.
Courtesy Sidney Janis Gallery, New York.

by the grain of wood, by letter shapes, and by a linoleum pattern; their surfaces are further enriched by charcoal and pastel lines and dots.

Project 138 *Examine the Picasso and Braque studies illustrated (Figs. 376, 377), and try your hand at a similar approach. (You may want to translate some of your more literal studies.) Do not simply copy the Cubist mannerisms. Try rather to understand the pictorial conventions that concerned the Cubists, such as the simplification of form to a geometric essence, the flattening of space in relation to the picture plane, and the concern with pictorial composition.*

Even the recent tendency to dissolve the time-honored demarcation between two-dimensional and three-dimensional art has found expression in the contemporary still life. As the measurements of Tom Wesselmann's *Drawing Maquette for Still Life #59* (Fig. 378) indicate, the work includes a three-dimensional base supporting and participating in the study. The drawn portions themselves are in pencil on Bristol board and cardboard. Ambiguity plays an ingenious role, for the eye cannot easily discern where real space exists and where spatial illusions are created through drawn shadows.

Project 139 *Create an "arrangement" or collage using one of your drawings in conjunction with studio equipment. As Wesselmann has done (Fig. 378), replace some of the actual implements with renderings. Concentrate on creating a unified whole in which the line movements, lights and shadows, colors, and textures mesh in a satisfying relationship. If you can photograph your arrangement, you will be able to judge its effectiveness with greater objectivity. The photograph will by its very nature weld the two-dimensional and three-dimensional aspects of the study into a single entity.*

SIX
Synthesis in Drawing

The concept of imagination is almost as difficult to understand and define as the dynamics of its operation are elusive. We know readily enough when imagination has been brought into play, and even more readily when it is absent. But just how this ephemeral quality functions remains something of a puzzle.

The *Oxford Universal Dictionary* defines imagination somewhat unimaginatively as "the power which the mind has of forming concepts beyond those derived from external objects." In our verbally oriented culture, conceptualization is a recurrent and largely automatic response to the abstract nature of language. A battery of acquired associations enables us to decode and interpret verbal and written symbols in individually meaningful terms. Each person has a certain uniqueness of viewpoint, because the living experiences of no two people are identical; consequently, everyone has the potential for some degree of imaginative activity. Translating imaginative potential into patterns of creativeness, like all other capacities, is developed and reinforced by habits of doing. A systematic approach to our discussion of imagination may help to introduce this phenomenon, which may well be the most important quality of the human mind. Imagination and creativeness are almost synonymous, except that imagination can function without any concrete results, as in daydreaming, whereas creativeness implies constructive action.

Imagination

The Elements of Imagination

The elements that comprise imagination are so diverse and so different in different people that we could not begin to describe them all. And even if we were to make an exhaustive list, adding all those factors together would still not approach the entire scope of imagination. Through imagination, for instance, fresh and unorthodox relationships are established between what appear to be unrelated fields of intellectual life. Just as anatomical study during the Renaissance yielded a most productive interaction between science and art (Figs. 259, 261–265), so today, through imagination, modern technology can stimulate fresh and original forms of artistic expression. In *First Look at the World's Weather* (Fig. 379) Nancy Graves created an original abstract pattern that suggests the impact of modern technology on the visual arts. There is no aspect of artistic expression in which the play of imagination is not necessary, for imagination fosters the heightened power of communication that characterizes the arts. Every person exhibits imagination to some degree, if only in the form of daydreaming. We develop the ability to transform imaginative potential into patterns of creativeness through doing.

In order to begin to understand how imagination works, we might isolate some of its aspects that are reasonably easy to categorize. Four of these are *empathy, fantasy, particularization,* and *generalization.*

379. NANCY GRAVES (1940– ; American).
First Look at the World's Weather. 1973.
Acrylic and India ink
on paper, 1'10½" × 5'.
Courtesy Janie C. Lee Gallery, Houston.

Empathy

The ability to empathize is basic to imaginative activity. It is characterized by the capacity to identify with the subject, to conceive and share feelings and experiences not readily evident in surface appearances, to perceive an emotional character even in inanimate objects, and above all to project this sympathetic attitude through the work of art. Empathy might also be described as the ability to externalize feelings; as such it enables the artist to give meaning to the commonplace, everyday aspects of the environment.

Project 140 As an illustration, think about how differently you might feel toward various kinds of dolls (rag, porcelain, and so forth) and stuffed animals. How would these feelings modify the way in which you might draw each? What conscious exaggerations of line movement, of light and dark, of texture would communicate your feelings more forcefully than would an objective drawing? Such intensifications represent means whereby we can communicate our unique insights (Fig. 380). *If you have difficulty in conjuring specific associations, select some of the following exercises as a point of departure:*

1. *Prop a rag doll or teddy bear in a position that best shows its softness and pliability. Draw your subject using either soft pencil or charcoal, rubbed and erased to emphasize three-dimensional form and texture; or use brush and ink in a free style with bold shading.*
2. *Pose a porcelain doll and carefully observe the delicate forms of its arms and legs and the patterns of its garments. Do a contour drawing in fine, hard pencil line. Give roundness to the porcelain parts by shading with powdered graphite, smudged on with fingers or cloth. Attempt another interpretation of the subject in pen and ink with wash.*

3. *Observe an old-fashioned tin soldier. Use fine pen lines for the initial outline and the delineation of features and clothing. With brush and ink (perhaps in colors), create solid areas of decorative tone. Try the exercise again, this time in felt-tip pen, alternating simple line for contour and detail with bold hatching for solid masses. For one last translation of your subject, etch the soldier in scratchboard.*

380. Beth van Hoesen (1926– ; American). *Dolls.* 1965. Ink, $9\frac{3}{4} \times 10\frac{7}{8}''$. Courtesy the artist.

381. HIERONYMUS BOSCH (1450–1516; Dutch). *Tree Man in a Landscape.* c. 1500.
Pen and brown ink, $10\frac{15}{16} \times 8\frac{3}{8}''$. Albertina, Vienna.

Fantasy

The ability to fantasize involves conceiving objects, as well as combinations
of and relationships between objects, that do not occur in the external world.
This is perhaps the most obvious aspect of imagination and most familiar to
the layman. Hieronymus Bosch's well-known *Tree Man in a Landscape* (Fig.
381) is a splendid example of this kind of pursuit, combining as it does elements

of plant, human, bird, fish, and insect forms. Familiar forms are assembled in a manner that violates all rational everyday relationships and thereby conjures a grotesque and ominous but fascinating world.

Project 141 *Draw a dream* (Figs. 382, 383). *Use free association, starting without preconceptions and improvising as you go along* (Fig. 64). *Employ a medium such as chalk, charcoal, or powdered graphite, which you can manipulate freely and from which lights can be erased.*

above: 382. SALVADOR DALI (1904– ; Spanish-French).
Composition of Figures of Drawers. 1937.
Brush and India ink on white paper, $21\frac{1}{2} \times 29\frac{7}{8}''$.
Fogg Art Museum, Harvard University, Cambridge
(gift of Dr. and Mrs. Allen Roos).

left: 383. ALFRED KŪBIN (1877–1959; Czech-Austrian).
The Serpent Dream. c. 1905.
Pencil, $9\frac{15}{16} \times 8\frac{1}{4}''$.
Albertina, Vienna.

Fantasy does not always assume such obvious forms. It can project changes in size from large to small or small to large on such a scale as to violate all conventional thinking. Thus Christo conceived of wrapping the Allied Chemical Tower in New York City with paper or plastic and tying it firmly with cord, as if to facilitate its transfer to another site (Fig. 384). As the catalogue to the Whitney Museum exhibition remarks, this fanciful drawing challenges and teases the viewer with an idea that will never be realized.

Fantasy can also depart almost completely from the world around us and move into a realm of playful improvisation. Paul Klee was an acknowledged master of this type of imaginative activity, as a glance at *A Balance-Capriccio* will confirm (Fig. 385). Fanciful forms, playfully assembled and executed in delicate pen lines, plus a lively variety of textures, work together to provide a fleeting glimpse into the subtle mind of this master.

Project 142 Much of the charm of *A Balance-Capriccio* (Fig. 385) rests in the sense that the balance of the forms seems as convincing and rational as the forms are irrational. *You might enjoy working with forms of a more solid nature than those employed by Klee; try, for instance, ink blots on paper. Make a great variety: spatters, smears, elongated runs, and so forth. Cut out the ones that please you and reassemble them in a pasted collage. Anthropomorphize the blots by adding eyes, ears, hands, and feet, and arrange these "figures" to create a vivid "nightmare."*

Particularization and Generalization

We have been discussing imagination as it relates to fantasy, dreams, and memory. The third and fourth forms of imaginative activity mentioned above represent opposite facets of the ability to "see" relationships, similarities, and differences; it is this capacity that enables us to classify, relate, and differentiate. Particularization means selecting the characteristic details that evoke the image of the whole. The caricaturist does this with remarkable effectiveness, individualizing a face by exaggerating unique features to the point where likeness and fantasy are poised in delicate equilibrium (Fig. 328).

Project 143 *Imagine how you would caricature a friend or acquaintance from memory. Be as unflattering in your assessment as possible, exaggerating every*

above: 384. CHRISTO (1935– ; American).
Packed Building
(*Project for Allied Chemical Tower, No. 1 Times Square*). 1968.
Pencil, charcoal, and color pencil, 8 × 3′.
Private collection, Paris.

right: 385. PAUL KLEE
(1879–1940; Swiss-German).
A Balance-Capriccio. 1923.
Pen and ink, 9 × 12⅛″.
Museum of Modern Art, New York
(A. Conger Goodyear Fund).

278 *Synthesis in Drawing*

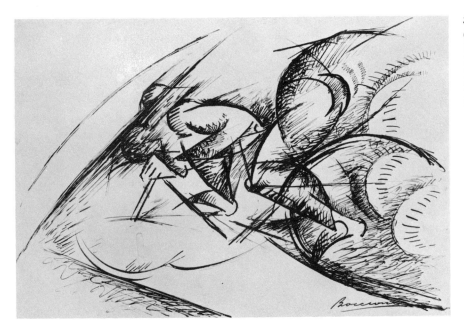

386. Umberto Boccioni
(1882–1916; Italian).
Study for "Dynamic Force of a Cyclist," II.
1913. Ink, $8\frac{1}{4} \times 12\frac{1}{4}''$.
Yale University Art Gallery,
New Haven, Conn.
(Collection of the Société Anonyme).

conceivably comical aspect: posture, squint, unbecoming clothes. Remember that your aim is to particularize, to stress unique features. Ball-point or felt-tip pen would be a good choice for this exercise. Neither medium can be erased and this can prevent logic from overwhelming imaginative freedom. *Be "scribbly," not neat.*

Another aspect of particularization is the ability to play with a fact of appearance until its character is most sharply defined and to communicate this with such intensity that the observer sees the object with the sensitivity of the artist. An etcher of distinction describes how she works:

> I do many sketches of a subject from life, often ten or more. . . . First, I do a general composition, then a studied 'in proportion' drawing. From this I do many line sketches to find a spontaneous line that feels more 'alive' than actual. This is the emotional part and it is rare that I can go back and correct it without spoiling the overall quality. I pin the sketches on the wall of the study and find the one that 'feels' the most! Then I spend much time in composing it, using strips of paper to decide the format—an eighth of an inch can make such a difference in space relationships. An originally vertical composition may become horizontal, but the drawing remains the same. I draw each leaf separately and am always amazed at their individuality. If I try to fill in from my knowledge they become stylized and don't work with the overall line quality. Each hair on a chest is special and I can't draw grass without knowing each blade.

Project 144 *Make a study of flower or leaf forms greatly enlarged. A close-up of a section of a flower or a cluster of leaves carefully rendered can lead to a rhythmic composition of great beauty. Rubbed charcoal works well for a black and white study; colored chalk or felt-tip pens for a color study.*

Generalization creates symbols that reveal relationships and similarities. The artist who discards individual idiosyncrasies of form to create a monumental symbol, as did Michelangelo with the human body, has this capacity (Fig. 259). Umberto Boccioni was intrigued with the idea of communicating a dynamic sense of movement through another mode of generalization—semiabstracted forms. In his study for *Dynamic Force of a Cyclist* (Fig. 386) he created an abstraction to symbolize speed and movement—the dynamic

elements of cycling. Much as a poetic phrase can condense into a few words a complex experience that would demand lengthy prose exposition, so here, through imagination, a complex time-space experience is compressed into a potent abstract pattern. See also Plate 20 (p. 263).

Project 145 Analytical and inventive capacities must work together to achieve such imaginative compression. *Think of a form that conveys the interdependence of man and machine. Or conceive a mask to symbolize beauty, introspection, tranquility, or anguish* (Fig. 387).

Now do a drawing to fit the title "Me and My Automobile." Begin by assessing yourself. (Are you fat, thin, male, female, black, white?) Using a medium with which you are familiar, draw a schematic symbol that you feel correctly symbolizes your unique character. Do the same for your automobile, or the automobile of your dreams. Do not draw the actual object; symbolize it. Fuse these two images, yourself and your automobile, by either cutting them out and arranging the pieces on a new surface, or reworking both in a revised composition.

Composition

Selection and emphasis also play an important role in imagination, and to a great extent these are controlled by composition. Figures 388–391 show four possible arrangements that might be employed by an artist drawing a tree upon a hilltop. If the hilltop is placed high on the page with the tree small against the sky, one immediately senses the long slope of hill, the hilltop profile interrupted by the accent of the tree (Fig. 388). Placed low on the page, the hilltop and tree convey a sense of the vastness of the sky, its unbroken expanse emphasized by the sinuous line of the hill and the undulating broken surface of the earth (Fig. 389). Perhaps the artist is impressed by the massive strength

387. Marlene Rothkin (20th century; American). *Psychic Self-Portrait.* c. 1970. Oil on paper, 29 × 23″. Courtesy the artist.

top: 388. DANIEL M. MENDELOWITZ
(1905– ; American). *Oak.*
Nylon- and ball-point pen, 6 × 7½″.

left: 389. Revised composition of Figure 388.

below left: 390. Revised composition of Figure 388.

below: 391. Detail of Figure 388.

of the tree, and so draws it close up, placing it in the middle of the page, stressing the weighty trunk and the powerful branches by allowing the central mass of the tree to fill the entire page (Fig. 390). Or the artist may be most concerned with the way the prevailing winds have shaped and broken the branches, therefore selecting a portion of the tree in which strong diagonal and horizontal lines dominate the composition, while the absence of other than a few scattered masses of leaves suggests the wind-torn struggle for existence that has given the tree its particular character (Fig. 391). Here high placement, low placement, close-up, and still further close-up indicate selection and emphasis of the aspects of the tree that attracted the artist. Imaginative play with various compositional arrangements made possible Figure 390, the drawing most satisfying to the artist and thus most expressive of the artist's insight.

Imagination also frees the artist to manipulate the sketches that are essentially raw material, to rearrange the parts to satisfy a personal compositional sense or expressive desires. In *Cows* (Fig. 392) Beth van Hoesen sketched a group of cows quietly resting while chewing their cuds. Such a sketch may satisfy the artist as is or provide the material from which other arrangements are derived. A single pair of cows might be separated from the group and placed against a grassy hill topped by a bit of fence (Fig. 393). This arrangement emphasizes the bovine heads and bony skeletons. A second, strikingly vertical composition could be made by selecting two groups of resting cows and separating them by the fence, thus creating an impression of movement into deep space (Fig. 394). The sense of space might then be emphasized by suggesting background fields topped by distant hills. If one were using a sketch as the basis for a print or painting, one might thus experiment with the original material to ensure the most satisfying arrangement before proceeding with the more finished work of art.

Project 146 Imagination involves a flexibility of viewpoint as well as the capacity to invent freely. *Choose a topic such as "Picnic under a Tree," "Reading in the Garden," or "Swimming." Make two or three preliminary drawings in soft pencil on tracing paper and reassemble the parts of the drawings in ways suggested in the previous two passages (Figs. 388–394). Try a number of combinations and placements of your elements. When you find the relationship that satisfies you, cement the pieces in place and trace the unified drawing which you have composed.*

Imagination and the Art Elements

We have just seen a variety of drawings in which some aspect of the external world provided a point of departure for an imaginative interpretation of experience. The art elements can in themselves provide inspiration, for a line, a texture, or a pattern can also stimulate imaginative activity. Paul Klee

opposite: 392. BETH VAN HOESEN (1926– ; American). *Cows.* 1970. Pencil, 9 × 12″. Courtesy the artist.

above: 393. Revised composition of Figure 392.

right: 394. Revised composition of Figure 392.

created a charming ink drawing, *Costumed Puppets* (Fig. 395), which appears to have been inspired by a source other than observing puppets. Close examination reveals this drawing to be made almost entirely from lines that begin and end in spirals. One can visualize Klee entertaining himself by seeing how many such lines he could use to construct parts of the human anatomy or costume details, improvising playfully almost in the spirit of doodling.

As in all of Klee's works, the formal and abstract factors interplay continuously with evocative and poetic elements (Figs. 107, 250, 291, 323, 357, 385,

395). Thus, though his initial inspiration may have been lines beginning and ending in spirals, and though we may be fascinated by the ingenuity with which Klee fitted the spirals together to make the doll-like figures, the completed work evokes a sense of the whimsical and droll gaiety of puppets. The titles of his works, the works themselves, and his diaries all reveal imaginative play of exhilarating variety and sensitivity. Klee saw relationships between remote and previously unrelated objects, as the depths of his subconscious mind fed the artist's capacity to generate fanciful and unexpected affinities. The faded, pastel colors of an old cloth, a certain kind of line, or some unusual texture might provide the initial stimulus, after which his imagination, moving in its own oblique and unpredictable trajectory, made illuminating contacts with the cityscape, the landscape, the world of music, literature, the theater, or other of his many areas of intense enthusiasm.

Imagination can, of course, operate on a purely abstract and formal level and remain there. In a small untitled ink drawing by Kandinsky, forms appear to have been improvised essentially in terms of contrasts of shape, texture, and value, but without any desire to relate these formal aesthetic elements to the external world (Fig. 396). Thus, big sweeping curves on the right contrast with the small tight curves on the left. Curves play against rectangular forms, triangles balance precariously or hang. Textures appear scribbled, ruled, vertical and horizontal, and values range from solid black to sharp white.

Imagination and Temperament

Viktor Lowenfeld, one of the most systematic students of the development of pictorial expression, perceived that various types of personalities reacted to visual experience in different ways. Lowenfeld theorized that there are two main types of expression that represent two extreme poles of artistic personality: the *visual* and the *haptic*. Visual people concern themselves primarily with the visible environment. Their eyes constitute their primary instrument for perception, and they react as spectators to experience. Haptic or nonvisual people, on the other hand, relate their expression to their own bodily sensations and the subjective experiences in which they become emotionally involved; they depend more on touch, bodily feelings, muscular sensations, and empathic responses to verbal descriptions or dramatic presentations. Quite obviously, the temperament—the predominant personality type—of the artist will seriously affect the way imagination is brought to bear. To illustrate this point, we might compare two artists, Edgar Degas and Vincent van Gogh, as characteristic examples, respectively, of visual and haptic personalities.

Edgar Degas made the depiction of forms in movement—whether in the home (Pl. 3, p. 59), the street, the cafe, the theater (Fig. 35), or the race track (Fig. 42)—a major concern of his work, and the visual "truth" of his pictorial statements gives ample evidence of this concern. In *Groupe de Danseuses Vues en Buste* (Fig. 35), his sharp eye and trained hand recorded with unerring certainty and remarkable economy the subtle nuances of gesture, balance, and form. Degas' freest sketch is controlled; the lines never live for their own sake but exist only to describe. Thus the scribbled shadow-contour that defines the raised forearm at the upper left never oversteps its descriptive function to become simply a flourish.

By contrast, the direct passion with which Van Gogh worked shaped a style of enormous expressive intensity. Van Gogh seems to feel each surface he describes in physical terms; he empathizes with each roughness, smoothness, as well as each movement beneath the surface (Figs. 106, 178, 219, 340). In comparison to Degas' restrained and objective approach, Van Gogh's style seems positively frenetic.

397. Jasper Johns (1930– ; American). *Numbers.* 1960.
Charcoal on paper; 3 of 10 drawings matted separately, each $2\frac{3}{4} \times 2\frac{1}{4}''$.
Courtesy Leo Castelli Gallery, New York.

Almost no one is completely visual or completely haptic in orientation, and, more than ever before in history, contemporary artists are exploring the environment through senses and sources other than their eyes. In drawing a figure, a contemporary artist might wisely assume the pose he or she wishes to depict, feel its tensions in the back, head, leg and arm positions, perceive the distribution of weight and balance or stress of the posture (p. 208). In seeking to render the texture of a subject, an artist might supplement visual perception with actual tactile experience. To the degree that one remains receptive to a wide variety of stimuli, a rich and diverse imagination develops.

Improvisation

Imaginative play in artistic expression can take the form of improvising on a simple and familiar motif. In his ten *Numbers* (Fig. 397) Jasper Johns has enriched the simple Arabic numbers by playful texturing of background areas. Almost any familiar shape or object can provide the subject for visual improvisation, in the same way that a simple melodic theme can initiate elaborate musical invention.

Project 147 *Select an object, pattern, or symbol from a source you do not ordinarily think of as artistic material—the supermarket, the newspaper, a car wash (Fig. 398), or an airport (Fig. 399)—and see in how many ways you can imagine using this as subject matter for a composition; or in how many ways you might treat it to express various experiences or feelings associated by you with this theme. Translate a sound effect—a ringing telephone, chimes, or some favorite piece of music—into patterns.*

Project 148 Doodling is an imaginative activity and can function as a stimulus to creativeness (see pp. 34, 39–41), as can choosing a line, texture, form, or pattern from an existent work of art. Cracks on plaster walls, the patterns on stained walls, a string dipped in ink and dropped on a piece of paper (Fig. 400), ink blots, and rubbings can also provide starting points for aesthetic

398. ROBERT BECHTLE
(1932– ; American).
Rainbow Carwash. 1967.
Pencil and watercolor, $14\frac{1}{2} \times 23''$.
Courtesy John Berggruen Gallery,
San Francisco.

left: 399. BETH VAN HOESEN
(1926– ; American).
Airport. 1970.
Pencil, $10\frac{3}{4} \times 13\frac{7}{8}''$.
Courtesy the artist.

below: 400. Doodle. String and ink
on pebbled mat board, $4 \times 5\frac{1}{2}''$.

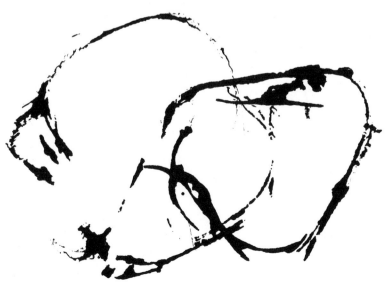

Imagination **287**

401. ANDRÉ MASSON (1896– ; French).
Birth of Birds. 1925. Pen and ink, $16\frac{1}{2} \times 12\frac{3}{8}''$.
Museum of Modern Art, New York.

above: 402. CHARLES BURCHFIELD (1893–1967; American).
Nostalgia. 1917. Pencil, $12 \times 9\frac{1}{2}''$.
Collection Mrs. Walter Ferris, Wilmington, Del.

below: 403. GEORGES MATHIEU (1921– ; French).
Untitled. 1958. Brush and white ink on black paper, $25\frac{5}{8} \times 39\frac{1}{4}''$.
Museum of Modern Art, New York (John S. Newberry Collection).

creation. Any concept or experience that stimulates you to draw acts as a legitimate and important resource for artistic activity (Fig. 401).

Study Kandinsky's untitled drawing (Fig. 396). It is in essence an elaborated doodle. Working with one of your own doodles, consciously add a variety of textures to the original forms. Increase the sense of depth, solidity, or the suggestions of identifiable objects.

Imagination and Emotion

A most subtle function of imagination lies in giving form to feelings and emotional states that rest deep within the psyche below the level of verbalization. This province of artistic activity has its most readily recognized expression in music, but drawing and painting provide a parallel avenue of expression in visual form. Charles Burchfield's *Nostalgia* (Fig. 402), for example, is a charming pencil drawing from his early years, which projects a tender yearning to reexperience the dreams, fears, and fantasies of childhood. Georges Mathieu's untitled drawing (Fig. 403) evokes the feelings of joy and vitality in a form far more powerful than an illustration of a joyful or ecstatic human action would be. In addition, the drawing possesses a more universal appeal. Here feeling is given a pure expression that any person might share, while a more concrete visualization would demand a parallel experience on the part of the observer and therefore limit the possible strength of shared emotion. In Gustav Klimt's design for a project entitled *Philosophy* (Fig. 404), we

404. GUSTAV KLIMT (1862–1918; Austrian).
Study for "Philosophy." 1898–99.
Black chalk and pencil, $35\frac{5}{16} \times 24\frac{7}{8}''$.
Kunsthistorisches Museum, Vienna.

right: 405. ROBERTO MATTA
(R. M. Echaurren; 1912– ;
Chilean-French).
Untitled. 1939.
Crayon and pencil, $19\frac{5}{8} \times 25\frac{1}{2}''$.
Collection Mr. and Mrs.
Joseph Pulitzer, Jr., St. Louis, Mo.

below: 406. Anonymous, aged 5.
Mask. c. 1945.
Plasticine and metal parts, $2 \times 2\frac{1}{2} \times 2''$.
Collection the author.

unexpectedly encounter dream or subconscious images depicted in an emotionally expressive manner that belies the title. A crayon-and-pencil drawing by Roberto Matta (Fig. 405) assembles a number of curious semiabstract patterns that cannot be identified specifically but that nevertheless communicate a sense of visceral, slippery, almost repellent organic forms—alive, sensual, and fascinating. Because the creatures of the drawing challenge almost nonverbal depths of feeling, they convey a fresh dimension of experience.

Imaginative Use of Media

Imagination manifests itself in how, what, and with what one draws. The imaginative person thinks of unconventional uses for materials, or unorthodox combinations of media, and extends the limits of technique by invention. Given a piece of chalk, for example, the imaginative artist might use the end—sometimes sharp, sometimes blunt—or the side, twisting it so that the stick alternately makes soft smears and sharp edges; one might rotate it on the paper, crumble it, and then smear the crumbs to create granular and blotchy effects, or rub the applied chalk with smooth cloth, with a heavily textured material, with corduroy to create striped textures. The artist may experiment with using the chalk on different types of paper, with various erasers, or with placing boldly textured materials under the paper so that the drawing assumes some of the textural pattern of the underlying material. Such a person will be equally imaginative about inventing situations in which these effects can be used for expressive purposes.

Project 149 *Try drawing with the hand you do not ordinarily use.* Drawing with the left hand, assuming you are right-handed, develops new linear and textural qualities, since the habits of hand movement that have become integral to the drawing act are disrupted. The result will undoubtedly prove less skilled, but a valuable, vital freshness may ensue.

Traditional concepts of "correct" methods for using or combining materials may inhibit—by defining too strictly the boundaries of acceptability—the imaginative exploration that discovers new art forms. Children are rarely hindered by such artificial constraints, and from their artwork mature artists

407. DAVID HAMMONS (1943– ; American).
Injustice Case. 1970.
Mixed media body print, 5′3″ × 3′4½″.
Los Angeles County Museum of Art
(Museum Purchase Fund).

can take refreshing inspiration. A plasticine mask constructed by a precocious
five-year-old many years before the concept of "mixed media" gained wide-
spread popularity takes its fearsome image from incorporated screws, bolts,
and other metal objects and their impressions in the maleable base material
(Fig. 406).

A bold imaginative leap in the exploitation of media was required of
David Hammons to conceive his *Injustice Case* (Fig. 407). The artist used his
entire body and the chair to which he was bound as another artist might print
an etching plate or lithographic stone. Covering his body with paint, ink, and
other art materials, then pressing the entire ensemble to a piece of paper,
he created a unique protest against injustice. Both the scale of the print and
its content contribute to the power of the image.

Unusual mixtures of media often result in unexpected patterns and textures.
A fascinating and highly effective visual quality was devised by Théodore

Géricault in his *Ancient Sacrifice* (Pl. 21, p. 264). Here pen and brown ink combined with gouache on oiled paper yield a strange and unique drawing. Highlighted body surfaces projecting from the background gloom convey a heightened sense of mystery appropriate to the ancient rite. The almost viscous texture created by the puddled gouache suggests dried blood and evokes the atmosphere of a strange and unholy ritual. The heavy dull color reinforces the prevailing somber atmosphere. Géricault showed his powerful imagination by the subtle way in which he used materials that were not miscible.

Artists have been encouraged to explore new uses and combinations of materials by the great expansion of artists' media that has resulted from modern technological developments. Plastic paints, metallic paints and papers, synthetic pigments, cellophanes, new types of inks and pencils—all challenge the artist's inventive powers. The iconoclasm of the early 20th-century Dadaists and the consequent introduction of nonartistic objects and materials into the pictorial matrix also stimulated artists to explore the potentialities of unorthodox materials, so that what started as a derisive gesture resulted in an enlarging of the artistic vocabulary. Thus, collage and assemblage, where junk, discarded objects, and materials from everyday life are incorporated into and become part of a painting or piece of sculpture, has also extended and broadened the practice of drawing. In his *Battle of Fishes* (Fig. 253) André Masson has used oil, pencil, sand, and other unconventional materials on canvas to create more interesting textures than can be achieved by restricting the use of oil paint to traditional applications.

Project 150 *Gather new (to you) or unusual materials that you think have decorative possibilities. Pick a lively subject—"Mexican Market," "Holiday Festivities," "Parade"—and compose an abstraction. Make your colors, patterns, and compositional movements express the festive atmosphere.*

The abundance of new materials and the inventive attitude toward techniques so characteristic of today is not an unmixed blessing. An undue concern with invention, with new materials and techniques, can mitigate against more profound expressive concerns. It is easy to become enamored of surface qualities without giving sufficient thought to the deeper levels of interpretation and meaning that constitute the major significance of works of art. It is also possible to flit from one fascinating material to the next without ever fully exploring the potential of any one. However, a period of exploration and experimentation is necessary for every artist, because only by such a process does one find the materials best suited to one's individual temperament.

Whether you draw only for your own fulfillment or for a potential audience, you are inevitably creating something unique, something that never existed before. In a world made increasingly uniform by communications and technology, the very direct, personal art of drawing holds more appeal than ever before.

Conclusion

The creativeness that marks every human activity—whether in the arts, the sciences, or simply in the day-to-day events of living—sometimes coalesces to form those pinnacles in history that we identify by such names as "Renaissance," "Industrial Revolution," or "Technological Age." Yet no era has been devoid of creative energy, and no individual lacks the ability to create. Some people cook or dress creatively, others write, draw, paint, compose music, or do scientific research. In our appreciation of the genius in a Rembrandt, a Michelangelo, or a Picasso, we must not forget the contributions of untold millions who have helped make our world the diverse, exciting place it is.

Index